ET SVPER HANC PETRAM

POPE
FRANCIS

POPE
FRANCIS

FATHER MICHAEL COLLINS

Penguin Random House

This book is dedicated with infinite love and gratitude to my mother, Helen, who has always been a wonderful support and tower of strength.

Senior Editor Georgina Palffy
Senior Art Editor Gillian Andrews
Editors Helen Ridge, Carey Scott
Editorial Assistant Stuart Neilson
US Editors Christine Heilman, Margaret Parrish
Designers Stephen Bere, Bobby Birchall, Saffron Stocker
Special Photography Fotografia Felici
Picture Research Renata Latipova
Additional Picture Research Sarah Hopper, Jenny Faithfull
Managing Editor Gareth Jones
Senior Managing Art Editor Lee Griffiths
Publisher Liz Wheeler
Deputy Art Director Karen Self
Publishing Director Jonathan Metcalf
Art Director Phil Ormerod
Senior Jacket Designer Mark Cavanagh
Jacket Designer Suhita Dharamjit
Jackets Coordinator Claire Gell
Managing Jackets Editor Saloni Singh
Jacket Design Development Manager Sophia M.T.T.
Senior DTP Designer Harish Aggarwal
Pre-production Producers Ben Marcus, Gillian Reid
Senior Producer Mandy Inness

First American Edition, 2015
Published in the United States by DK Publishing
345 Hudson Street, New York, New York 10014

Copyright © 2015 Dorling Kindersley Limited
A Penguin Random House Company
Fotografia Felici photographs copyright ©
Fotografia Felici S.n.c. 2015

15 16 17 18 19 10 9 8 7 6 5 4 3 2 1
001—285000—Aug/2015

Published in Great Britain by Dorling Kindersley Limited.

A catalog record for this book is available from the Library of Congress.

ISBN: 978-1-4654-3983-3

DK books are available at special discounts when purchased in bulk for sales promotions, premiums, fund-raising, or educational use. For details, contact: DK Publishing Special Markets, 345 Hudson Street, New York, New York, 10014 or SpecialSales@DK.com.

Printed in Hong Kong

A WORLD OF IDEAS:
SEE ALL THERE IS TO KNOW

www.dk.com

CONTENTS

PREFACE

Addressing his fellow cardinals shortly before the conclave that would elect him pope, Jorge Bergoglio offered a short meditation. He compared the Church to the moon: when, like the moon, the Catholic faith reflects the light of the Son of God, all is well; when, however, the Church thinks it has the light within itself, it falls into the trap of narcissism.

For this reason, Cardinal Bergoglio asserted, the Church has to reach out continuously to the margins of society. It is here, among the oppressed, the poor, and the marginalized, that the message of Jesus of Nazareth is revealed once again.

True to his word, when the choice of the cardinals fell on him, Pope Francis sought out the margins. His first trip outside Rome was not to a splendid city but rather to a small island off the coast of North Africa, home to thousands of migrants and refugees. Apart from the comfort he offered to them and his gratitude for the islanders' hospitality, he also turned the spotlight of the world's media on the scandal of human trafficking. During his visits to Roman parishes, meanwhile, Pope Francis spends more time in the soup kitchens and the encampments of illegal migrants than with materially more fortunate parishioners.

"Jorge, do not change, continue to be yourself, because to change at your age would be ridiculous," he told himself immediately after his election. He continued, therefore, doing many of the things he had done for years, and, admitting that administration was not his strong point, he assembled a group of nine cardinals to help reform the Roman Curia.

For many, Pope Francis's unpredictability is part of his charm, but for some it is a source of exasperation. He happily breaks protocols that have surrounded the papacy for years, and is at his most relaxed in the company of ordinary people. He regularly departs from, or dispenses with, official scripts, recounting anecdotes and dispensing pithy, down-to-earth advice. He calls people who have written to him and chats with them about their problems.

This variability has sometimes courted trouble. His expressions do not always translate well into other languages or cultures, although people generally understand the Pope's meaning and appreciate his sincerity.

So what are the passions that drive Pope Francis? The answer is evident. He believes in the truth of Jesus. A flash of Latin temper will break out when he talks of the oppression of people, notably the abuse of the most vulnerable in society. He is vocal in his desire to broaden the role of women in the Church, and he shows great compassion toward those who struggle with various aspects of Christian life. People across the world are fascinated to see how this first Jesuit pope will impact the Catholic Church.

The photographs of Pope Francis in this book have been assembled by the Felici Studio in Rome. By showing formal ceremonies in the Vatican as well as impromptu encounters with ordinary people, they offer a unique glimpse of the Pope's life as he moves through the year.

Michael Collins

July 2015

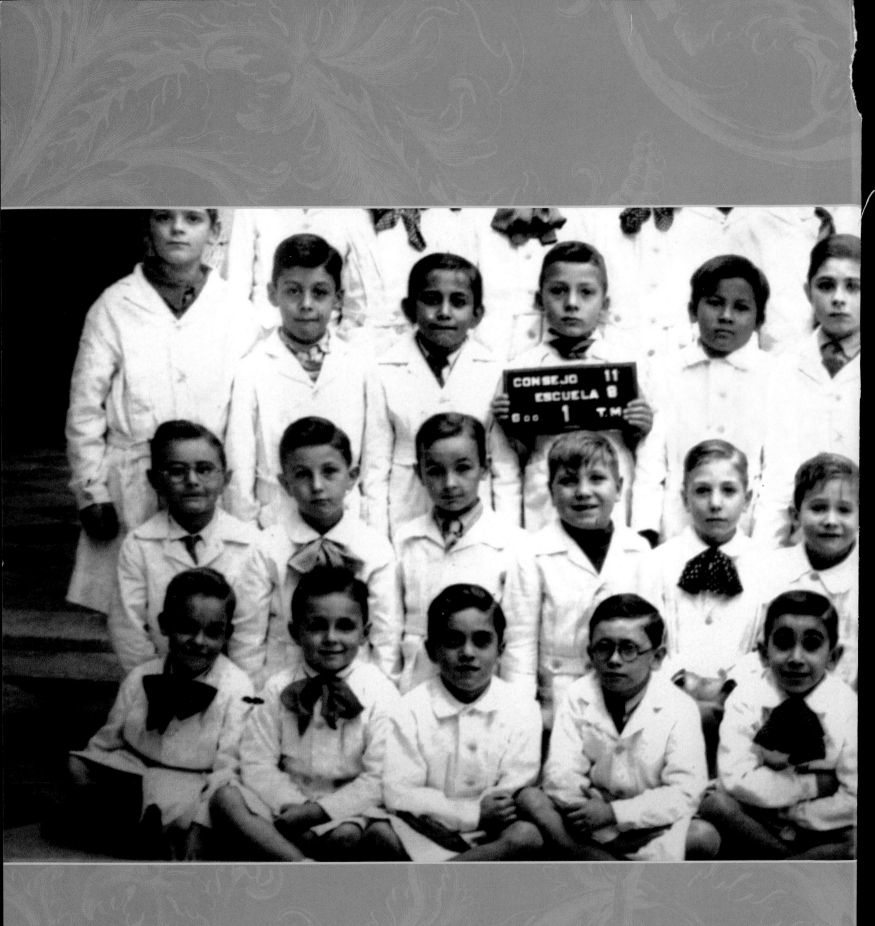

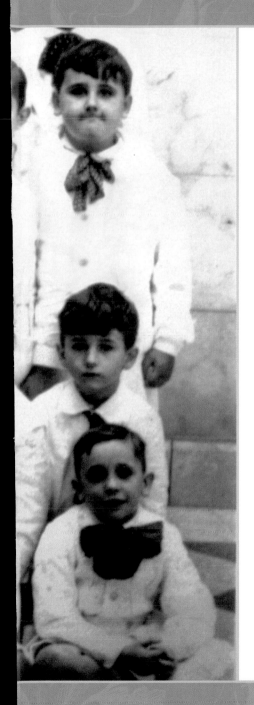

INTRODUCTION

 ## PATH TO THE PAPACY

On March 13, 2013, Cardinal Jorge Mario Bergoglio, Archbishop of Buenos Aires, was elected to the papacy, becoming the first Pope Francis. Also the first Jesuit pope in the history of the Catholic Church, and the first-ever pope from the Americas, Cardinal Bergoglio was largely unknown to most of the world's 1.2 billion Catholics, for he had avoided public attention throughout his life, instead dedicating himself to the pastoral care of the people of his native Argentina. To those in his diocese, he was known for his humility in the service of the poor, the sick, and the marginalized in the slums of Buenos Aires, and for his modest lifestyle—he chose to travel on foot or by bus and subway around the city. These are the qualities that have made Pope Francis (front row, far right in his elementary school class photo, opposite) one of the most popular of popes, endearing him to millions of people around the globe.

THE ELECTION IN 2013 OF A POPE FROM LATIN AMERICA WAS HAILED AS A BREAK WITH CENTURIES OF TRADITION. YET, ALTHOUGH POPE FRANCIS WAS THE FIRST-EVER POPE TO BE ELECTED FROM OUTSIDE EUROPE, HIS ANCESTRY WAS DEEPLY ROOTED IN ITALIAN SOIL. ROSA AND GIOVANNI BERGOGLIO, THE GRANDPARENTS OF THE FUTURE POPE, JORGE MARIO BERGOGLIO, HAD SET SAIL FROM ITALY FOR ARGENTINA IN JANUARY 1929 ALONG WITH THEIR 24-YEAR-OLD SON MARIO. FASCISM WAS THEN ON THE RISE IN ITALY AND THE BERGOGLIO FAMILY HOPED TO MAKE A FRESH START IN THE NEW WORLD.

 The Bergoglio family settled in the Argentinian capital, Buenos Aires, a city with a large migrant population, of which the biggest group was Italian. Three of Giovanni Bergoglio's brothers had already settled in Argentina, where they ran a paving company. Although affected by the economic depression of the 1930s, their business survived the crisis. Mario Jose Bergoglio, a trained accountant, found employment with the railroads.

In 1934, Mario met Regina Maria Sivori, and the two were married on December 12 the following year. Their son Jorge, the first of five children, was born on December 17, 1936. Jorge was just 13 months old when his mother gave birth to his brother Alberto Horacio. Grandparents Rosa and Giovanni offered to help look after the children. Jorge later recalled with fondness how it was through his grandparents that he learned his faith and the Italian language.

The family was completed with the birth of three more children, Oscar Adrian, Marta Regina, and Maria Elena. The children's upbringing was typical of migrants of that time. They were educated by religious sisters, the Daughters of Our Lady of Mercy, at the Colegio Nuestra Señora de la Misericordia in the Flores neighborhood where they lived.

The Bergoglios maintained much of their Italian heritage through their language, faith, and traditions. Along with other Italian families, they regularly attended religious festivals and processions and, with his father, the young Jorge joined the local parish soccer team of San Lorenzo. Each weekend, father and son attended soccer and basketball games. Here, Jorge's lifelong passion for sports began.

BERGOGLIO'S VOCATION

At the age of 17, Jorge considered a vocation in the priesthood, but postponed the decision in order to continue his education. He gained a university degree in chemistry and worked as a technician for a few years before joining the Diocesan Seminary of Buenos Aires in the Villa Devoto region. While studying there, Jorge developed pneumonia and underwent an operation on his lung to remove three cysts.

▲ WEDDING BELLS
Mario Jose Bergoglio and Regina Maria Sivori on their wedding day, December 12, 1935. The couple married after a year's courtship.

After three years at the seminary, Bergoglio decided to become a Jesuit and, on March 1, 1958, he entered the Society of Jesus. Bergoglio was interested in Eastern cultures and hoped to become a missionary in Japan. In the end, this ambition was not realized as his superiors felt that his lung operation had left him too delicate for the travel involved.

The Jesuit Order, founded by St. Ignatius Loyola in the 16th century, emphasized the education of young people and the development of a strict moral life. Over the centuries, it had become one of the most prominent and successful religious orders in the Catholic Church. Jesuits train for a period of between eight and 14 years.

Jorge and his companions spent their novitiate, or initial preparation period, studying spirituality in the town of Córdoba. In 1959, a year after entering the order, Jorge suffered the first major bereavement of his life when his grandfather Giovanni died from a sudden heart attack.

On March 12, 1960, Jorge took his vows of poverty, chastity, and obedience, returning to Argentina in 1963 to graduate with a degree in philosophy from the Colegio Máximo de San José in San Miguel. From 1964 to 1965 he taught literature and psychology at Jesuit high schools—he had developed a deep interest in Latin American literature—and from 1967 to 1970 he studied theology and obtained a further degree from the Colegio de San José.

ORDINATION

Jorge Bergoglio was ordained a priest on December 13, 1969, four days before his 34th birthday. A few weeks later, he set off for Madrid, where he completed the last stage of his spiritual formation, known within the order as tertianship. This is a one- or two-year period of strict discipline before taking the final vows. The journey to Spain was Bergoglio's first trip to Europe.

At the time, the Catholic Church was full of energetic enthusiasm following the Second Vatican Council, a meeting of the world's bishops held between 1962 and 1965 that addressed contemporary issues for Catholics and all humanity. The meeting, convened by Pope John XXIII (1958–63),

THE EARLY YEARS

BERGOGLIO'S JOURNEY FROM BUENOS AIRES TO ROME

had fostered the hope of unity between the main Christian Churches and improved relations with Judaism and other world religions. Soon, however, divisions between Catholics themselves slowed down the pace of change.

In 1972, Father Bergoglio returned to Argentina, where he took charge of the novitiate, or training center, for young Jesuits at which he himself had trained. He was strict, yet well-liked due to his sense of humor and willingness to share tasks such as laundry duty and cooking with the students. In the following year, on April 22, 1973, Father Bergoglio made his "perpetual profession" and became a full member of the order.

JESUIT PROVINCIAL

Just three months later, the young Jesuit received a surprise promotion when, on July 13, 1973, Father Pedro Aruppe, General of the Jesuits, made him Provincial Superior of the Society of Jesus in Argentina. Bergoglio was now responsible for the Argentinian province, which consisted of 15 houses, 166 priests, 32 religious brothers, and 20 students. Bergoglio also became the link between the Jesuits in Argentina and their headquarters in Rome. He would hold this position for six years, until 1979.

Bergoglio traveled extensively to meet the Jesuits throughout the province, but it was not an entirely positive experience. There was a deep division within the Jesuits—and other religious orders—following the Second Vatican Council. Some were in favor of modernizing elements of Church discipline, while others preferred to retain the status quo. Bergoglio himself was on the conservative side. Even though he had been a member of the order for 14 years, several members did not appreciate his youth and resented his approach to problems. On August 1, 1974, Jorge's grandmother Rosa died at the age of 90. This was a deeply felt loss. His grandfather Giovanni had died a decade earlier, so both of the key figures of Jorge's childhood had now passed away.

CRISIS AND CONFLICT

While the first three years of Bergoglio's stewardship had been marked by tensions within the order, the rest of his mandate coincided with a brutal period of political and social upheaval in Argentina. In 1976, President Isabel Perón was overthrown during a military coup. A junta (a government led by a committee of military leaders), headed by General Jorge Videla, seized power.

The junta executed activists and political opponents of the military dictatorship (estimates range from 13,000 to 30,000), many of whom simply "disappeared," in what has become known as Argentina's Dirty War.

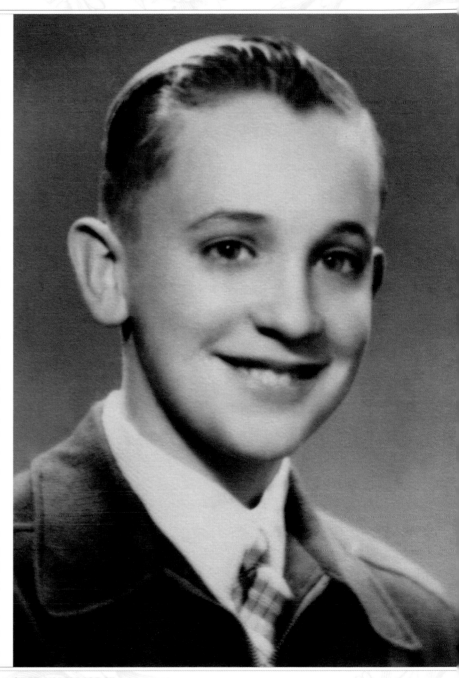

⌃ THE YOUNG JORGE
This photograph, though undated, shows the young Jorge Mario Bergoglio at about age 11, while he was a pupil in the Don Bosco school.

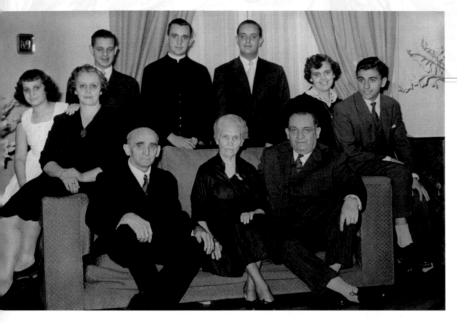

< A FAMILY GATHERING
The Bergoglio family with grandparents
Giovanni and Rosa, seated between parents
Mario and Regina Maria, at an informal
gathering. Jorge is back row, second from left.

Father Bergoglio also offered his services in the nearby parish of San José, in the district of San Miguel. He celebrated Mass, heard confession, and taught catechism to local children. He was no longer involved in the administration of the order, a welcome relief after the violent and traumatic years of Videla's military dictatorship, which finally ended in 1983.

In 1986, Father Bergoglio finished his term as rector at the college and traveled to Frankfurt, Germany, to prepare for a doctorate in theology. He never completed it, returning instead to Argentina, where he was appointed first to teach at the Colegio del Salvador in Buenos Aires, and then as spiritual director and confessor at the Jesuit church in the city of Córdoba.

BISHOP OF BUENOS AIRES

At this time, the archbishop of Buenos Aires, Cardinal Quarracino, needed an auxiliary bishop to assist him in the administration of the diocese, which numbered two and a half million Catholics. He discussed this idea with the papal nuncio (an ecclesiastical diplomat), Archbishop Calabresi. On May 13, 1992, Bergoglio met the nuncio at an airport, seemingly by chance, and they exchanged a few words. As the flight was called the papal diplomat took his leave. "One last thing," he said casually. "You have been named auxiliary bishop of Buenos Aires and the appointment will be announced on the 20th."

The stunned Jesuit could not understand why he would be summoned from obscurity to be a leader in the Argentinian capital, but Cardinal Quarracino had heard of Father Bergoglio's qualities and believed that as a native, or *porteño*, he was a good choice for the multicultural capital. Accordingly, on June 27 that same year, Bergoglio was ordained a bishop in the Cathedral of Buenos Aires and was assigned to one of the five episcopal areas of the capital.

He instituted changes immediately. Rather than reside in the comfortable surroundings of the diocese, he lodged with his fellow Jesuits, and preferred to walk the streets and travel the city by bus or subway rather than be driven around it by car. And so, Bishop Bergoglio soon became a familiar figure to the people of the city as he went about his daily life.

His style of decision-making was also different from his predecessors. Although final decisions ultimately lay with him, he listened to his advisors and to the people.

The regime brought disharmony within the Church, too. While many priests and religious sisters allied themselves openly with the dissidents, others tacitly supported the de facto rulers. Priests who supported rebels—or even those who sought to improve social conditions—became targets of intimidation. Several were murdered by the regime, joining the ranks of the disappeared.

Father Bergoglio found himself caught in the political crossfire. He urged his fellow Jesuits to be prudent and not to get involved in political resistance, but he helped many to escape the purges led by the junta. When two of Bergoglio's former professors were captured, he negotiated behind the scenes for their release, pleading personally with General Videla on their behalf. Pope John Paul II eventually took a stance urging bishops and priests to avoid political confrontation and warning that revolutionary acts could lead to bloody conflict.

A RETURN TO TEACHING

When his term as Provincial finished in 1980, Father Bergoglio was appointed rector, with teaching responsibilities, at the Jesuit Colegio Máximo de San José, where he himself had studied. Tragically, on January 8 the following year, his mother, Regina Maria, suffered a fatal heart attack at her home in Buenos Aires. Jorge Bergoglio now headed his family of three brothers and two sisters.

∧ THE JESUIT STUDENT
An undated photograph captures a
cheerful Jesuit student Jorge Bergoglio
during the early years of his theological
training in Argentina.

Priests noticed the change immediately. The new bishop often telephoned them to ask if he could drop by their parish, insisting, however, that there be no fuss. He made a particular priority of visiting the slum areas. Buenos Aires had a number of shantytowns around its periphery, where nearly three-quarters of a million people lived in dwellings made of concrete blocks, corrugated iron, and cardboard. Sewer systems and sanitation were almost nonexistent.

Bergoglio enjoyed celebrating some of the many popular festivals in honor of the saints in these shantytowns. He asked the people there to call him simply Padre Jorge, rather than the formal title of bishop. When he returned from a day visiting these poor districts, the new bishop often sent requests to people in wealthier areas, urging them to share their resources. Not all such requests were met with enthusiasm, however.

As Cardinal Quarracino approached his retirement, the elderly prelate wondered who would replace him. The Cardinal had become fond of the Jesuit over the five-year period Bergoglio had assisted him, and trusted his counsel. On a visit to Rome, the Cardinal urged Pope John Paul II to appoint Bishop Bergoglio as his successor. Accordingly, on June 3, 1997, Bergoglio was appointed coadjutor bishop—co-bishop with right of automatic succession.

ARCHBISHOP BERGOGLIO

On February 28 the following year, Archbishop Quarracino suffered a fatal heart attack and Bergoglio became the new archbishop of Buenos Aires. He traveled to Rome to receive the *pallium*, the stole of office, from Pope John Paul II. Ever frugal, he dissuaded most of his family and friends from undertaking the long and expensive journey to the Eternal City.

Bergoglio's frugality was to remain a hallmark of his time as archbishop. Although entitled to reside in the imposing episcopal residence, Archbishop Bergoglio chose to live in a small one-bedroom flat. He rarely ate out, preferring to shop for his groceries and cook for himself. He continued to walk everywhere or travel by mass transit. Maintaining the habits of a lifetime, he rose at 5am for prayer and study. Between 7am and 8am, he made himself available to speak with his priests, using the telephone he had had installed for this reason. While the day was filled with appointments, he kept his own agenda, his tattered black diary, which he always carried in his pocket, filled with his minuscule writing.

Shortly after his appointment, a scandal erupted concerning money that had gone missing from diocesan funds. Archbishop Bergoglio instituted an inquiry and insisted on transparent financial accountancy.

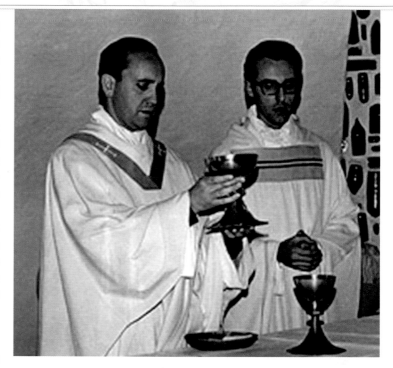

The new archbishop also encouraged priests to work in the poor parts of the diocese, sometimes against their wishes. Under his leadership, the quota of clergy assigned to work in the slum areas doubled and had notable success in improving the quality of life there. The archbishop had sympathy and admiration for priests who worked in difficult situations and supported them as best he could.

While some of the young priests Archbishop Bergoglio appointed to the slums were inexperienced and ineffectual, the archbishop was strict with his clergy and demanded their best efforts. He ridiculed the pomposity of some priests and the laziness of others, comparing them with the peacock. "I often say, from the front, the peacock is magnificent, but from behind, it is a different story!"

Archbishop Bergoglio also regularly visited the slums and impoverished shantytowns unannounced to celebrate Mass, frequently staying afterward to meet the people of the area over a simple meal. Here he heard their heart-rending stories of drug abuse, prostitution, extortion, and social exclusion, and disease caused by poor sanitation.

Archbishop Bergoglio did not limit himself to caring for the Catholics of Buenos Aires. He reached out to members of other faiths, notably those from the Jewish and Islamic communities. The archbishop also became a close friend of Rabbi Abraham Skorka, with whom he hosted a weekly TV show and collaborated on a book of conversations.

CARDINAL BERGOGLIO

On February 21, 2001, Pope John Paul II created Bergoglio a cardinal during a consistory (a meeting of the College of Cardinals) held at the Vatican. On this occasion, Bergoglio traveled to Rome with a small number of relatives. Following the ceremony, he and his sister Maria Elena went to Turin and Portocomero to see the area from which their grandparents had emigrated seven decades earlier. Visiting the house where his father had lived before his departure to the New World in 1929, Bergoglio took a small bag of soil from the garden as a memento.

SYNOD LEADER

In 2001, last-minute touches were being made to the Synod of Bishops at the Vatican—which takes place every two or three years and brings together a number of the world's bishops to discuss contemporary issues—when the 9/11 attacks took place. Cardinal Edward Egan, the archbishop of New York, was the relator, or principal secretary, of the Synod. Egan insisted on remaining in his diocese following the attacks and asked Pope John Paul II to appoint a replacement. The pope chose Cardinal Bergoglio to lead the Synod.

Two hundred and fifty-two bishops from 118 countries, along with several advisors and experts, gathered at the Vatican in early October. Cardinal Bergoglio oversaw the three-week session with quiet efficiency. He had almost no experience with international meetings of this kind, but he proved to be effective and carried the Synod to a successful conclusion. This drew him to the attention of many cardinals at the Vatican and to bishops throughout the world. In turn, Bergoglio had broadened his understanding of the global Church.

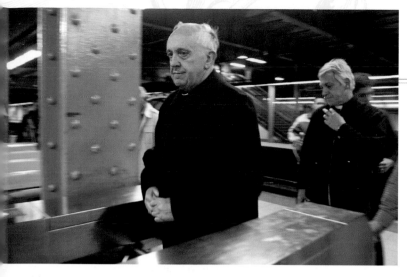

< PUBLIC TRANSPORTATION
Ever humble, Cardinal Bergoglio
takes the Buenos Aires subway
before celebration of a *Te Deum*
Mass at the Metropolitan Cathedral.

THE COMMON GOOD

Back home, Argentina was in the midst a dramatic economic collapse. The financial situation caused political instability, and the election of Néstor Carlos Kirchner as president in May 2003 failed to stem the decline. Cardinal Bergoglio became a vocal critic of the new regime, and later of the rule of Kirchner's wife, who succeeded him as president in 2007. Through his homilies and public addresses, he urged all politicians to work for the common good, rather than taking advantage of the poor and socially marginalized. In 2006, Cardinal Bergoglio opposed the legalization of abortion in Argentina, again placing him in opposition to the Kirchner-led government.

CONCLAVE AND A NEW POPE

When Pope John Paul II died after a long illness on April 2, 2005, the world's cardinals gathered at the Vatican to elect his successor. Four million mourners attended the funeral—one of the largest Christian gatherings in history. The conclave to elect his successor began two weeks later in the Sistine Chapel.

One hundred and fifteen cardinals considered the most suitable candidate to succeed the charismatic, if controversial, Polish pontiff. Two names quickly emerged: Jorge Bergoglio and Joseph Ratzinger. On the second day of voting, Cardinal Ratzinger gained more than the 77 votes necessary for election, and took the name Benedict XVI. Stepping into the shoes of Pope John Paul II, whose pontificate had lasted almost 27 years, proved an enormous challenge. While Pope John Paul was outgoing and expansive, Pope Benedict was more reserved. Cardinal Bergoglio never spoke about the conclave, but he returned to Buenos Aires clearly relieved that he had not been elected. He continued his daily routine of meetings and administration, often visiting the sick or needy in the slums, prisons, and hospitals.

RESIGNATION AND RETIREMENT

In 2011, Cardinal Bergoglio concluded a six-year term as President of the Episcopal Conference of Latin America and the Caribbean. Latin America is home to 432 million Catholics, almost three-quarters of the population of the continent. As leader of the regional bishops, Bergoglio had gained an invaluable insight into the needs and strengths of Catholicism in the various nations.

Cardinal Bergoglio continued to foster closer relations between the Catholic Church, evangelical Christians, and various other religious groups in Buenos Aires. He regularly attended non-Catholic religious ceremonies— notably at Jewish synagogues and Islamic mosques—and he invited various religious leaders to the cathedral join in prayers for peace in the Middle East.

Shortly before his 75th birthday, in December 2011, Cardinal Bergoglio submitted, as required by Church law, his resignation as Archbishop of Buenos Aires to Pope Benedict. He began to dispose of his books and personal belongings and made arragements to move into a retirement home for priests in his native Flores, in a year or two, once his resignation had been accepted. The Cardinal could hardly have been prepared for what awaited him.

A PAPAL APPOINTMENT

On February 11, 2013, Pope Benedict XVI announced to an assembly of cardinals his intention to abdicate. Citing reasons of health and age, he explained that he no longer felt physically able to continue. The pontiff's retirement would be effective from 8pm on the 28th day of that same month.

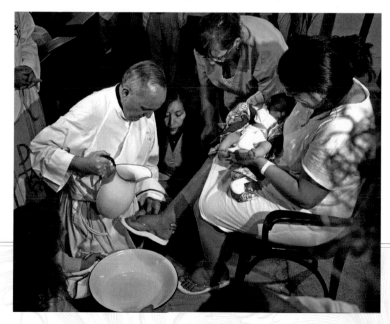

< FAITH IN BUENOS AIRES
Vivid expressions of Catholic faith
can be seen in the slum districts of
Buenos Aires, as here at the Virgin
of the Miracles of Caacupe church.

> SINCERE SERVICE
Each year on Holy Thursday, Cardinal
Bergoglio celebrated Mass at prisons
and hospitals, repeating Jesus's gesture
of washing feet at the Last Supper.

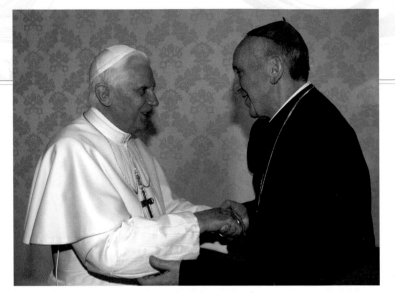

> **BENEDICT MEETS BERGOGLIO**
Pope Benedict XVI meets his future
successor, Archbishop of Buenos Aires
Cardinal Bergoglio, at the Vatican
shortly after his own election as pope.

The cardinals were both surprised and perplexed: no pope had willingly abdicated since 1415. All the cardinals of the world assembled in Rome the following month. According to regulations laid down by Pope Paul VI (1963–78), only those under the age of 80 could vote for the new pope. On March 12, 115 electors entered the Sistine Chapel, where, swearing on the Book of the Gospels, each cardinal undertook before God to elect only the most suitable candidate.

The ballot of the first evening was inconclusive and the cardinals returned to their temporary residence at Santa Marta, in the shadow of St. Peter's Basilica. The next morning, two ballots were cast. The Argentinian cardinal was clearly the lead candidate. On the second ballot of the afternoon, Cardinal Jorge Mario Bergoglio passed the required two-thirds majority of 77 votes and was canonically elected Bishop of Rome. In keeping with tradition he assumed a new name, Francis.

Led into the room behind Michelangelo's celebrated *Last Judgment*, the new pontiff donned the white garments laid out by the tailor. Offered a jeweled pectoral cross, the new pope said he would prefer to keep his old metallic cross. Similarly, when offered a pair of crimson shoes, Francis said that his old black ones were comfortable and would serve him well.

The thousands of spectators in St. Peter's Square waited anxiously to see if a new pope had been elected. At four minutes past seven, white smoke unfurled from the chimney on the Sistine Chapel roof. As it swirled around in the dark sky, the bells of the basilica began to toll. A pope had been elected and the cardinals had done their duty. The sense of release and excitement was electrifying. Roars of delight rose from the crowds.

An hour later, Pope Francis appeared on the balcony of St. Peter's Basilica. His first greeting, a simple "*buonasera*" (good evening), won the hearts of many. Explaining that the cardinals had gone to the ends of the earth to find a successor, he saluted his predecessor, Pope Benedict XVI, and asked the assembled crowds to pray for him before he offered his own blessing.

CHALLENGES AND CHANGE

From his first appearances, Pope Francis's humility appealed to the public, who warmly embraced him. He chose to live in the functional guesthouse, Casa Santa Marta, rather than the sumptuous papal apartments of the Apostolic Palace that had been used by his predecessors. The new pope explained the decision as a natural preference to live close to others for company, rather than as an isolated monarch in a palace.

The task facing Pope Francis was enormous. Pope Benedict's sudden abdication had caused confusion and a deep crisis, and it was essential that the new pope offer firm guidance. Prior to the conclave the cardinals had discussed the various problems confronting the Church. The scandals were numerous, the most serious of all being the abuse of minors by clergy and the resulting cover-up by superiors. Financial irregularities and corruption within the finances of the Holy See were also rife. A different approach was needed.

Within a month of his election, Pope Francis had set up a commission of cardinals from each of the five continents to be his "kitchen cabinet," or unofficial advisors. The commission's first task was to oversee a reform of the

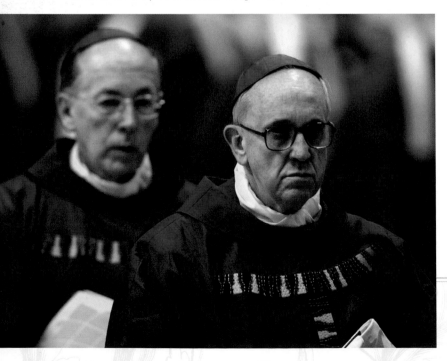

< **LATIN AMERICAN CARDINALS**
Cardinal Bergoglio of Buenos Aires
and Cardinal Juan Luis Cipriani Thorne
of Peru celebrate Mass in St. Peter's at
the time of Pope Benedict's election.

Roman Curia (the administrative body of the Holy See), and financial experts were called in to overhaul the Holy See's financial institutions and ensure greater transparency in Vatican affairs.

As before his election, Pope Francis's priority was the poor and marginalized. It was for this reason that he chose the island of Lampedusa, off the southern coast of Italy, for his first visit outside Rome. For years, impoverished African migrants had journeyed to the small island in the hope of migrating farther northward into Europe and starting a new life, many drowning en route. Francis showed his concern for them by visiting Lampedusa, but he was also being shrewd. He knew that the media were following his every move, and that a trip to Lampedusa would turn the spotlight of the international media on the migrants' circumstances.

In contrast to the rather shy Pope Benedict, Pope Francis was a whirl of activity. His collaborators, who were used to simply providing Pope Francis's predecessor with pre-prepared dossiers, now found themselves being quizzed for ever more detailed information.

The new pope's friendly informality was appealing to many. The public saw his easy, relaxed manner at the General Audience held each Wednesday morning. He would often invite people to join him in the Jeep as he was driven through St. Peter's Square, and he greeted the sick personally. Each morning, he invited people to join him at the Casa Santa Marta for Mass. Here, he delivered off-the-cuff homilies that were full of anecdotes.

Pope Francis's accessibility was unprecedented. He was happy to be interviewed by journalists and to appear on TV. Soon people began to read and hear the Pope's real words rather than a journalist's interpretation of them, but not everybody was happy with this down-to-earth style. Some pined for the days when the pope was an absolute monarch. Pope Francis was unpredictable. A pope who plunged into crowds, baptized the children of unmarried parents, and refused to condemn gay people was confusing to many Catholics.

For his openness, his humility, his concern for marginalized people, and his commitment to change through dialogue, Pope Francis has undoubtedly captured the attention of the public. Many people—non-Catholics as well as Catholics—would like to know more about him.

This book aims to give readers a greater insight into Pope Francis's life, following him on a fascinating journey through the lens of the photographers who accompany the Pope each day and offers a glimpse of his life behind the scenes.

> **INAUGURATION DAY**
Pope Francis holds up the Book of the Gospels at the Mass of Inauguration in St. Peter's Square on March 18, 2013. Thousands of people attended the Mass.

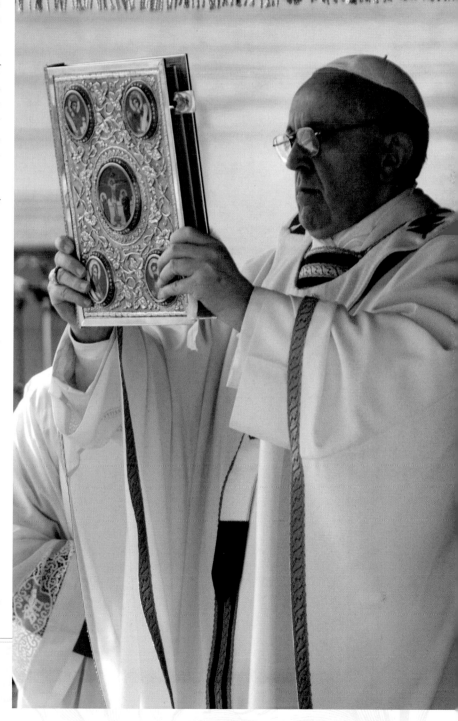

∨ **ST. PETER'S BASILICA**
Crowned by Michelangelo's majestic
cupola, the basilica rises above Bernini's
colonnaded piazza, while to the right
stands the 16th-century Apostolic Palace.

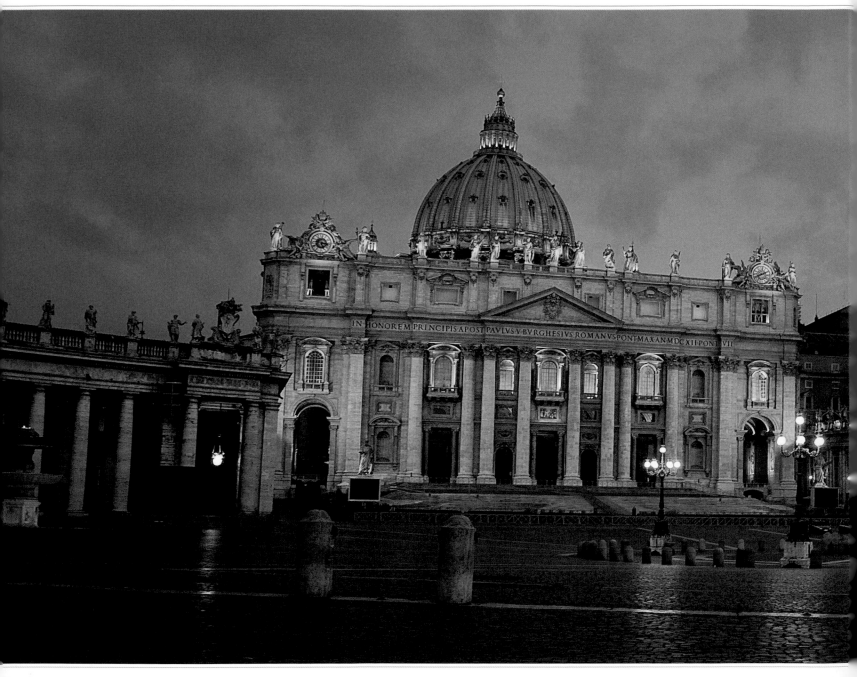

A NEW POPE

THE PAPAL ELECTION

On February 11, 2013, Pope Benedict XVI stunned the Catholic world by announcing his resignation. Just over a month later, on March 13, Cardinal Bergoglio was elected his successor, adopting the name Francis. According to tradition, the new Pope Francis addressed the crowds that gathered in St. Peter's Square. He began with an informal "*buonasera*" ("good evening"). He explained that the cardinals had gone almost "to the ends of the earth" to find a new pope. Before offering his blessing to the crowds, he bowed in silence, asking the people to pray for their new bishop. "And now, we take up this journey: bishop and people. This journey of the Church of Rome, which presides in charity over all the Churches. A journey of fraternity, of love, of trust among us. Let us always pray for one another. Let us pray for the whole world that there may be a great spirit of fraternity."

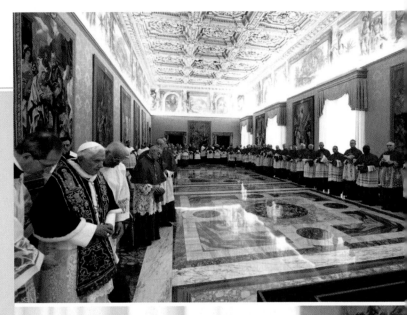

> **PAPAL ENTRANCE**
Pope Benedict enters the Hall of the Consistory in the Apostolic Palace. Almost none of his cardinals were prepared for the shock announcement.

On the morning of February 11, during a formal meeting with a number of his cardinals at the Apostolic Palace, Pope Benedict XVI announced his intention to abdicate. He would step down from the papacy on the last day of the month. "Having repeatedly examined my conscience before God," the Pope said in a subdued voice, "I have come to a certainty that my strength, due to an advanced age, is no longer suited to the adequate exercise of the Petrine ministry." Not since the abdication of Pope Gregory XII in 1415 had a pontiff resigned, and that was not for personal reasons but as a result of the historic split within the Catholic Church known as the Great Western Schism.

Having given his blessing, the Pope left the hall. The bewildered cardinals respected Pope Benedict's honesty and integrity in resigning from an office that he no longer felt able to fulfill, but they now had to face the practical consequences. The first step was to announce the decision to the media. The world reacted with astonishment. Even Pope Benedict's ideological opponents were taken by surprise.

It emerged that Pope Benedict had started to think of retirement following a fall during a papal visit to Mexico the previous March. He was now in his mid-80s, in a role that was, in the 21st century, similar to that of a multinational company director. The Pope felt that he was no longer physically or mentally capable of meeting the strenuous demands of the modern papacy.

When elected to the papacy, Pope Benedict—then Cardinal Joseph Ratzinger—had already spent 23 years in the Roman Curia, in charge of the theological office of the Holy See. He was elected at the age of 78 by fellow cardinals who valued his theological prowess but who wanted to avoid another lengthy pontificate. Pope Benedict was a respected theologian and prolific author, but had a shy, reserved nature, and he lacked the charisma of his Polish predecessor John Paul II.

Nonetheless, Pope Benedict had accomplished much during his eight-year pontificate. The German pontiff had tackled the scandal of child abuse by clerics and the subsequent cover-up by bishops and religious superiors, and tried to help heal those wounded. Despite his age, Pope Benedict had also undertaken a series of journeys, which took him to 24 countries during the time that he was pope.

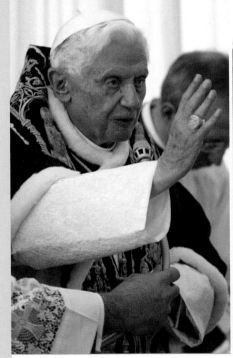

∧ **SOLEMN PAPAL BLESSING**
The strain showing visibly on his face, Pope Benedict blesses the assembled cardinals. Those present recall the intense silence that ensued.

∧ **QUIET LEAVE-TAKING**
Aware of the enormous impact of his announcement, the Pope takes his leave of the cardinals, who are left to ponder the future.

BENEDICT'S ABDICATION
SURPRISE ANNOUNCEMENT SHOCKS CARDINALS AND WORLD

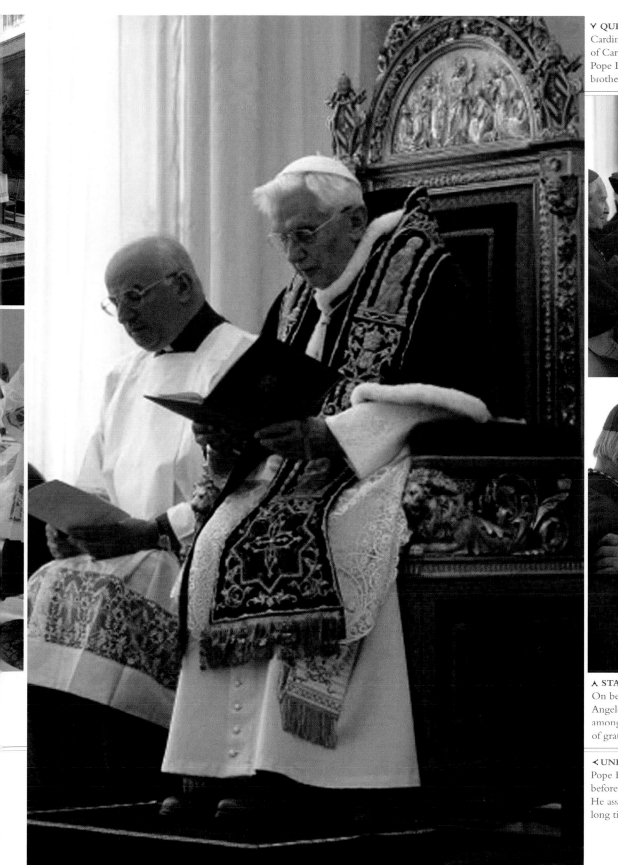

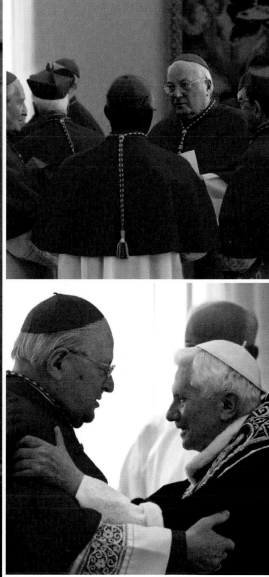

⋎ QUESTIONING CARDINALS
Cardinal Sodano, Dean of the College
of Cardinals, had been informed by
Pope Benedict the previous day. His
brother cardinals ask him for details.

⋏ STATEMENT OF GRATITUDE
On behalf of the cardinals, Cardinal
Angelo Sodano, the most senior
among them, made a brief statement
of gratitude for Benedict's pontificate.

⋖ UNEXPECTED SPEECH
Pope Benedict prays with the cardinals
before making his resignation speech.
He assured them it was the result of a
long time of prayer and reflection.

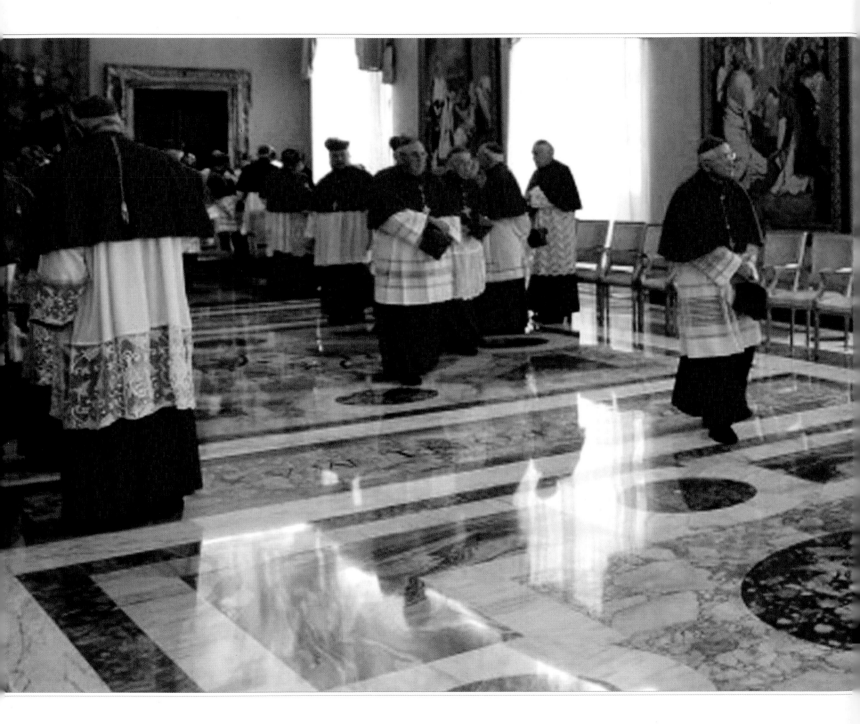

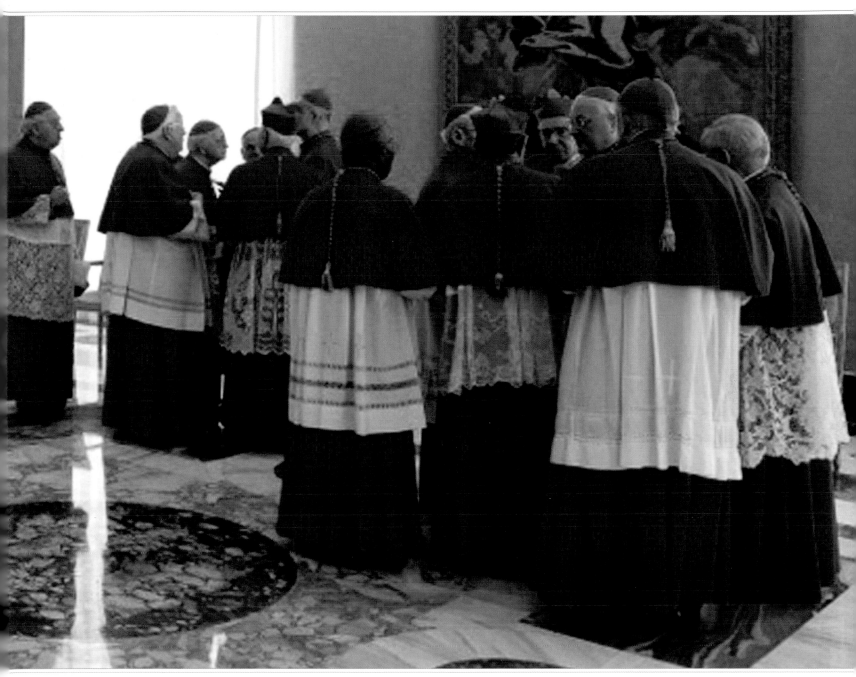

▲ **ASTONISHED CARDINALS**
The stunned cardinals gather in small
groups to ascertain if they have heard
correctly and properly understood Pope
Benedict's statement, read out in Latin.

THE CARDINALS WHO RESIDED IN THEIR DIOCESES AROUND THE GLOBE AND HAD NOT BEEN PRESENT WHEN POPE BENEDICT ANNOUNCED HIS RETIREMENT WERE NOW SUMMONED TO ROME. AFTER A SOMBER FAREWELL ON THE MORNING OF FEBRUARY 28, POPE BENEDICT LEFT THE VATICAN BY HELICOPTER FOR THE COUNTRY RESIDENCE OF THE POPES AT CASTEL GANDOLFO IN THE ALBAN HILLS NEAR ROME. HERE HE WOULD REMAIN UNTIL HIS SUCCESSOR WAS ELECTED, AFTER WHICH HE COULD RETIRE TO THE LIFE OF PRAYER AND CONTEMPLATION FOR WHICH HE NOW YEARNED.

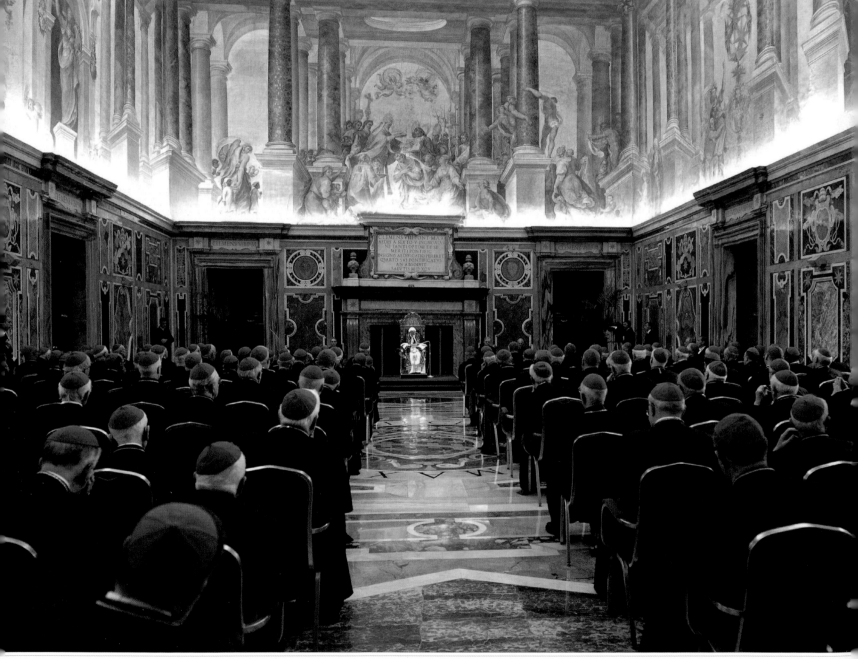

▲ OBEDIENCE AND REVERENCE
At his farewell to the cardinals on the morning of his formal abdication, Pope Benedict promises "unconditional reverence and obedience" to his successor.

FINAL FAREWELL

A SOMBER GOODBYE TO CARDINALS AND PEOPLE

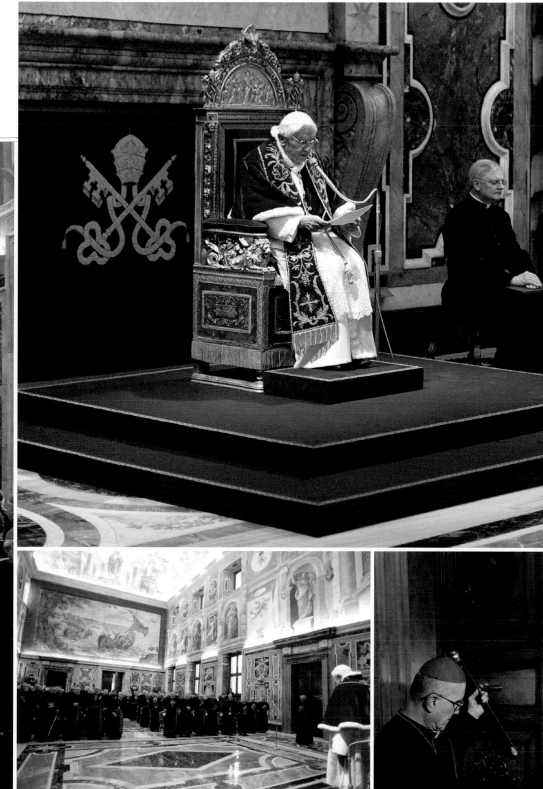

< WORDS OF CLOSURE
"May the College of Cardinals be
like an orchestra, where the diversities
... always contribute to the greater,
unifying harmony."

Ⅴ VATICAN DEPARTURE
At 5.30pm, Pope Benedict XVI leaves
the Vatican one last time as Pope, flying
by helicopter to Castel Gandolfo.

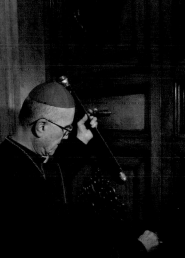

Ⅴ RIBBONS AND WAX
Aides tie ribbons around the brass
door handles and press molten
wax to prevent access.

Ⅴ APPRECIATION
The cardinals applaud in
appreciation of the Pope before
offering personal words of farewell
as he prepares to leave the Vatican.

> APARTMENTS SEALED
Tarcisio Bertone, Chamberlain of the
Church, seals the papal apartments
in the Apostolic Palace. They remained
closed until the election of a new pope.

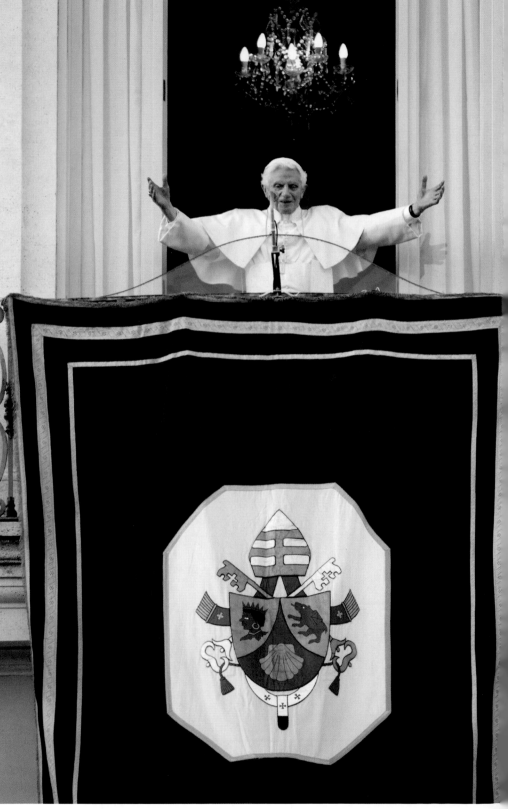

ᐯ **LAST ADDRESS**
Arriving at the papal country residence at Castel Gandolfo, Pope Benedict addressed the crowds for the last time, from a balcony overlooking the piazza.

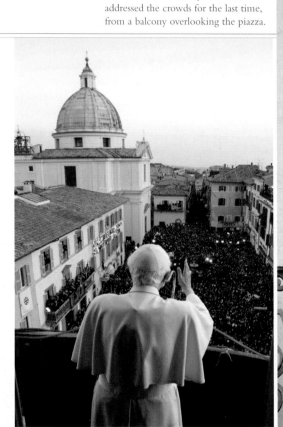

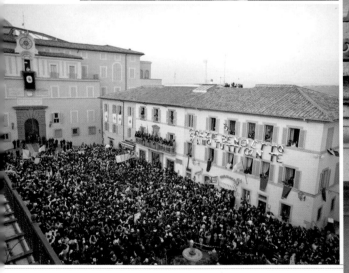

ᐱ **WELL-WISHERS**
The piazza in front of the papal villa was packed with well-wishers. Silver balloons spelled out, "Thank you Benedict, we are all with you."

FINAL PILGRIMAGE

"After 8pm this evening I will simply be a pilgrim who is starting the last phase of his pilgrimage on this earth," Pope Benedict told the crowds.

DOORS CLOSED

At exactly 8pm, with Swiss precision, Swiss Guards closed the door of the papal villa and withdrew their service, ending Pope Benedict's pontificate.

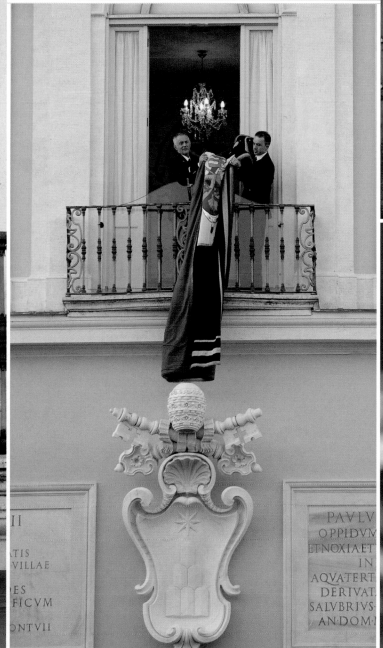

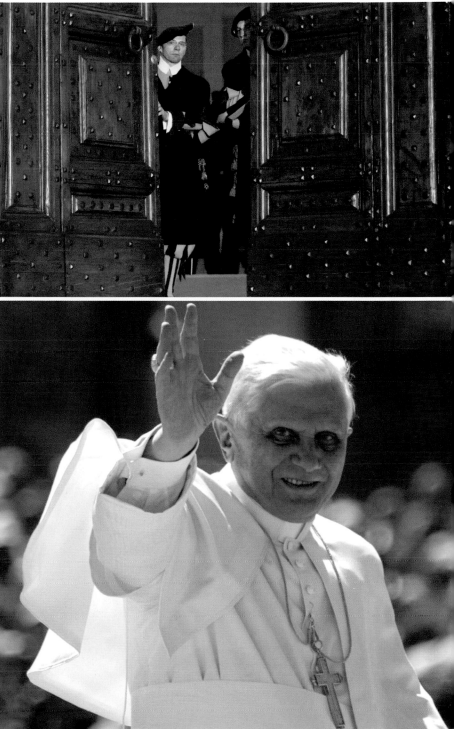

∧ PAPAL CREST FURLED

As the Pope gave his last blessing and withdrew into the villa, aides rolled up the drape bearing Pope Benedict's crest for the last time.

∧ FAREWELL WAVE

Retiring by nature, Pope Benedict followed in the footsteps of the charismatic John Paul II. His abdication changed the face of the modern papacy.

> ELIGENDO MASS
On the morning of March 12, the day the conclave opens, the cardinals and people gather in St. Peter's Basilica to celebrate Mass.

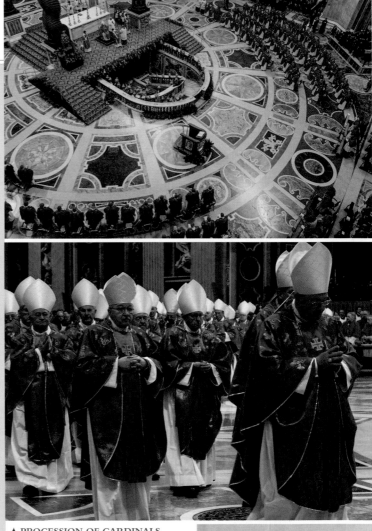

Over the following days, some 200 cardinals prepared to elect a new pope. One hundred and twenty under the age of 80 were eligible to vote in conclave. While in theory any baptized male can be elected pope, in reality it is always a cleric and invariably a member of the College of Cardinals.

On the morning of March 12, 2013, the cardinals celebrated Mass with the faithful in St. Peter's Basilica. That afternoon, the 115 cardinal-electors, five fewer than the maximum number, filed into the Sistine Chapel. The cardinal-electors having taken an oath to conscientiously vote for the best candidate, the conclave began. Exactly 24 hours later, Jorge Mario Bergoglio was elected, taking the name Pope Francis. Since the 6th century, the pope had traditionally assumed a new name upon election; not in two thousand years had one taken the name of Francis.

After a while spent in prayer, Pope Francis went to address the people gathering in St. Peter's Square. After an informal "*buonasera*" ("good evening"), the new pope continued: "You all know that the duty of the conclave was to give a bishop to Rome. It seems that my brother cardinals have gone almost to the ends of the earth to get him, but, here we are! I thank you for the welcome that has come from the diocesan community of Rome. First of all I would like to pray for our Bishop Emeritus Benedict XVI. Let us all pray together for him, that the Lord will bless him and that our Lady will protect him…"

A few moments silence were followed by: "And now let us begin this journey: the bishop and the people. This journey of the Church of Rome, which presides in charity over all the churches, a journey of brotherhood in love, of mutual trust. Let us always pray for one another. Let us pray for the whole world that there might be a great sense of brotherhood. My hope is that this journey of the Church that we begin today, together with the help of my Cardinal Vicar, may be fruitful for the evangelization of this beautiful city.

"And now I would like to give the blessing. But first I want to ask you a favor. Before the bishop blesses the people, I ask that you would pray to the Lord to bless me—the prayer of the people for their bishop. Let us say this prayer—your prayer for me—in silence." The new pope concluded by giving the Apostolic Blessing in Latin.

^ PROCESSION OF CARDINALS
All the cardinals, including the cardinal-electors, proceed to the High Altar before the Eligendo Mass begins.

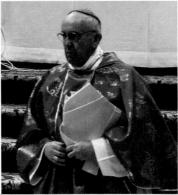

> ONE OF THE MANY
Jorge Mario Bergoglio removes his miter, little knowing that within 24 hours he will have been elected pope.

PAPAL ELECTION

A CONCLAVE OF CARDINALS ELECTS A NEW POPE

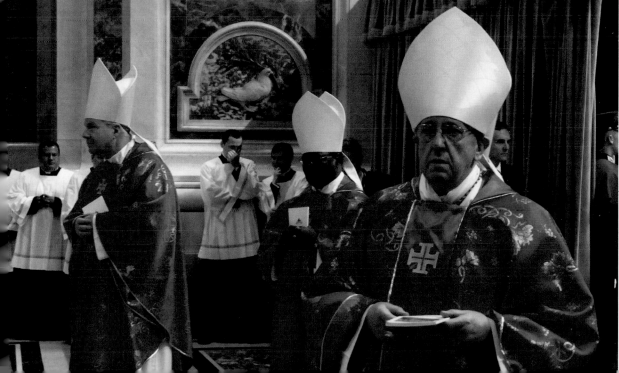

∧ CONCELEBRATION
The cardinals concelebrate Mass with Cardinal Angelo Sodano, Dean of the College of Cardinals.

< LAST MASS AS CARDINAL
For Cardinal Jorge Bergoglio (right), this was the last Mass prior to entering the conclave from which he would emerge as pope.

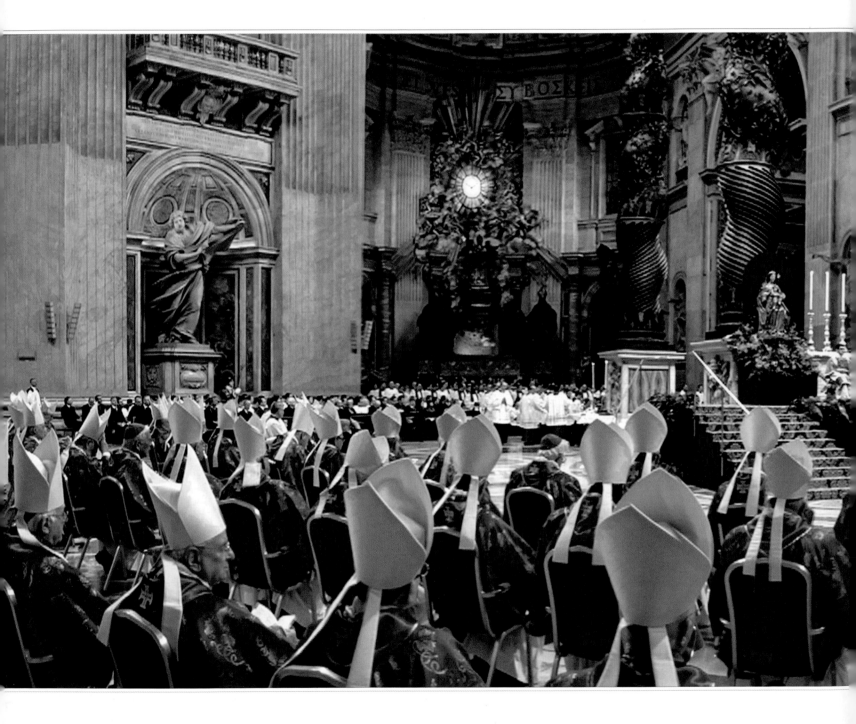

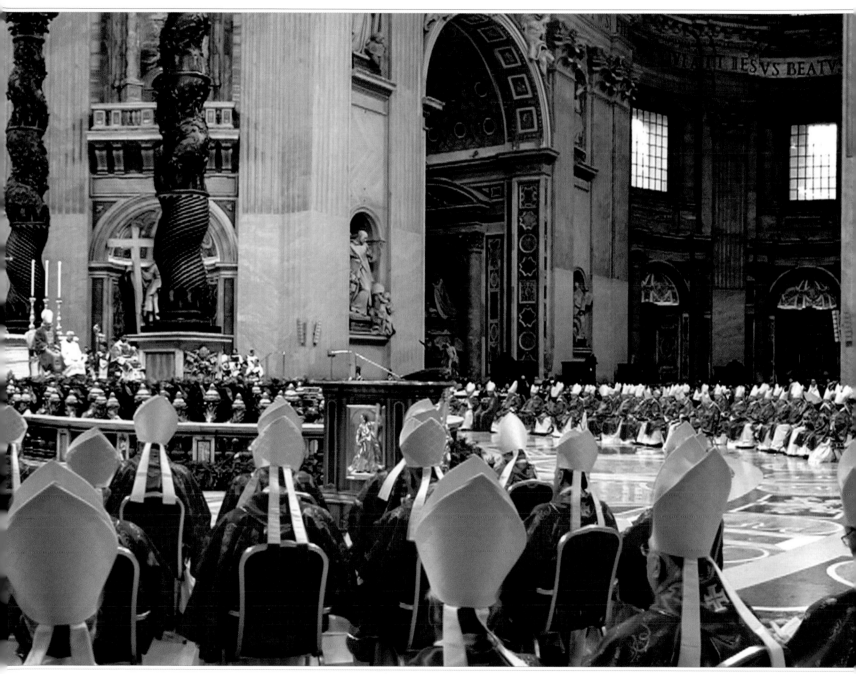

▲ *MISSA PRO ELIGENDO SUMMO PONTIFICE*
Cardinals gather around the High Altar in St. Peter's
Basilica for the *Missa pro Eligendo Summo Pontifice*,
the Mass for the Election of a Supreme Pontiff.

FOLLOWING THE MASS FOR THE ELECTION OF THE POPE, THE CONCLAVE OF CARDINALS BEGINS IN THE AFTERNOON BY CASTING ONE BALLOT. EACH SUBSEQUENT DAY, TWO BALLOTS ARE CAST IN THE MORNING AND TWO IN THE AFTERNOON. DURING THE VOTING, THE CARDINALS ARE SEALED INTO THE SISTINE CHAPEL. IF NO POPE IS ELECTED AFTER THREE DAYS, ONE DAY IS SET ASIDE FOR PRAYER. AFTER SEVERAL SIMILAR INCONCLUSIVE SESSIONS, THE CARDINALS WITH THE TWO HIGHEST VOTES ARE ELIGIBLE FOR A RUNOFF ELECTION.

Y COME, HOLY SPIRIT
The conclave begins as the cardinal-electors process from the Pauline Chapel singing the hymn *Veni Creator Spiritus* (Come, Holy Spirit).

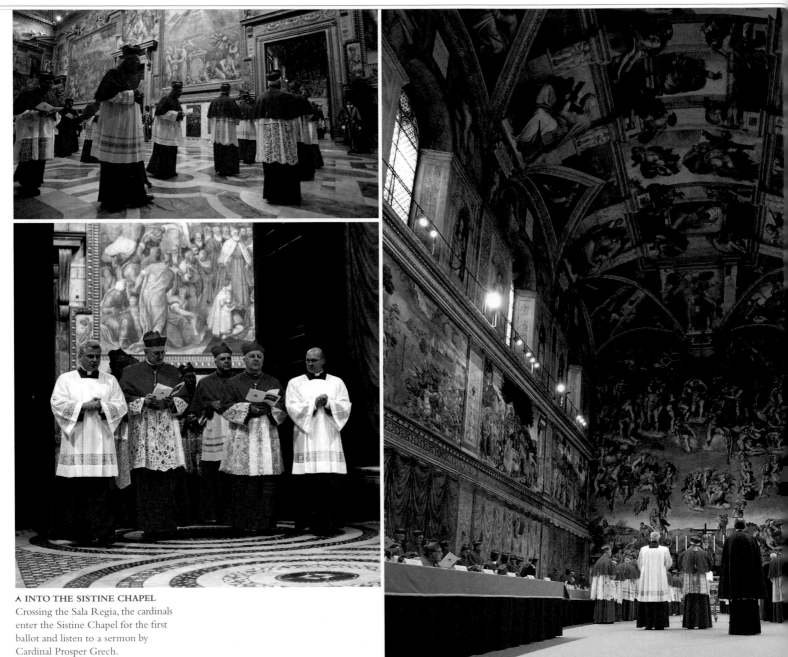

∧ INTO THE SISTINE CHAPEL
Crossing the Sala Regia, the cardinals enter the Sistine Chapel for the first ballot and listen to a sermon by Cardinal Prosper Grech.

THE CONCLAVE
CARDINAL-ELECTORS VOTE FOR A NEW POPE

> CHRIST THE WITNESS
"I call as my witness Christ the Lord, who will be my judge, that my vote is given to the one who before God I think should be elected."

⋏ CARDINALS' VOWS
Each cardinal swears on the Gospel, "I vow, promise, and swear. Thus may God help me and these Holy Gospels which I touch with my hand."

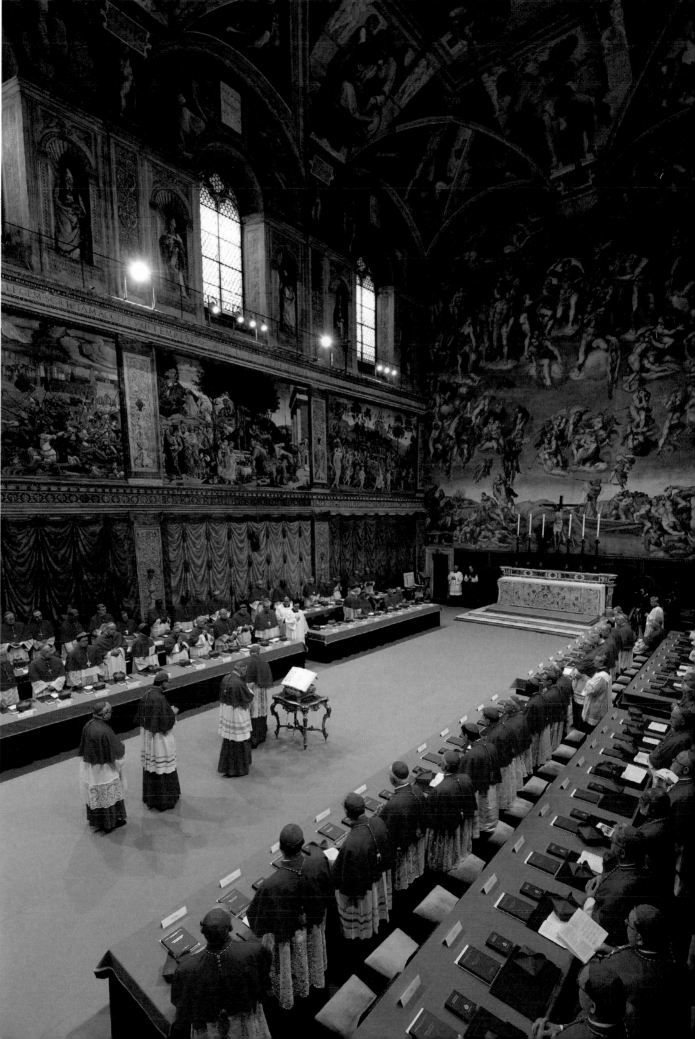

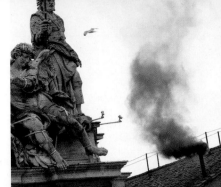

➤ BLACK SMOKE
Ballot papers are burned in a stove in the chapel, from which rises a chimney built specially for the occasion. Black smoke indicates a negative vote.

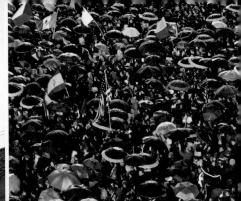

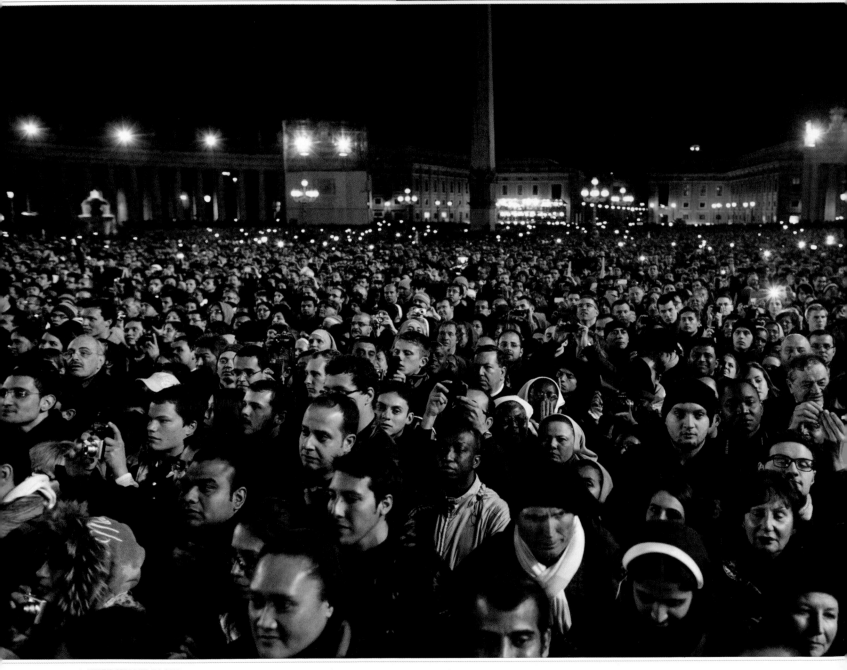

ʌ EXPECTANT FACES
The patiently waiting crowds closed their umbrellas as the clock ticked toward 7pm, when the votes were due to be burned, announcing the last result of the day.

< UNDAMPENED ENTHUSIASM
Steady rain poured down all
afternoon until shortly before 7pm.
Despite the damp, there was an air
of excitement among the crowds.

⋎ WHITE SMOKE
At 7·05pm, white smoke began to
billow from the chimney, indicating
that a new pope had been chosen.
The crowds roared in delight.

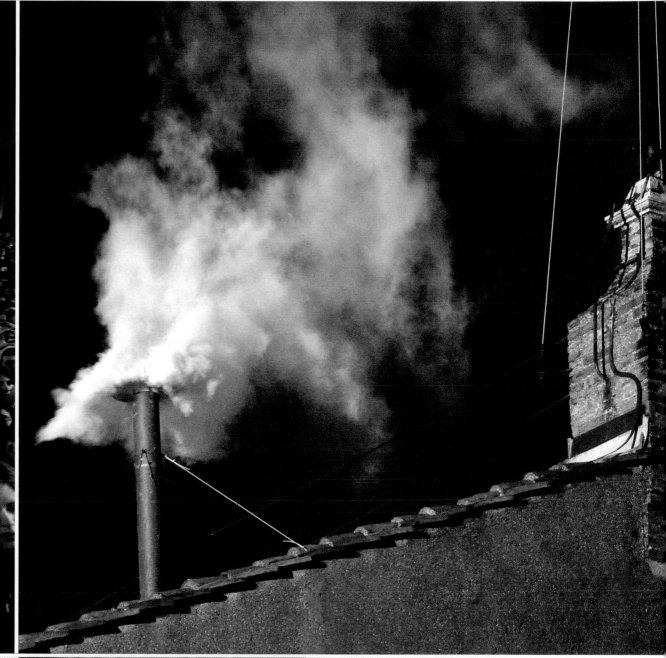

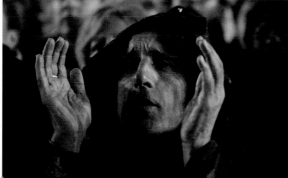

< JOYFUL GREETINGS
There was a delay of an hour before
Pope Francis appeared in public. People
prayed, sang, and exchanged joyful
greetings with complete strangers.

⌄ **SWISS GUARD AT THE READY**
As the smoke alerts the outside world
that a pope has been elected, the Swiss
Guard takes up its position in front
of the facade of St. Peter's Basilica.

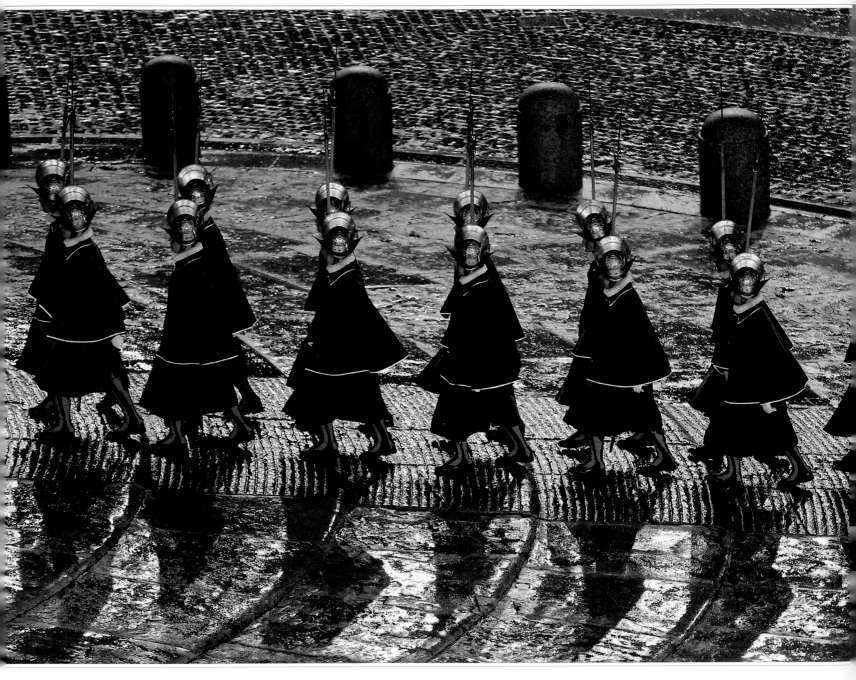

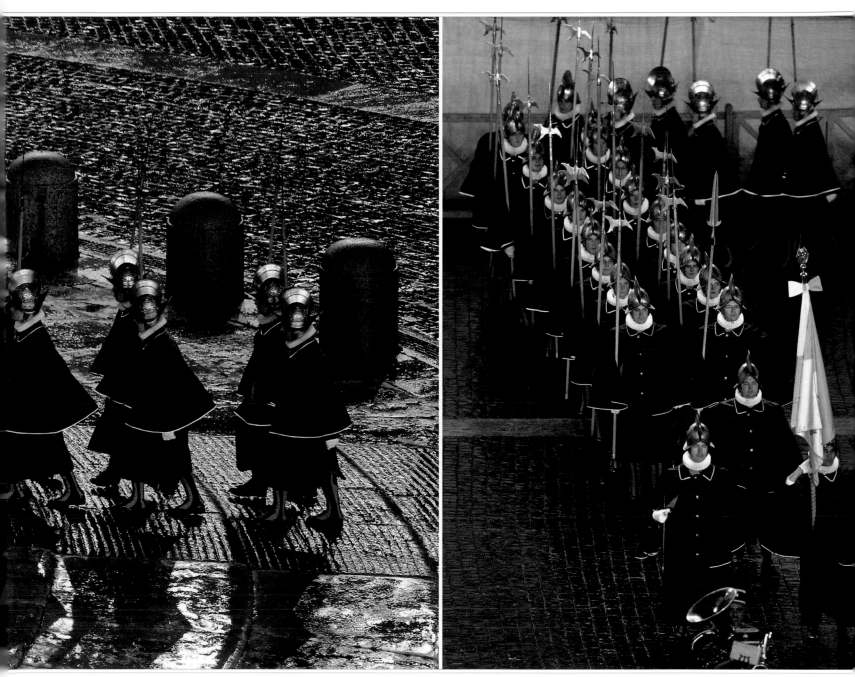

A BAND POISED TO PLAY
The band stands ready to play the
Vatican anthem as the Swiss Guard
waits in the rain for the announcement
of the new pope's election.

AS SOON AS HE HAD GREETED THE CARDINALS WHO ELECTED HIM, THE NEW POPE FRANCIS

✝ WITHDREW TO PRAY QUIETLY IN THE PAULINE CHAPEL. HE THEN WENT TO THE CENTRAL LOGGIA OF ST. PETER'S BASILICA, OVERLOOKING THE THOUSANDS WHO HAD FLOCKED TO THE SQUARE TO SEE HIM. FROM HERE, POPE FRANCIS COULD GREET HIS NEW FLOCK. IT WAS AN EMOTIONAL MOMENT FOR EVERYBODY IN THE SQUARE AND ALMOST OVERWHELMING FOR FRANCIS, THE FIRST POPE OF THE CATHOLIC CHURCH FROM THE AMERICAS.

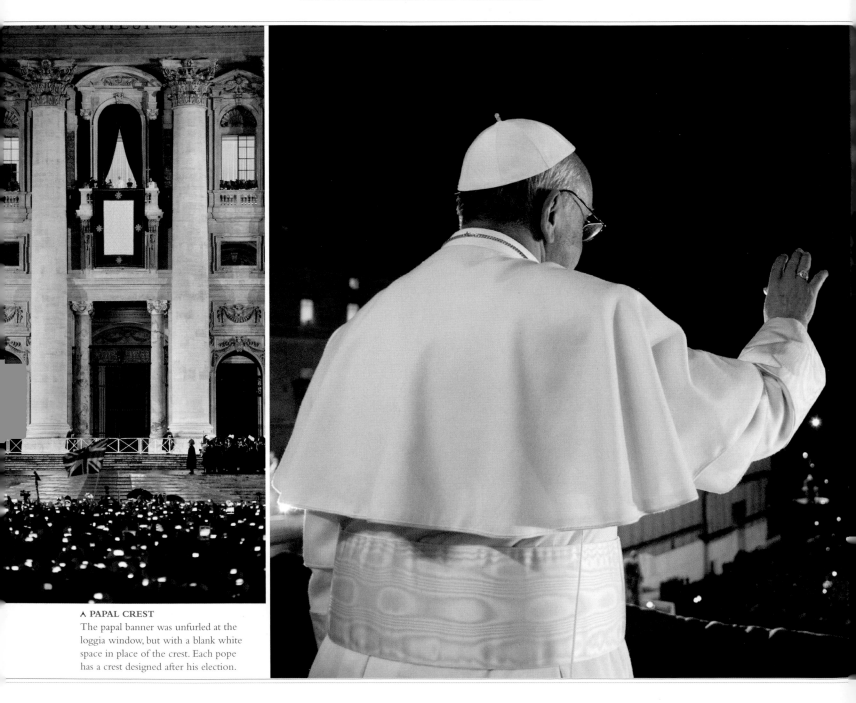

A PAPAL CREST
The papal banner was unfurled at the loggia window, but with a blank white space in place of the crest. Each pope has a crest designed after his election.

HABEMUS PAPAM

WE HAVE A POPE

Y **HUMBLE WAVE**
Even in the moment of his glory,
Pope Francis retained his humility.
He insisted on wearing simple robes,
everyday shoes, and his own plain crucifix.

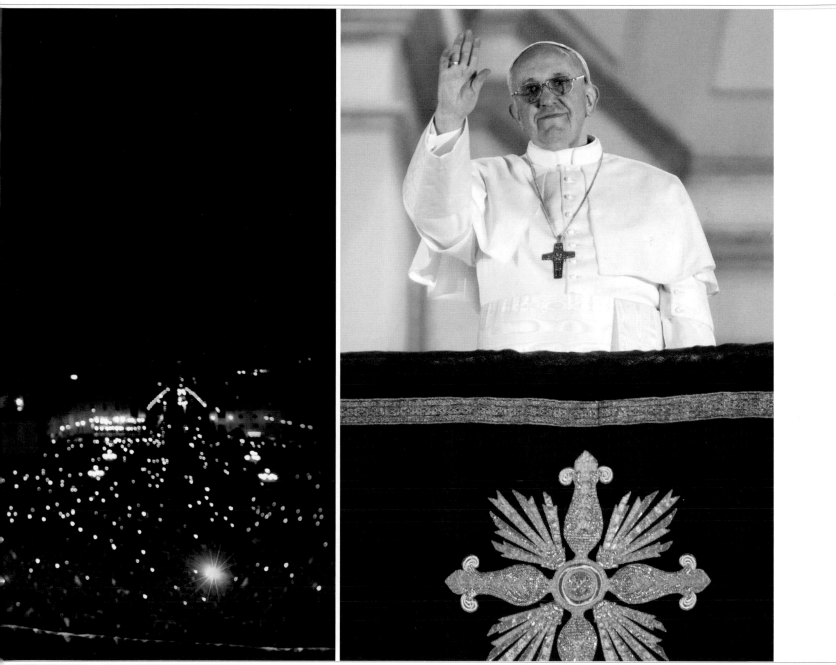

A **FRANCIS GREETS THE PEOPLE**
The new Pope Francis greets the
many thousands of people thronging
St. Peter's Square in anticipation of his
election—an astonishing spectacle.

ON SUNDAY, MARCH 17, THE NEW POPE FRANCIS CELEBRATED MASS IN THE SMALL PARISH CHURCH ✝ OF SANT'ANNA INSIDE THE GATES OF THE VATICAN. WORD SPREAD RAPIDLY THAT THE POPE INTENDED TO CELEBRATE HIS FIRST SUNDAY IN THE PARISH CHURCH, AND PEOPLE CRAMMED INTO THE TINY BUILDING. AT THE END OF MASS, THE POPE JESTED THAT MANY IN THE CONGREGATION WERE FROM ARGENTINA, INCLUDING A PRIEST WHO WORKS WITH STREET CHILDREN, AND WONDERED HOW THEY HAD GOTTEN A PLACE AT THE MASS. "TODAY," HE QUIPPED, "THEY ARE ALL PARISHIONERS!"

ᵛ BLESSING THE PEOPLE
Having reverenced the crucifix on his arrival, the Pope blessed the people in the church with Holy Water, recalling their baptism.

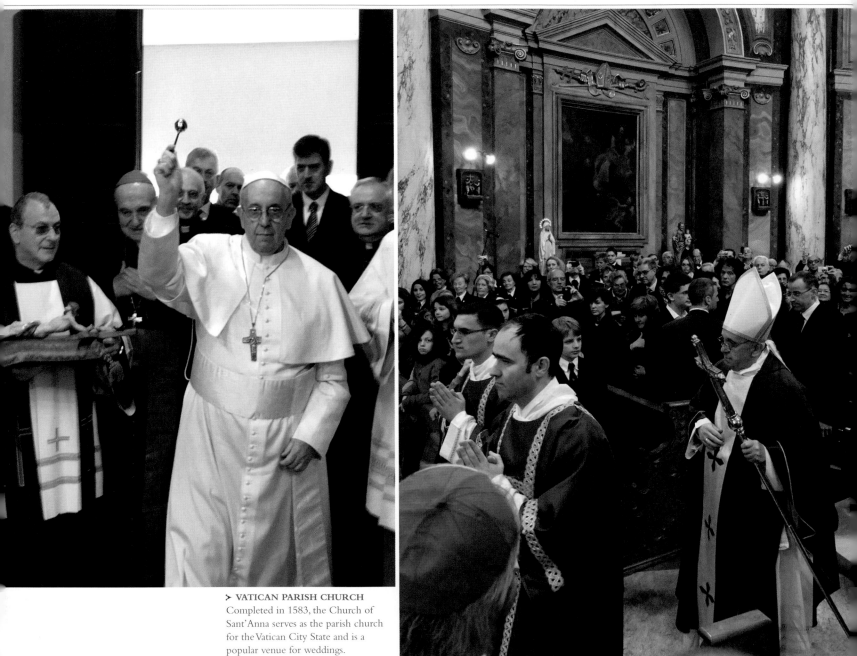

➤ VATICAN PARISH CHURCH
Completed in 1583, the Church of Sant'Anna serves as the parish church for the Vatican City State and is a popular venue for weddings.

MASS AT SANT'ANNA
FIRST SUNDAY MASS AT THE VATICAN PARISH CHURCH

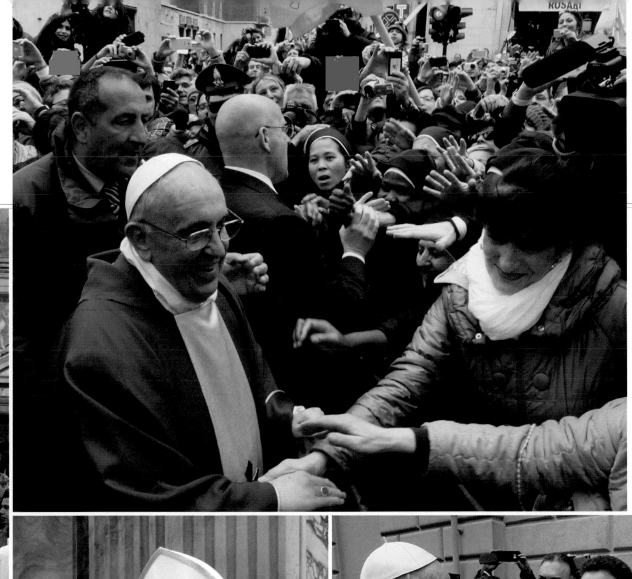

< SCANT SECURITY
The new pontiff's
personal security guards
were horrified to see Pope
Francis walk out onto Italian
soil and into the midst of
the crowds.

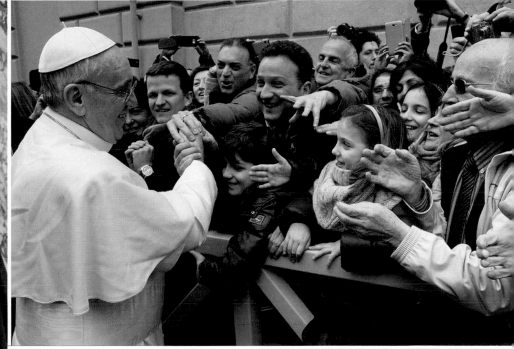

< FORGIVING GOD
Speaking off the cuff, the Pope said,
"God never tires of forgiving us. Never!
It is we who get tired of asking Him
for forgiveness."

^ RAPPORT WITH THE PEOPLE
From the beginning, Pope Francis
established a relaxed rapport with
the ever growing crowds that visit
him in the Vatican each year.

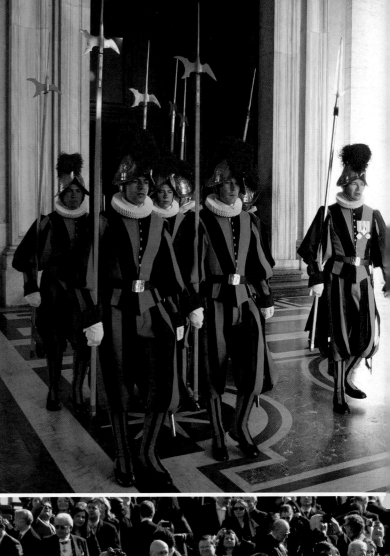

> AVANT GUARD
A Swiss Guard contingent marches through the atrium of St. Peter's Basilica for the Mass, attended by six sovereign rulers and 31 heads of state.

From the early hours of March 19, tens of thousands of excited Romans, as well as visitors from all over the world, poured into St. Peter's Square for the Mass of Inauguration. Soon, all the available chairs were taken and more than 150,000 people were standing, embraced by Bernini's vast colonnade. On the platform, presidents and prime ministers mingled with cardinals and prelates. Dignitaries from 132 countries attended the ceremony, determined to take part in the historic occasion.

Half an hour before Mass was due to begin, the new Pope drove through the flag-waving crowds in a surprise appearance. Arriving at the basilica, he went to pray at the tomb of St. Peter under the dome of Michelangelo. Silver trumpets pierced the air as the Sistine Choir sang the motet "Tu Es Petrus" (You Are Peter). The Pope descended into the *confessio*, the crypt where tradition holds that St. Peter was buried. The Ring of the Fisherman (Bishop's ring) and *pallium* (stole) had been placed overnight in the tomb. Two deacons carried them out ahead of the Pope and cardinals into the brightly sunlit square.

As Mass began, the Pope was invested with the ring and *pallium*, the insignia of the episcopal office.

He wore a simple miter and his vestments from Buenos Aires. Six cardinals, representing the entire college, offered their obeisance. In his homily, Pope Francis spoke of the role of Joseph in Christianity. He recalled that this was also the name day of his predecessor, Joseph Ratzinger, Benedict XVI. Joseph's role was to protect Mary and the baby Jesus. Joseph is a custodian of every Christian, Pope Francis said.

Speaking off the cuff, he added: "I would like to ask all those who have positions of responsibility in economic, political, and social life, and all men and women of good will, that we may be 'protectors' of creation, protectors of God's plan inscribed in nature, protectors of each other and of the environment... But to be 'protectors,' we also have to keep watch over ourselves! Let us not forget that hatred, envy, and pride defile our lives! Being protectors, then, also means keeping watch over our emotions, over our hearts, because they are the seat of good and evil intentions: intentions that build up and tear down! We must not be afraid of goodness or even tenderness!"

After the Mass, the Pope met delegates of all the nations who offered him good wishes as his custodianship of the Church began.

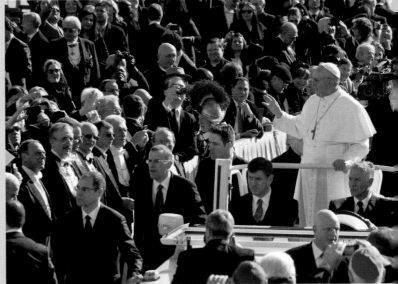

∧ DRIVE-THROUGH
Before the Mass began, Pope Francis spent half an hour driving through the hundreds of thousands of people who packed St. Peter's Square.

MASS OF INAUGURATION
KEEPING WATCH OVER OUR HEARTS AND EMOTIONS

< CONFESSIO
The *confessio* is a sunken area just below
the High Altar and the cupola designed
by Michelangelo, marking the burial
place of the Apostle Peter.

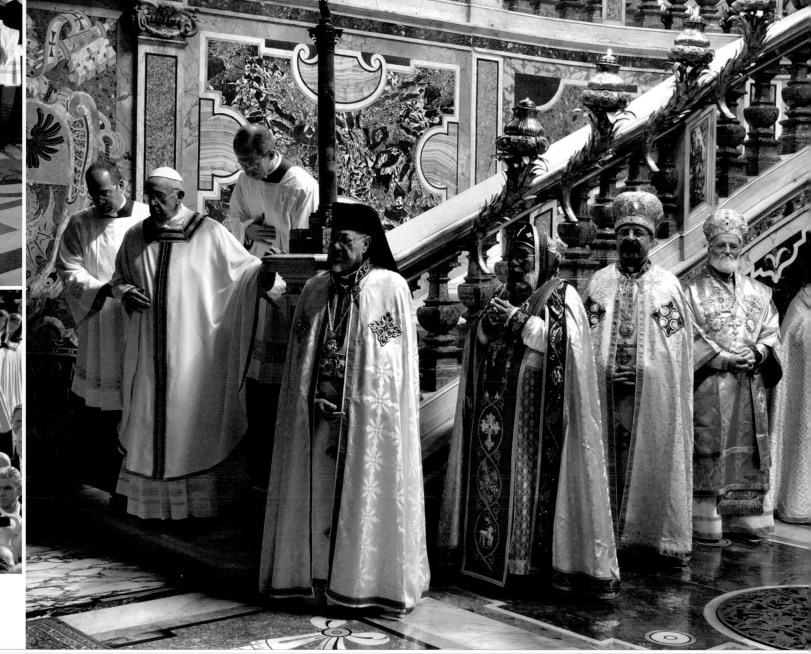

Λ DESCENT INTO THE CRYPT
Accompanied by the patriarchs and
metropolitan archbishops of the Eastern
Church, Pope Francis descends the steps
to the *pallium* niche above St. Peter's tomb.

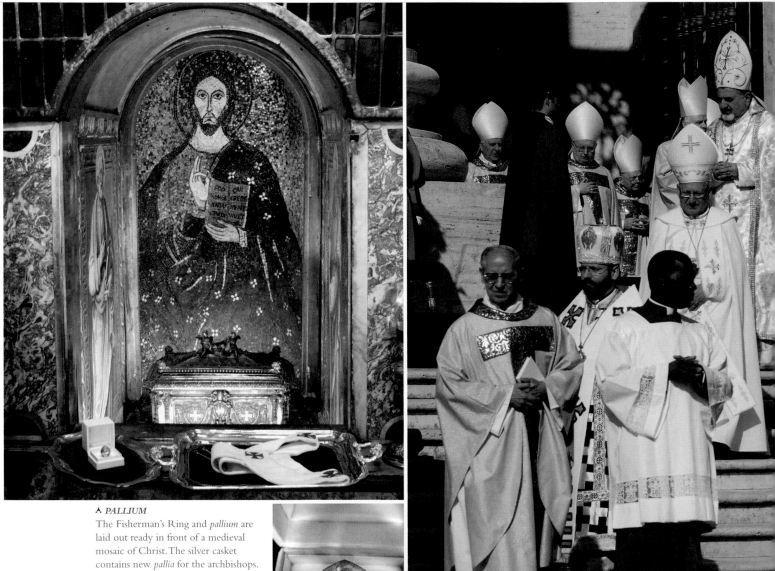

⋀ *PALLIUM*
The Fisherman's Ring and *pallium* are laid out ready in front of a medieval mosaic of Christ. The silver casket contains new *pallia* for the archbishops.

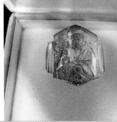

➤ FISHERMAN'S RING
The gold-plated ring designed by Enrico Manfrini for Pope Paul VI depicts St. Peter holding a pair of keys, symbolizing the keys of heaven.

> **SIMPLE MITER AND CHASUBLE**
For the ceremony, Pope Francis chose
the simple miter and matching chasuble
that he had worn since his time as a
bishop in Argentina.

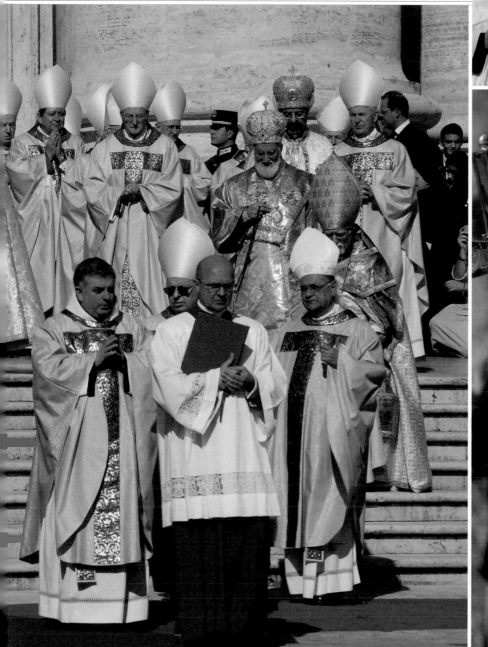

⋀ COLORFUL PROCESSION
The colorful procession of prelates
and bishops from Eastern and Western
Churches emerges from St. Peter's
Basilica onto the steps.

⋀ FERULE
Pope Francis arrives on the steps
of St. Peter's carrying a ferule, or
processional cross, which was made for
his predecessor, Pope Benedict XVI.

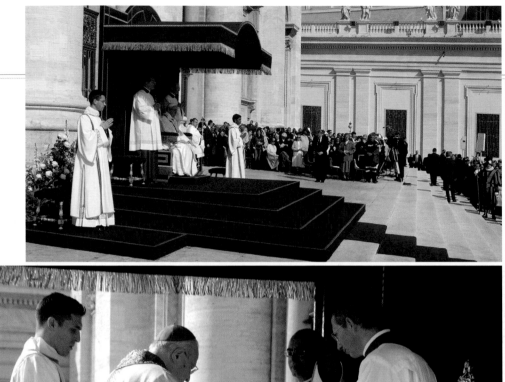

< BROADCAST TO MILLIONS
The ceremony of inauguration was followed by millions around the world on internet, radio, and television, and covered by more than 5,600 journalists.

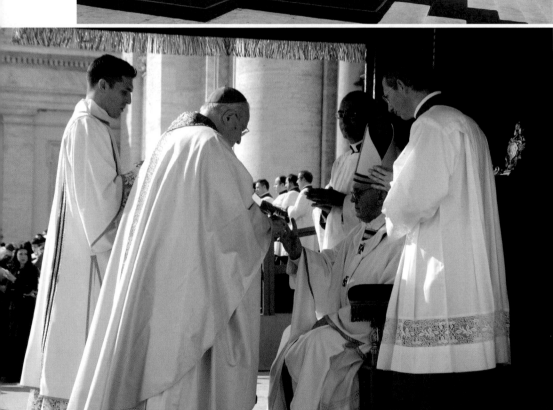

ʌ PALLIUM AND RING
The white woolen *pallium*, embroidered with four red crosses, is placed on the Pope's shoulders before he receives the Fisherman's Ring.

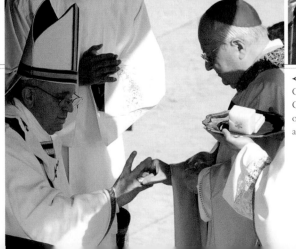

< RING FINGER
Cardinal Angelo Sodano, Dean of the College of Cardinals, places the Ring of the Fisherman on the pontiff's finger as Mass begins.

‹ GREETING THE CHILDREN
Following a tradition set on the day of his inauguration, Pope Francis drives through St. Peter's Square, meeting and talking to both adults and children.

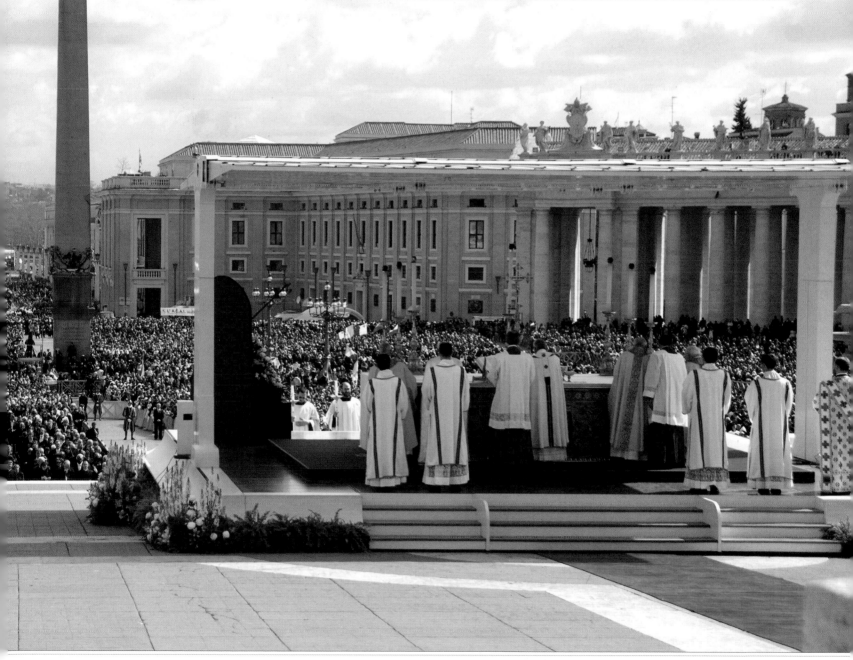

⋀ INVOCATION OF THE HOLY SPIRIT
"I implore the intercession of the Virgin Mary, Saint Joseph, Saints Peter and Paul, and Saint Francis, that the Holy Spirit may accompany my ministry—pray for me!"

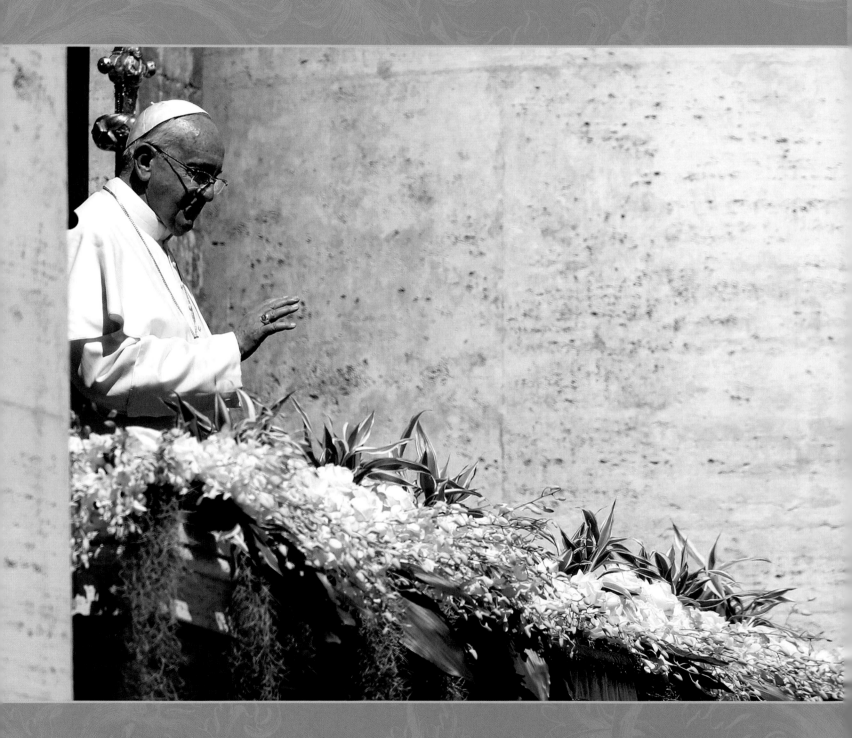

PAPAL YEAR

 ## THE POPE'S CALENDAR

As he approached his 75th birthday in December 2012, Cardinal Jorge Bergoglio submitted his resignation as Archbishop of Buenos Aires to Pope Benedict XVI. His intention was to retire to a home for elderly priests. Little could he have guessed that within a few months he would be called to the highest office in the Church. The principal role of the Pope is Bishop of the Diocese of Rome. But, as successor to Peter, he also has an important position in the wider life of the Church. Pope Francis has tried to move away from the over-centralization of the papacy, allowing bishops greater independence in their dioceses. In addition to his day-to-day duties at the Vatican, he regularly undertakes demanding pastoral visits to different parts of the world. Choosing to visit the peripheries, he always visits prisons, hospices, and rehabilitation centers on these journeys.

POPE FRANCIS IS THE 266TH SUCCESSOR OF ST. PETER AS BISHOP OF ROME. IN THIS ROLE, THE POPE'S PRIMARY RESPONSIBILITY IS THE SPIRITUAL WELFARE OF THE PEOPLE OF THE DIOCESE. HOWEVER, OVER THE CENTURIES, THE BISHOPS OF ROME HAVE BEEN ACCORDED A SPECIAL PLACE OF HONOR AMONG THE WORLD'S BISHOPS. ALTHOUGH THE POPE IS ONE AMONG EQUALS, HIS ROLE IS SEEN BY MOST CHRISTIANS AS AN IMPORTANT SOURCE OF UNITY. WITH IMPROVED MEANS OF COMMUNICATION AND TRAVEL, THE ROLE OF THE POPE HAS BECOME EVER MORE VISIBLE ON A GLOBAL SCALE.

Each day, Pope Francis follows the same routine. In keeping with a lifetime's habit, he rises before 5am. Since his election, he has resided in the Casa Santa Marta, a custom-built residence for Vatican clergy and a small number of guests, which is situated behind St. Peter's Basilica. Unless celebrating a liturgy elsewhere, Pope Francis begins his day with Mass in the chapel of the residence at 7am. A number of people are invited to the Mass, after which they have the opportunity to meet the Pope briefly. He then eats breakfast in the large refectory.

Early each morning, Pope Francis meets with the Prefect of the Papal Household, Archbishop Georg Gänswein, and reviews the appointments of the day. In general, the Prefect arranges the official appointments that take place in the morning, while Pope Francis decides whom he wishes to meet in the afternoon. A number of rooms, as well as space in the nearby Pope Paul VI Audience Hall, are available for these meetings.

On Wednesday mornings, Pope Francis greets pilgrims from all around the globe at the General Audience, which takes place in St. Peter's Square, and on Sunday mornings, he prays the Angelus from a window in the Apostolic Palace overlooking the square.

Pope Francis also has a vast amount of paperwork to review every day. Various offices send documents to the Secretariat of State, which correlates and prioritizes them for Pope Francis's attention. He attends to some in the morning, while taking care of others in the evening. Decisions are returned to the Secretariat of State, to be processed and dispatched to other offices. A particular responsibility of the Pope is choosing candidates for bishops throughout the Catholic Church.

By mid-morning, Pope Francis begins a series of private audiences. Official visits, by heads of state or senior politicians, for example, take place at the Library of the Apostolic Palace. If the weather is fair, the Pope will walk from his residence at the Casa Santa Marta, through the Courtyard of the Parrot, and into the Courtyard of St. Damascus, which leads to the Palace. If the weather is inclement, he will be driven in his Ford Focus hatchback.

At lunchtime, Pope Francis returns to the Casa Santa Marta. Although a table is set aside for him and his collaborators, he often chooses to sit down and dine with the other residents. He then observes the Italian tradition of a short siesta, after which he returns to his desk. From 5pm, he has more meetings on a vast range of subjects until evening prayers, which is followed by supper in the refectory with the other residents at 8pm. Occasionally, the Pope will invite guests, and a table is set aside for this. After supper, he retires for the evening, to review more paperwork and to make telephone calls.

As Bishop of Rome, Pope Francis also presides at a number of liturgies, which are celebrated in St. Peter's Basilica, at the cathedral of St. John Lateran, or in one of Rome's 335 parishes. He entrusts the day-to-day running of the Diocese of Rome to his vicar, Cardinal Agostino Vallini. Nonetheless, the Pope continues to visit the parishes regularly, and he often invites parishioners and clergy to come to see him at the Vatican.

MAJOR CELEBRATIONS

In addition to these regular, more routine events, there are a number that occur less frequently—often as little as once a year—but are enormously important occasions in the papal calendar. These range from the well-loved celebrations

A YEAR IN THE LIFE
EVENTS IN POPE FRANCIS'S CALENDAR

of Easter, in March or April, and Christmas, as well as more intimate occasions, such as the Feast of the Baptism of the Lord, which takes place in January, and the Feast of the Visitation in May.

INTERNATIONAL PROFILE

Over the past century, the profile of the papacy around the world has risen immeasurably. The 26-year pontificate of Pope John Paul II (1978–2005), in particular, highlighted the international role of the papacy as never before. During those years, Pope John Paul issued scores of theological documents and embarked on some 200 journeys crisscrossing the globe. It is estimated that the Polish pontiff covered more than a million miles during the last quarter of the 20th century.

His successor, Pope Benedict (2005–2013), traveled considerably less and for shorter distances. Although not particularly fond of travel, Pope Francis has committed himself to this international aspect of his papacy. Each visit requires meticulous planning in advance. Local authorities have to be contacted, while the logistics of the visit require patience and exactitude. Speeches need to be written and advice sought from the host country as to appropriate choices of venue. Security is always a concern, especially as Pope Francis prefers to walk though crowds or to be driven with the minimum escort.

INCREASING POPULARITY

Pope Francis enjoys extraordinary popularity, with the numbers attending ceremonies and events at the Vatican tripling in the first two years of his pontificate, from 2 to 6 million per year, and those numbers continue to grow.

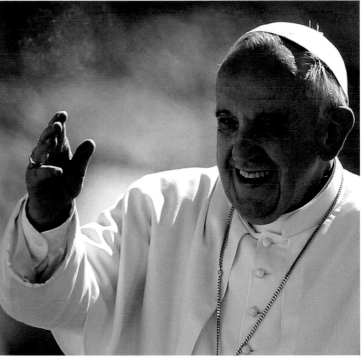

ʌ ENJOYING THE CROWD
Pope Francis waves to the crowds as he arrives at St. Peter's Square for the General Audience, which is held every Wednesday.

ᴠ PANORAMIC VIEW
St. Peter's Square is packed with pilgrims and sightseers for the Sunday Angelus, delivered from a window in the Apostolic Palace.

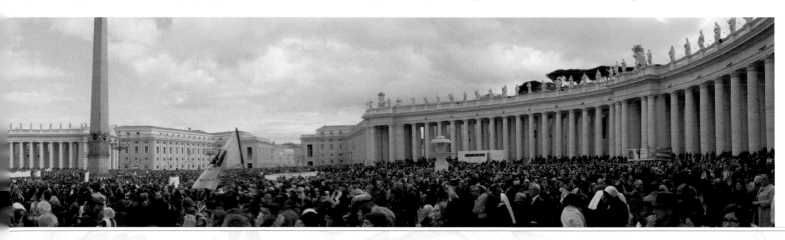

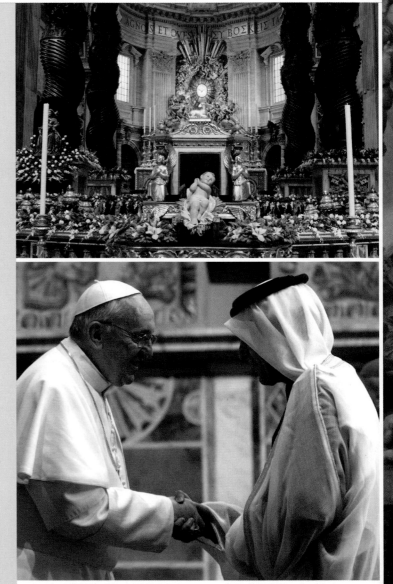

At the Vatican, the New Year begins with a Mass celebrated by Pope Francis at St. Peter's Basilica, attended by ambassadors from the countries accredited to the Holy See. The first day of January is the Feast of Mary, Mother of God, and the International Day of Prayer for World Peace. The Pope composes a message for the occasion that examines the international situation.

At midday, the Pope delivers the Angelus address to the crowds in St. Peter's Square from his study window in the Apostolic Palace. His public ceremonies and Angelus addresses are broadcast live around the world on a number of TV and radio networks and on the internet.

On January 6, the Church celebrates the Feast of the Epiphany, one of the oldest Christian feasts. It recalls the visit of the Magi to Mary, Joseph, and the infant Jesus in Bethlehem.

The Christmas season ends on the Sunday after Epiphany, the Feast of the Baptism of the Lord. On this day, Pope Francis baptizes a number of infants in the Sistine Chapel. Their parents are usually lay employees at the Vatican.

The papacy has the longest established diplomatic service in the world, dating back to the middle of the 5th century. Today, 180 countries have full diplomatic relations with the Holy See. Once a year, in mid-January, Pope Francis meets with the ambassadors of these countries in the 16th-century hall of the Sala Regia. Apostolic nuncios, the papal ambassadors, are assigned to the governments of these countries to promote issues of common interest. The national governments appreciate this link with the Vatican, which they regard as an invaluable listening post. The Holy See also maintains a number of missions throughout the world to international organizations such as the United Nations and to a number of charitable and legal bodies.

Each year, at the end of the month, the Pope meets with his theological advisors, members of the Congregation for the Doctrine of the Faith, at a plenary session. The advisors come from all over the world to the Vatican for this purpose. They consider important issues concerning Church teaching, and how to make it more effective and meaningful to Christians. In 2015, Pope Francis expressed his concern that there were so few female theologians represented and asked for the imbalance to be corrected.

∧ **DIPLOMATIC RECEPTION**
The Pope receives diplomats and exchanges New Year's greetings in the sumptuously decorated 16th-century Sala Regia in the Apostolic Palace.

> **BAPTISM**
On the Feast of the Baptism of the Lord, the Pope baptizes several infants in the 15th-century Sistine Chapel, whose walls are decorated with frescoes.

JANUARY
THE START OF A NEW PAPAL YEAR

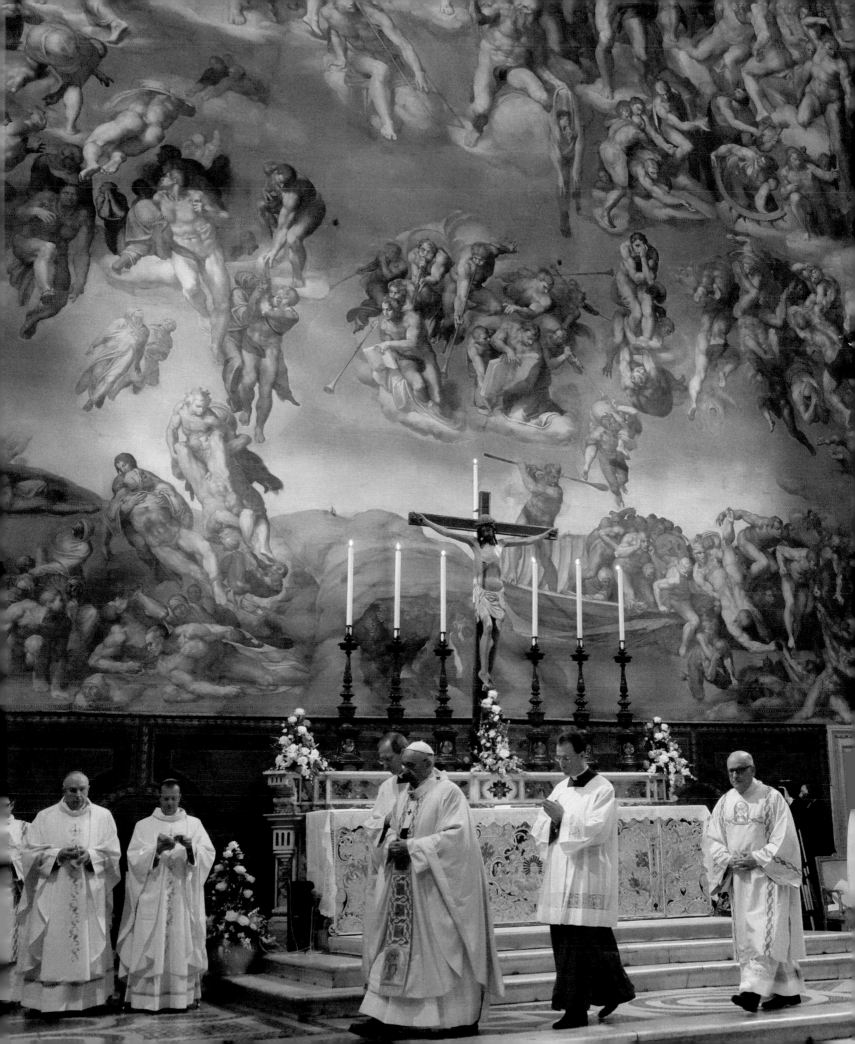

FROM EARLIEST TIMES, THE CHURCH IN ROME HAS CELEBRATED THE FEAST OF MARY, THE MOTHER OF GOD, EVERY YEAR ON THE FIRST DAY OF JANUARY, EIGHT DAYS AFTER THE NATIVITY OF JESUS. IT WAS IN THE YEAR 431, AT THE COUNCIL OF EPHESUS, THAT THE CHRISTIAN BISHOPS FIRST HONORED MARY AS THE MOTHER OF JESUS. SINCE JESUS WAS VENERATED AS THE SON OF GOD, THE TITLE ACKNOWLEDGED THAT MARY WAS THE MOTHER OF HER DIVINE SON. THE FEAST DAY OF MARY EMPHASIZES THAT JESUS HAS TWO NATURES—ONE HUMAN, ONE DIVINE.

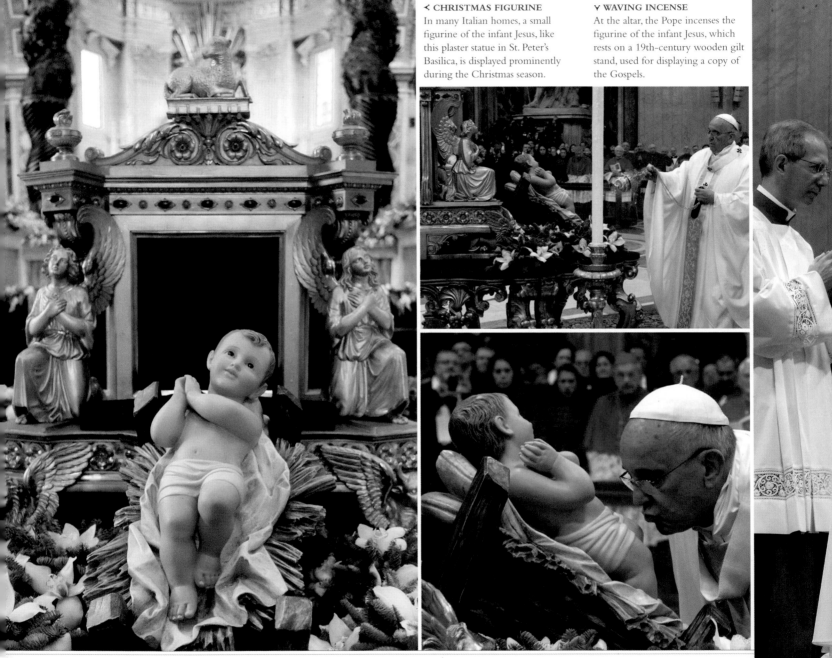

< CHRISTMAS FIGURINE

In many Italian homes, a small figurine of the infant Jesus, like this plaster statue in St. Peter's Basilica, is displayed prominently during the Christmas season.

v WAVING INCENSE

At the altar, the Pope incenses the figurine of the infant Jesus, which rests on a 19th-century wooden gilt stand, used for displaying a copy of the Gospels.

^ PRINCE OF PEACE

The Pope kisses the statue of the newborn baby as he prepares to begin Mass. One of the ancient titles of Jesus is "Prince of Peace."

FEAST OF MARY

CELEBRATING THE MOTHER OF GOD

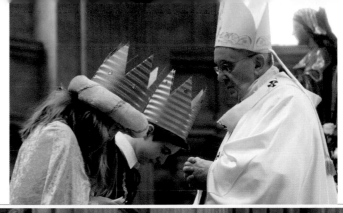

∨ CHILD MAGI
Three children, representing the Wise Men, or Magi, and wearing symbolic robes and crowns, bring wine and bread to the altar.

➤ HEADS BOWED
The children bow their crowned heads before Pope Francis as they pass the bread and wine to him during the Liturgy of the Eucharist.

THE WORD "EPIPHANY" HAS ITS ROOTS IN THE GREEK VERB MEANING "TO REVEAL."

✝ THE FEAST OF THE EPIPHANY IS CELEBRATED EVERY YEAR ON JANUARY 6 IN ST. PETER'S BASILICA. IT COMMEMORATES THE JOURNEY OF THE MAGI, OR WISE MEN, WHO FOLLOWED THE LIGHT OF A STAR TO BETHLEHEM, WHERE THEY FOUND MARY, JOSEPH, AND THE BABY JESUS. THE PRAYERS OF THE MASS RECALL THE BAPTISM OF JESUS, WHEN HE BEGAN HIS PUBLIC MINISTRY AS AN ADULT, AND ALSO HIS FIRST MIRACLE, WHEN HE TURNED WATER INTO WINE AT CANA IN GALILEE.

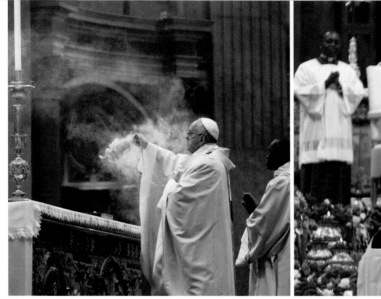

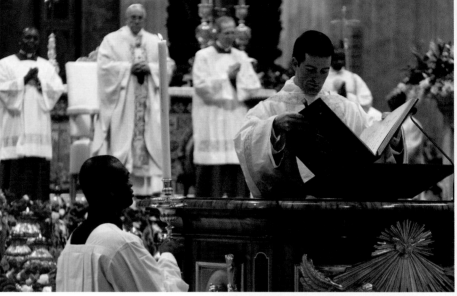

⋏ SWEET SCENT
At the beginning of the Mass, Pope Francis incenses the altar with perfumed gum arabic, which, when burned on charcoal, produces a sweet-scented smoke.

⋏ BIBLE READINGS
The deacon prepares to proclaim the Gospel. The most important passages read from the Bible are those from one of the Four Gospels.

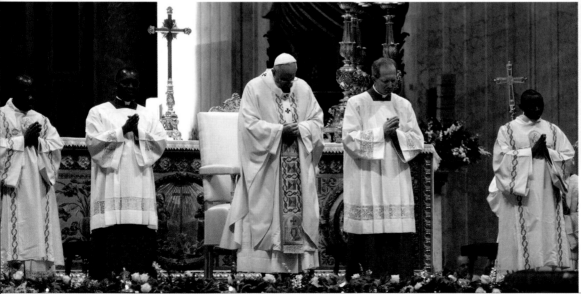

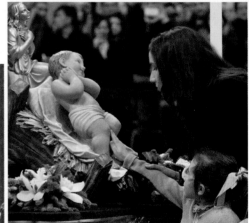

⋏ ADORATION
Two girls approach the statue of the infant Jesus. Most Catholic families have a crib at home with figures that recall the birth of Jesus in Bethlehem.

⋖ ASKING FOR FORGIVENESS
Pope Francis bows his head and invites everyone present to recall their sins, in the knowledge that God will forgive them as they ask for mercy.

> PREPARING FOR MASS
A server prepares for the celebration of Mass by lighting six candles on the High Altar. The statue of Mary and Jesus is decorated with white roses.

EPIPHANY

COMMEMORATING THE VISIT OF THE MAGI

ᴠ LIGHT OF THE EPIPHANY
Shafts of light stream through the
windows illuminating the High Altar
in St. Peter's as the Pope celebrates
Mass for the Feast of the Epiphany.

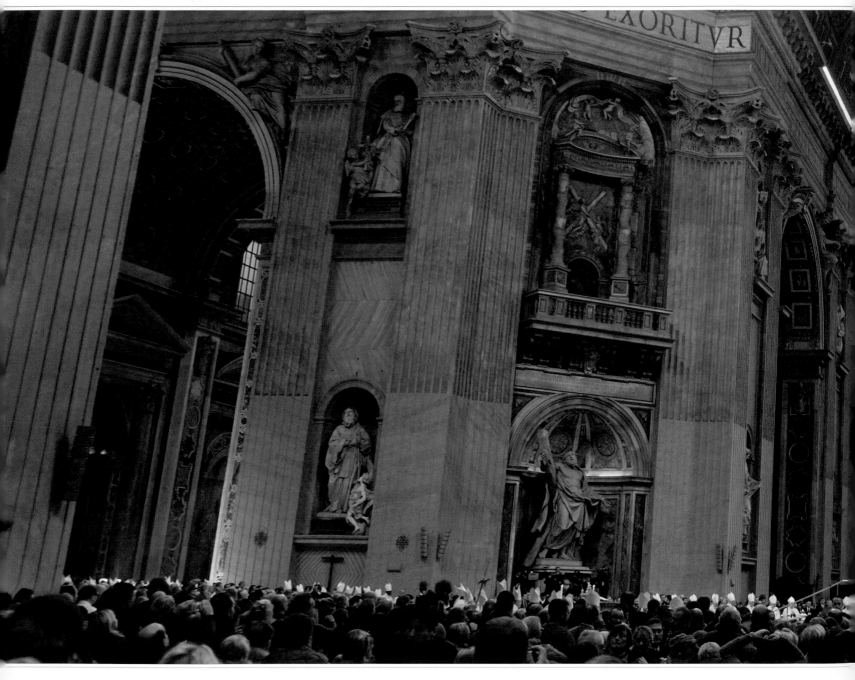

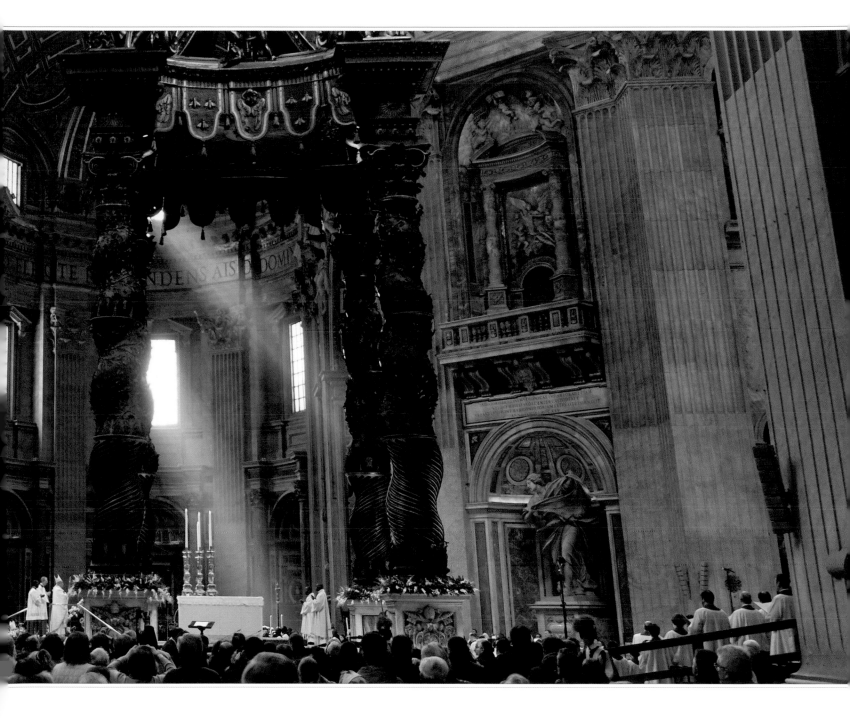

THE SISTINE CHAPEL IS THE VENUE FOR AN INTIMATE OCCASION THAT TAKES PLACE SHORTLY AFTER CHRISTMAS. AT THE FEAST OF THE BAPTISM OF THE LORD, POPE FRANCIS BAPTIZES SEVERAL BABIES, WHOSE PARENTS ARE USUALLY LAY EMPLOYEES AT THE VATICAN. THE CHAPEL WAS DESIGNED BY BACCIO PONTELLI FOR POPE SIXTUS IV AND BUILT BETWEEN 1473 AND 1481. IT WAS DECORATED BY SOME OF THE GREATEST RENAISSANCE ARTISTS, INCLUDING GHIRLANDAIO, PERUGINO, BOTTICELLI, AND, MOST FAMOUSLY OF ALL, MICHELANGELO, WHO PAINTED THE CELEBRATED CEILING.

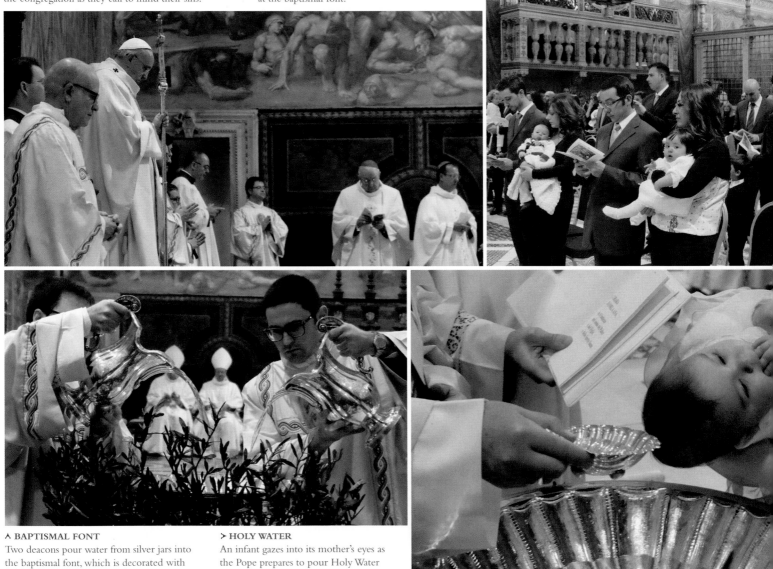

˅ CALLING FOR GOD'S FORGIVENESS
The Pope begins the Mass with the Penitential Rite, invoking God's forgiveness of the members of the congregation as they call to mind their sins.

＞ BABES IN ARMS
Parents of the babies hold them in their arms as they await the moment of baptism by Pope Francis at the baptismal font.

˄ BAPTISMAL FONT
Two deacons pour water from silver jars into the baptismal font, which is decorated with stylized olive branches, a symbol of peace.

＞ HOLY WATER
An infant gazes into its mother's eyes as the Pope prepares to pour Holy Water on its head from a silver scallop shell.

FEAST OF THE BAPTISM
AN INTIMATE FAMILY CEREMONY

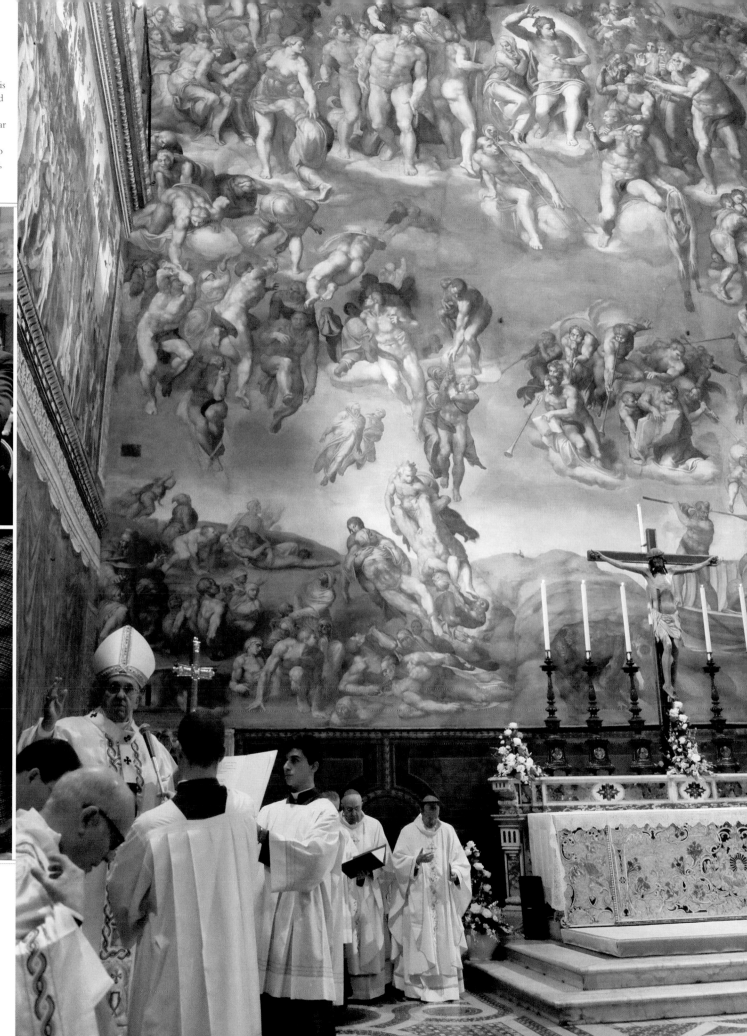

> **FRESCO**
The Pope gives his
blessing at the end
of Mass. Rising
up behind the altar
is Michelangelo's
magnificent fresco
The Last Judgment,
painted between
1536 and 1541.

ᴠ **SISTINE CHAPEL BAPTISM**
The Feast of the Baptism of the Lord
is celebrated each year in early January,
when the Pope baptizes infants in the
Sistine Chapel, painted by Michelangelo.

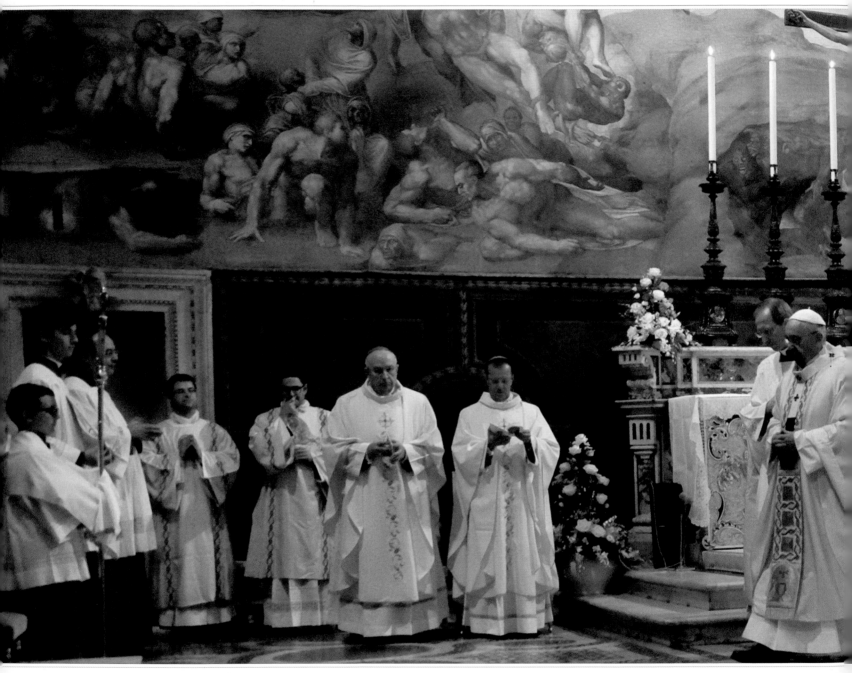

ONCE A YEAR IN MID-JANUARY, POPE FRANCIS MEETS THE AMBASSADORS OF THOSE COUNTRIES THAT MAINTAIN DIPLOMATIC RELATIONS WITH THE HOLY SEE. THE PAPACY HAS THE LONGEST-ESTABLISHED DIPLOMATIC SERVICE IN THE WORLD, DATING BACK TO THE MIDDLE OF THE 5TH CENTURY. SOME 180 COUNTRIES CURRENTLY HAVE FULL DIPLOMATIC RELATIONS WITH THE VATICAN. APOSTOLIC NUNCIOS, THE PAPAL AMBASSADORS, ARE ACCREDITED TO THE NATIONAL GOVERNMENTS AND SEEK TO FOSTER ISSUES OF COMMON INTEREST.

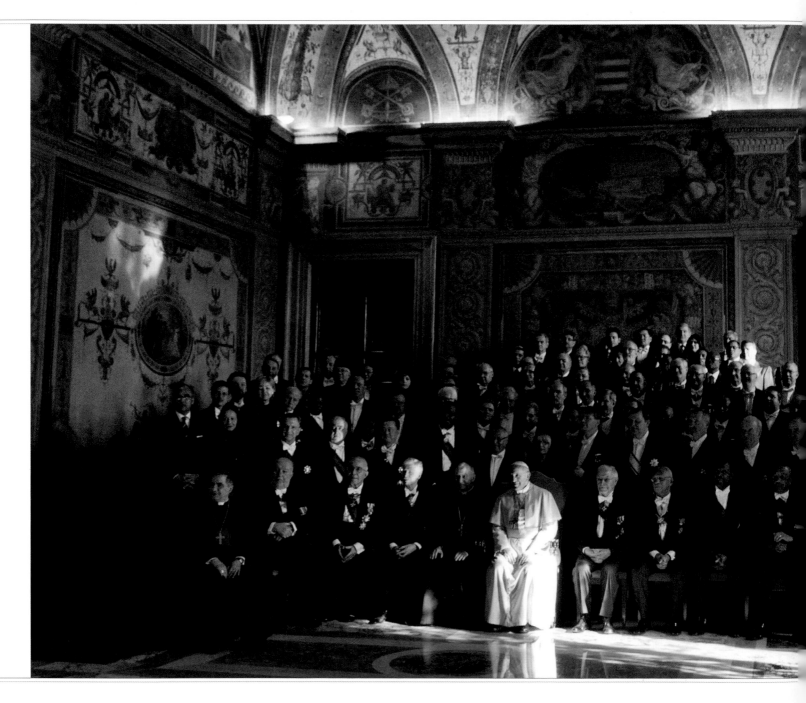

MEETING AMBASSADORS

PAPAL DIPLOMACY AT WORK

> PAPAL ADDRESS
Each year, the Pope delivers an important speech examining a range of issues, such as human trafficking, drug abuse, crime, ethics, humanitarian aid, and climate change.

∨ GROUP PHOTOGRAPH
In the Sala Ducale of the Apostolic Palace, designed by Bernini, diplomats gather for a group photograph with Pope Francis.

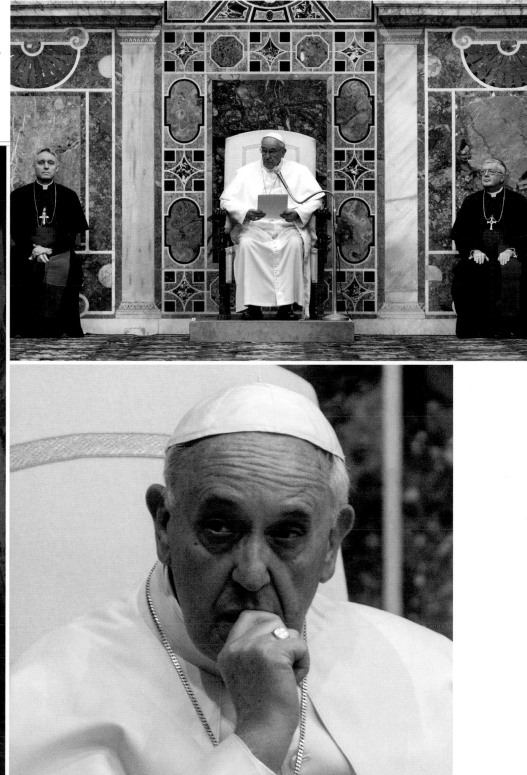

> VATICAN MISSIONS
The Holy See has a number of missions throughout the world. Most governments appreciate their links with the Vatican, regarded as an invaluable "listening post."

∧ PENSIVE POPE
Pope Francis is a passionate advocate of the political forum and seeks to awaken the consciences of world leaders concerning human rights.

EACH YEAR, CHRISTIANS OBSERVE A WEEK OF PRAYER FOR CHRISTIAN UNITY, WHICH CULMINATES IN THE FEAST OF ST. PAUL ON JANUARY 25. POPE FRANCIS THEN JOINS OTHER CHRISTIAN LEADERS FOR VESPERS AT THE BASILICA OF ST. PAUL OUTSIDE THE WALLS IN ROME, WHERE THE FIRST GREAT MISSIONARY IS BURIED. POPE FRANCIS REGULARLY MEETS OTHER CHRISTIAN LEADERS DURING HIS PASTORAL VISITS AND ALSO AT THE VATICAN, WHERE HE HAS INTRODUCED A NEW LEVEL OF INFORMALITY, INVITING HIS GUESTS TO STAY WITH HIM OR SHARE A MEAL IN THE REFECTORY.

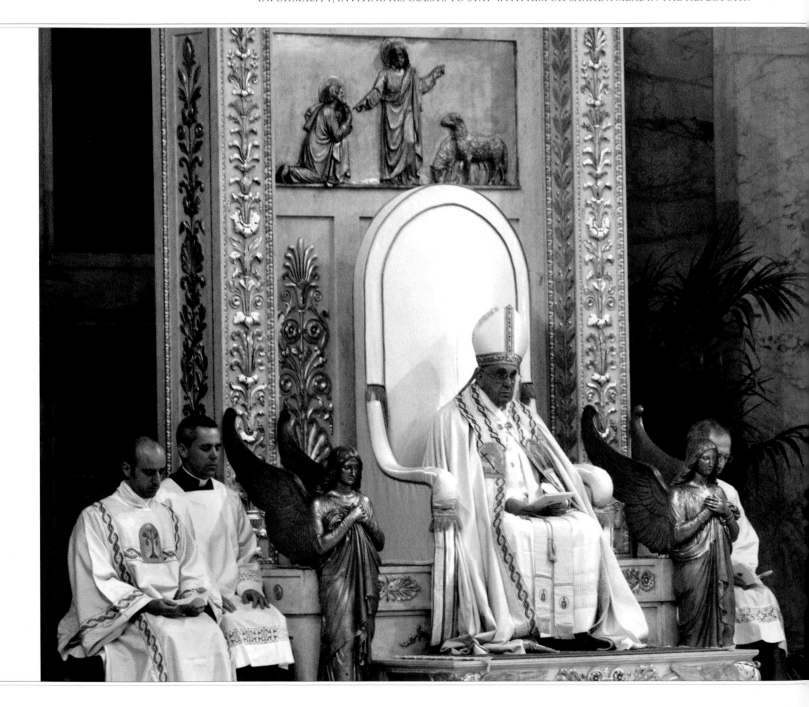

FEAST OF ST. PAUL

CELEBRATING THE CONVERSION OF ST. PAUL

◄ UNITED BY LOVE
"Let us overcome our conflicts, our divisions, and our self-seeking, and be united with one another by the power of love," said Pope Francis.

∨ LITURGICAL HIGHLIGHT
The celebration of Vespers at the Feast of St. Paul is one of the liturgical highlights of the pontiff's year and is celebrated with special solemnity.

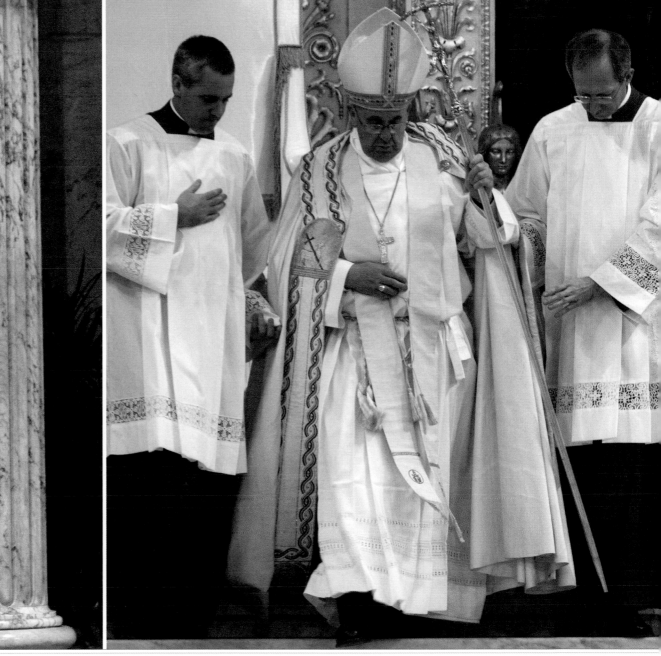

⋏ ANNUAL GATHERING
Catholics and other Christian leaders gather each year at St. Paul Outside the Walls in Rome to celebrate Vespers, the Evening Prayer of the Church.

✝ POPE FRANCIS IS PROUD OF HIS ARGENTINIAN HERITAGE. HE LOVES THE CULTURE, LITERATURE, MUSIC, ART, FOOD, AND THE SPANISH LANGUAGE. BEFORE HIS ELECTION, HE RARELY LEFT ARGENTINA APART FROM BRIEF VISITS TO OTHER LATIN AMERICAN COUNTRIES AND TO ROME. TODAY, HE ENJOYS MEETING THE ARGENTINIANS WHO VISIT HIM AT THE VATICAN AS WELL AS THE ARGENTINIAN DIASPORA IN EUROPE. POPE FRANCIS GLADLY WELCOMES GROUPS SUCH AS HIS FAVORITE SOCCER TEAM (SAN LORENZO DE ALMAGRO), SCHOOL GROUPS, OR DELEGATIONS FROM HIS NATIVE LAND.

⋀ OPPONENTS OF OPPRESSION
Pope Francis is passionate in his opposition to human trafficking and slavery and regularly urges governments and military forces to help end these practices.

⋗ BATTLE AGAINST EXPLOITATION
Speaking with his fellow countrymen, the Pope urged them to fight against the exploitation of the weak and vulnerable and promised to pray for their own safety.

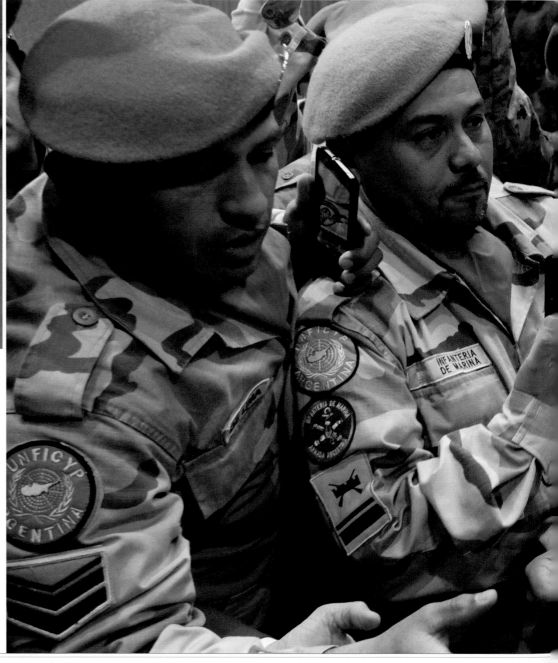

PEACEKEEPERS

POPE FRANCIS MEETS ARGENTINIAN BLUE BERETS

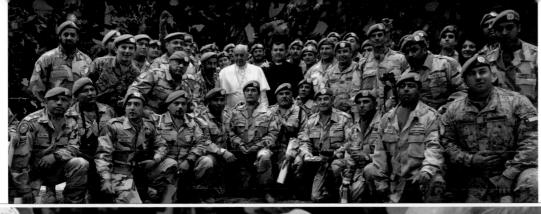

< UNITED NATIONS PEACEKEEPERS
Pope Francis poses with Argentinian
soldiers wearing the distinctive blue
berets of the UN peacekeeping force
at the end of a General Audience in
the Pope Paul VI Hall.

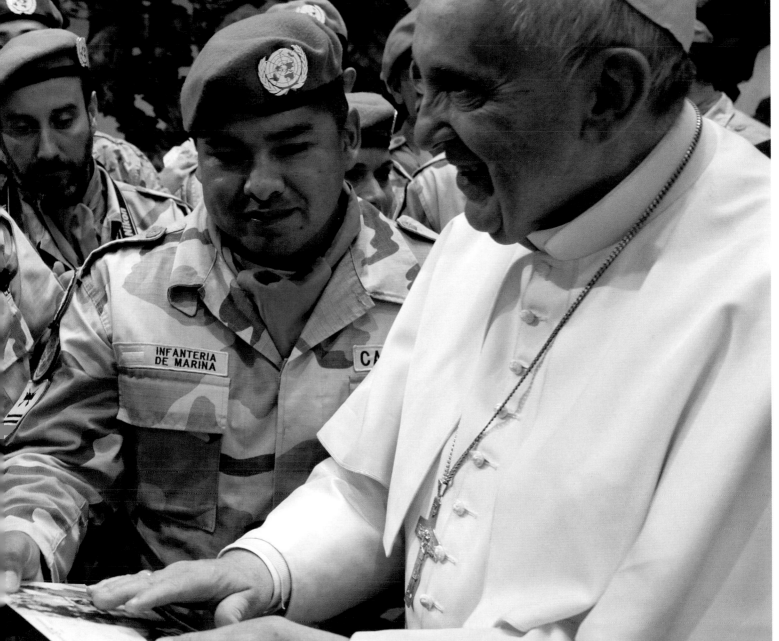

> MESSAGE OF HOPE
"Human beings can experience
conversion—they should never despair
of being able to change their lives.
May this be a message and hope for all,"
Pope Francis said.

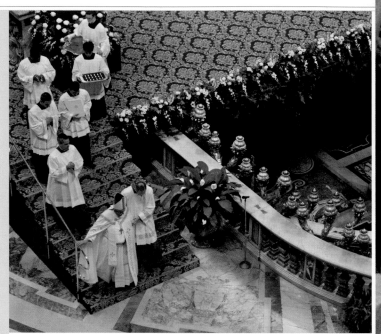

> CANDLEMAS
The torchlit procession begins in the atrium of St. Peter's, with the blessing of the candles, and arrives at the High Altar for the celebration of Mass.

The Feast of the Presentation of the Lord, celebrated on February 2 at St. Peter's Basilica, commemorates an important event in the early life of Jesus. When the infant was 40 days old, Mary and Joseph brought him to the temple and dedicated him to God. They encountered the elderly Simeon—described as "holy and devout" by St. Luke in his Gospel—who hailed Jesus as the "glory of Israel" and "the light of the Gentiles."

The feast is also called Candlemas—by tradition, all candles that are to be used in worship throughout the year are blessed on this day. Thousands of consecrated men and women, members of the Church's religious orders, join Pope Francis for the celebration, and the Church honors the contribution they make—in prayer, education, health, and other spheres of life.

In 1992, Pope John Paul II instituted the World Day of the Sick, which is celebrated on February 11, the Feast of Our Lady of Lourdes. The feast day was chosen because the Virgin Mary had reportedly miraculously healed many sick pilgrims and visitors.

The Diocese of Rome has a very active group of volunteers, who organize pilgrimages to the French shrine. Hundreds of them regularly take the sick, on specially chartered trains, to Lourdes. The volunteers also accompany invalids and the sick to the Vatican to celebrate World Day of the Sick each year on February 11.

Many romantic couples celebrate St. Valentine's Day on February 14 with gifts and greeting cards. Pope Francis hosts a special audience in St. Peter's Square for couples contemplating marriage.

The Feast of the Chair of Peter, celebrated on February 22, is one of the oldest feasts in the Roman calendar. According to tradition, a chair used by St. Peter was kept in the catacomb of Priscilla. In the ancient world, a chair was a symbol of teaching authority, much as a "chair" in a university is regarded today. The Feast of the Chair of St. Peter is a visible sign of the teaching authority of the bishops under the leadership of the Pope.

In February, Pope Francis creates new cardinals at a public ceremony, called a consistory, at the Vatican. He has to ensure that there are always 120 cardinal-electors (cardinals under 80 years of age who are eligible to vote) available for a conclave in case the papacy should become vacant.

^ PROCESSION
Pope Francis leads a procession to open the Year of Consecrated Life 2015-16, dedicated to the charism of the numerous religious orders in the Church.

> SIMPLE HABITS
Many religious sisters and brothers have modified or dispensed with their traditional habits and now wear much simpler clothing.

FEBRUARY

PILGRIMAGES AND CEREMONIES OF LIGHT

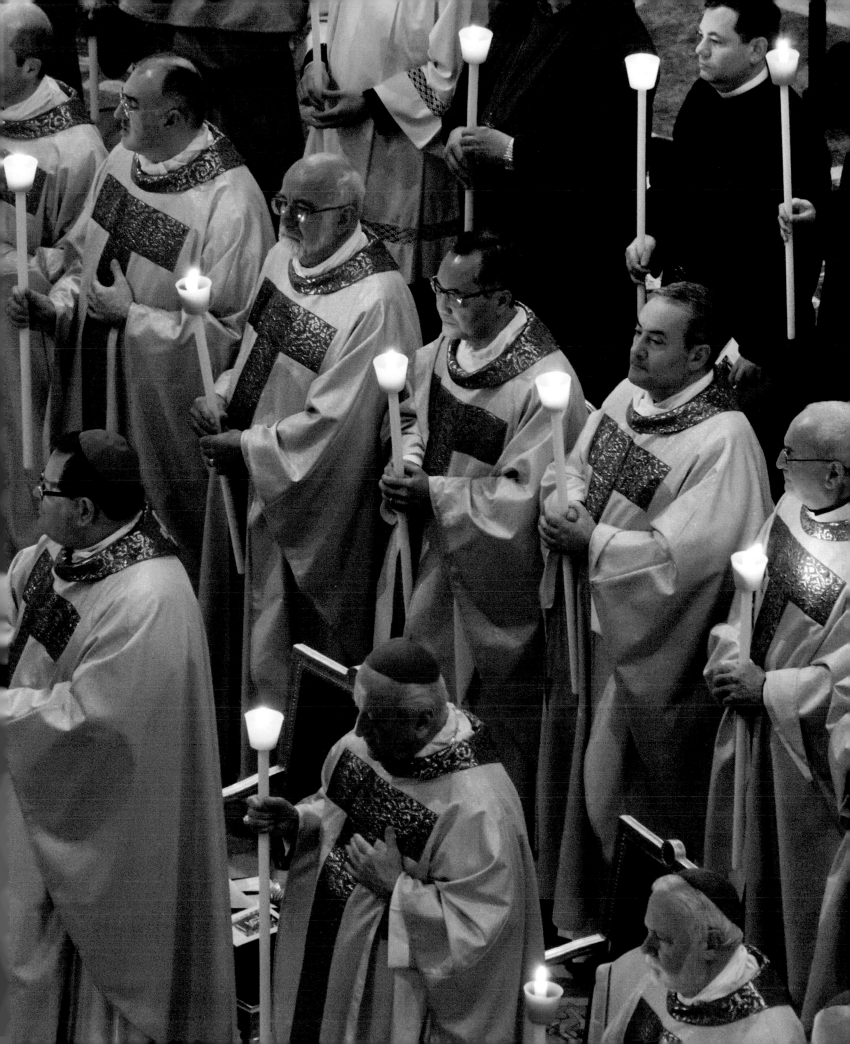

ON FEBRUARY 2, 2015, AT THE FEAST OF THE PRESENTATION OF THE LORD, ALSO KNOWN AS

✠ CANDLEMAS, POPE FRANCIS INAUGURATED A YEAR OF CONSECRATED LIFE. THE CELEBRATION
FOCUSED ON THE CONTRIBUTION TO THE CHURCH AND TO SOCIETY BY THOSE MEN AND WOMEN
WHO TAKE VOWS OF OBEDIENCE, CHASTITY, AND POVERTY. HE URGED THEM TO BE COURAGEOUS
AND PRAYED THAT THEIR "SHINING WITNESS OF LIFE WILL BE A LAMP" AND THAT IT WOULD "GIVE
LIGHT AND WARMTH TO ALL GOD'S PEOPLE."

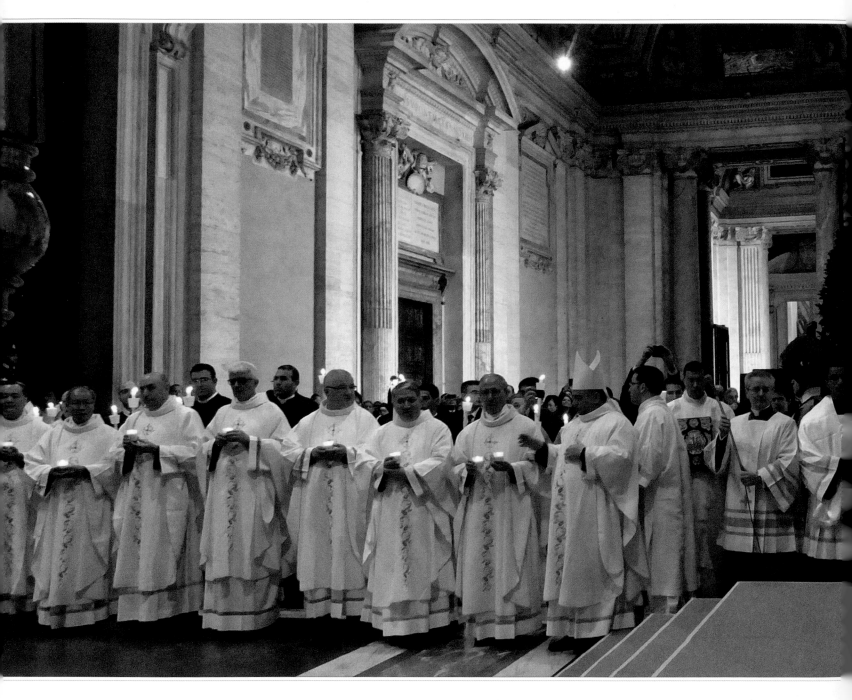

CANDLEMAS

THE BLESSING OF THE CANDLES

◄ CANDLELIGHT
Worshippers light their candles and sing a refrain from the Gospel of Luke: "A light of revelation to the Gentiles and glory for your people Israel."

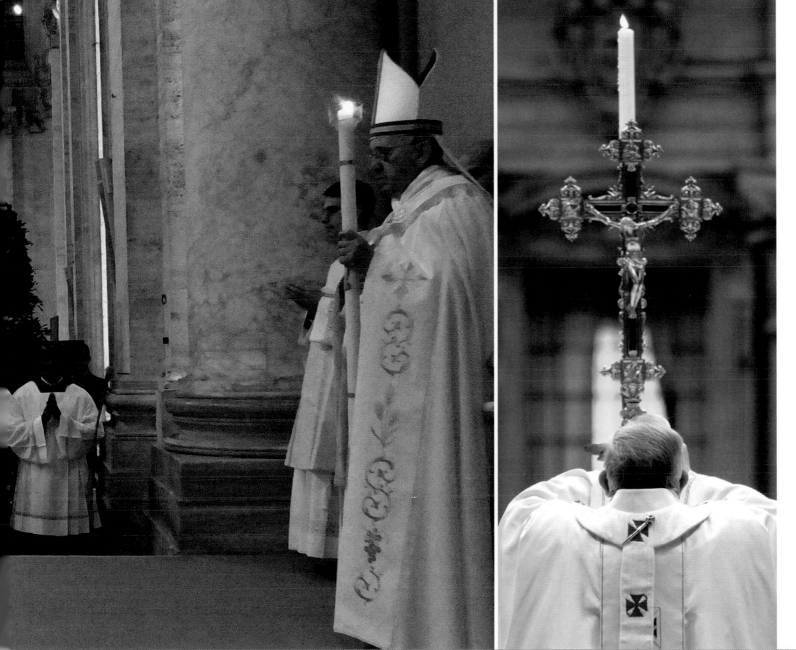

ʌ BLESSING OF CANDLES
Before Mass, everyone gathers in the atrium of St. Peter's, where candles to be used in worship in the coming year are blessed. The congregation then proceeds into the church singing hymns.

ʌ ELEVATING THE HOST
Standing in front of a gilt 17th-century crucifix, Pope Francis elevates the Host and the chalice for the clergy and congregation during the Eucharistic Prayer.

⋎ RENEWAL OF VOWS

During Mass, deacons, priests, and bishops holding lamps assemble around the High Altar in St. Peter's Basilica and renew their religious vows in the gathering dusk.

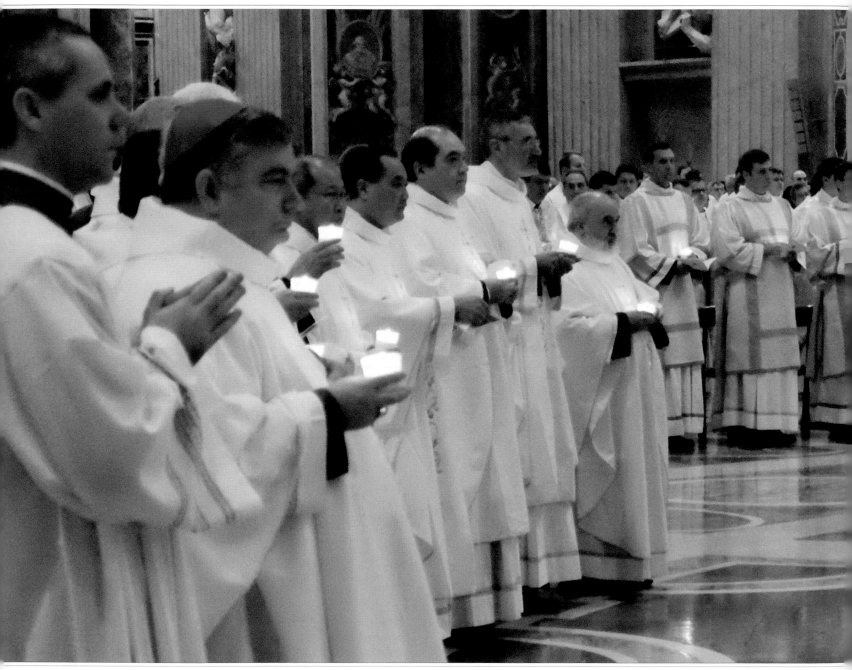

THE COLLEGE OF CARDINALS COMPRISES SOME 200 SENIOR BISHOPS, WHO ACT AS TRUSTED ADVISORS TO THE POPE. WHEN THE SEE OF ROME BECOMES VACANT, IT IS THE RESPONSIBILITY OF 120 CARDINAL-ELECTORS, WHO MUST BE UNDER THE AGE OF 80, TO SELECT A NEW BISHOP OF ROME. IN ORDER TO KEEP THE NUMBER OF CARDINALS OF THE REQUIRED AGE CLOSE TO ITS MAXIMUM, THE POPE HOLDS A CONSISTORY. DURING THIS CEREMONY, WHICH OFTEN TAKES PLACE IN THE MONTH OF FEBRUARY, NEW MEMBERS JOIN THE COLLEGE OF CARDINALS.

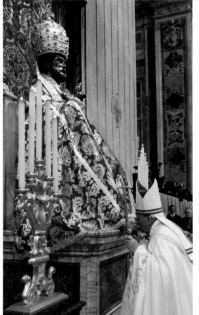

< ACT OF HUMILITY
Pope Francis kisses the foot of a decorated 13th-century bronze statue of St. Peter cast by the sculptor Arnolfo di Cambio.

> RARE APPEARANCE
On February 22, 2014, Emeritus Pope Benedict XVI made his first public appearance at a consistory since his resignation the year before.

∨ CARDINAL CHOICE
Pope Francis has made a point of choosing cardinals from poor parts of the world and where Catholics are in a minority or are persecuted.

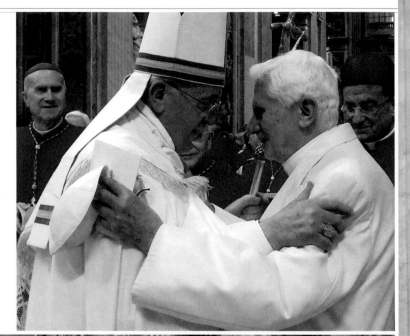

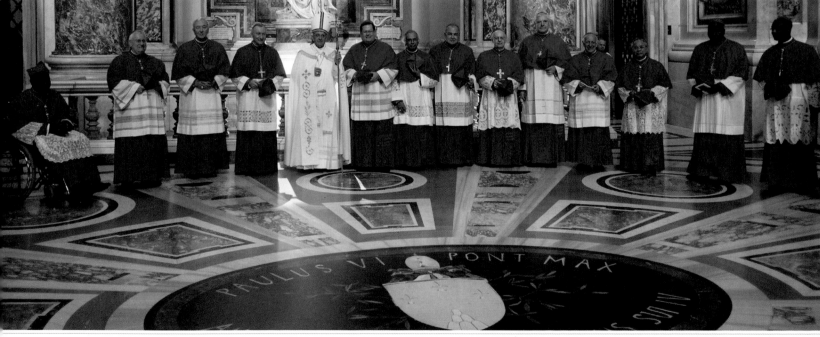

HOLDING A CONSISTORY
THE CREATION OF NEW CARDINALS

HIC IN VATICANO CONDITORIO COLLOCAV

SANCTA
HELENA
AVGVSTA

< CONSISTORY CHOIRS
The celebrated Choir of Westminster Cathedral, London, joined the Sistine Choir on February 22, 2014, to sing at the consistory for new cardinals.

⌄ DRESSED IN RED
Each new cardinal receives a scarlet silk, three-cornered hat, called a biretta. Scarlet is the color reserved for cardinals' formal dress.

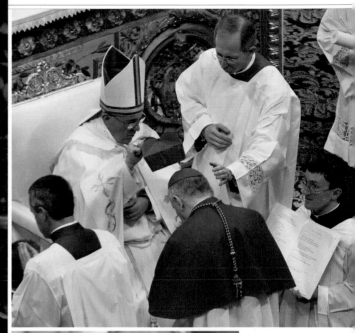

⌃ RING OF OFFICE
Every bishop wears a ring by virtue of his office. Cardinals are given a special ring that signifies their relationship with the Successor of Peter, the Pope.

∨ **INTERNATIONAL GATHERING**
The College of Cardinals was originally made up of the
25 priests, or pastors, of the parishes of Rome. Today, they
come from every nation around the globe.

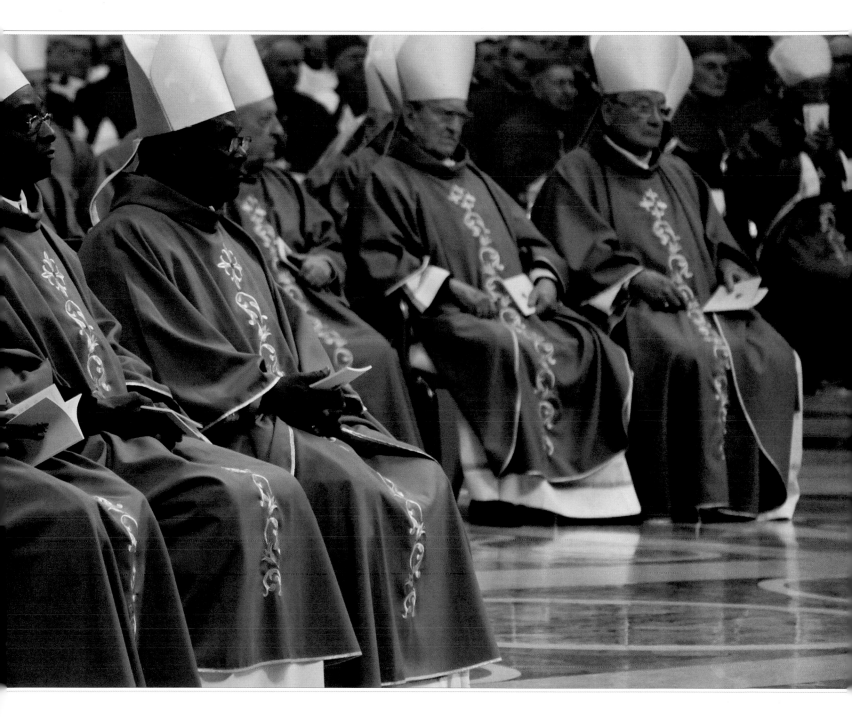

EVERY WEDNESDAY MORNING, POPE FRANCIS HOLDS A GENERAL AUDIENCE FOR PILGRIMS. AT THE BEGINNING OF HIS PONTIFICATE, THE NUMBERS ATTENDING VATICAN CEREMONIES EACH YEAR TRIPLED FROM THE 2 MILLION UNDER POPE BENEDICT TO ALMOST 6 MILLION. GENERAL AUDIENCES HAD BEEN HELD IN THE POPE PAUL VI AUDIENCE HALL, COMPLETED IN 1971, BUT IT ACCOMMODATES FEWER THAN 8,000 PEOPLE. SO, REGARDLESS OF THE WEATHER, POPE FRANCIS NOW HOSTS GENERAL AUDIENCES, WHICH CAN NUMBER BETWEEN 50,000 AND 70,000, IN ST. PETER'S SQUARE, WHERE LARGE SCREENS ARE ERECTED.

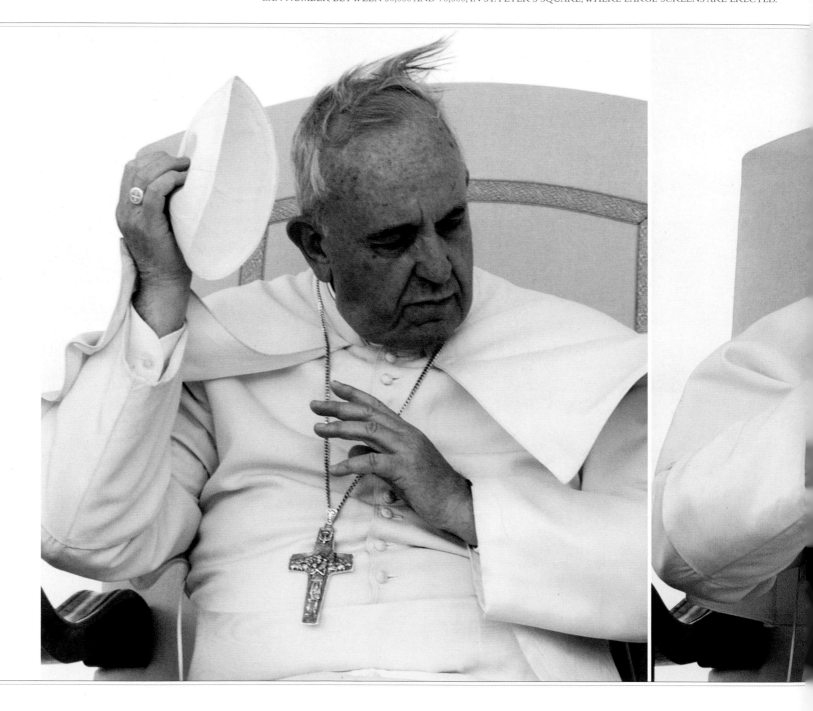

SARTORIAL MISHAPS

AT THE MERCY OF THE ELEMENTS

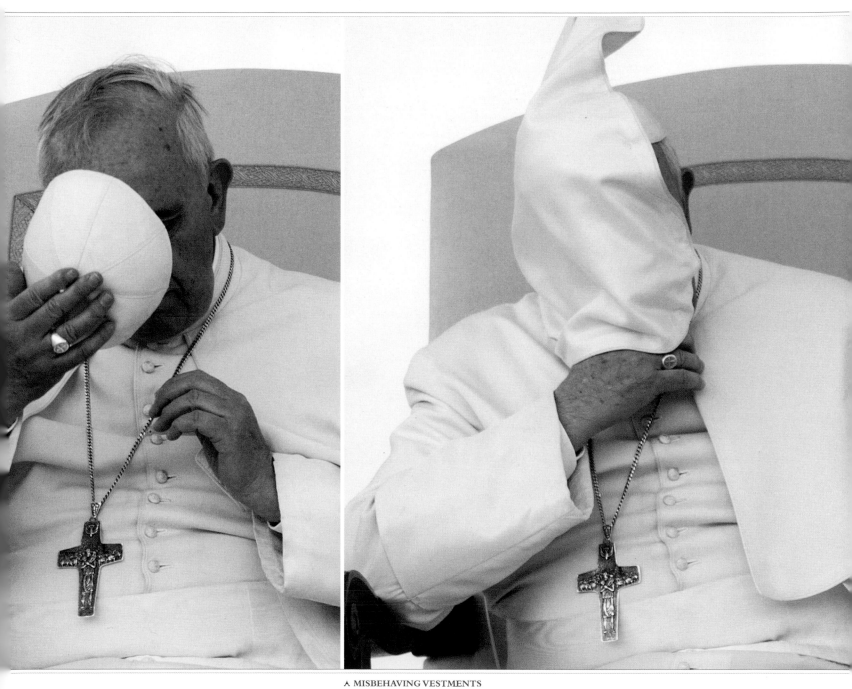

⋏ MISBEHAVING VESTMENTS
Occasionally the elements conspire against the Pope during the
General Audiences, which are held outdoors in St. Peter's Square.
Even in the summer, a gust of wind can be a distraction.

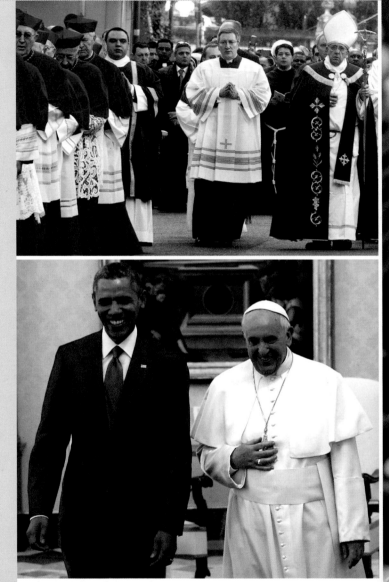

v PENITENTIAL PROCESSION
According to a tradition dating to at least
the 6th century, the Pope takes part in a
penitential procession on Ash Wednesday.

As spring arrives in Rome, the cold winter gives way to longer and brighter days. In the Church calendar, the period of Lent and Easter is celebrated in March and April. The date of Easter, as established by the First Council of Nicaea in 325, falls on the first Sunday after the full moon following the March equinox. This means that it varies from year to year, and can fall on any day between March 22 and April 25.

The season of Lent, comprising 40 days, is a preparation for Easter. It recalls the period that Jesus spent in the desert before he began his public ministry of teaching and healing. In the early Church, people who wished to be baptized spent the period of Lent studying the faith and listening to talks on Christian doctrine. Christians accompanied their progress with prayer and almsgiving.

Lent begins with Ash Wednesday, which can fall in February or March. On this day, Pope Francis travels to the 5th-century church of Santa Sabina on the Aventine Hill, overlooking the Circus Maximus. Here he celebrates the Mass for the Imposition of Ashes. During Lent, the Pope and members of the Roman Curia travel to the town of Ariccia in the Alban Hills outside Rome, where they spend a few days in retreat and prayer. In this rural setting, the Pope and his collaborators are able to listen undistracted to daily meditations and catch up with spiritual reading.

Pope Francis has inaugurated an annual Lenten liturgy, which includes the Sacrament of Penance and Reconciliation. The liturgy, during which penitents confess their sins and receive God's forgiveness, is celebrated in St. Peter's Basilica.

In March, the Pope invites the clergy of Rome to the Vatican to discuss the best way of looking after their parishes. The informal meeting also includes a question-and-answer session. Pope Francis emphasizes the fact that, as Bishop of Rome, he cares for the city's people and priests. Rome is a complicated city. It boasts a glorious cultural heritage and hosts several million visitors every year, yet in some areas unemployment is widespread, and thousands live in poverty. Pope Francis often recalls with gratitude his paternal grandparents, who taught him Italian as a child. His fluency in the language allows him to better understand the needs and aspirations of his people.

^ SPECIAL AUDIENCE
President Obama had his first special
audience with Pope Francis on
March 27, 2014, during which they
discussed contemporary issues.

> ASH WEDNESDAY
Although the Pope generally prepares
a text for his homilies, he often lays it
aside to speak off the cuff. This style is
much more engaging for his audience.

MARCH
PENANCE AND UNDERSTANDING

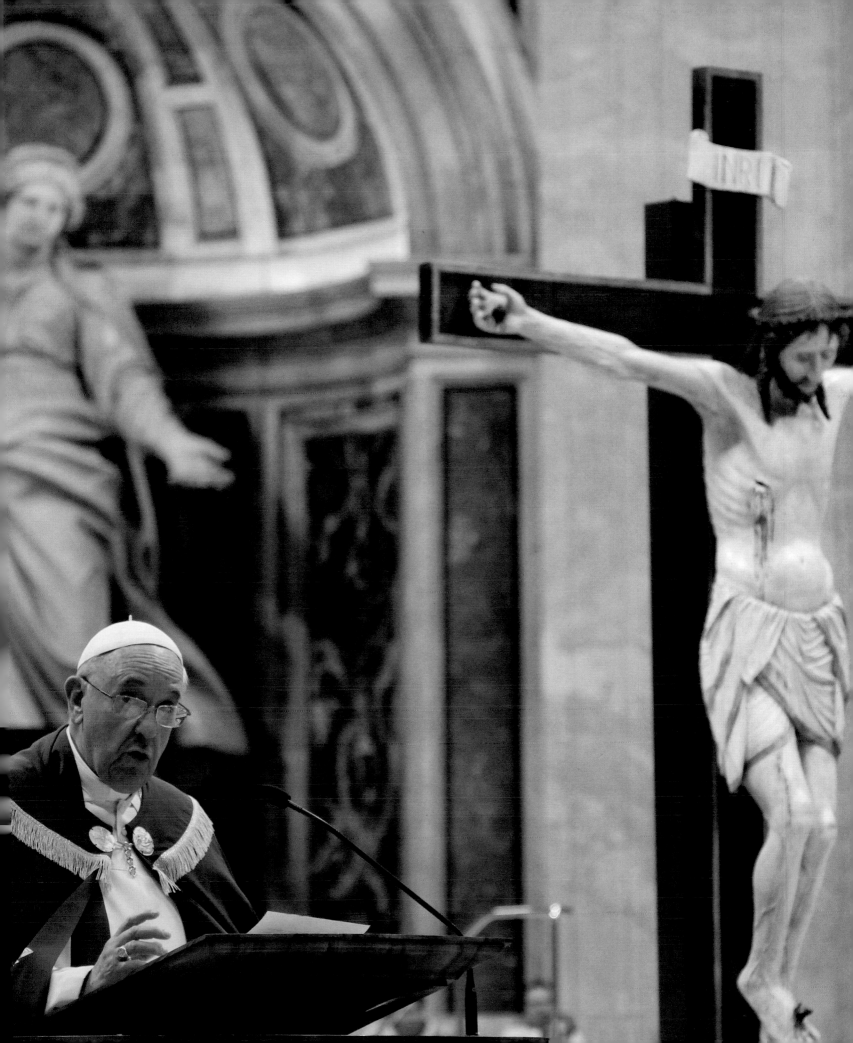

✠ ASH WEDNESDAY IS THE BEGINNING OF LENT, WHICH LASTS FOR 40 DAYS AND IS MARKED BY PRAYER AND FASTING. ACCORDING TO A CUSTOM DATING FROM THE 6TH CENTURY, THE POPE CELEBRATES MASS ON ASH WEDNESDAY IN THE DOMINICAN CHURCH OF SANTA SABINA IN ROME. BUILT IN 432 AD, THE CHURCH STANDS ON THE AVENTINE HILL, OVERLOOKING THE CIRCUS MAXIMUS AND THE TIBER RIVER. BEFORE THE MASS, THERE IS A PENITENTIAL PROCESSION TO SANTA SABINA FROM THE BENEDICTINE CHURCH OF SANT'ANSELMO NEARBY.

➤ ARRIVING AT SANTA SABINA

The procession from Sant'Anselmo arrives at the Benedictine Church of Santa Sabina, where Pope Francis celebrates Mass and sprinkles ashes on the heads of the clergy and congregation.

⌃ PARTICIPATING CARDINALS

Cardinals Jozef Tomko and Francis Arinze arrive at Sant'Anselmo to participate in the liturgy. Both headed important congregations in the Roman Curia before their retirement.

➤ ASHES TO ASHES

Pope Francis places ashes on the heads of cardinals on Ash Wednesday as a reminder that life is fleeting and that sooner or later all returns to dust.

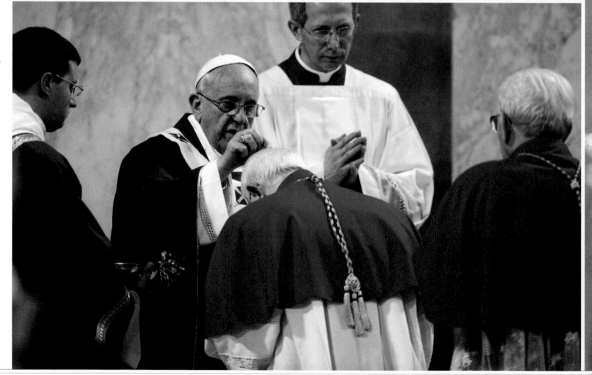

ASH WEDNESDAY

THE FIRST DAY OF LENT

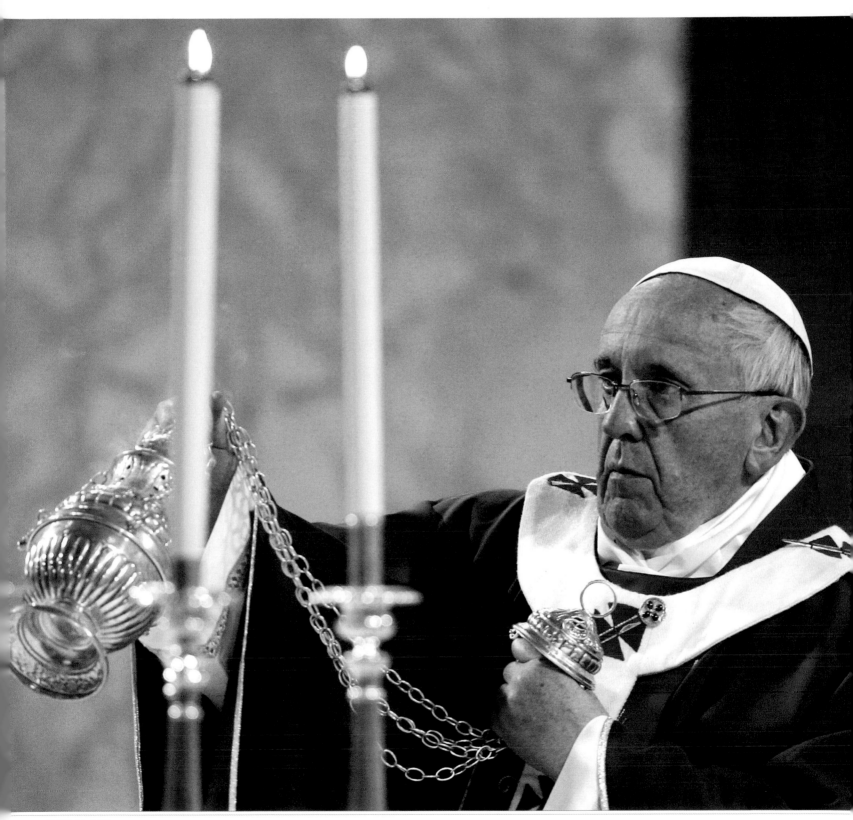

˄ TRUST IN GOD
"The call to conversion is a push to return to the arms of God, a tender and merciful Father, to trust him and to entrust ourselves to him," Pope Francis said.

FOLLOWING HIS ABDICATION ON FEBRUARY 28, 2013, EMERITUS POPE BENEDICT XVI RESIDED AT CASTEL GANDOLFO IN THE ALBAN HILLS. HE RETURNED TO THE VATICAN IN MAY AND WENT TO LIVE IN A CONVERTED CONVENT IN THE VATICAN GARDENS, TO LIVE QUIETLY "IN THE TWILIGHT OF MY YEARS AND PREPARE FOR ETERNITY WITH GOD." POPE FRANCIS AND HIS PREDECESSOR HAVE ESTABLISHED A GOOD RELATIONSHIP AND VISIT EACH OTHER REGULARLY. POPE FRANCIS VALUES THE EXPERIENCE OF THE EMERITUS PONTIFF AND OFTEN TAKES ADVICE FROM HIM.

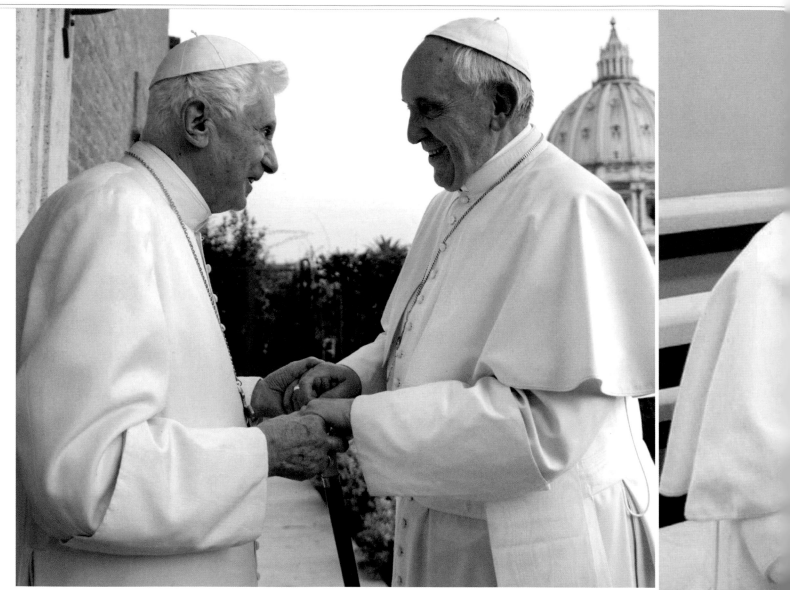

ᴧ CHRISTMAS GREETINGS
On December 24, 2013, Pope Francis called on his predecessor at his home to exchange Christmas greetings. Pope Francis brought a gift of a *panettone*, a traditional Italian Christmas cake.

➤ PRAYING TOGETHER
Pope Francis and Emeritus Pope Benedict pray together in the chapel of the papal country residence at Castel Gandolfo on March 23, 2013. The photograph captures the first time the two prayed together as popes.

THE POPES TOGETHER
MUTUAL RESPECT AND ADMIRATION

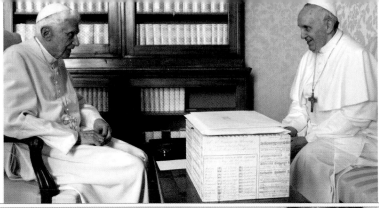

◄ HANDOVER
Emeritus Pope Benedict gave a box of files from his time in office to his successor Pope Francis when the new Pope visited him at Castel Gandolfo on March 23, 2013.

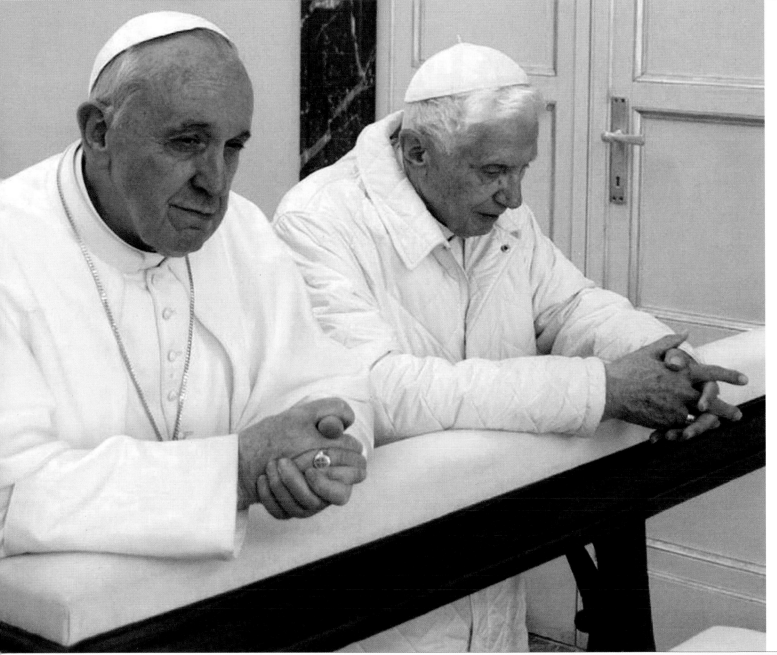

AS CAPITAL OF ITALY, ROME IS REGULARLY HOST TO A LARGE VARIETY OF PRESTIGIOUS VISITORS.

✝ MONARCHS, HEADS OF STATE, AND POLITICIANS OFTEN INCLUDE A VISIT TO THE VATICAN. POPE FRANCIS RECEIVES HIS DISTINGUISHED VISITORS AT THE APOSTOLIC PALACE. ON MARCH 27, 2014, PRESIDENT BARACK OBAMA OF THE UNITED STATES PAID HIS SECOND VISIT TO THE VATICAN, HAVING BEEN RECEIVED IN AUDIENCE BY POPE BENEDICT XVI IN 2009. THE HOLY SEE AND THE UNITED STATES, WHICH IS HOME TO MORE THAN 70 MILLION CATHOLICS, HAVE LONG HAD WARM DIPLOMATIC RELATIONS.

➤ GÄNSWEIN'S WELCOME
Archbishop Georg Gänswein, Prefect of the Papal Household, welcomes President Obama to the Vatican.

Λ GUARD'S SALUTE
A Swiss Guard salutes the presidential cortège as the diplomatic vehicles arrive in the courtyard of the Apostolic Palace before the meeting.

➤ CHARITY GIFT
The President offered a box of fruit and vegetable seeds to be planted in the Vatican gardens, suggesting that the harvest could be given to charity.

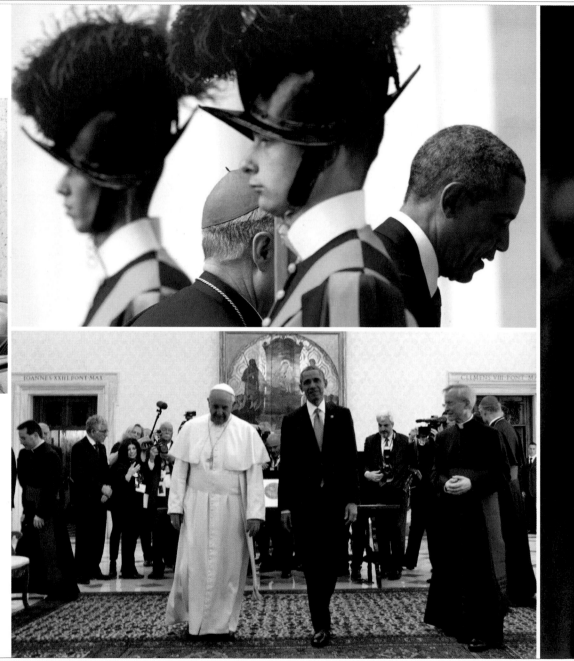

MEETING OBAMA

POPE FRANCIS MEETS THE US PRESIDENT

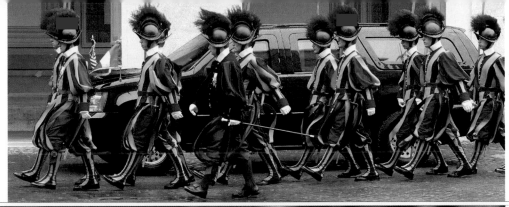

> **SWISS GUARDS' FAREWELL SALUTE**
Swiss Guards escort President Obama as he leaves in his car after the informal meeting with Pope Francis at his private library in the Apostolic Palace.

⋎ **INTERNATIONAL ISSUES**
During their hour-long meeting, the two men discussed the international situation with regard to human rights, conscientious objection, religious freedom, climate change, and human trafficking.

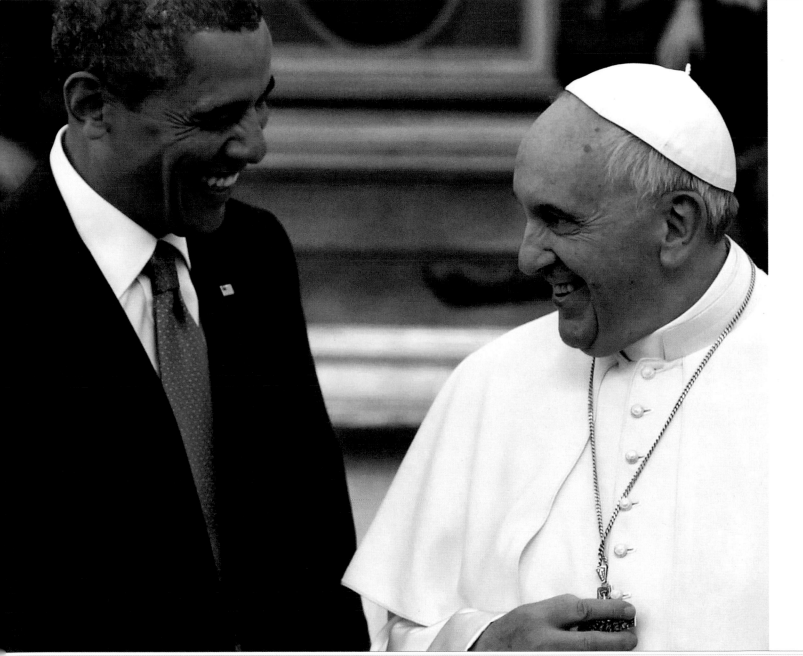

LENT IS A TIME OF PENANCE AND RENEWAL FOR CHRISTIANS. POPE FRANCIS HAS ENCOURAGED

✝ CATHOLICS TO AVAIL THEMSELVES OF THE SACRAMENT OF PENANCE AND RECONCILIATION. IN MARCH 2014, HE INAUGURATED "24 HOURS FOR THE LORD" WHEN CHURCHES AROUND ROME STAY OPEN NIGHT AND DAY TO RECEIVE PENITENTS. SPEAKING AT A GENERAL AUDIENCE ON FEBRUARY 19 THAT YEAR, THE POPE NOTED THAT SOME PEOPLE ARE EMBARRASSED BY CONFESSION: "EVEN EMBARRASSMENT IS GOOD. IT'S HEALTHY TO HAVE A BIT OF SHAME. IT DOES US GOOD BECAUSE IT MAKES US HUMBLE."

➤ TIME OF REPENTANCE
"During the time of Lent, the Church, in the name of God, renews her appeal to repentance. It is the call to change one's life," Pope Francis told the people.

ᵜ ST. PETER'S FORGIVENESS
"Whose sins you forgive they are forgiven and whose sins you retain they are retained," Jesus is recorded as saying to St. Peter in St. John's Gospel.

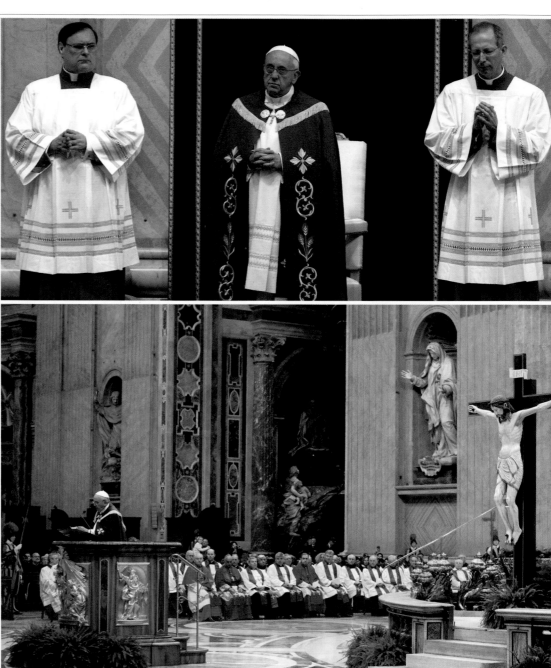

➤ THE LORD AWAITS US
"Our Father expects us always, he doesn't just leave the door open to us, but he awaits us, for he is awaiting his children," Pope Francis preached.

24 HOURS FOR THE LORD

POPE FRANCIS CONFESSES HIS SINS

Penitents line up to confess their sins
to one of the scores of priests available at
St. Peter's. The Penance Service is replicated
in thousands of churches globally.

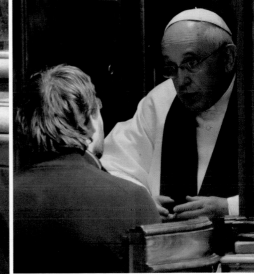

⋏ CONFIDENTIAL SACRAMENT
Pope Francis welcomes a young man in the
Sacrament of Penance and Reconciliation.
The sacrament remains entirely confidential
between the priest and the penitent.

< CONFESSIONS OF POPE FRANCIS
As he walks toward his confessional,
the Pope sees a priest and unexpectedly
decides to confess his own sins before he
hears the confessions of penitents.

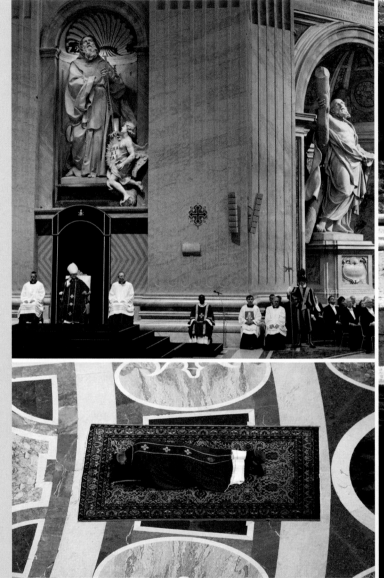

∨ EASTER SUNDAY
On Good Friday in 2014, as part of Holy Week, Pope Francis presides over the Celebration of the Lord's Passion in St. Peter's Basilica, recalling the crucifixion and death of Jesus.

In the Christian calendar, the week before Easter is known as Holy Week, and recalls the last days of Jesus's life. It opens on Palm Sunday, when Christians remember the enthusiastic welcome Jesus received on entering Jerusalem before the Passover. His followers cut branches from palm trees and placed them on the ground. Others laid down their cloaks as he passed by. By the end of the week, the exuberance had evaporated.

On Holy Thursday, the Church commemorates the Last Supper and the betrayal of Christ. In the morning, the Pope celebrates the Mass of Chrism, during which oils to be used in the sacraments of Baptism, Confirmation, Holy Orders, and the Anointing of the Sick are blessed and consecrated.

On his first Holy Thursday in 2013, Pope Francis broke with the tradition of celebrating the Solemn Mass of the Lord's Supper in St. Peter's Basilica, instead choosing a detention center for juveniles at Casal del Marmo. During the ritual Washing of Feet, he knelt to wash the feet of 12 young offenders. The next year, he celebrated the Mass of the Lord's Supper at Our Lady of Providence rehabilitation center for the elderly and disabled.

Christians traditionally mark Good Friday with prayer and fasting. It recalls the day on which Jesus was crucified and died. In churches throughout the world, the solemn Celebration of the Lord's Passion takes place. In St. Peter's Basilica, Pope Francis presides over the afternoon liturgy, during which the Passion narrative of the death of Jesus is read, the crucifix is venerated, and Holy Communion is distributed. That evening, Pope Francis goes to Rome's ancient arena, the Colosseum, where he follows the Via Crucis (Way of the Cross) with the thousands of people assembled there.

Silence marks Holy Saturday, the day on which Christ lay in the tomb. In the late evening, Pope Francis leads the Easter Vigil at St. Peter's Basilica, a Mass during which the Paschal candle is lit and the Easter Proclamation is sung. The Pope also administers the Sacrament of Baptism.

On Easter Sunday, hundreds of thousands of people gather in St. Peter's Square to celebrate Mass with Pope Francis. Afterward, the pontiff imparts the traditional blessing *Urbi et Orbi* (To the City and the World) from the loggia, or main balcony, on the facade of the basilica.

∧ ABASEMENT
Pope Francis prostrates himself before the High Altar in a sign of abasement during the Celebration of the Lord's Passion on Good Friday.

≻ COAT OF ARMS
The Pope delivers the traditional Easter Sunday blessing, *Urbi et Orbi*, from the loggia of St. Peter's. The enormous banner depicts his coat of arms.

APRIL

HOLY WEEK AND EASTER

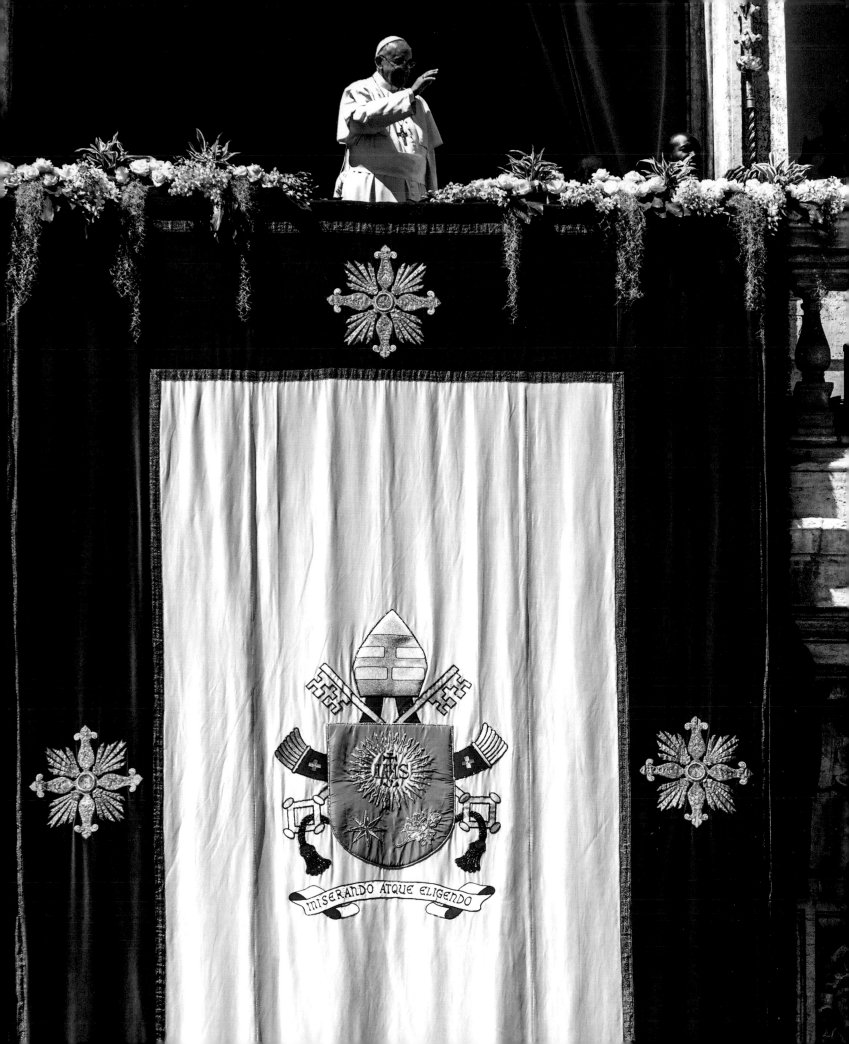

✝ **THE DATE FOR THE ANNUAL CELEBRATION OF EASTER CHANGES EACH YEAR. IN THE WEST, IT HAS** BEEN CELEBRATED SINCE THE 4TH CENTURY ON THE FIRST SUNDAY FOLLOWING THE FIRST FULL MOON AFTER THE SPRING EQUINOX. PALM SUNDAY IS THE START OF HOLY WEEK, LEADING UP TO EASTER. IN THIS WEEK, CHRISTIANS FOLLOW THE LAST DAYS OF JESUS'S LIFE. CROWDS GATHER IN ST. PETER'S SQUARE AND LISTEN TO A PASSAGE OF THE GOSPEL. CARRYING PALM BRANCHES, THEY THEN FORM A PROCESSION TO THE BASILICA, WHERE THE POPE CELEBRATES MASS ON THE STEPS.

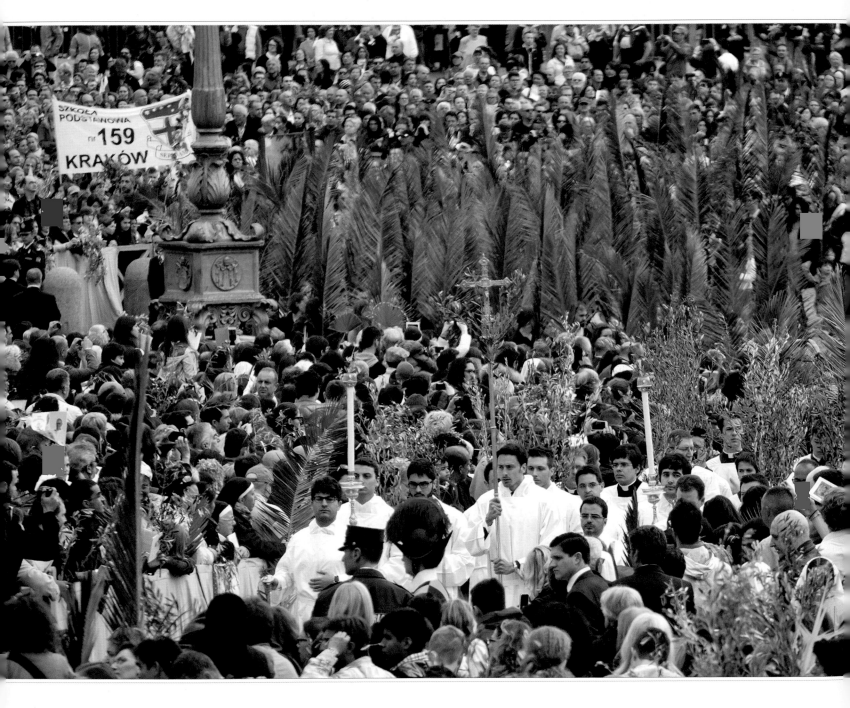

PALM SUNDAY

MARKING JESUS'S ARRIVAL IN JERUSALEM

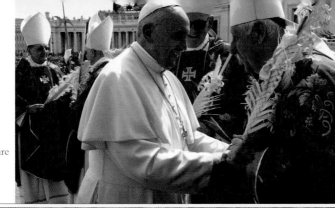

➤ GREETING THE CARDINALS
Pope Francis greets the cardinals as they assemble before the Palm Sunday Mass in St. Peter's Square.

∨ PALM SUNDAY PROCESSION
Thousands gather in St. Peter's Square as the Pope leads the Palm Sunday procession, commemorating Jesus's entry into Jerusalem.

⋀ LISTENING TO THE GOSPELS
During Mass, an account from the Gospels is read, narrating the passion and death of Jesus. Pope Francis, his head bowed, listens attentively.

∨ ARRIVING FOR MASS
Pope Francis, carrying a braided palm branch, approaches the steps of St. Peter's Basilica, where he will celebrate Mass for Palm Sunday.

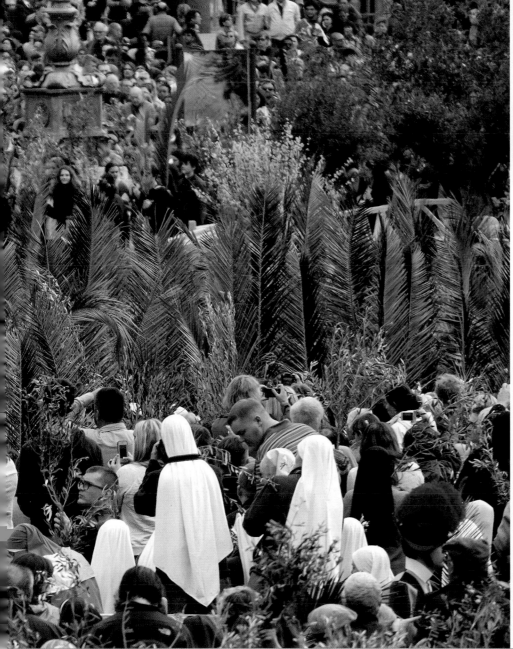

⋁ PROCESSION OF CARDINALS
Cardinals carrying braided palm branches proceed toward
the altar on the steps of St. Peter's to celebrate Mass. The
palms represent the welcome given to Jesus by the crowds
who waved palm leaves as he entered Jerusalem.

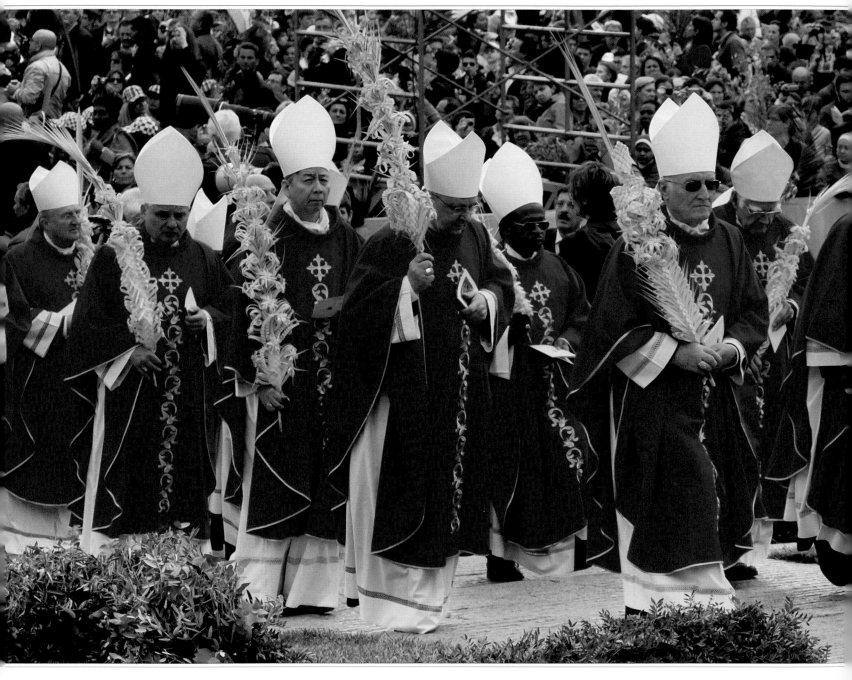

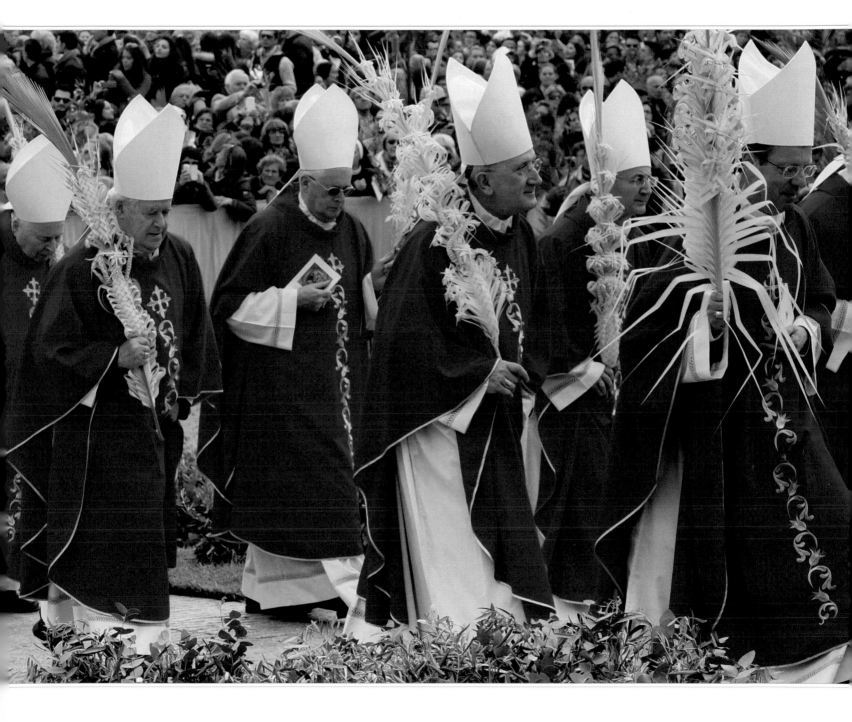

DIOCESAN BISHOPS THROUGHOUT THE WORLD GATHER WITH PRIESTS AND PEOPLE IN THEIR CATHEDRALS ON HOLY THURSDAY. DURING THE MASS OF THE CHRISM, WHICH IS CELEBRATED IN THE MORNING, OILS ARE BLESSED. THESE ARE USED FOR THE ADMINISTRATION OF THE SACRAMENTS IN THE COMING YEAR. DURING THIS MASS, BISHOPS, PRIESTS, AND DEACONS RENEW THE VOWS THEY MADE AT ORDINATION. IN ROME, THE POPE GATHERS THE PEOPLE OF THE DIOCESE IN ST. PETER'S BASILICA, AND HUNDREDS OF PRIESTS FROM THE PARISHES AND THOSE STUDYING IN ROME JOIN HIM.

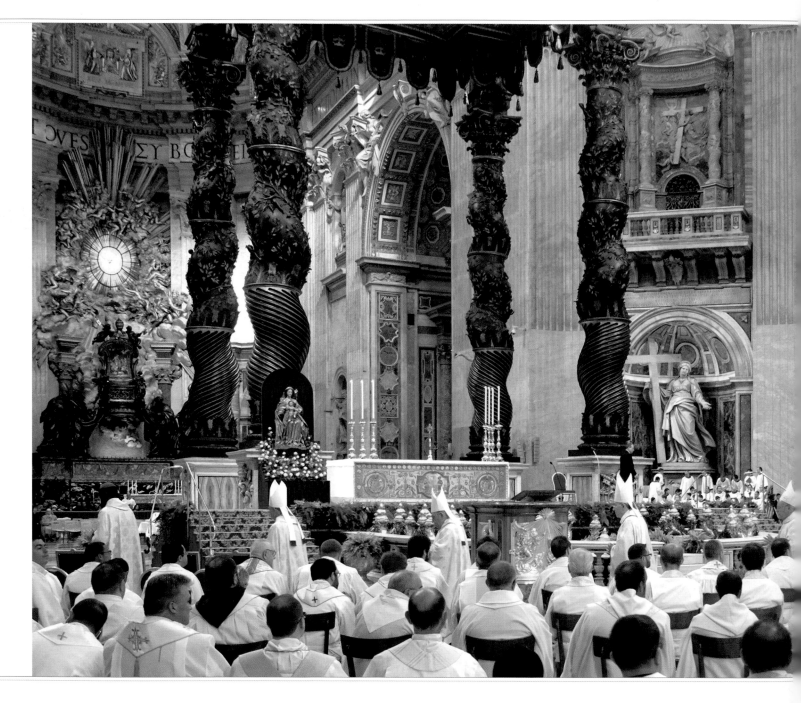

HOLY THURSDAY

CELEBRATING THE MASS OF THE CHRISM

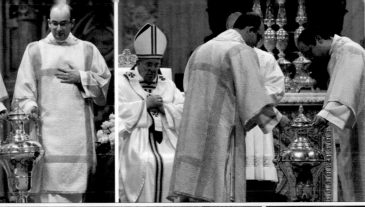

> FLASK OF OIL
The deacons carry a silver flask of olive oil, which Pope Francis will bless during the Mass of the Chrism.

< PRECIOUS COMMODITY
Pure olive oil was used by Jews in worship, particularly in sacrifices at the temple. It was considered a precious commodity.

∧ MASS UNDER THE DOME
Bishops and priests take their place in St. Peter's Basilica prior to the commencement of the Mass of the Chrism, which is celebrated beneath the great dome designed by Michelangelo.

∧ BLESSING THE FLASK OF OIL
Pope Francis blesses a flask of olive oil before adding some aromatic balsam. In Jewish tradition, monarchs, priests, and prophets were anointed with this perfumed oil.

∨ HOLY COMMUNION
Clergy approach the High Altar for
Holy Communion. The three silver
vessels contain oil for the administration
of the sacraments in Rome.

ON HOLY THURSDAY IN 2013, TWO WEEKS AFTER HIS ELECTION, POPE FRANCIS CELEBRATED THE MASS OF THE LORD'S SUPPER IN A DETENTION CENTER FOR JUVENILES IN ROME. WHILE THIS WAS THE FIRST TIME HE CELEBRATED HOLY THURSDAY AS POPE, IT WAS IN KEEPING WITH HIS PRACTICE FOR TWO DECADES IN BUENOS AIRES. FOLLOWING THE EXAMPLE OF JESUS AT THE LAST SUPPER, POPE FRANCIS WASHED THE FEET OF 12 YOUNG OFFENDERS BETWEEN 14 AND 21 YEARS OLD, INCLUDING A MUSLIM GIRL. "THIS COMES FROM MY HEART AND I LOVE DOING IT," THE POPE EXPLAINED.

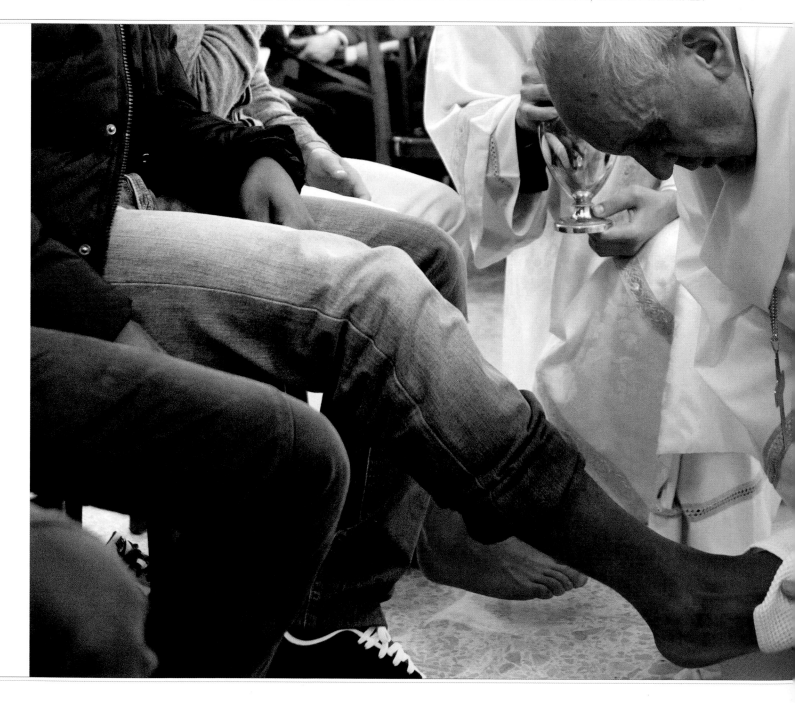

WASHING OF FEET
AN ACT OF HUMILITY

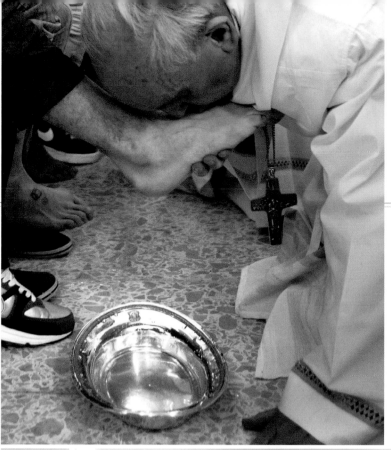

⋎ HUMBLE ACTION
Just as Jesus did at the Last Supper, Pope Francis kneels to wash the feet of young offenders at Casal del Marmo detention center in Rome on Holy Thursday in 2013.

⋖ CARESS FROM JESUS
"This is a caress from Jesus because he came to serve and to help us," the Pope told the youths, many of whom were from African or Slavic countries.

⋎ MASS AT CASAL DEL MARMO
" What does this mean? It means we must all help each other, and by helping we do good for each other. It is why Jesus came," Pope Francis said.

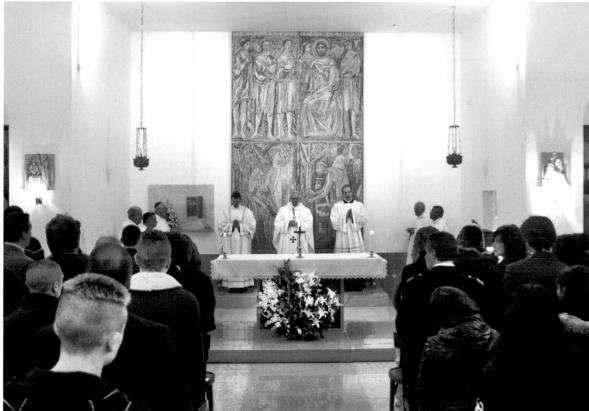

GOOD FRIDAY IS ONE OF THE MOST SOLEMN DAYS IN THE CHRISTIAN CALENDAR. IT IS WHEN CHRISTIANS MEDITATE ON THE SUFFERINGS AND DEATH OF JESUS BY CRUCIFIXION. IT IS A DAY OF PRAYER AND FASTING. IN CHURCHES THROUGHOUT THE WORLD, CATHOLICS GATHER TOGETHER WHILE AN EXTRACT FROM THE GOSPEL OF ST. JOHN IS READ. THIS RECOUNTS THE LAST HOURS IN THE LIFE OF JESUS. IN THE SECOND PART OF THE LITURGY, CATHOLICS RECEIVE HOLY COMMUNION BEFORE LEAVING THE PLACE OF WORSHIP IN SILENCE.

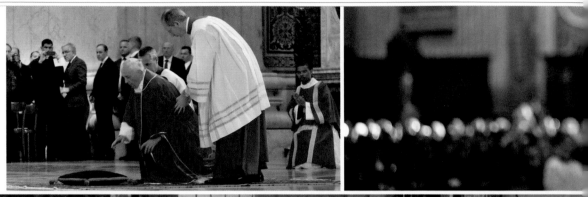

> **THE CEREMONY BEGINS**
The ceremony of the Celebration of the Lord's Passion begins in silence as Pope Francis is helped to the ground, where he prostrates himself before the High Altar.

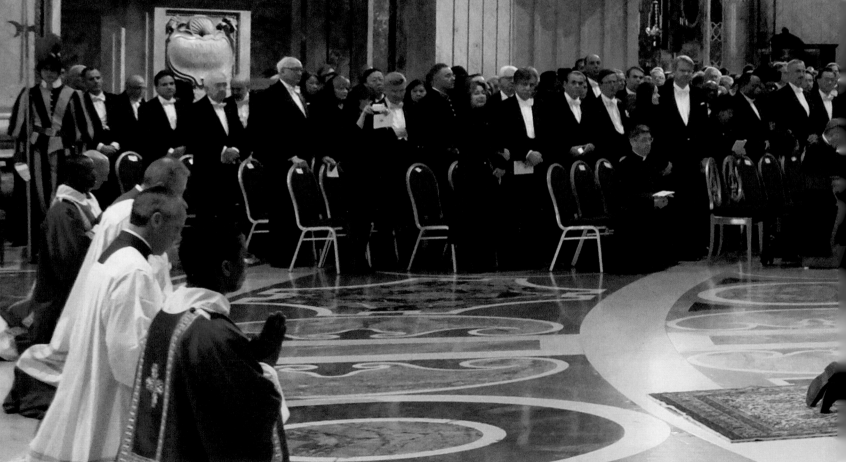

GOOD FRIDAY
REMEMBERING THE LORD'S PASSION

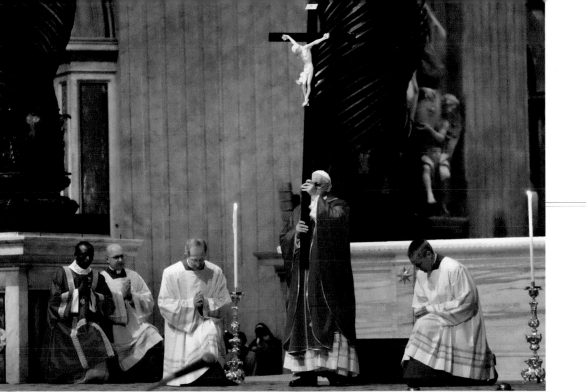

> **RECALLING THE CRUCIFIXION**
Pope Francis holds up a crucifix for those present to recall the moment of Jesus's death. They also kiss the feet of the corpus in a gesture of repentance.

∨ **FRANCISCAN PREACHER**
The Franciscan friar Father Raniero Cantalamessa preaches a meditation during the Good Friday ceremony.

∧ **SILENT CEREMONY**
The service begins in silence, without the accompaniment of sacred music, as Pope Francis prostrates himself.

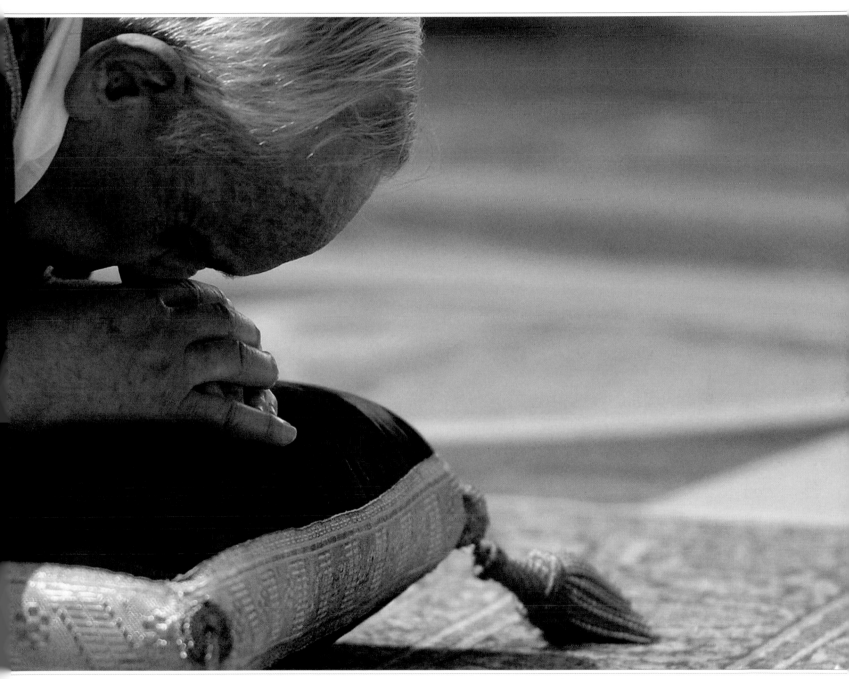

⋏ SILENT PRAYER

Pope Francis prostrates himself on the floor before the High Altar of St. Peter's Basilica at the beginning of the ceremonies on Good Friday. He then leads the congregation in silent prayer.

EACH YEAR ON GOOD FRIDAY, PEOPLE GATHER TO PRAY THE VIA CRUCIS, OR WAY OF THE CROSS, AT THE COLOSSEUM IN ROME. POPE FRANCIS PARTICIPATES IN THE PRAYER SERVICE, WHICH MARKS THE 14 STATIONS OF THE CROSS, RECALLING THE LAST TWO DAYS OF THE LIFE OF JESUS AND HIS CRUCIFIXION. THE GREAT AMPHITHEATER WAS A POPULAR PLACE OF ENTERTAINMENT FOR THE ANCIENT ROMANS, WHO GATHERED TO WATCH GLADIATORS DO BATTLE AGAINST EACH OTHER, AS WELL AS AGAINST EXOTIC ANIMALS THAT THEY IMPORTED FROM VARIOUS PARTS OF THE ROMAN EMPIRE.

> PRAYERS AND HYMNS
With hymns and prayers, the people meditate on the sufferings of Jesus as he was condemned to death by crucifixion in Jerusalem.

ᵛ MEDITATIONS
Each year, a different spiritual writer is invited to compose a set of meditations, which lead the pilgrims to consider the passion of Jesus.

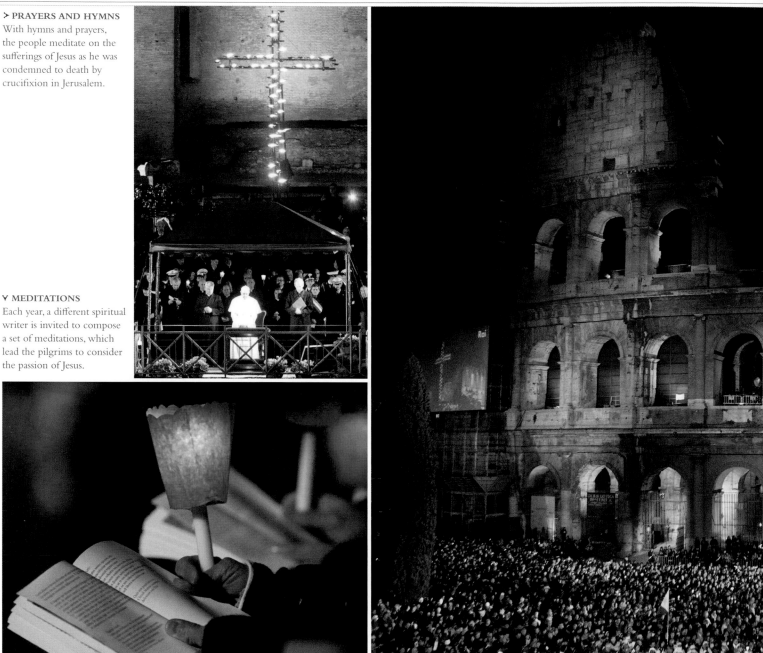

VIA CRUCIS
TORCHLIT PROCESSION TO THE STATIONS OF THE CROSS

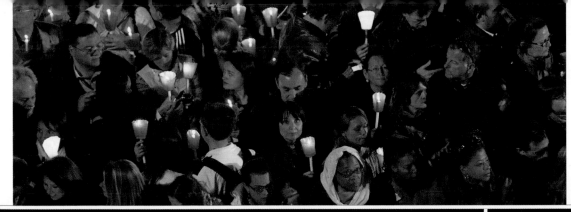

< **GLOBAL REACH**
People come to Rome from all over the world to participate in the Easter ceremonies, which begin on Palm Sunday and conclude a week later, on Easter Sunday.

˅ BLESSING THE CROWDS
Pope Francis blesses the crowds gathered in Rome's Colosseum as the Via Crucis reaches its close.

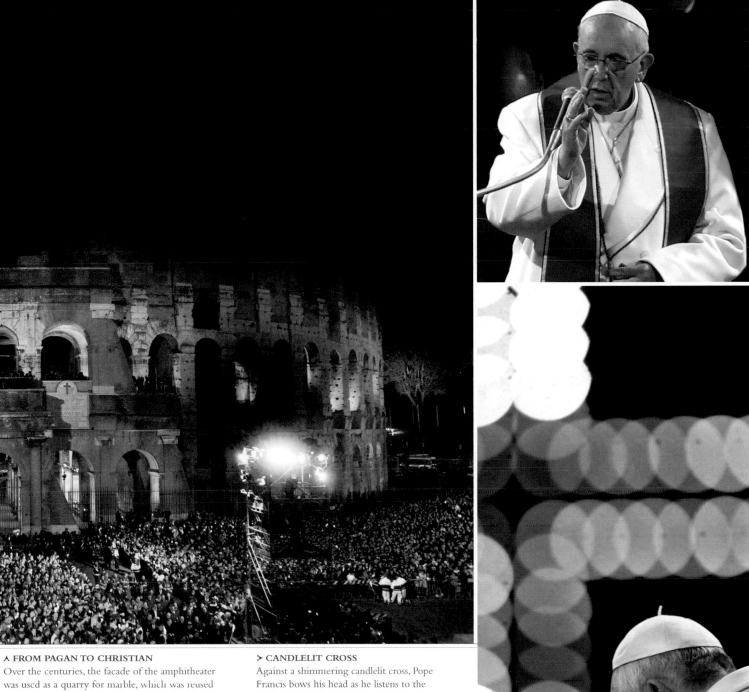

˄ FROM PAGAN TO CHRISTIAN
Over the centuries, the facade of the amphitheater was used as a quarry for marble, which was reused to construct some of Rome's important buildings—churches, hospitals, and palaces among them.

˃ CANDLELIT CROSS
Against a shimmering candlelit cross, Pope Francis bows his head as he listens to the meditations and prayers that accompany each station of the Via Crucis.

THE EASTER VIGIL IS THE HIGHLIGHT OF THE LITURGICAL YEAR. IN PARTS OF THE WORLD, THE VIGIL BEGINS AT SUNSET ON HOLY SATURDAY AND ENDS ON EASTER SUNDAY AT SUNRISE. IN THE FIRST PART OF THE CEREMONY, THE EASTER CANDLE IS LIT AND A HYMN OF PRAISE, THE *EXULTET*, IS SUNG. AS MASS BEGINS, THE CONGREGATION LISTENS TO PASSAGES FROM THE SCRIPTURES. DURING THE VIGIL, IT IS COMMON FOR CATECHUMENS, PEOPLE PREPARING TO ENTER THE CHURCH, TO BE RECEIVED, AND SEVERAL PEOPLE ARE BAPTIZED DURING THE MASS.

˃ PASCHAL FIRE

In the atrium of St. Peter's, the Paschal fire is blessed. In the Easter hymn, the *Exultet*, Christ is praised for dispelling the darkness caused by fear and sin.

˅ LOWERED LIGHTS

The lights are lowered in the basilica as the congregation waits quietly for the ceremony to begin. Bernini's Altar of the Chair can be seen in the distance.

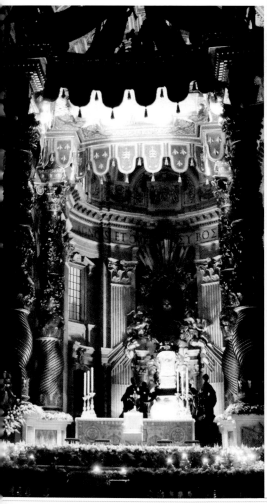

˄ WORDS FROM THE *EXULTET*

"Rejoice, O Mother Church! Exult in glory!
The risen Savior shines upon you!
Let this place resound with joy…"

HOLY SATURDAY

EASTER VIGIL

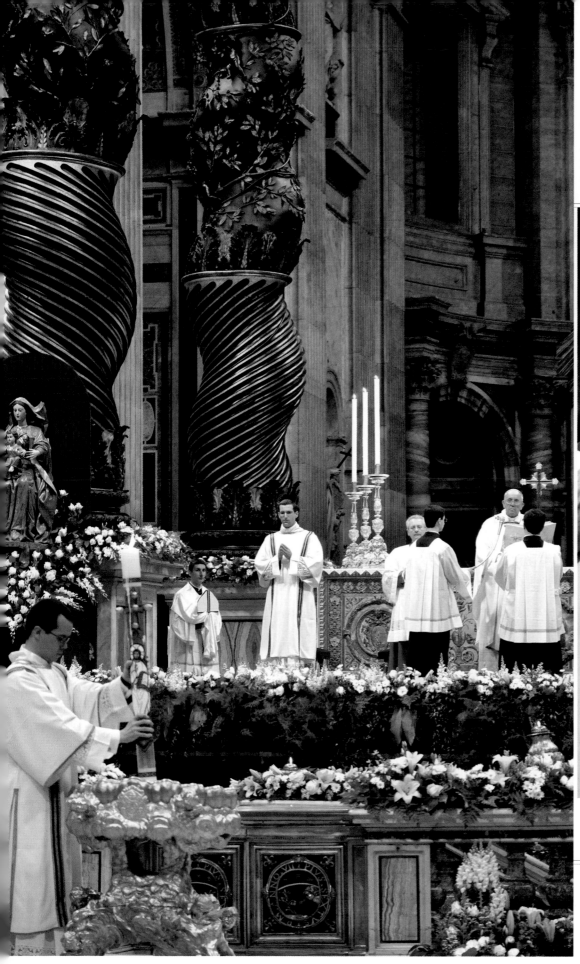

‹ PREPARING FOR BAPTISM
In preparation for baptism, the
water is blessed. The deacon
lowers the Paschal candle, which
is decorated with an image of
the risen Jesus, into the font.

ʌ ANOINTING
A man is anointed on the forehead with the
oil of catechumens following his baptism.
His sponsor's hand rests on his shoulder.

✳ 113

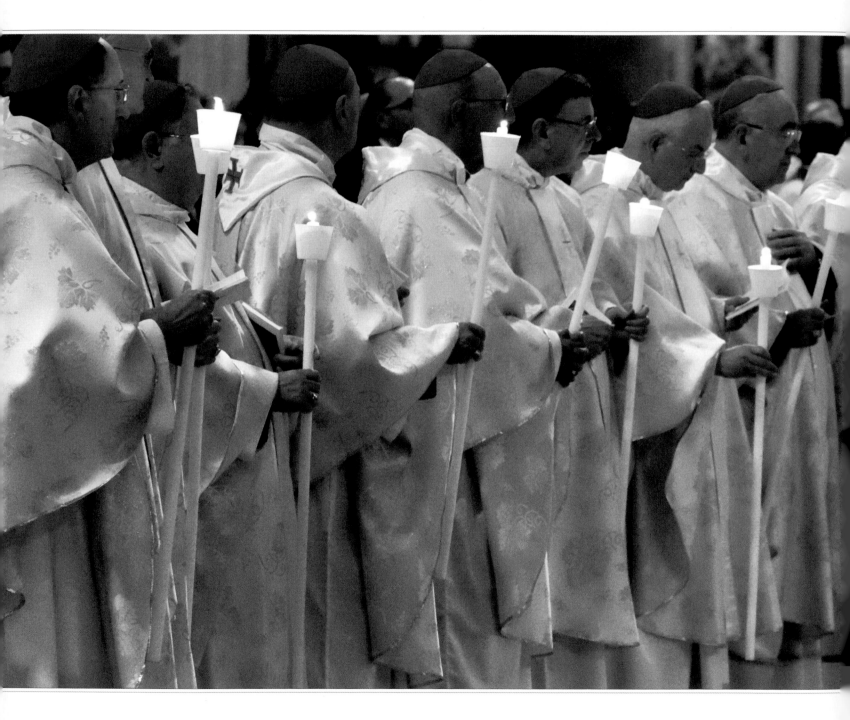

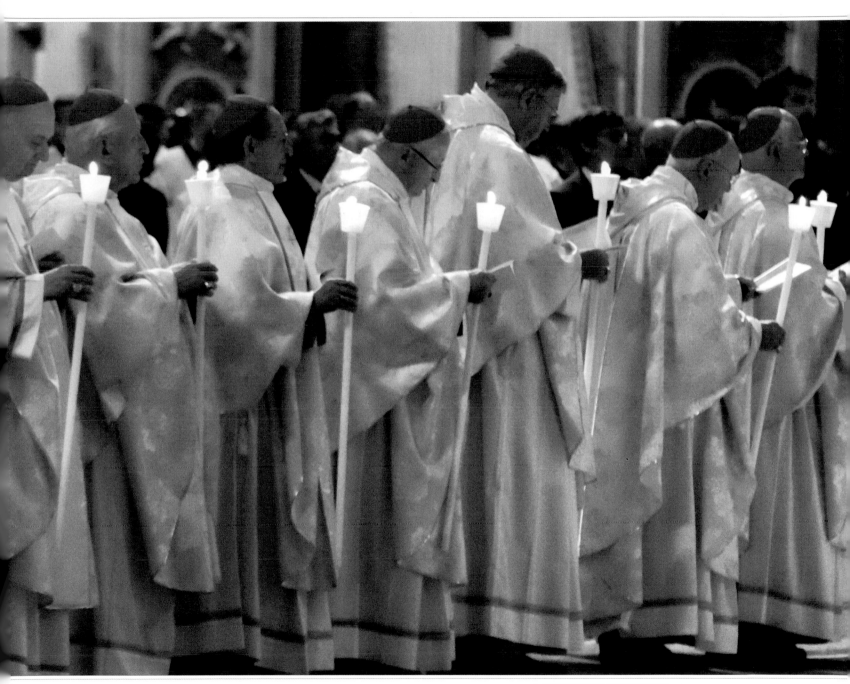

˄ COMMITTED CHRISTIANS
During the Easter Vigil, the clergy, carrying lit candles, and members of the congregation are invited to recall their baptism and renew their commitment to living a worthy Christian life.

HOLY WEEK CULMINATES ON EASTER SUNDAY. THIS IS THE MOST IMPORTANT FESTIVAL IN THE

✝ CHRISTIAN CALENDAR AND IS CELEBRATED WITH THE GREATEST JOY, AS IT COMMEMORATES JESUS'S RESURRECTION FROM THE DEAD. THOUSANDS OF PILGRIMS AND LOCAL PEOPLE CROWD INTO ST. PETER'S SQUARE FOR THE EASTER MASS, WHICH THE POPE CELEBRATES ON THE STEPS OF ST. PETER'S, AND PRIESTS AND DEACONS GIVE HOLY COMMUNION TO THE FAITHFUL IN THE SQUARE. THE POPE DELIVERS HIS TRADITIONAL EASTER ADDRESS AND BLESSING, *URBI ET ORBI*, FROM THE LOGGIA OF THE BASILICA.

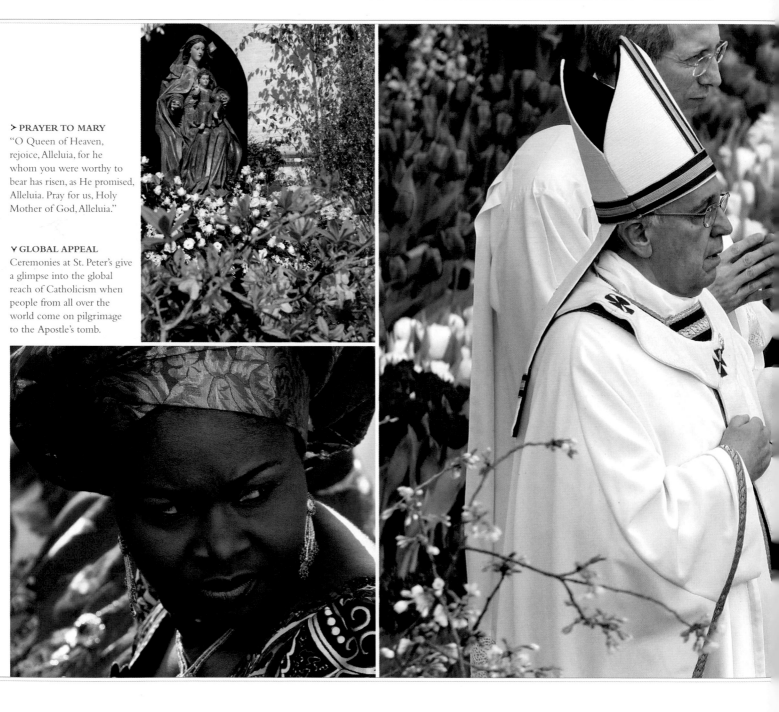

› PRAYER TO MARY
"O Queen of Heaven, rejoice, Alleluia, for he whom you were worthy to bear has risen, as He promised, Alleluia. Pray for us, Holy Mother of God, Alleluia."

⌄ GLOBAL APPEAL
Ceremonies at St. Peter's give a glimpse into the global reach of Catholicism when people from all over the world come on pilgrimage to the Apostle's tomb.

EASTER SUNDAY
A TIME OF CELEBRATION

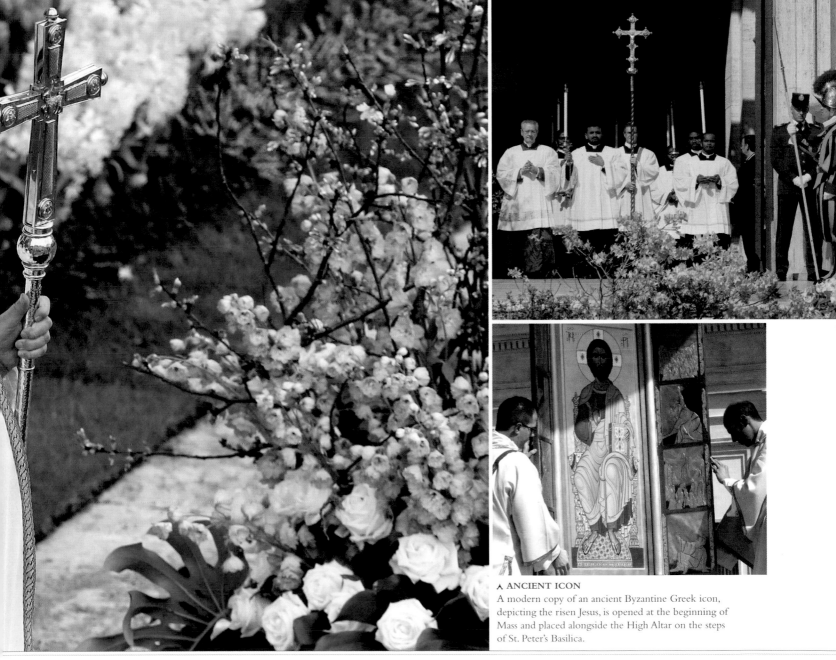

MILITARY BANDS
For the main ceremonies of Christmas and Easter, the bands of Italy's armed forces gather in St. Peter's Square to offer an official salute to the Pope.

OUTDOOR MASS
The procession emerges from St. Peter's. As the church cannot accommodate the crowds, Mass is celebrated on its steps.

ANCIENT ICON
A modern copy of an ancient Byzantine Greek icon, depicting the risen Jesus, is opened at the beginning of Mass and placed alongside the High Altar on the steps of St. Peter's Basilica.

FLORAL GIFT
Each year, a different country offers the Pope a gift of flowers, which are used to decorate the space around the sanctuary for Easter Sunday Mass.

< LATIN AND GREEK
On Easter Sunday, the Gospel is sung by
two deacons in Latin and in Greek, bridging
Western and Eastern Catholics, after which
the Pope venerates the Book of the Gospels.

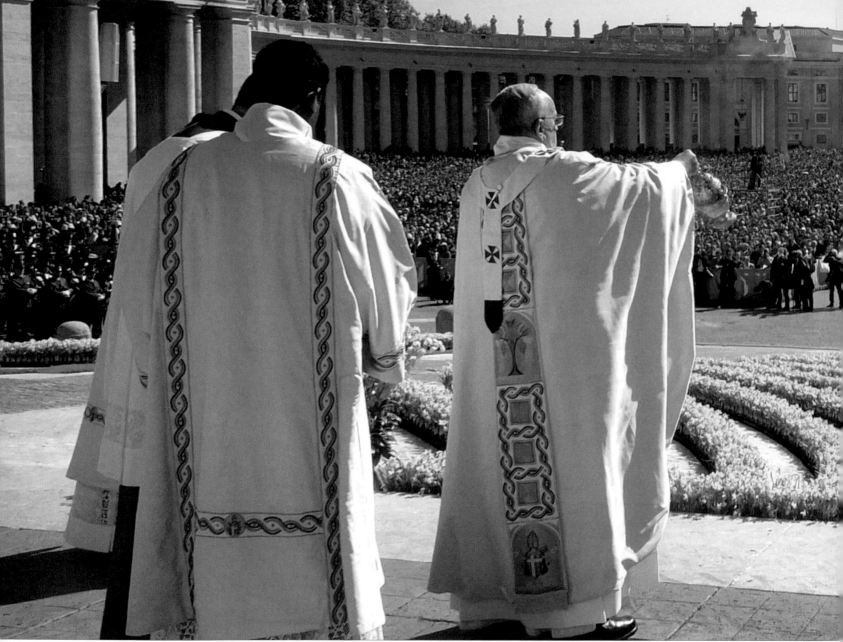

˄ INCENSING THE PASCHAL CANDLE
In front of the hundreds of thousands of
people in St. Peter's Square, Pope Francis
incenses the Paschal candle, which is lit
during the Easter Vigil and then burns at
every Mass for the 50 days of Eastertide.

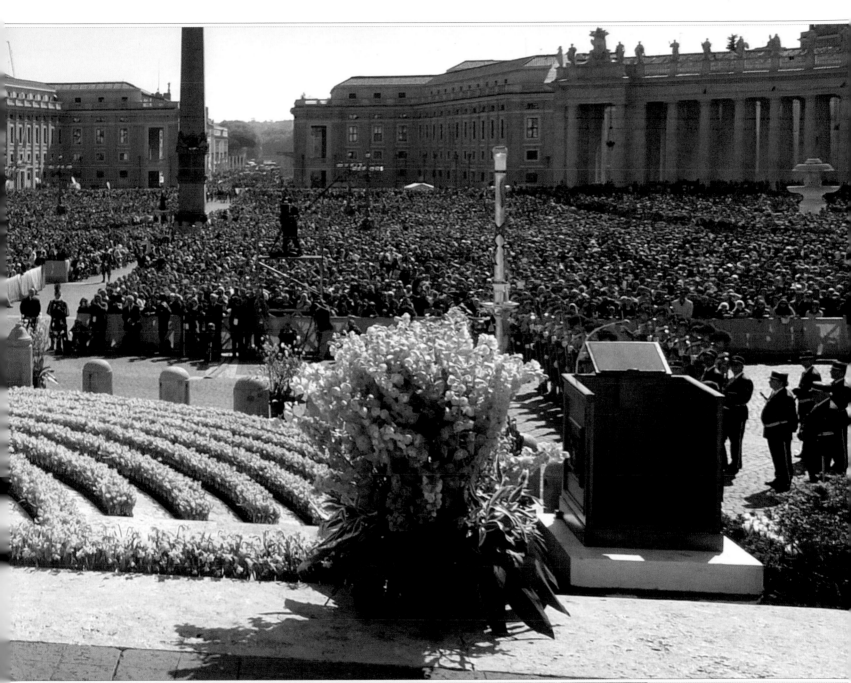

< SACRED HOST
Priests hold ciboria filled with the sacred hosts, which are consecrated during Mass and distributed to the faithful gathered in St. Peter's Square by priests and deacons.

✠ ON APRIL 27, 2014, POPE FRANCIS PRESIDED OVER THE HISTORIC CANONIZATION OF TWO OF HIS PREDECESSORS. THE UNIVERSALLY POPULAR POPE JOHN XXIII (1958–63) HAD CONVOKED THE SECOND VATICAN COUNCIL AND SPURRED ON THE SEARCH FOR UNITY AMONG CHRISTIANS. POLISH-BORN JOHN PAUL II (1978–2005) HAD TRANSFORMED THE MODERN PAPACY DURING HIS 26-YEAR-LONG PONTIFICATE. THE CEREMONY IN ST. PETER'S SQUARE WAS UNIQUE IN THAT IT WAS CELEBRATED BY POPE FRANCIS AND HIS IMMEDIATE PREDECESSOR, THE EMERITUS POPE BENEDICT.

⋎ POPE JOHN PAUL II
Thousands of Poles traveled to Rome to participate in the canonization ceremony of Polish-born Pope John Paul II.

⋎ POPE JOHN XXIII
Italians have an enormous affection for Pope John XXIII, remembered for his simple piety and sense of humor.

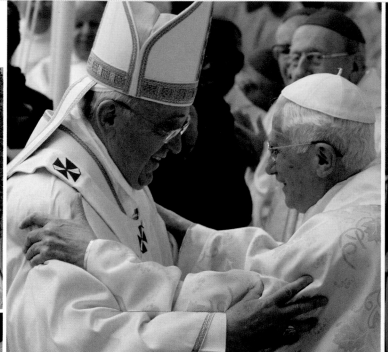

⋏ WARM RAPPORT
As Mass commences, Pope Francis salutes Emeritus Pope Benedict. The two have established a warm rapport, visiting each other regularly and exchanging advice.

⋋ UNIQUE POSITION
The Emeritus Pope takes his place in the sanctuary ahead of the canonization ceremony. He was in the unique position of having known both Pope John XXIII and Pope John Paul II.

⋋ FEAST DAYS
Pope Francis decrees that the Church celebrate the feast days of St. John XXIII on October 11 and of St. John Paul II on April 2.

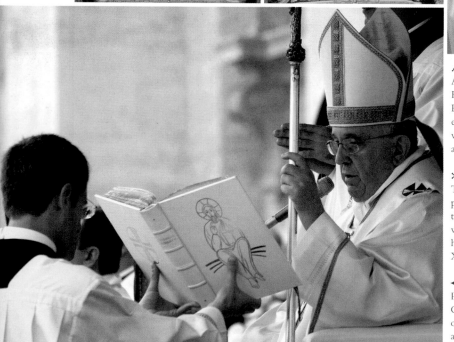

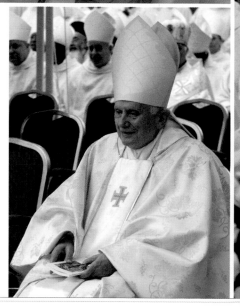

CANONIZATION OF POPES
ST. JOHN XXIII AND ST. JOHN PAUL II

> PAPAL RELICS

Relics of the two Popes, in small silver containers, are brought in procession to the altar.

∨ RECOLLECTION

Pope Francis recalled during the Mass that "St. John Paul II once said that he wanted to be remembered as the Pope of the Family."

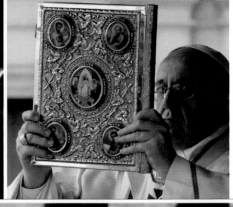

< BROADCAST

After proclaiming the Gospel, Pope Francis blesses the congregation gathered in St. Peter's Square. The ceremony was broadcast onto large screens erected in several public places throughout Rome.

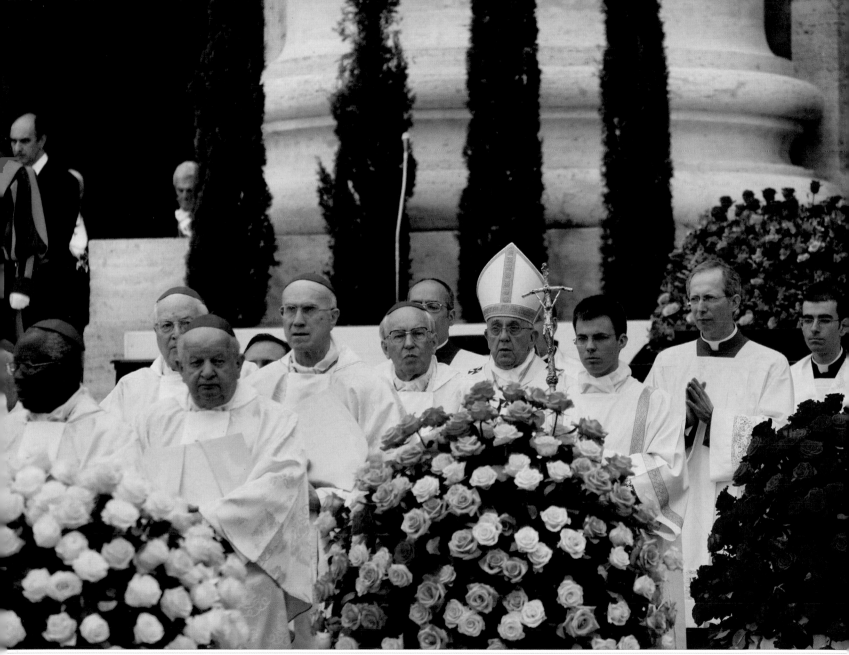

∨ JUBILANT CROWDS
Pilgrims arrived days before the canonization ceremony for Pope John XXIII and Pope John Paul II. Many slept on the streets in order to secure a place in St. Peter's Square.

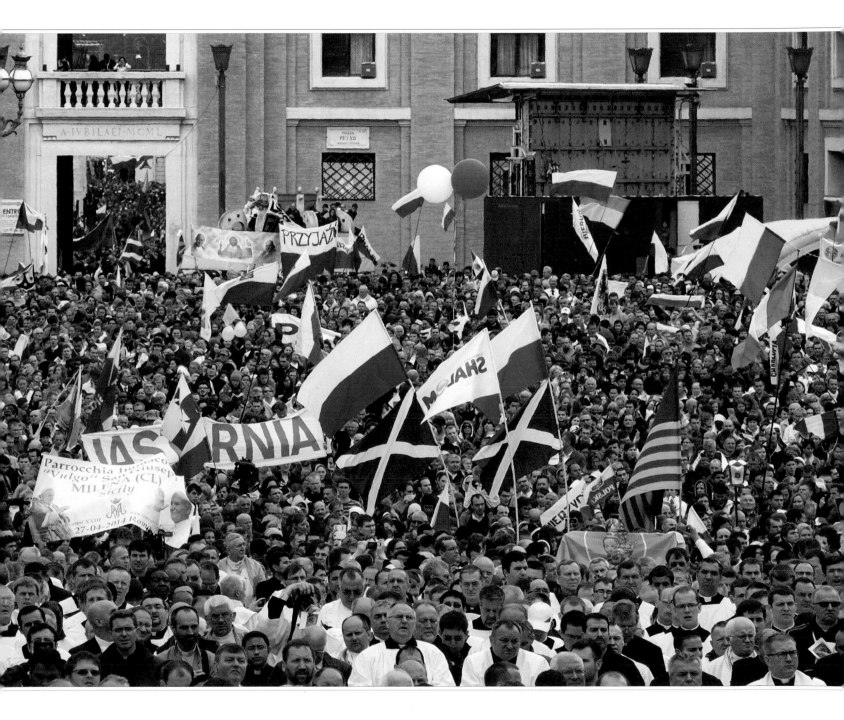

< EXPANDING CHURCH
Pope John Paul II was the most widely traveled pontiff in history and expressed a particular fascination with Africa, where the Church is expanding rapidly.

> JOYFUL SEMINARIANS
Enthusiastic seminarians from Central and Latin America, home to some 40 percent of the world's Catholics, are caught up in the joyful atmosphere of the day.

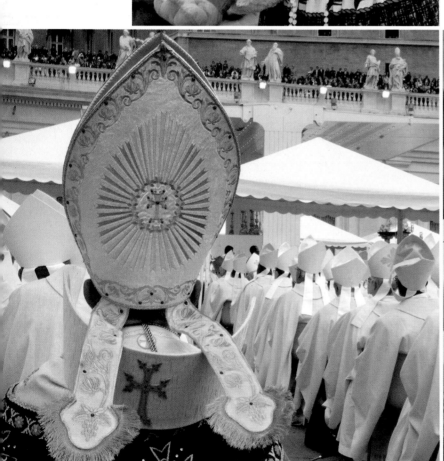

∧ ELABORATE RITUAL
Although the papal liturgies have been simplified over recent decades, large ceremonies such as these still involve elaborate ritual and colorful vestments.

> RICH HISTORY
As the first Slavic pontiff, Pope John Paul II understood better than his predecessors the rich historic traditions of Christianity in the East.

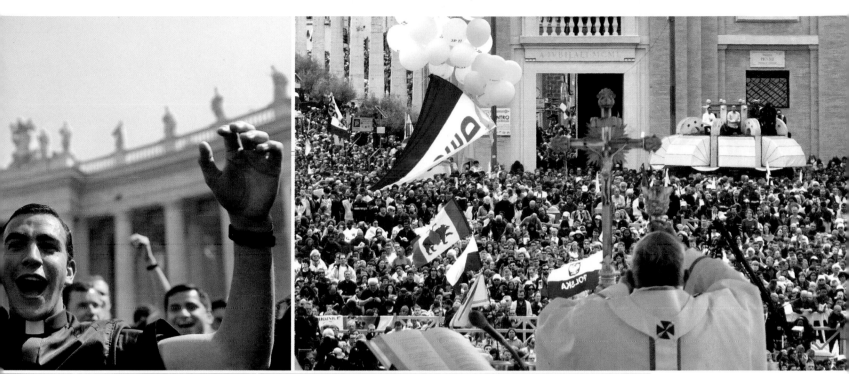

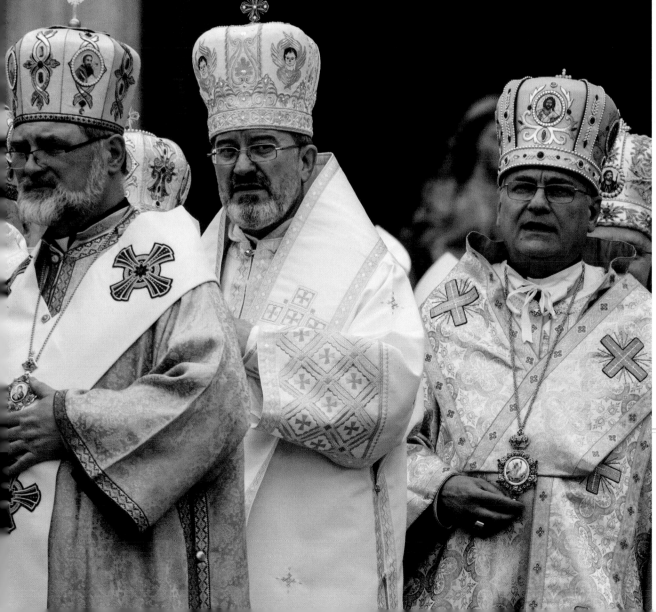

⋀ OUTNUMBERED
Poles far outnumbered Italians at the double canonization ceremony. Many of them attribute the fall of the Iron Curtain in part to Pope John Paul II.

As the Italian weather warms, the crowds visiting Rome swell. Numbers attending the Pope's General Audiences grow week by week through the spring. Early summer is a popular time for school excursions too. Students visiting Rome are as eager as other visitors to attend one of the Pope's public appearances at the Vatican.

The Easter season ends with the Feast of Pentecost, celebrated 50 days after Easter Sunday, in May or early June. With the season of Lent and Eastertide concluded, Pope Francis continues his usual routine. His day revolves around meetings in the Casa Santa Marta, St. Peter's Basilica, and the Apostolic Palace.

Although he chose not to reside in the sumptuous Apostolic Palace designed by Domenico Fontana, Pope Francis receives heads of state and other important visitors in the Apostolic Library. Distinguished visitors arrive by car through the gates of the Holy Office at the side of St. Peter's Square. Cortèges circle the rear of the basilica and enter the Courtyard of St. Damascus, where a guard of honor of the Swiss Guard greets the guests.

The Prefect of the Papal Household escorts visitors to the library on the second floor to meet the Pope, who spends up to an hour in discussion. After a formal exchange of gifts, the guests visit the Cardinal Secretary of State on the third floor.

Each year in May, various confraternities make their annual trips to Rome. These organizations were established in medieval times to care for the sick and dying. The diversity of groups such as the Legion of Mary, founded in Ireland by Frank Duff, the Focolare movement, founded in Italy by Chiara Lubich, and the Charismatic Renewal, displays the wide array of Catholic traditions.

Rome is home to a number of Catholic universities and colleges. As seminarians complete the final year of their studies, they are ordained to the priesthood. As Bishop of Rome, Pope Francis presides over a number of ordinations for his diocese.

May is also a month of popular devotions directed at the Virgin Mary. The month concludes with the Feast of the Visitation of the Blessed Virgin Mary to her cousin Elizabeth. Pope Francis joins pilgrims in a procession to the grotto of Our Lady of Lourdes in the Vatican Gardens. Here Pope and pilgrims sing hymns in honor of the Blessed Virgin Mary.

< CONFRATERNITIES
Tens of thousands of members of Catholic confraternities—prayer groups and other charitable bodies dedicated to taking care of the sick—gather to celebrate Mass in St. Peter's Square.

> FIDELITY TO THE POPE
In a colorful ceremony on May 6, young recruits to the Swiss Guard take their oath of fidelity to serve the Pope and the cardinals.

ᴠ PRIVILEGE
It is a privilege to study for the priesthood in one of the international seminaries in Rome and, for some, to be ordained by the Pope.

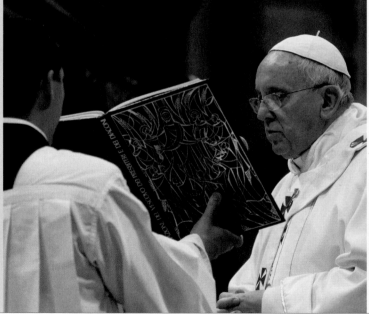

MAY

CONFRATERNITIES AND DEVOTION

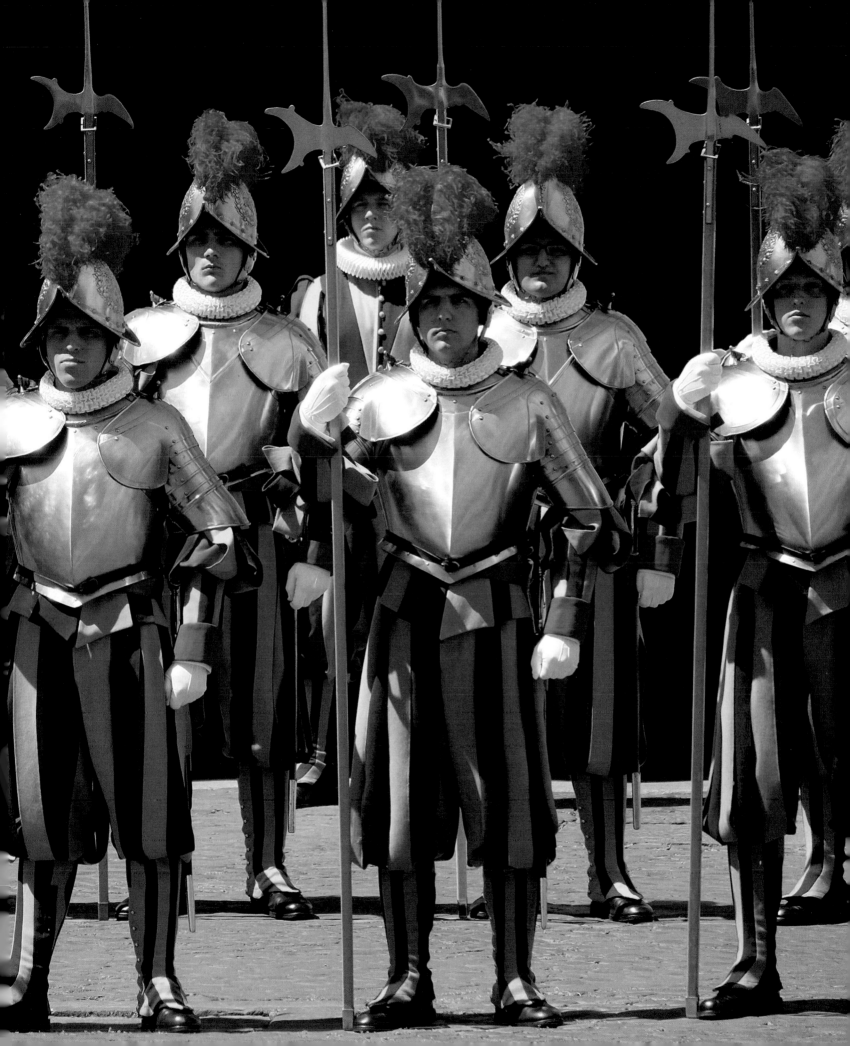

✠ ONE OF THE TRADITIONAL HALLMARKS OF CATHOLICISM IS THE NUMBER OF DIFFERENT SPIRITUAL CONFRATERNITIES DEDICATED TO PRAYER AND PHYSICAL WORKS OF MERCY. IN PARTICULAR, THEIR MEMBERS LOOK AFTER THE SICK AND THE DYING. SOCIETIES SUCH AS THE LEGION OF MARY OR THE ST. VINCENT DE PAUL SOCIETY, WHICH HELP PEOPLE SPIRITUALLY AND MATERIALLY, ARE TO BE FOUND IN MOST CATHOLIC PARISHES. PROCESSIONS LED BY CONFRATERNITIES ARE A POPULAR EXPRESSION OF PIETY. ON MAY 5, 2013, A PROCESSION TO ST. PETER'S SQUARE CULMINATED IN THE POPE SAYING MASS.

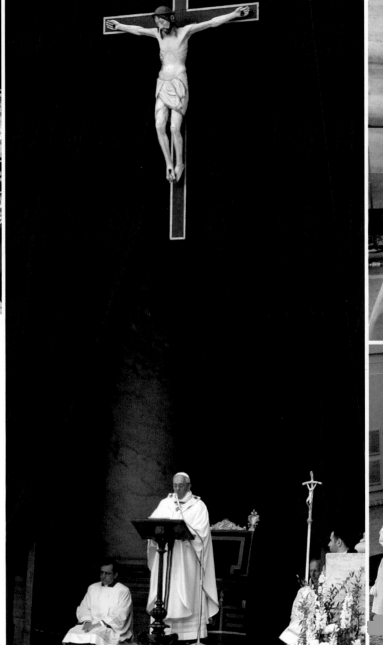

ᐱ **MEDIEVAL TRADITION**
Many confraternities began in the Middle Ages. Elaborate statues and crucifixes were carried at their processions, and still are today.

ᐸ **PREPARING FOR MASS**
Members of a confraternity prepare for the Mass with Pope Francis. In the past, confraternities vied with each other for the most ornate artwork.

ᐱ **EXHORTATION**
At the Mass in St. Peter's Square, Pope Francis urged the 100,000-strong congregation to be "missionaries of God's love and tenderness."

CONFRATERNITIES
RELIGIOUS GROUPS FROM AROUND THE WORLD

⋎ HOLY COMMUNION

Participants at every Mass offer bread and wine for the Eucharist, which, for Catholics, become the very presence of the risen Jesus Christ.

⟩ UNDETERRED BY RAIN

After the Mass, and in spite of the inclement weather, Pope Francis thanked the organizers of the Mass and greeted the crowds.

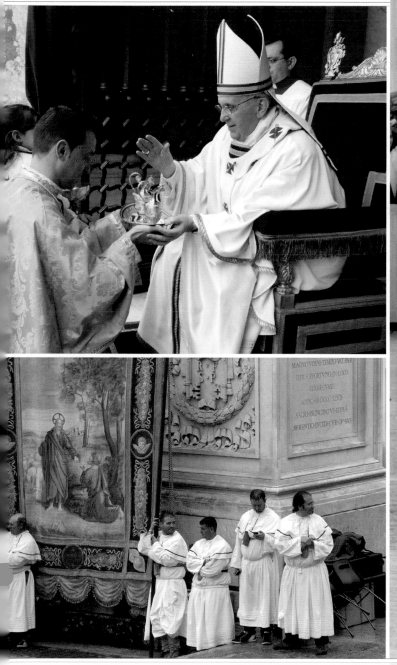

⋏ BANNER WAVING

Members of a confraternity hold a large banner representing St. Peter with the risen Christ. Popular piety has a special place in Pope Francis's affections.

⟩ TRADITIONAL GUARD

The Swiss Guard, dressed here in rain capes, are trained in crowd control and are present every time the Pope appears in public.

EACH YEAR ON MAY 6, NEW RECRUITS JOIN THE PONTIFICAL SWISS GUARD IN A COLORFUL CEREMONY. THE DATE RECALLS THE OCCASION IN 1527 WHEN 147 OF THE 189 SWISS GUARDS WERE MASSACRED WHILE DEFENDING POPE CLEMENT VII FROM THE TROOPS OF EMPEROR CHARLES V. THE POPE MANAGED TO ESCAPE TO THE RELATIVE SECURITY OF CASTEL SANT'ANGELO NEARBY. THE SACK OF ROME LASTED A WEEK AND LED TO THE WIDESPREAD LOOTING OF THE CITY. SUBSEQUENT PONTIFFS REWARDED THE FIDELITY OF THE SWISS GUARD BY RETAINING THEIR SERVICES.

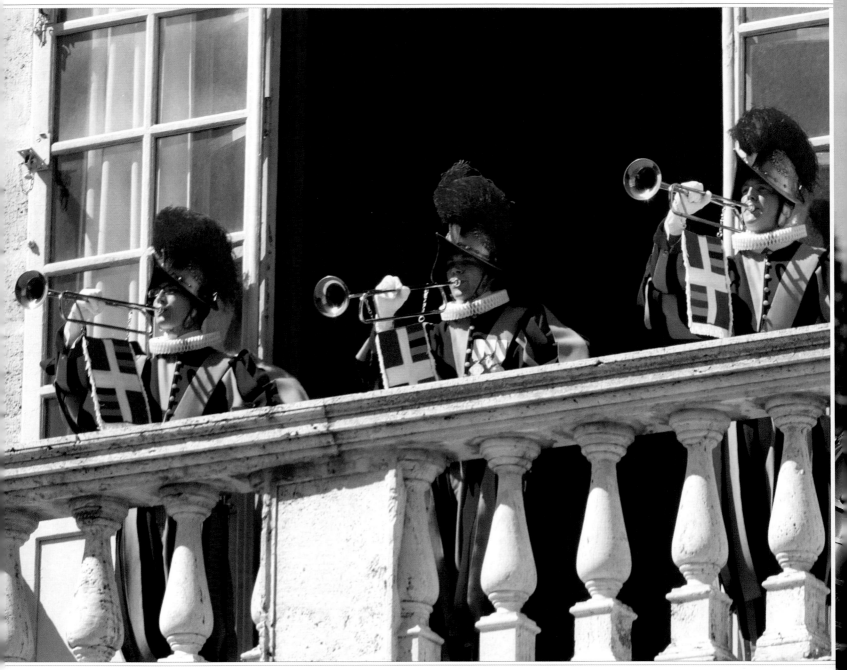

A TRUMPET CALL
Three trumpeters request the attention of guests at the start of the ceremony in the Courtyard of St. Damascus in the Apostolic Palace.

THE SWISS GUARD
THE VATICAN ARMY

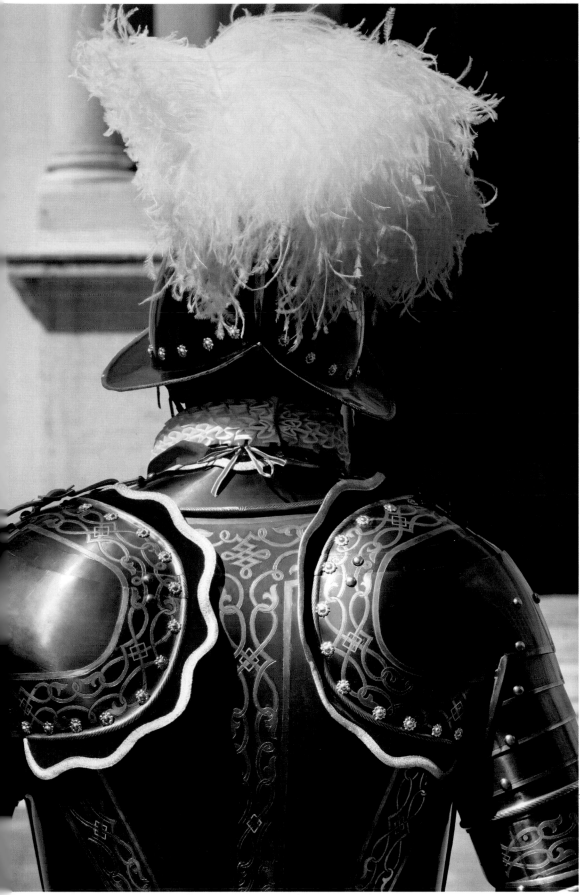

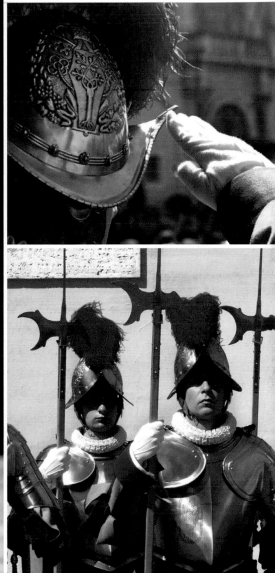

∨ COAT OF ARMS
The metal helmets of the Swiss Guard bear the coat of arms of Pope Julius II, of the Della Rovere family, who first engaged the mercenary guards in 1506.

∧ BATTLE DRESS
Inspired by 16th-century dress, the present uniforms of red, yellow, and blue were designed in 1914. The breastplate references 16th-century armor.

< COMMANDING ATTENTION
The painted metal cuirass and epaulettes of the Commander of the Swiss Guard are among the most elaborate and colorful of the Pontifical Corps.

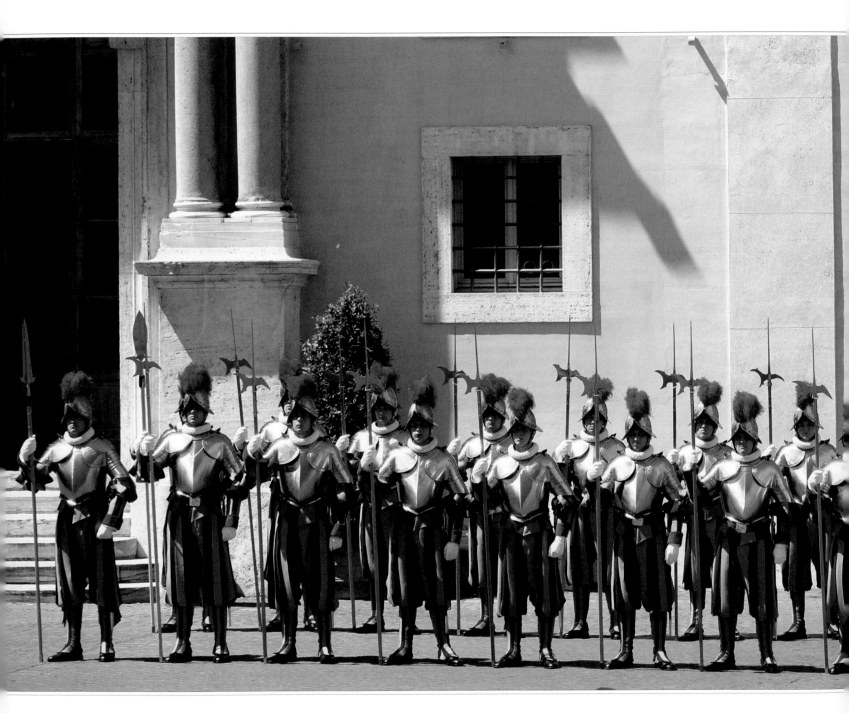

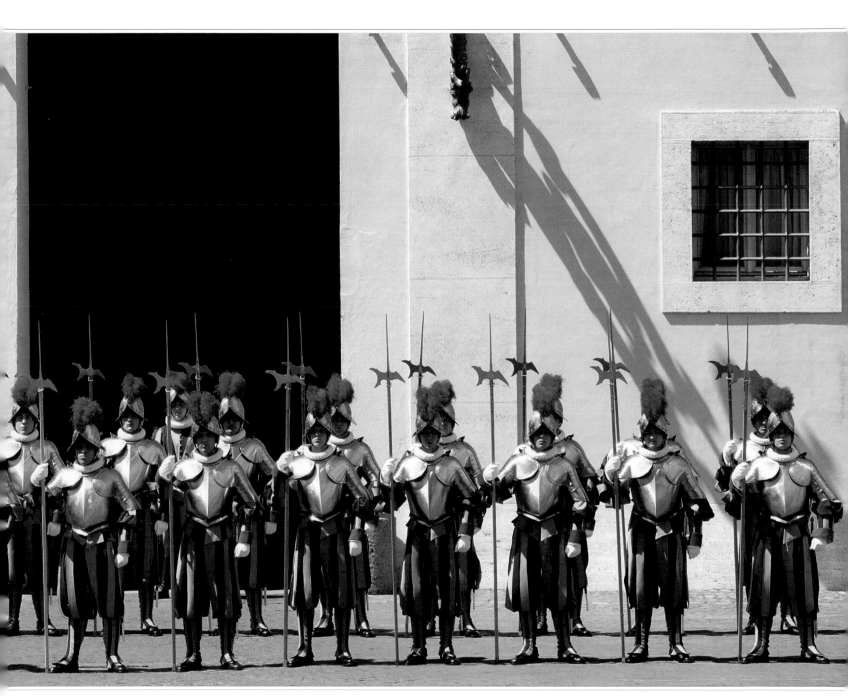

▲ FORMAL ATTIRE
On solemn occasions, the Guards don
their most formal attire, including the
metal breastplate and upturned morion,
or helmet, with ostrich plumes.

Y HIERARCHY OF COLOR
New halberdiers are easily recognized by their red plumes. The uniform weighs almost 8lb (3.5kg). In bad weather, a wool serge or cotton cloak is worn.

> MUSICAL ACCOMPANIMENT
In addition to their guard duties, several members of the Swiss Guard play instruments and provide brass band music for ceremonies.

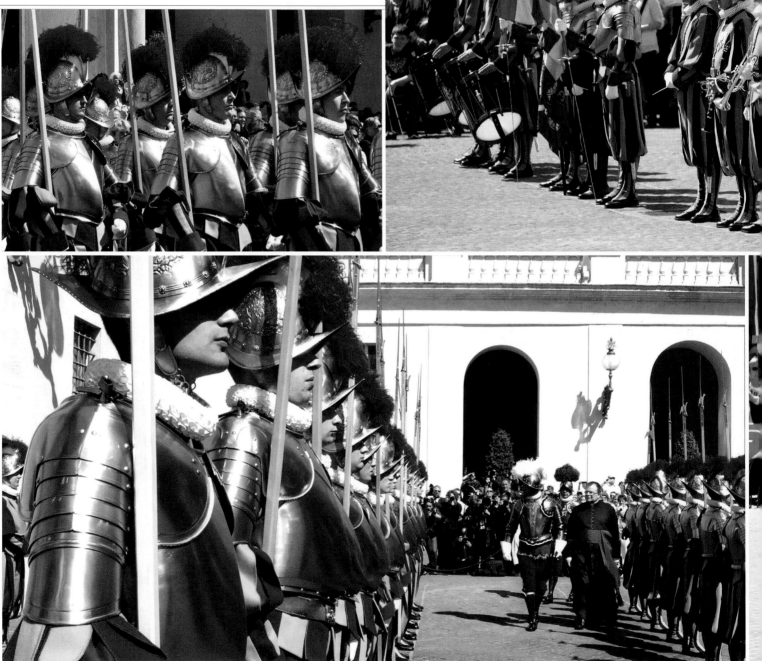

ʌ CEREMONIAL INSPECTION
The Commander of the Swiss Guard, in full regalia, accompanies the Chaplain as he inspects the new recruits and the Guard of Honor.

< HEAVENLY HELP
The young recruit holds up two fingers and the thumb of his right hand as he calls upon God the Father, Son, and Holy Spirit in his swearing-in ceremony.

Λ TAKING THE OATH OF LOYALTY
In their oath of loyalty, Swiss Guard recruits swear to "faithfully, loyally, and honorably serve the Supreme Pontiff Francis and his legitimate successors."

Λ OPPORTUNITIES
For the young Swiss recruits, the prospect of spending some years in Rome offers extraordinary opportunities. Many Guards make lifetime friendships.

AS A SIGN OF THE UNIVERSALITY OF THE CATHOLIC CHURCH, SEVERAL THOUSAND SEMINARIANS STUDY FOR THE PRIESTHOOD IN ROME AT A NUMBER OF PONTIFICAL UNIVERSITIES. AFTER ORDINATION, THE MAJORITY RETURN HOME TO THEIR DIOCESE OR RELIGIOUS CONGREGATION, OR BECOME MISSIONARIES. A SMALL NUMBER OF THEM REMAIN IN ROME IN ORDER TO PURSUE POSTGRADUATE STUDIES. AS OF 2014, THERE WERE SOME 57,924 STUDENTS FOR THE PRIESTHOOD THROUGHOUT THE WORLD, A SMALL FRACTION OF WHOM STUDY IN ROME.

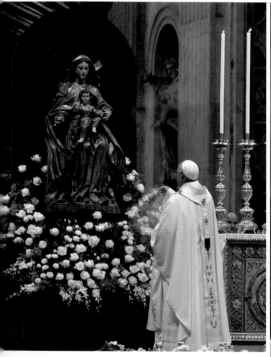

⋏ ORDINATION MASS
At the end of the academic year, in early summer, the Pope ordains a number of students to the priesthood in St. Peter's Basilica.

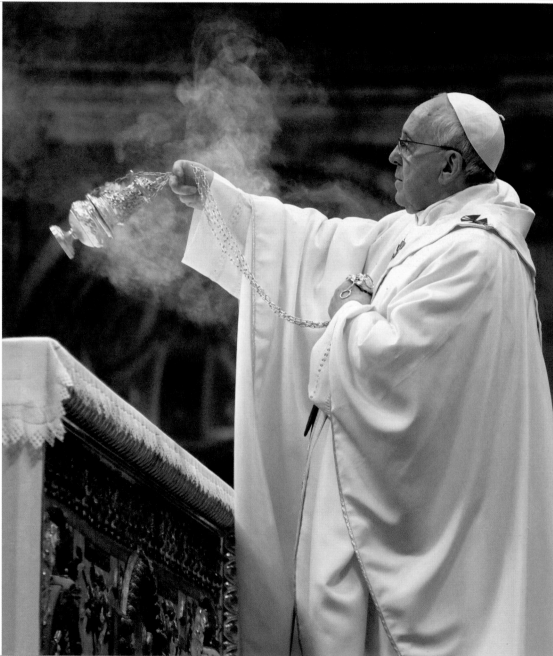

⋗ INCENSING THE ALTAR
The Mass at St. Peter's, which tradition maintains is the burial place of the saint, begins as the Pope incenses the statue of Mary (above) and the High Altar.

ORDINATION

FROM SEMINARIAN TO PRIEST

∨ CALLING ON THE SAINTS
Pope Francis leads the Litany of
the Saints, a sung invocation by the
congregation for the blessing and
protection of the candidates.

> SIGN OF OBEDIENCE
Before the Rite of Ordination, the
candidates prepare to take lifelong vows
and prostrate themselves on the ground
as a sign of obedience to the Pope.

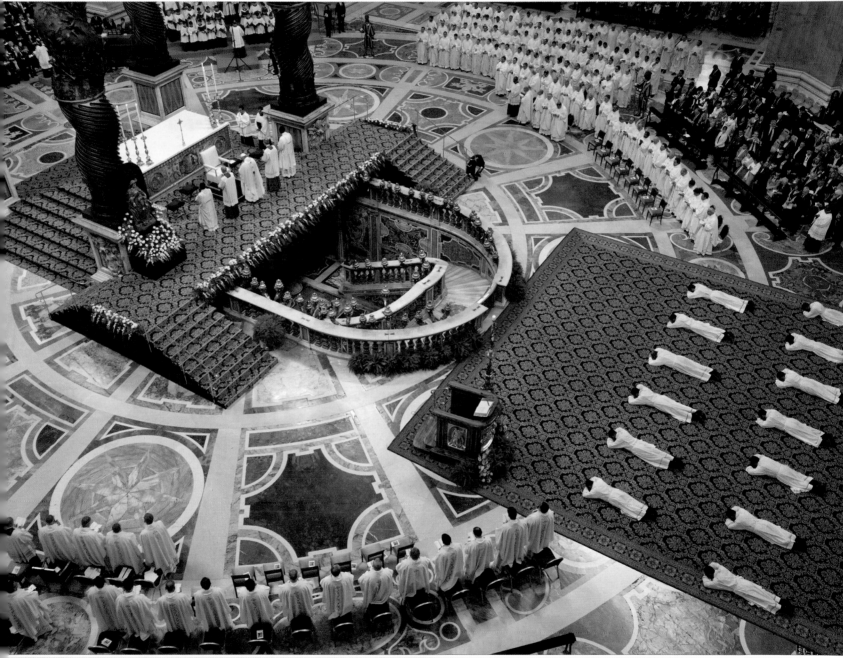

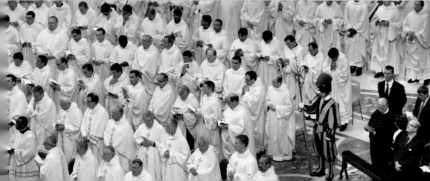

< JOYFUL CELEBRATION
Many strong friendships are forged
during the seminary years. Colleagues,
teachers, and pastors from Rome or
from home join in the celebration.

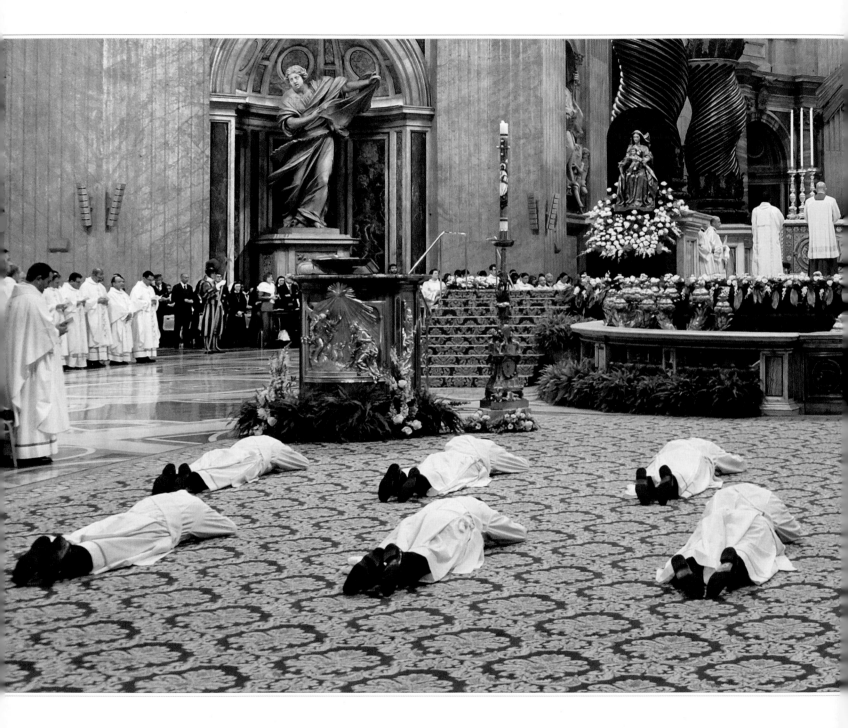

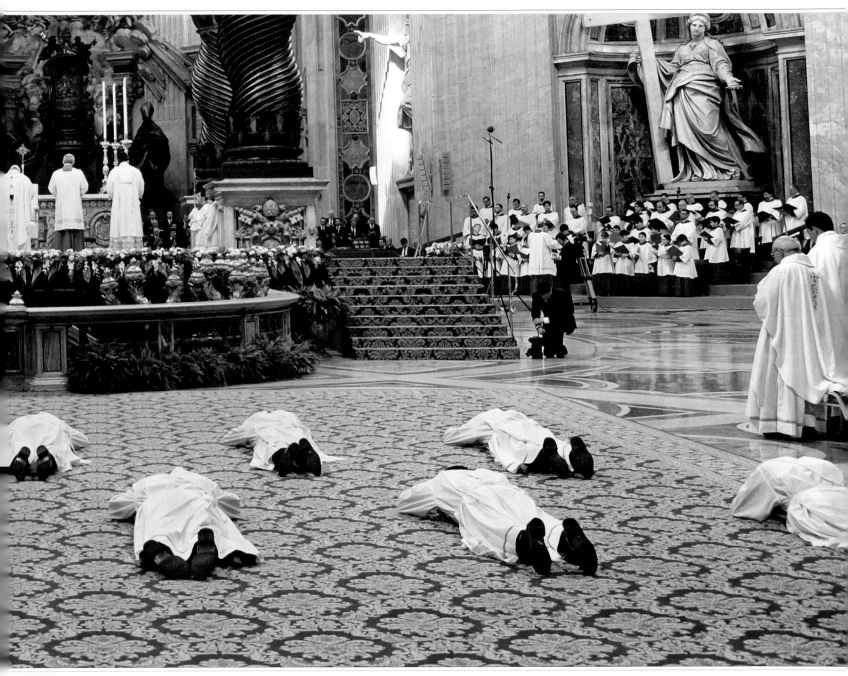

A LITANY OF THE SAINTS
Since ancient times, the Litany of the
Saints has been sung at important liturgies,
The congregation responds to each
invocation with the words, "Pray for us!"

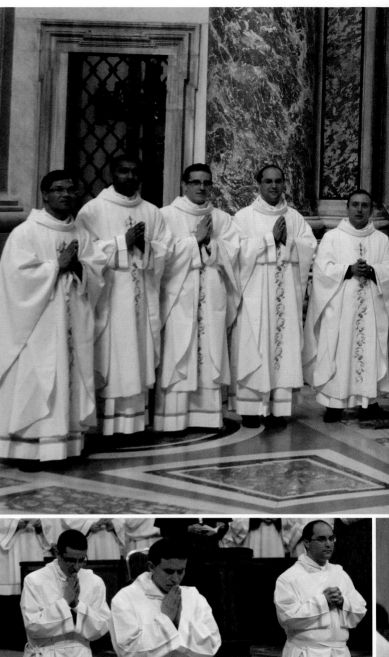

> **POSING IN PIETÀ**
The newly ordained priests, from all over the world, pose with the Pope in the Chapel of the Pietà at the end of the ceremony.

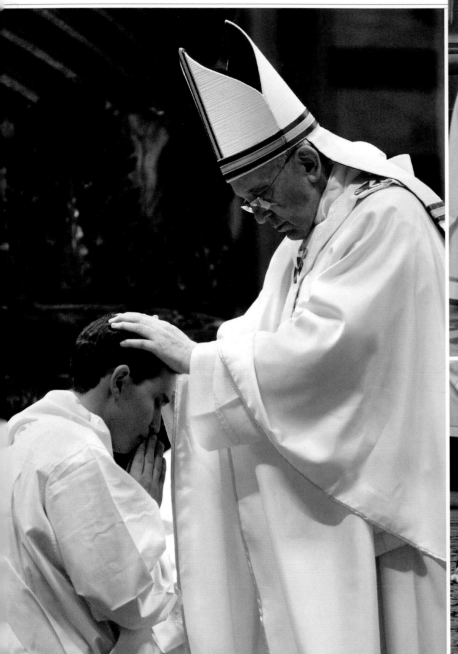

∧ **LAYING ON OF HANDS**
In keeping with the ancient tradition of priestly ordination, the Bishop of Rome lays his hands on the candidate, invoking the blessing of God on the new priest.

∧ **COMMITMENT TO CELIBACY**
Prior to their ordination, the candidates kneel in quiet prayer before they affirm publicly their commitment to celibacy and their obedience to the bishop.

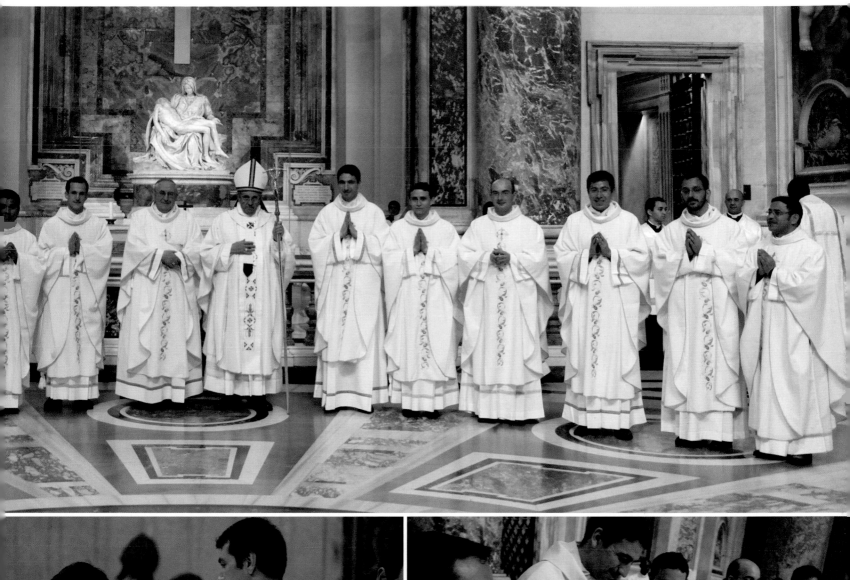

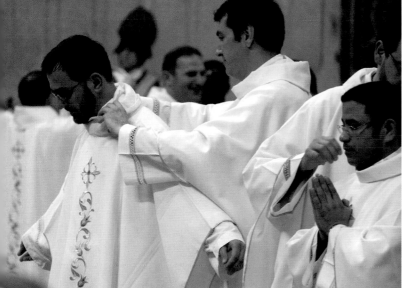

ATTIRED WITH A CHASUBLE
Moments after their ordination by
Pope Francis, the new priests are attired
with the chasuble, a robe that is worn
during the celebration of Mass.

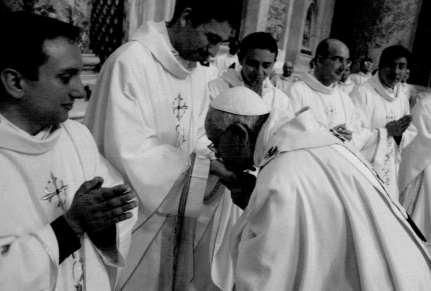

A PRIEST'S BLESSING
Following the ceremony, Pope Francis
asks for the blessing of each young
priest and kisses the hands of each in
a sign of reverence for their new state.

AS THE NUMBERS OF VISITORS AND PILGRIMS TO THE VATICAN SWELLED DURING THE 20TH CENTURY, THE POPES BEGAN THE CUSTOM OF HOLDING GENERAL AUDIENCES. TODAY, THEY ARE AN ESTABLISHED PART OF THE PAPAL CALENDAR. POPE FRANCIS NEVER MISSES AN AUDIENCE, HELD EVERY WEDNESDAY, UNLESS HE IS ABROAD ON A PAPAL VISIT OR INDISPOSED DUE TO ILLNESS. HE REALIZES THAT THEY MEAN A GREAT DEAL TO THOSE WHO TRAVEL LONG DISTANCES TO BE THERE. PEOPLE WITH DISABILITIES ARE ALWAYS PLACED IN THE FRONT ROWS, WHERE HE GREETS THEM PERSONALLY.

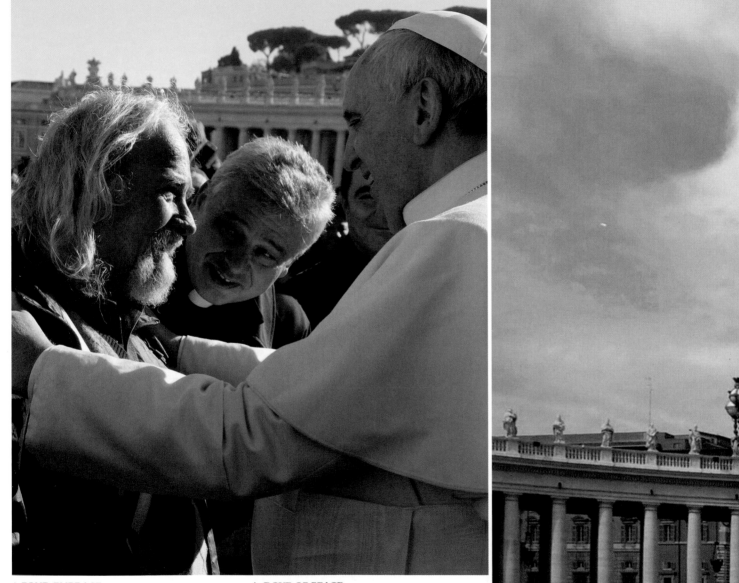

ʌ FOND EMBRACE
Archbishop Konrad Krajewski presents a visitor to Pope Francis. The Pope expanded the role of the Papal Almoner and has set up showers, a barbershop, and a food bank in the shadow of St. Peter's Basilica.

> DOVE OF PEACE
As he drives through the crowds greeting pilgrims, Pope Francis is presented by well-wishers with a dove, the biblical symbol of peace.

GENERAL AUDIENCE
MEETING THE PEOPLE

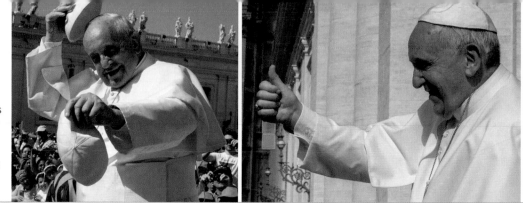

> SALUTING PILGRIMS
In order to greet as many people as possible, Pope Francis is driven through St. Peter's Square, saluting pilgrims and frequently stopping to talk.

< GIVING THE THUMBS-UP
Pope Francis is energized by people. His thumbs-up is an expression of his expansive and extroverted personality.

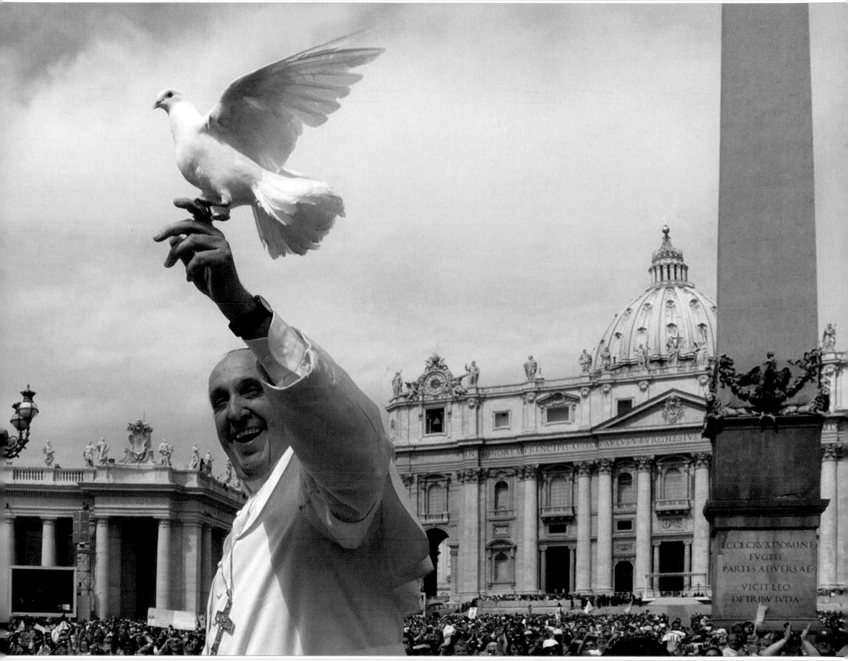

✝ IN EARLY SUMMER, SOME 500 CHILDREN FROM NAPLES VISITED THE POPE, ARRIVING AT THE VATICAN BY TRAIN, AS PART OF AN INITIATIVE TO ENGAGE CHILDREN AT RISK OF DROPPING OUT OF SCHOOL. THE POPE WELCOMED THE CHILDREN TO THE AUDIENCE HALL BESIDE HIS RESIDENCE. THEY BROUGHT HIM SOIL FROM THE NEAPOLITAN CATACOMBS AND A PLANT. "DO WE ALL HAVE THE CHANCE OF FINDING THE LIGHT?" THE POPE ASKED, REFERRING TO THE DARK CATACOMBS. A LITTLE GIRL SHOUTED "YES!" POPE FRANCIS ASKED HER TO SHOUT LOUDER SO EVERYONE COULD HEAR, AND THE CHILD DID.

⋏ REACHING FOR THE POPE
The children were excited when the Pope walked among them in the Audience Hall, asking them their names and where they came from.

◂ BOUQUET OF FLOWERS
As the children disembark the train, a girl gives the Pope a bouquet of yellow and white marguerite daisies, the colors of the Vatican flag.

THE CHILDREN'S TRAIN
A VISIT FROM THE CHILDREN OF NAPLES

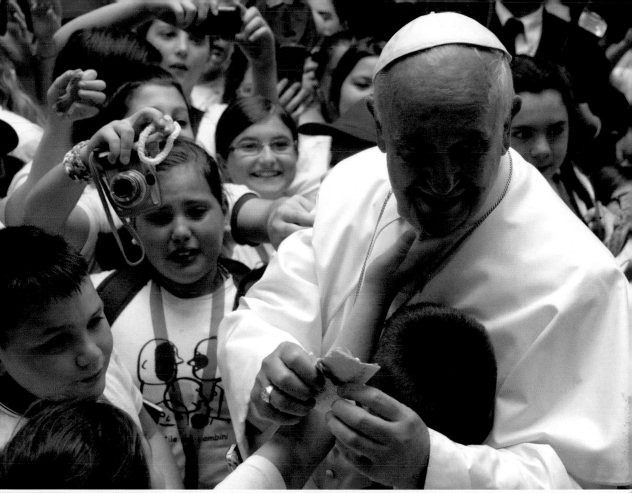

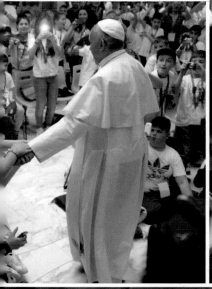

> MESSAGES OF LOVE
Many of the children brought Pope Francis cards and letters, and everyone wanted a photograph to remember their special day in Rome.

< GIFT OF CATACOMB SOIL
One of the children presented the Pope with a small terra-cotta pot. Inside was some soil from the catacombs of San Gennaro, dating from the 3rd century.

ʌ FOND FAREWELLS
After meeting the Pope, the children visited the Vatican and the Colosseum, although many were disappointed that the Pope could not join them.

✝ **EACH YEAR ON THE LAST DAY OF MAY, CATHOLICS CELEBRATE THE FEAST OF THE VISITATION,** WHICH RECALLS THE VISIT BY THE VIRGIN MARY TO ELIZABETH, WHEN SHE INFORMED HER COUSIN OF HER PREGNANCY. IN THE EVENING, PILGRIMS JOIN WITH POPE FRANCIS IN A TORCHLIT PROCESSION THROUGH THE VATICAN GARDENS TO A REPLICA OF THE GROTTO OF LOURDES. INCLUDED AMONG THE GUESTS OF HONOR ARE SICK AND DISABLED PEOPLE, WITH WHOM POPE FRANCIS HAS GREAT EMPATHY. HE REMINDS EVERYONE PRESENT OF THEIR DUTY TO HELP THOSE IN NEED..

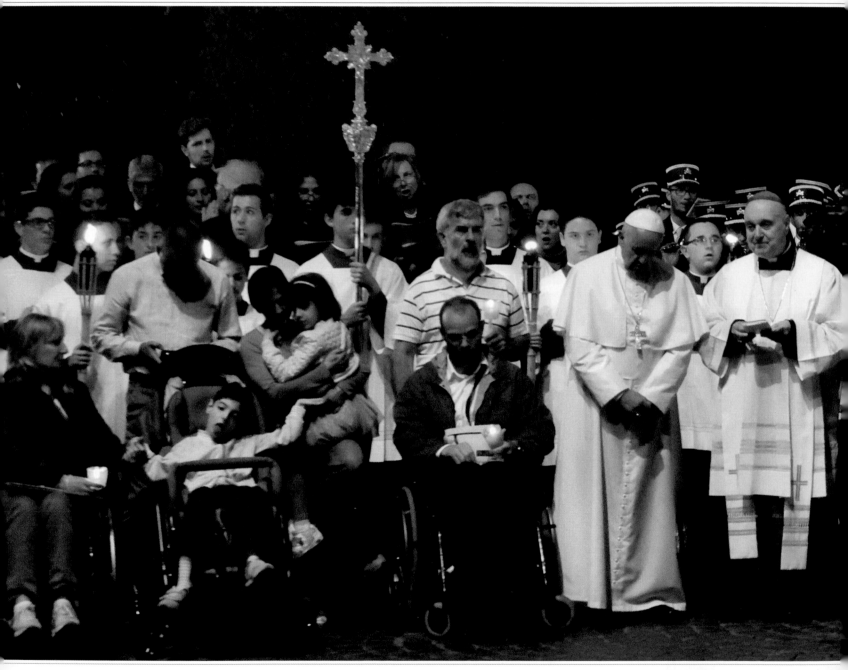

THE VISITATION
CELEBRATING MARY'S VISIT TO ELIZABETH

ʌ *AVE MARIA*
At the end of the procession, the band of the Papal Gendarmerie leads the people in singing the celebrated Lourdes hymn *Ave Maria*.

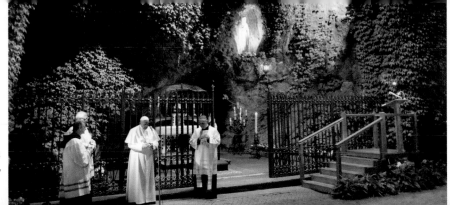

> GROTTO OF LOURDES
The Pope gives a blessing at the replica Lourdes Grotto, in the Vatican Gardens, a gift from the people of Lourdes to Pope Leo XIII in 1902.

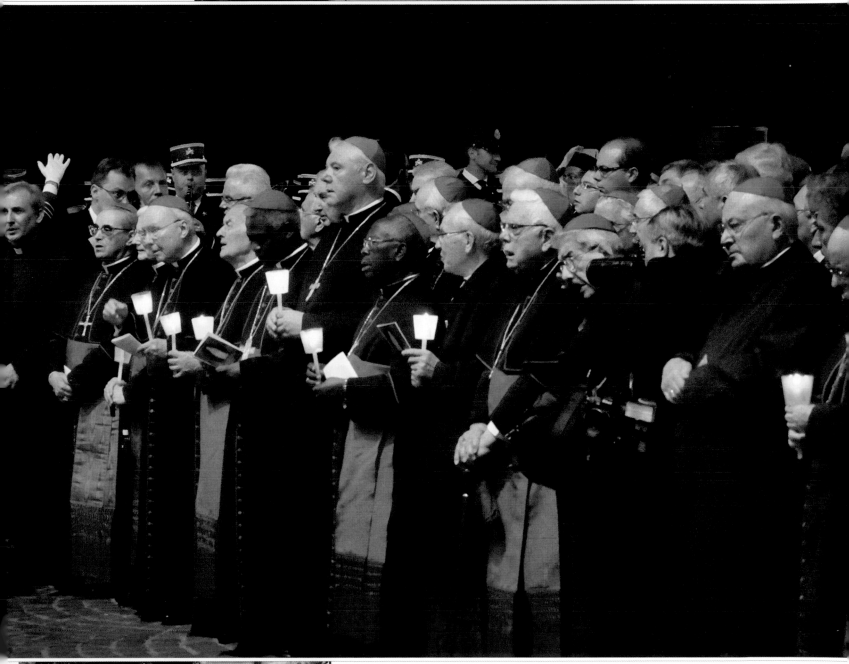

< WORDS OF HOPE
Pope Francis greets sick and disabled people, as well as their families, offering to each words of encouragement and the gift of rosary beads.

Early summer is the most pleasant time to visit Rome. Numbers attending the Pope's General Audiences peak in June, when the sunny weather offers the best opportunity for turning St. Peter's Square into a welcoming arena. Given Pope Francis's lifelong passion for sports, he offers a warm welcome to the thousands of young athletes who make a pilgrimage to the Eternal City.

Also taking place in June is the Feast of Corpus Christi, or the Body of the Lord, a celebration of Christ's presence in the Eucharist that dates from medieval times. Pope Francis celebrates Mass at the cathedral of St. John Lateran and then leads the worshippers in a procession to the Basilica of St. Mary Major, where he gives the Benediction.

Toward the end of June, Pope Francis meets with the clergy, catechists, and pastoral workers of the Diocese of Rome to exchange information about happenings in the 335 parishes of the diocese.

The liturgical high point of the month is the Feast of St. Peter and St. Paul, celebrated on June 29. According to tradition, the apostle Peter was crucified at the circus of Caligula at the Vatican, and Paul, the first great missionary and

writer, was beheaded on the Via Ostiensis. The Pope invites a number of archbishops from around the world to Rome for this feast day. Those appointed since the previous year receive a *pallium*, or woolen stole of office. The ceremony is held in St. Peter's Basilica or on the steps overlooking the square. The Pope also meets delegations of other Christian Churches in Rome for the feast day.

In addition to the annual liturgical feasts, the Pope attends numerous meetings throughout the month that include audiences with heads of state and exceptional visits.

One such visit occurred in June 2014. During a trip to the Holy Land in May of that year, the Pope met the presidents of Israel and of the Palestinian Authority and invited them to pray together in the Vatican. They accepted, and the two presidents joined the pontiff in the Vatican Gardens, where all three planted an olive tree, symbolic of peace.

The Pope receives invitations to visit from all over Italy. Virtually every city in the country has invited him, but Pope Francis always chooses out-of-the-way places. A small, modest town is more likely to receive a papal visit than a wealthy city.

< SUNBURST OF THE HOLY SPIRIT
At the center of Bernini's masterpiece of the Altar of the Chair is a sunburst of the Holy Spirit, made not from glass but from translucent alabaster marble.

> WASTE NO TIME
"Brother archbishops, today the Lord repeats to me, to you, and to all pastors: 'Follow me! Waste no time in questioning or in useless chattering,'" Pope Francis told the archbishops.

⋎ CONSECRATED WOMEN
Pope Francis dedicated 2015-16 to the role of consecrated women in the Church, praising their role in health care, prayer, education, and social work.

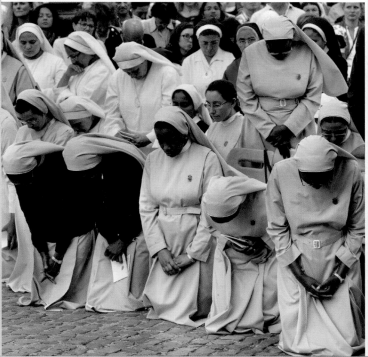

JUNE

PILGRIMAGES, FEAST DAYS, AND EXCEPTIONAL VISITS

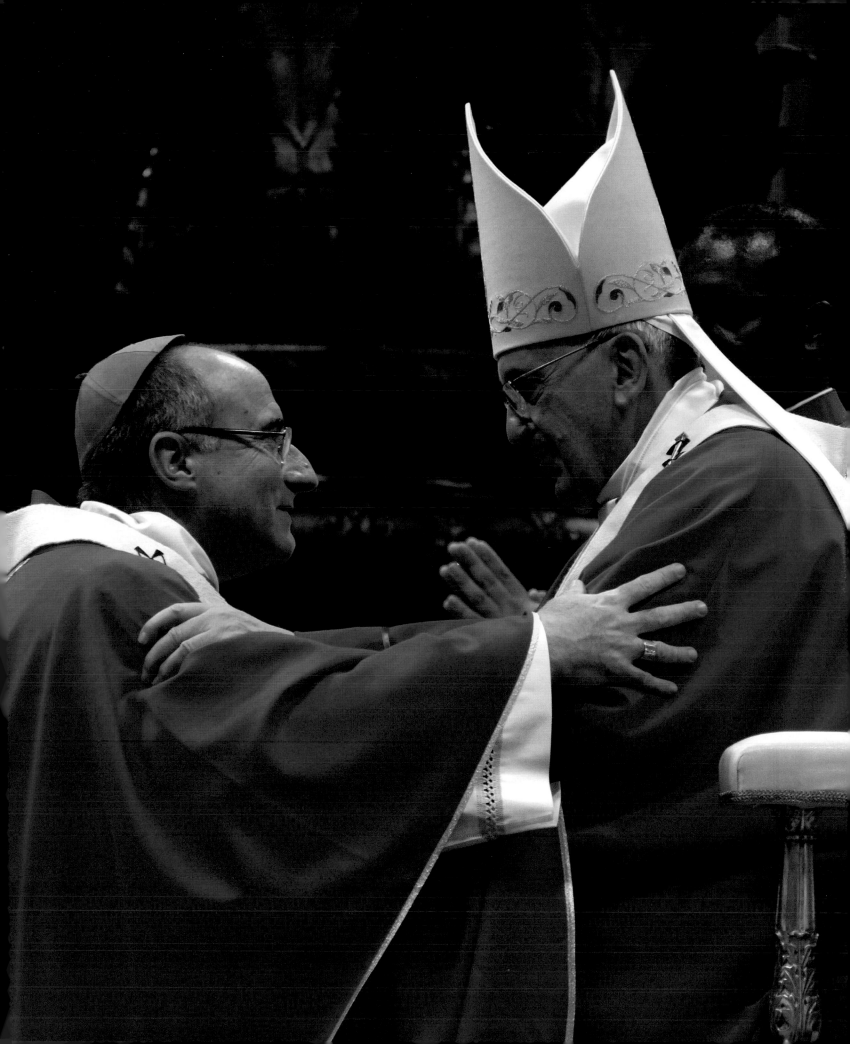

MORE THAN 100,000 ATHLETES AND FANS PACKED INTO ST. PETER'S SQUARE ON JUNE 7, 2014, TO CELEBRATE THE 70TH ANNIVERSARY OF THE ITALIAN SPORTS CENTER, THE ATHLETIC BRANCH OF CATHOLIC ACTION ORGANIZATION. WELCOMED AS THE "CAPTAIN," POPE FRANCIS SAID THAT MEMBERS OF A SPORTS TEAM SHOULD HELP EACH OTHER "TO COMPETE IN MUTUAL ESTEEM AND GROW IN BROTHERHOOD." HE INVITED THE YOUTHS TO "PUT YOURSELVES IN THE GAME, IN THE SEARCH FOR GOOD, IN THE CHURCH AND IN SOCIETY, WITHOUT FEAR, WITH COURAGE AND ENTHUSIASM."

˄ BAR WORK
Young gymnasts prepare to perform. The Pope reminded his audience that sports help develop the minds and bodies of young people in harmony.

˂ WEEKEND HIGHLIGHT
The event in St. Peter's Square was the highlight of a weekend of activities for those who flocked to the Eternal City to celebrate sports and faith.

SPORTS AUDIENCE
MEETING YOUNG ATHLETES

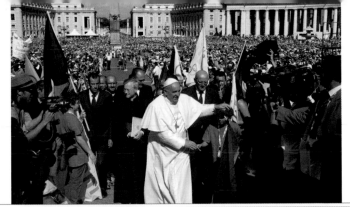

> **PACKED SQUARE**
St. Peter's Square was packed with tens of thousands of exuberant young people from all over Italy as athletes performed in front of the Basilica.

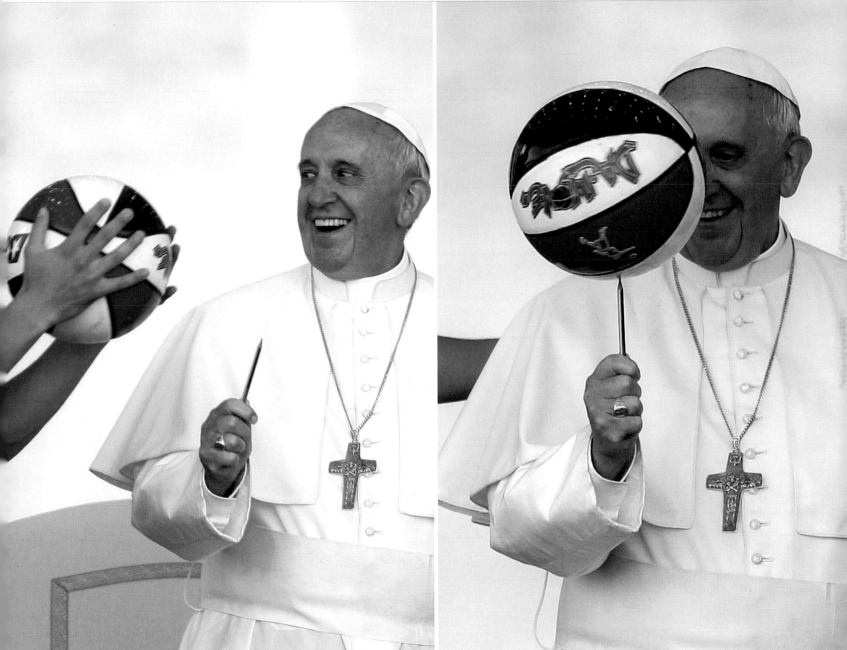

˄ TEAM SPIRIT

"Only if a sport remains a game will it do the body and spirit good. Always seek to do better with team spirit and with fairness," said Pope Francis.

˄ BALL SPINNING

Never too old to learn a new trick, Pope Francis is taught by basketball players how to spin a ball on a pencil, much to his amusement.

✝ THE WORD "PENTECOST" COMES FROM THE GREEK FOR "FIFTIETH." THE FEAST OF PENTECOST RECALLS THAT 50 DAYS AFTER EASTER, THE APOSTLES WERE GATHERED IN "AN UPPER ROOM" IN JERUSALEM, FEARFUL AFTER ALL THE EVENTS THAT HAD OCCURRED SINCE CHRIST'S CRUCIFIXION. BUT THE HOLY SPIRIT THEN FILLED THE ROOM AND INSPIRED THE MEN TO BELIEVE THAT JESUS HAD RISEN FROM THE DEAD AND WOULD CONTINUE TO BE WITH THEM, WHICH GAVE THEM COURAGE. THE FEAST OF PENTECOST IS SOMETIMES REFERRED TO AS THE BIRTHDAY OF THE CHURCH.

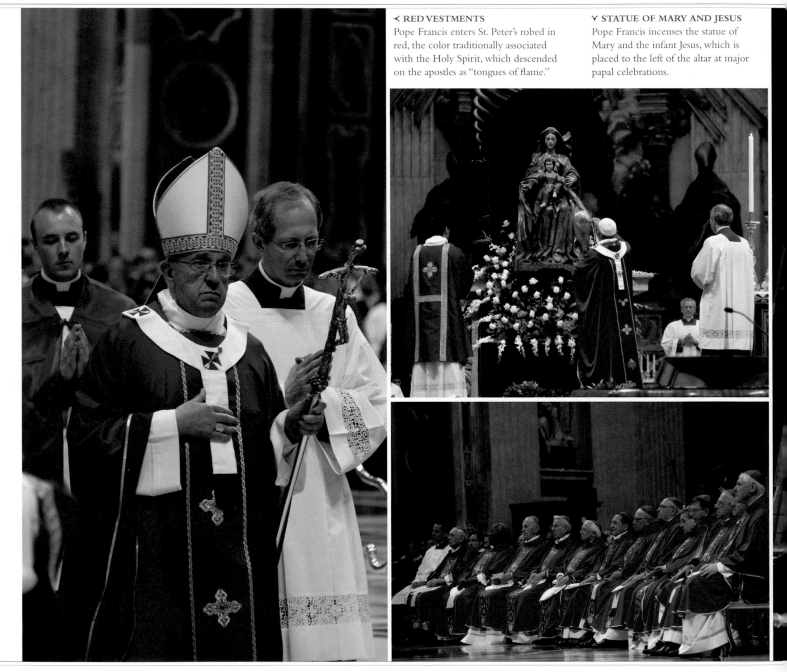

‹ RED VESTMENTS
Pope Francis enters St. Peter's robed in red, the color traditionally associated with the Holy Spirit, which descended on the apostles as "tongues of flame."

ᴠ STATUE OF MARY AND JESUS
Pope Francis incenses the statue of Mary and the infant Jesus, which is placed to the left of the altar at major papal celebrations.

ᴧ RAPT AUDIENCE
Cardinals celebrating Mass listen as Pope Francis preaches. Unlike his immediate predecessors, the Pope is not a polyglot and preaches only in Italian.

PENTECOST
THE BIRTHDAY OF THE CHURCH

> FOLLOWING THE PRAYERS
The congregation follows the Order of Mass with a booklet in which the prayers are printed in a number of different languages.

ʌ HEAVENLY LIGHT
Light streams through the upper windows of St. Peter's as people from all over the world gather to celebrate the Mass of Pentecost with the Pope.

DURING HIS TRIP TO THE HOLY LAND IN MAY 2014, POPE FRANCIS ISSUED A SPONTANEOUS INVITATION TO THE POLITICAL LEADERS OF ISRAEL AND THE PALESTINIAN AUTHORITY TO VISIT HIM IN ROME. TWO WEEKS LATER, ON JUNE 8, THE POPE WELCOMED THE PRESIDENTS OF THE PALESTINIAN AUTHORITY AND OF ISRAEL TO THE VATICAN. HE EXPLAINED THAT HE WOULD NOT ATTEMPT TO MEDIATE BETWEEN THE TWO SIDES IN THEIR LONG-RUNNING DISPUTE, BUT THAT HE WOULD SIMPLY PRAY WITH THE TWO LEADERS FOR PEACE IN THEIR LANDS.

CALL FOR PEACE

PRAYING FOR PEACE IN THE MIDDLE EAST

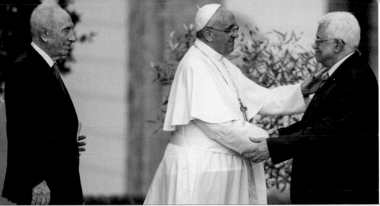

> HANDSHAKE OF PEACE
Pope Francis urged Israeli President Shimon Peres (left) and his Palestinian counterpart Mahmoud Abbas (right) to lead the search for peace.

Y WELCOME GUEST
Patriarch Bartholomew I of Constantinople (center right) was also the Pope's guest at the peace ceremony at the Vatican.

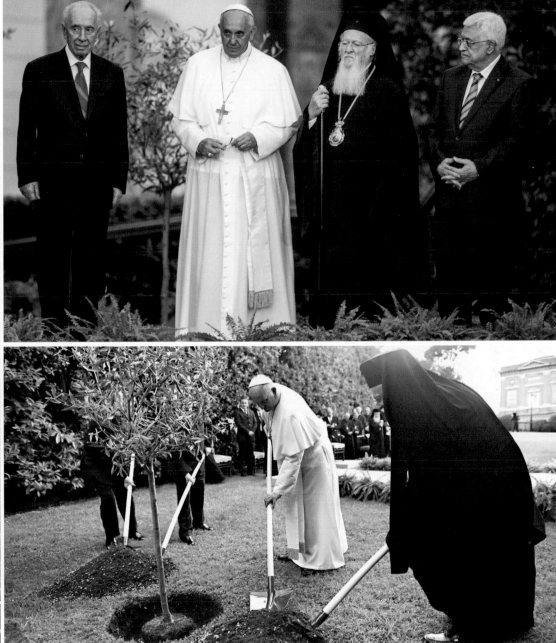

⋀ PRAYING FOR PEACE
Political leaders and Jewish, Christian, and Muslim religious leaders gather in the Vatican Gardens to pray for peace in the war-torn Middle East.

⋀ SYMBOLIC PLANTING
An olive tree recalls the covenant that God made with Noah, when a dove returned to the ark bearing a branch, indicating the end of the Great Flood.

EACH YEAR, IN THE MONTH OF JUNE, THE CHURCH CELEBRATES THE FEAST OF THE BODY AND
✝ BLOOD OF CHRIST, ALSO KNOWN AS CORPUS CHRISTI. IN ROME, THIS POPULAR DEVOTION BEGINS WITH
MASS AT THE CATHEDRAL OF ST. JOHN LATERAN, AFTER WHICH THE FAITHFUL WALK IN PROCESSION ALONG
THE VIA MERULANA TO THE BASILICA OF ST. MARY MAJOR. THE HOST, WHICH HAS BEEN PLACED IN A GOLD
MONSTRANCE, IS CARRIED IN THE PROCESSION TO AN ALTAR ERECTED ON THE STEPS OF ST. MARY MAJOR.
THE POPE THEN GIVES A BLESSING WITH THE MONSTRANCE.

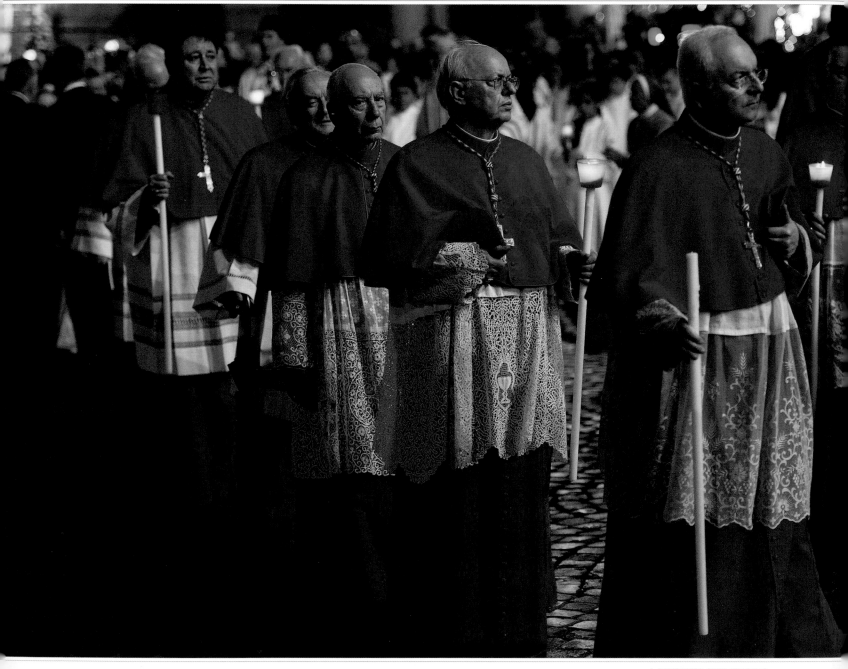

ᐱ LITANIES AND HYMNS
Singing litanies and hymns, thousands
join Pope Francis and the clergy in the
procession that wends its way along
the Via Merulana.

CORPUS CHRISTI

FEAST OF THE BODY AND BLOOD OF CHRIST

< PRAYING CARDINALS
Cardinals pray at the end of the Mass celebrated by the Pope in front of the Cathedral of St. John Lateran.

v HEAD BOWED IN PRAYER
Pope Francis bows his head at the beginning of Mass at St. John Lateran as he invites the congregation to recall their sins and ask God's forgiveness.

v GOLD MONSTRANCE
Holding the host in a jeweled gold monstrance, Pope Francis blesses the people gathered in the piazza before the Basilica of St. Mary Major.

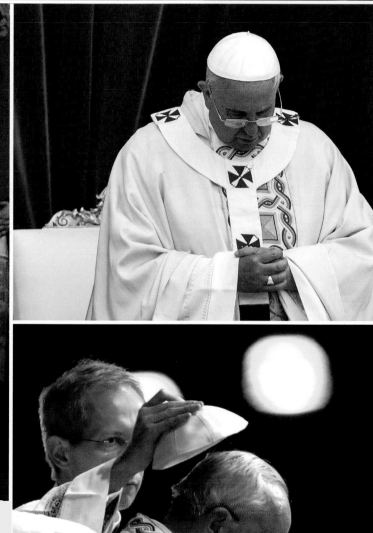

ʌ REMOVING THE *ZUCCHETTO*
The Master of Liturgical Ceremonies removes the pontiff's white *zucchetto* as he prepares to give the Benediction at the Basilica of St. Mary Major.

> ARRIVAL OF THE BISHOPS
A group of bishops arrives at St. Mary Major, after the mile-long, candlelit procession from Rome's cathedral, St. John Lateran.

THE LITURGICAL HIGH POINT OF THE MONTH IS CELEBRATED ON THE FEAST OF ST. PETER AND ST. PAUL ON JUNE 29. ACCORDING TO TRADITION, THE APOSTLE PETER WAS CRUCIFIED AT THE CIRCUS OF CALIGULA AT THE VATICAN, AND PAUL WAS BEHEADED ON THE VIA OSTIENSIS. UNTIL 2015, THE POPE CONFERRED THE PALLIUM, THE WOOLEN STOLE OF EPISCOPAL OFFICE, ON THE NEW ARCHBISHOPS APPOINTED SINCE THE CELEBRATION OF THE FEAST THE PREVIOUS YEAR. HENCEFORTH, THE CEREMONY WILL BE CARRIED OUT IN THE HOME DIOCESES.

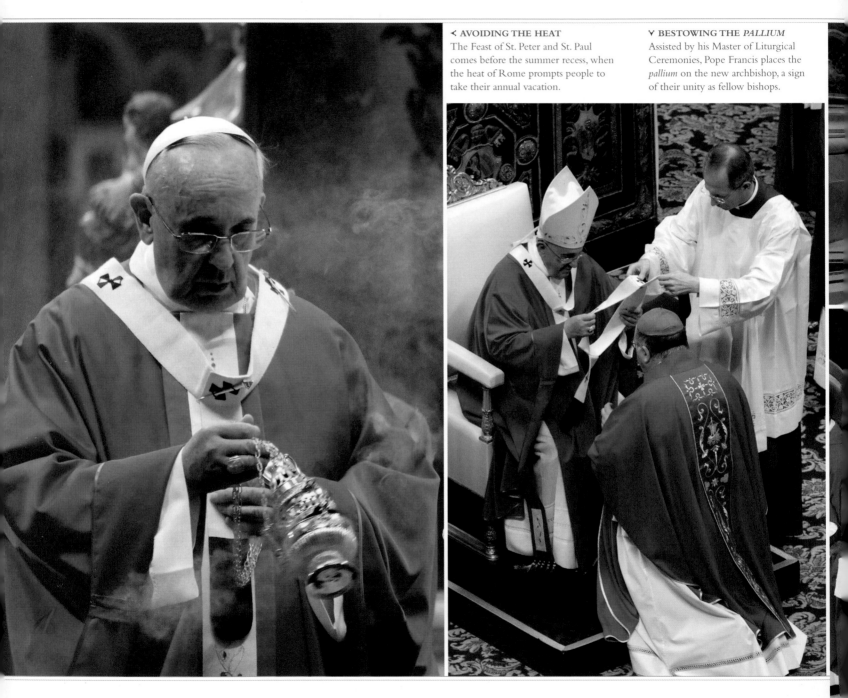

< AVOIDING THE HEAT
The Feast of St. Peter and St. Paul comes before the summer recess, when the heat of Rome prompts people to take their annual vacation.

∨ BESTOWING THE *PALLIUM*
Assisted by his Master of Liturgical Ceremonies, Pope Francis places the *pallium* on the new archbishop, a sign of their unity as fellow bishops.

FEAST OF SAINTS

CELEBRATING THE FEAST OF ST. PETER AND ST. PAUL

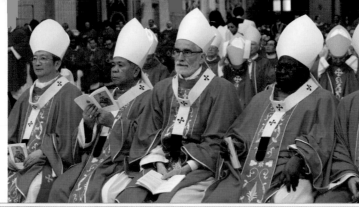

> WORLDWIDE FAITH
The liturgical feast demonstrates the spread of the Catholic faith over 2,000 years. Catholicism represents 18 percent of the world's population.

A POSING FOR THE CAMERA
After the Mass for the Feast of St. Peter and St. Paul, Pope Francis poses for a photograph with Metropolitan Ioannis and the newly appointed archbishops.

< PRAYING FOR UNITY
Metropolitan Ioannis, a delegate of Bartholomew I of Constantinople, and the Pope pray over St. Peter's tomb for the unity of the two Churches.

< UNLEAVENED HOST
Concelebrants gather around the altar holding unleavened host, which will be consecrated during the Mass and distributed to the congregation.

In July and August, most Italians take their summer vacation, leaving the cities for the cooler mountains or the seaside. As Romans begin to leave, activity slows in the Eternal City. Even the Casa Santa Marta empties as the clergy and residents take their vacations. In solidarity with those who cannot afford a vacation, Pope Francis has broken the papal tradition of vacationing at the Apostolic Palace in the Alban Hills. Even when he lived in Buenos Aires, he did not take an annual vacation. Now, as Pope, he remains in the Vatican throughout the summer months, although he cancels most public appearances. This allows him to catch up on reading and receiving friends. Occasionally, he has official visitors to stay and, from time to time, he hosts members of his family and circle of friends at the Casa.

The Apostolic Palace, where his predecessors spent most of July and August, is situated in the hilltop town of Castel Gandolfo, overlooking a volcanic lake and set in magnificent gardens. It was built on the site of a home of the 1st-century emperor Domitian. In the mid-17th century, Pope Urban VIII purchased the land and commissioned Baroque architect Carlo Maderno, who was responsible for a number of celebrated churches in Rome, to design the palace. During World War II, Pope Pius XII sheltered Jews from the Nazi occupiers in the palace and its surrounding buildings. It was also here that Pope Benedict spent several weeks following his abdication from the papacy in February 2013.

Although Pope Francis suspends the weekly Wednesday General Audiences for July and August, he still prays the Angelus at noon on Sundays. He also continues to receive special groups, such as the German altar servers on their annual pilgrimage to Rome. The sheer vitality and enthusiasm of the 50,000 young people makes for a carnival atmosphere in St. Peter's Square.

Also in July and August, Pope Francis undertakes short visits within Italy, as well as longer journeys abroad. In July 2013, he traveled to Brazil to participate in World Youth Day celebrations, and in August 2014, he visited South Korea to take part in the sixth Asian Youth Day. These pastoral visits are exhausting, and Pope Francis needs a week or two to recover when he returns to the Vatican.

< PUBLIC APPEARANCES
Even though the number of visitors to Rome and the Vatican tends to decrease in the hot summer months, the Pope still makes a few public appearances.

> ANNUAL PILGRIMAGE
Pope Francis enjoys the enthusiasm of the 50,000 young German altar servers gathered in St. Peter's Square during their annual pilgrimage to Rome.

∨ SOCCER JERSEY
A lifelong fan of soccer, the Pope proudly shows off a jersey with his name and number, a gift from young German visitors.

JULY AND AUGUST
TIME TO UNWIND

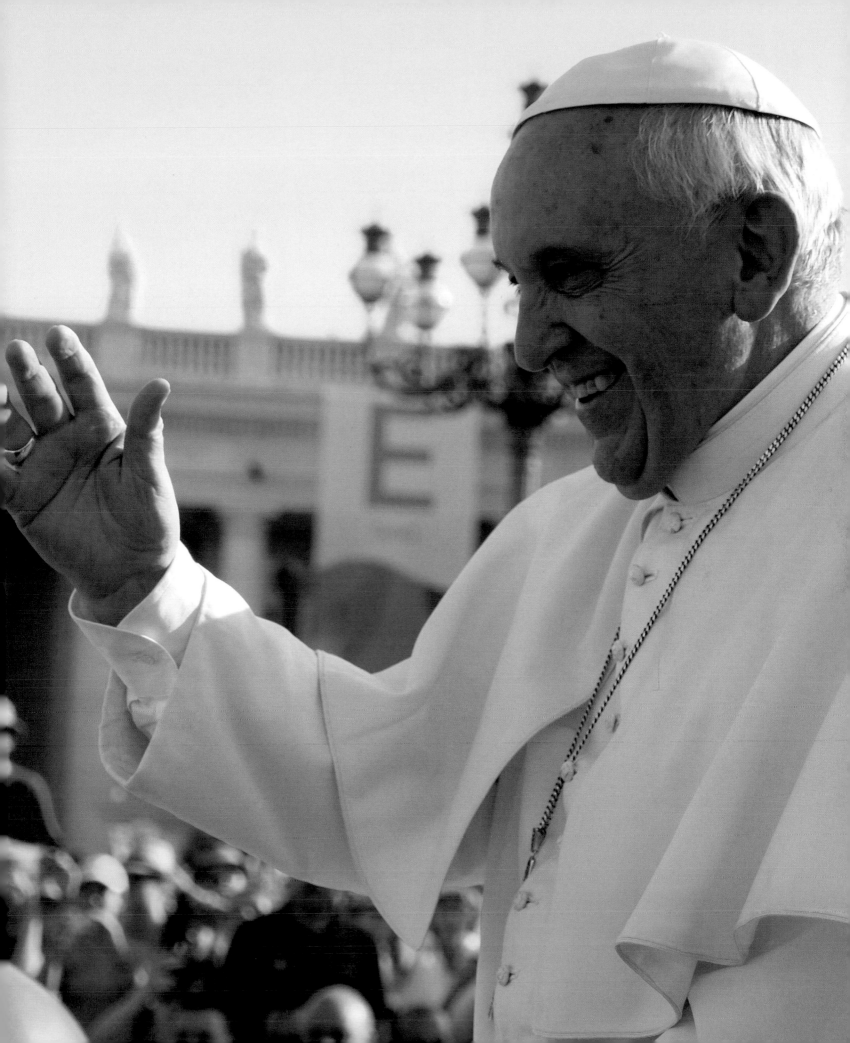

✝ SUMMER VACATION IN EUROPE IS A TIME WHEN YOUNG PEOPLE ARE ABLE TO TRAVEL FOR EXTENDED PERIODS. ON THE EVENING OF AUGUST 5, 2014, POPE FRANCIS MET WITH SOME 50,000 YOUNG GERMANS WHO HAD MADE THEIR WAY TO ROME. BETWEEN THE AGES OF 14 AND 22, THEY ASSIST WITH THE LITURGIES BACK HOME IN THEIR LOCAL PARISHES. AT THEIR AUDIENCE WITH POPE FRANCIS, THERE WAS SOMETHING OF A CARNIVAL ATMOSPHERE AS THEY SANG AND BORE TESTIMONY TO THE IMPORTANCE OF THEIR FAITH IN THEIR LIVES.

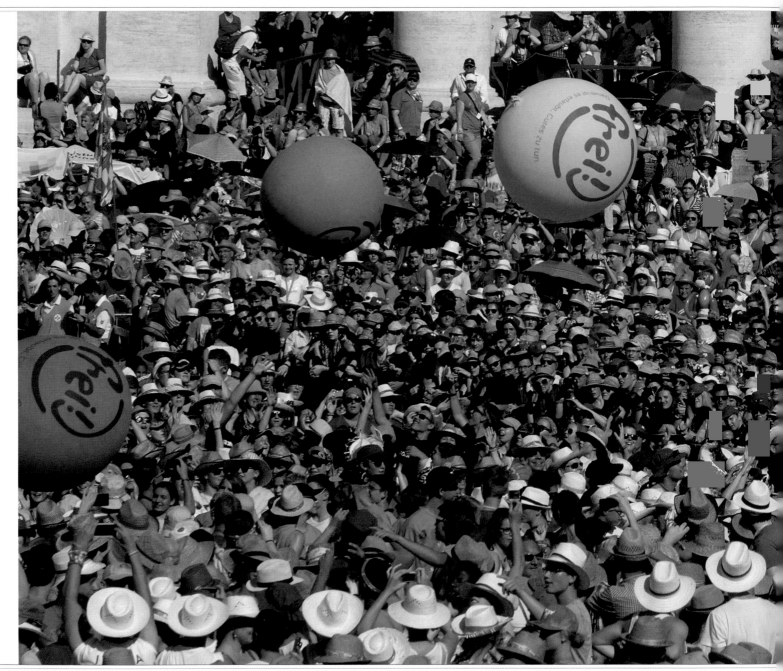

▲ BRIDGING THE AGE GAP
Pope Francis has established an extraordinary rapport with young people, who enjoy his banter and good-natured, spontaneous remarks.

YOUNG GERMANS
MEETING ALTAR SERVERS FROM GERMANY

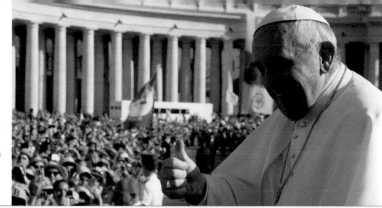

> SOUND ADVICE
Pope Francis greets the crowds. In his remarks, he urged the young people to value both their youth and their freedom and to use their gifts wisely.

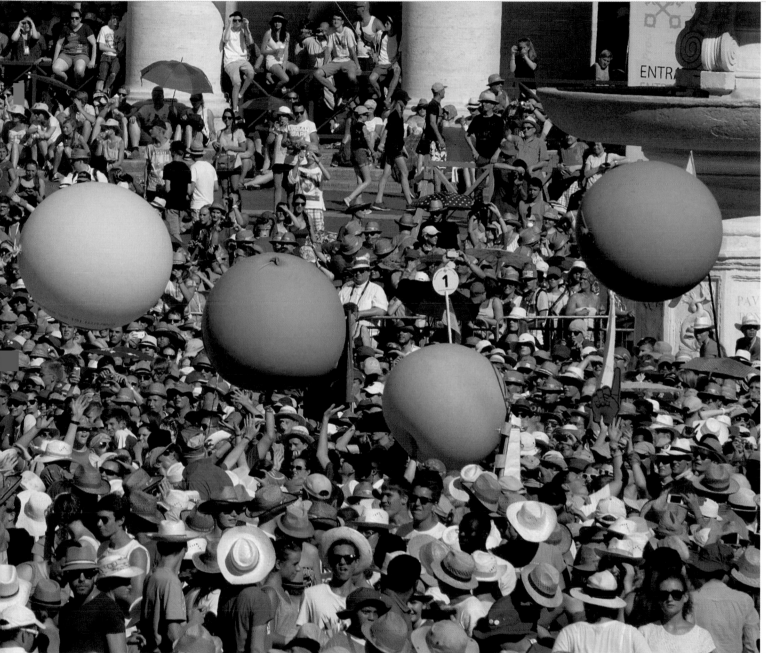

< JOINING HANDS
Standing on the steps of St. Peter's Basilica, facing the square, the Pope and a group of young Germans join hands to pray the Our Father.

WHEN HE DECIDED TO JOIN THE JESUIT ORDER, JORGE BERGOGLIO HOPED THAT HE WOULD SPEND HIS LIFE TEACHING YOUNG PEOPLE. ALTHOUGH HE DID TEACH FOR MANY YEARS IN HIS NATIVE ARGENTINA, HE GAVE THIS UP WHEN HE BECAME BISHOP OF BUENOS AIRES. YET EVEN AS BISHOP, HE ENJOYED MEETING YOUNG PEOPLE AND HAVING A DIALOGUE WITH THEM. NOW, AS POPE, HE HAS THE OPPORTUNITY TO MEET YOUNG PEOPLE IN A VARIETY OF SETTINGS, BOTH AT THE VATICAN AND DURING HIS VISITS ABROAD. HE ALWAYS SEEKS TO ENCOURAGE THEM IN THEIR PROFESSIONAL AND PRIVATE LIVES.

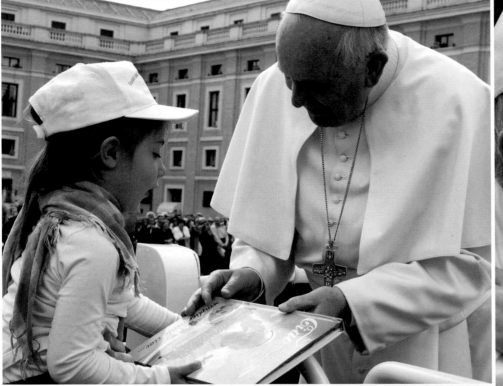

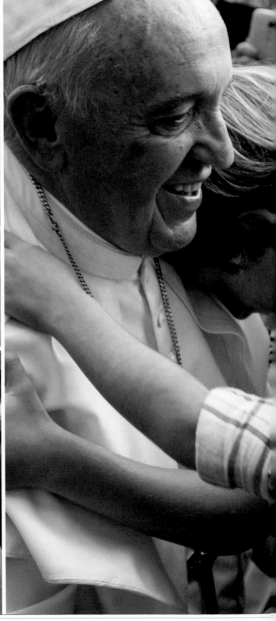

⋏ GIFT FROM A CHILD
A little girl presents Pope Francis with a children's book on his life, but he seems more interested in the child than in the gift.

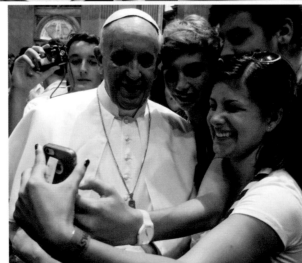

➤ CAPTURED IN A SELFIE
Modern technology has developed dramatically in recent years, and a selfie with Pope Francis is sure to be shared on social media within moments.

YOUNG AT HEART
MEETING CHILDREN AND YOUNG ADULTS

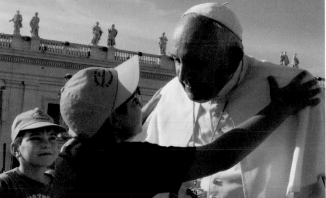

< OBVIOUS AFFECTION
A young boy shows his obvious affection for Pope Francis as he stretches out his arms to embrace him in St. Peter's Square.

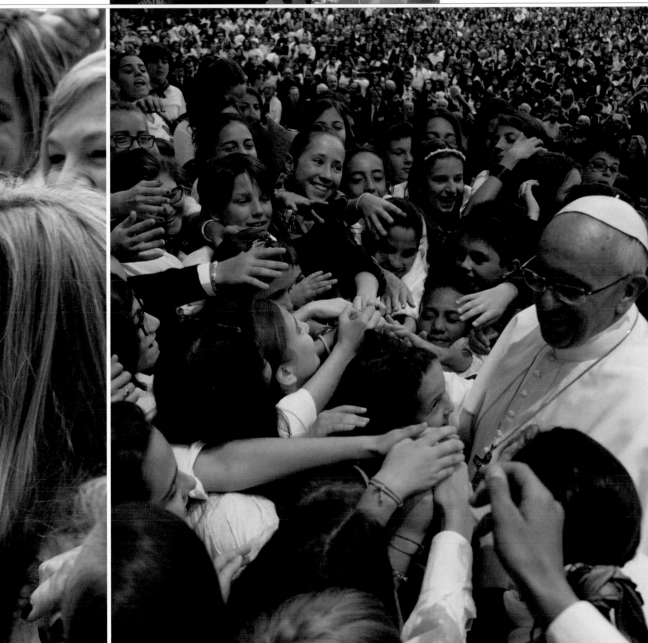

^ COMPANY OF CHILDREN
Pope Francis enjoys the company of children enormously, and he is able to put them at ease. He believes that children bring joy to society, not just to their parents.

^ SECURITY CHALLENGE
At times, the press of young people can be a challenge for the security teams, but Pope Francis seems totally unconcerned.

> UNSCRIPTED MOMENT
A little boy escapes from his father's care and runs up to the Pope, who gently reaches for him as he continues to read from his script.

POPE FRANCIS IS PROUD OF HIS LATIN AMERICAN AND ITALIAN HERITAGE. THE CATHOLIC CHURCH HAS THE LARGEST NUMBER OF FOLLOWERS IN LATIN AMERICA, THOUGH THIS IS DECREASING SLIGHTLY. THE POPE IS AWARE THAT CATHOLICISM MUST NOT SET ITSELF IN OPPOSITION TO THE VARIOUS OTHER CHRISTIAN DENOMINATIONS PRESENT IN LATIN AMERICA BUT MUST WORK FOR THE COMMON GOOD. HE ALLIES HIMSELF WITH PEOPLE OF ALL RELIGIOUS PERSUASIONS AND THOSE OF NONE, IN ORDER TO PROMOTE BASIC HUMAN VALUES. HIS ITALIAN HERITAGE IS OF INVALUABLE ASSISTANCE IN HIS DAILY LIFE.

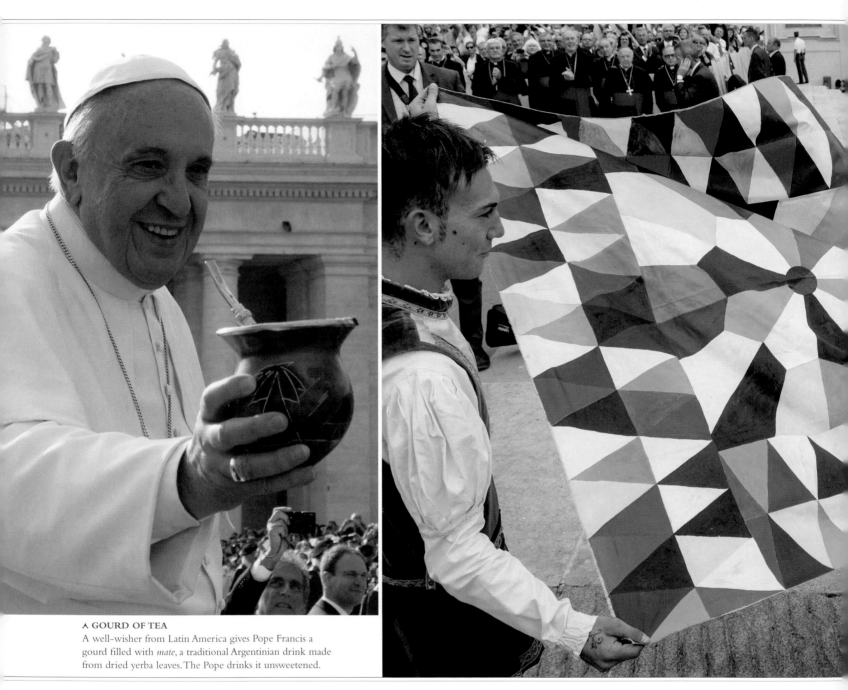

⋏ GOURD OF TEA
A well-wisher from Latin America gives Pope Francis a gourd filled with *mate*, a traditional Argentinian drink made from dried yerba leaves. The Pope drinks it unsweetened.

THE ARGENTINIAN
A POPE PROUD OF HIS HERITAGE

◄ FLAG WAVING

As pilgrims proudly wave their national flags, St. Peter's Square is turned into a kaleidoscope of color, reflecting the different nationalities of the visitors.

∨ SPONTANEOUS SONG

Mariachi musicians break into spontaneous song, adding an extra dimension to the sense of fun and excitement of the occasion.

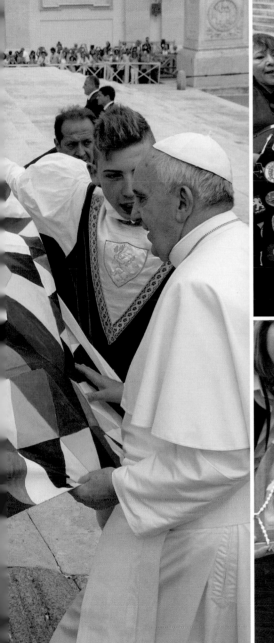

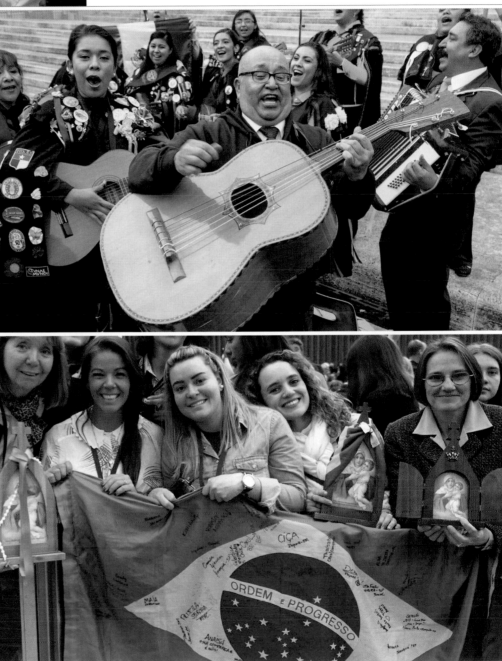

⋀ ADMIRING THE FLAG

The art of flag throwing dates back to the Middle Ages, when Italian towns and cities had various guilds, each of which was represented by a banner.

⋀ BRAZILIAN VISITORS

Visitors from Brazil, holding their national flag and some religious objects, hope that Pope Francis will notice them as he drives through the crowds.

⌃ CASTEL GANDOLFO
From the 16th century, the popes retired for their summer
vacation to the Apostolic Palace in Castel Gandolfo, in the
Alban Hills. Pope Francis does not continue this tradition,
and he has opened the gardens to the public.

After the summer lull, Italians go back to work, schools reopen, and activities in Rome resume, with the number of visitors to the city increasing once more.

Most of the set annual events, such as Christmas and Easter, are dictated by the liturgical calendar, but each year, Pope Francis initiates a number of unique events, which are often precipitated by the international situation.

In September 2013, he invited people to pray for peace in Syria and the Middle East at a time of rapidly rising tension in the region. A year later, he organized a special day of prayer with the elderly, where tens of thousands of older people gathered to share with him their stories, their struggles, their hopes, and their joys. It was one of the rare events attended by Emeritus Pope Benedict XVI.

In recent years, the number of lay catechists teaching the Catholic faith in schools and parishes has grown enormously. The Pope recognizes their unique contribution by inviting them and their students to St. Peter's Square as schools begin the new term.

Pope Francis continues his pastoral work of celebrating the sacraments. A high point is his blessing of marriages.

On September 14, 2014, he blessed the marriages of 20 couples who were from the Diocese of Rome.

Every five years, the world's bishops visit Rome to report on their dioceses. The visit is called *ad limina apostolorum*, meaning "to the threshold of the apostles." To make these visits efficient, the bishops are grouped together geographically and by language. The visits are an opportunity for the Pope to share his knowledge of the global Church and for the bishops to discuss their problems and seek solutions with members of the various offices that make up the Roman Curia.

From time to time, Pope Francis addresses important themes in an encyclical letter. His first, *Lumen Fidei*, the Light of Faith, was about the relationship between faith and reason. The second, *Evangelii Gaudium*, the Joy of the Gospel, examined contemporary issues of faith in his own colloquial style. It also touched on politics, the global economy, and the challenges ahead for the Church. Its upbeat tone was tempered by cautious words about the Christian responsibility of caring for the poor and disenfranchised. Like much of the Pope's writing, the words are pithy and memorable.

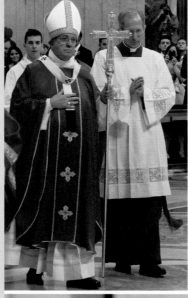

< RESUMPTION OF DUTIES
Public ceremonies at the Vatican that were largely suspended in August resume in September, and the Pope presides over a number of liturgies.

> SHADY REFUGE
Many take refuge beneath the shade of the vast Tuscan colonnade, described by the 17th-century architect Bernini as the "motherly arms of the Church."

∨ READY FOR CONSECRATION
African students for the priesthood in Rome bring ciboria, containers for the hosts, to the altar for consecration during the Mass.

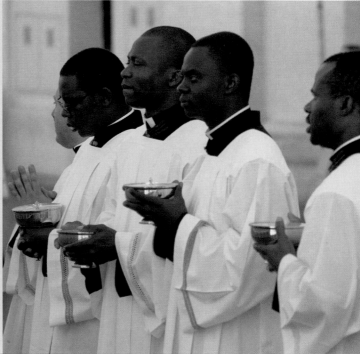

SEPTEMBER

THE END OF SUMMER

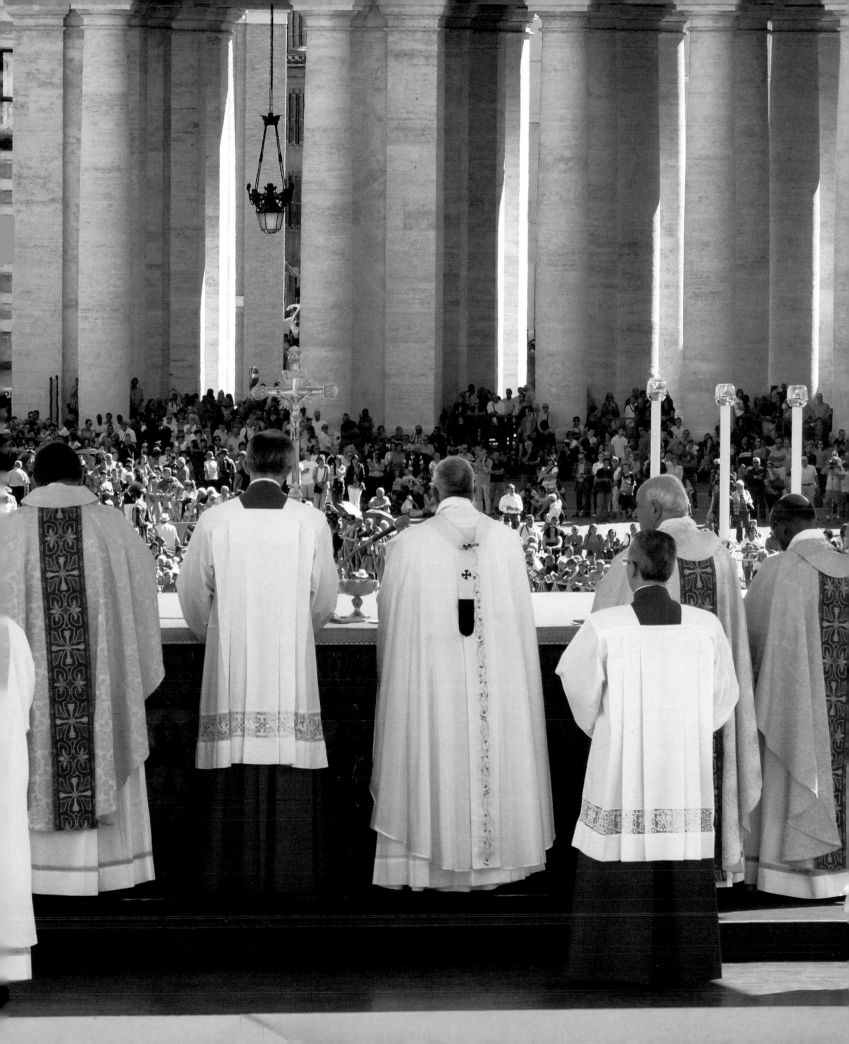

THEIR WEDDING DAY IS ONE OF THE MOST IMPORTANT EVENTS IN A COUPLE'S LIFE, AND THIS WAS ESPECIALLY TRUE FOR THE 40 YOUNG PEOPLE WHOSE MARRIAGES WERE BLESSED BY POPE FRANCIS ON SEPTEMBER 14, 2014. THE OCCASION IN ST. PETER'S BASILICA WAS EXCEPTIONAL. ONE BRIDE WAS ALREADY A MOTHER, WHILE OTHER PARTICIPANTS HAD BEEN MARRIED BEFORE. IN HIS HOMILY, THE POPE SAID THAT IT WAS NORMAL FOR A HUSBAND AND WIFE TO ARGUE, BUT HE URGED THEM NEVER TO LET THE SUN SET WITHOUT BEING RECONCILED, EVEN IF ONLY BY A SMALL GESTURE.

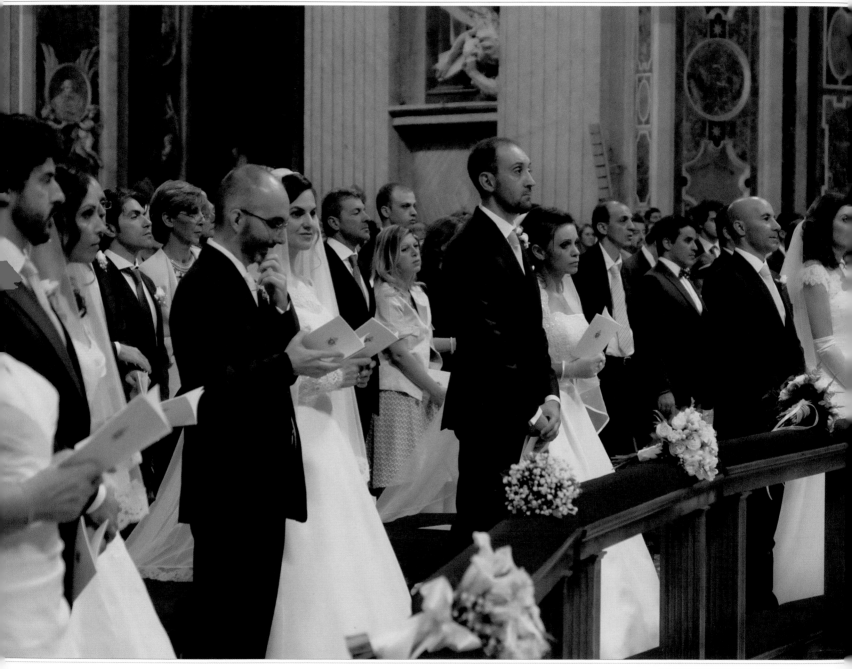

⋏ LOOKING TO THE FUTURE
Along with their proud parents and families, the couples prepare to exchange their marital vows, promising lifelong fidelity to each other.

GROUP WEDDING
TWENTY MARRIAGES BLESSED BY THE POPE

> **SILENT PRAYER**

The Pope pauses for a few moments in silent prayer for the couples. He urged them never to lose hope despite disappointments and upsets.

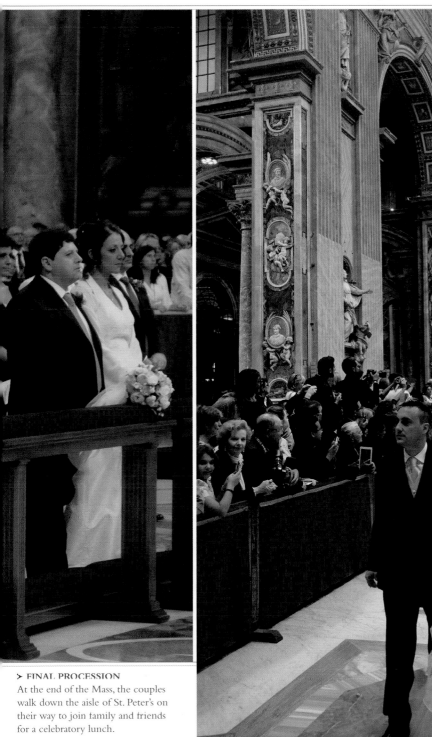

> **FINAL PROCESSION**

At the end of the Mass, the couples walk down the aisle of St. Peter's on their way to join family and friends for a celebratory lunch.

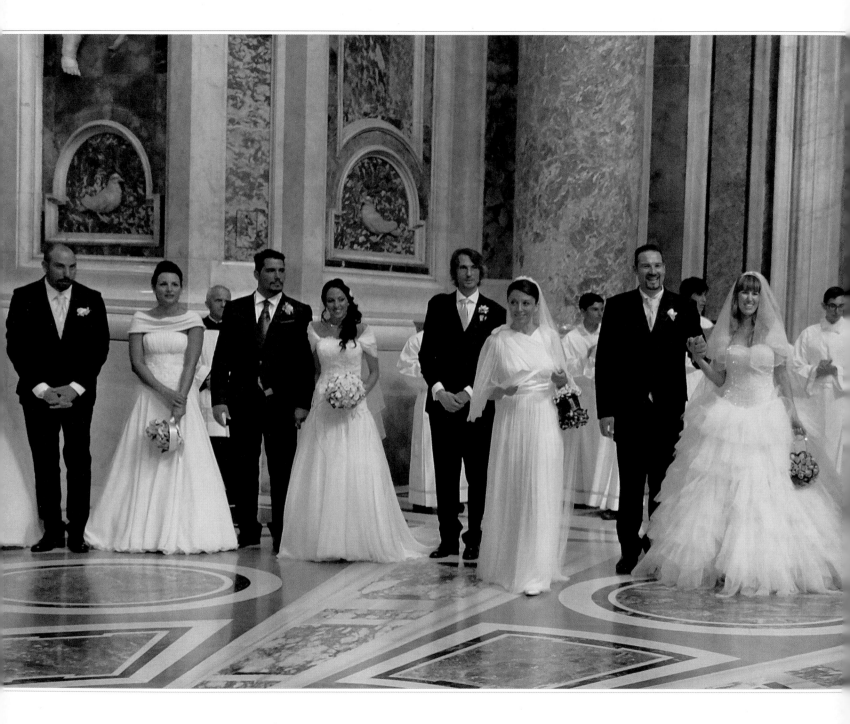

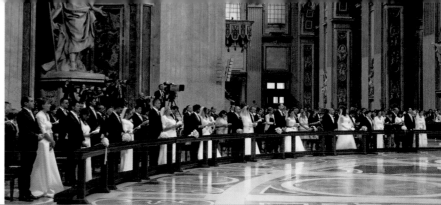

> MARRIAGE AND FAMILIES
Pope Francis blessed the marriages of 20 couples at the Vatican just three weeks before the opening of the Synod on the Family in October.

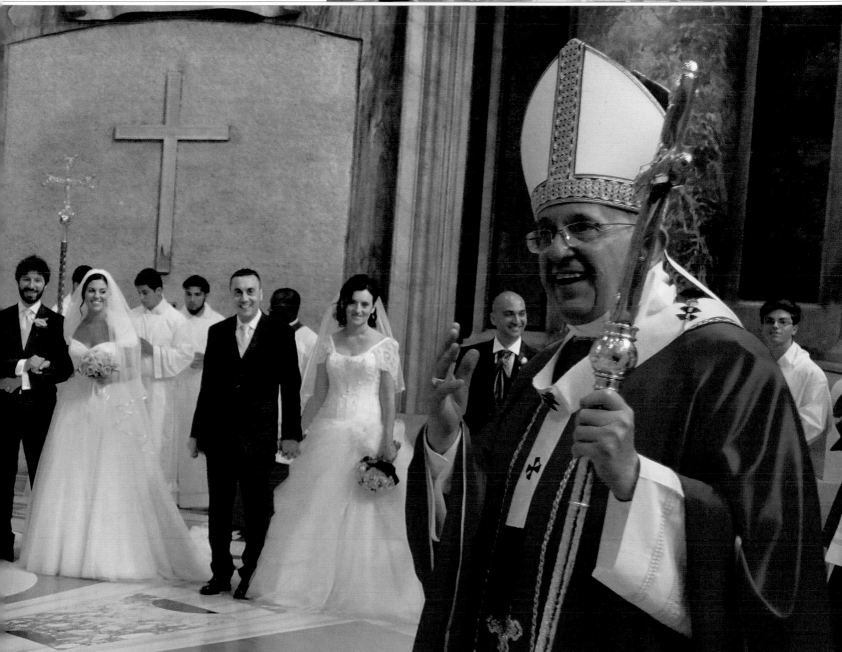

ʌ GOOD WISHES
Following Mass, Pope Francis joined the happy spouses in the Chapel of the Pietà, where he offered them and their families his good wishes and blessing.

175

ON SEPTEMBER 28, 2014, POPE FRANCIS CELEBRATED MASS FOR GRANDPARENTS AND THE ELDERLY.
THE POPE OFTEN RECALLS HIS GRANDPARENTS WITH AFFECTION, ESPECIALLY HIS PATERNAL GRANDMOTHER—AS A CHILD AT HER KNEE, HE LEARNED THE ITALIAN LANGUAGE AND THE CATHOLIC FAITH. THE MASS WAS PRECEDED BY TESTIMONIALS FROM SEVERAL PEOPLE PRAISING THE BLESSING OF A LONG LIFE. PARTICULARLY POIGNANT WAS A COUPLE FROM THE CITY OF MOSUL IN IRAQ, WHO GREETED POPE FRANCIS ON BEHALF OF MANY ELDERLY PEOPLE WHO ARE SUFFERING PERSECUTION.

∨ **GRANDFATHER FIGURE**
Emeritus Pope Benedict XVI makes a rare public appearance. Pope Francis often remarks that having him in the Vatican is like having a grandfather nearby.

> **HELPING HAND**
Emeritus Pope Benedict is seated by his former secretary and Prefect of the Papal Household, Archbishop Georg Gänswein, who still resides with him.

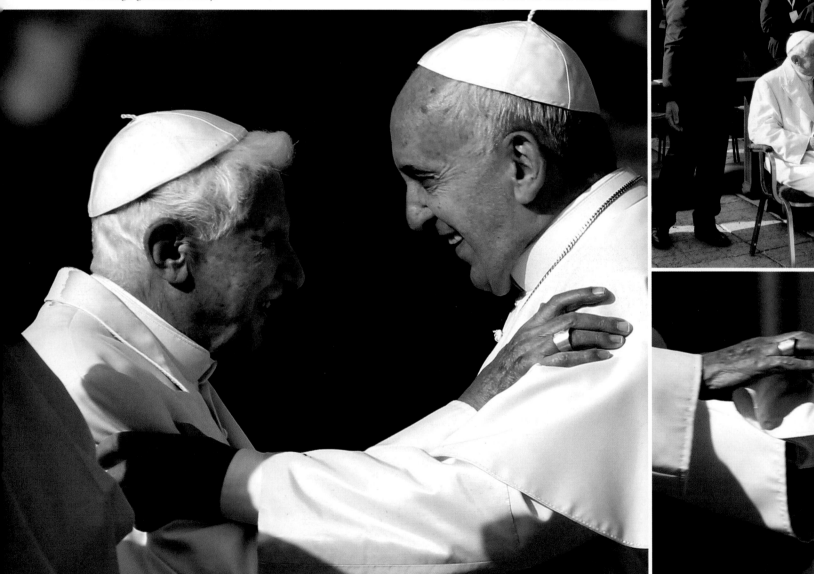

∧ **WARMTH AND REGARD**
There is evident warmth and regard between the Pope and Emeritus Pope Benedict. Pope Francis calls his predecessor regularly for advice.

THE ELDERLY

A SPECIAL DAY OF PRAYER

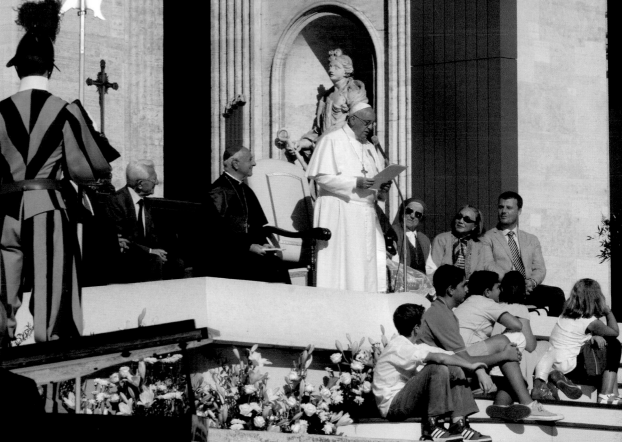

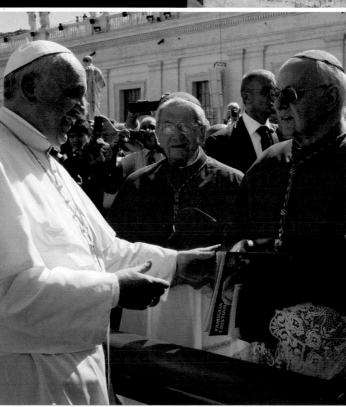

⋀ READING MATTER
A cardinal brought a copy of the popular Jesuit-run Italian periodical *Famiglia Cristiana* to pass the time as he waited for the Pope to arrive.

⋀ CHILD'S IMPRESSION
A little girl waits patiently for her turn to meet Pope Francis and present him with a picture that she drew of herself with the pontiff.

ⅴ SIGHTLINES

All eyes look in the same direction as the Pope's Jeep is driven around St. Peter's Square, ensuring that everybody has a good view of the pontiff.

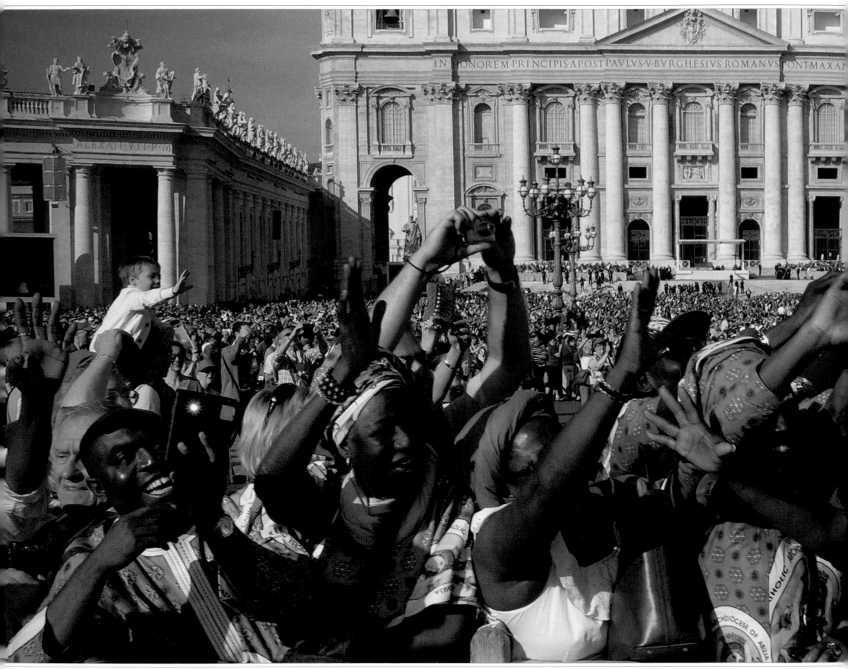

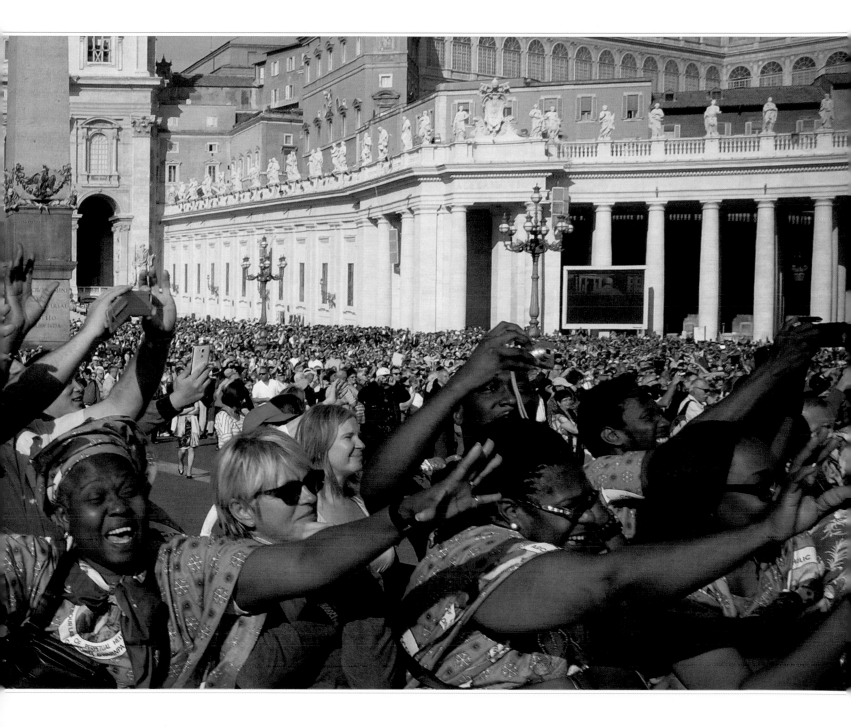

Big events continue to take place at the Vatican in October. As the universities of Rome begin a new term, the Pope celebrates Mass for the students, faculties, and administrative staff.

In 1965, at the close of the Second Vatican Council, Pope Paul VI established the Synod of Bishops. The synod provides a forum for representatives of the world's bishops and advisors, who meet every two or three years to discuss contemporary issues. In the first two years of his pontificate, Pope Francis convened two sessions of the Synod of Bishops.

Pope Francis encouraged the bishops to speak openly during these synodical sessions, which were scheduled for October of 2014 and 2015. The theme chosen was the place of the family in the Church and within society.

Just before the sessions were due to begin in 2014, a special day of celebration with families was held in St. Peter's Square. Members of families, from grandparents to aunts and uncles, as well as parents and children, spoke about the value of the Christian family and its role within society.

In the first three weeks of October 2014, around 250 bishops from all over the world assembled at the Pope Paul VI Audience Hall. Before proceedings began, Pope Francis expressed his clear wish that the Synod would be a place of constructive debate. The bishops deliberated on challenging issues such as the taking of Holy Communion by divorced and remarried couples and gay people. Unlike previous synods, the 2014 sessions allowed a robust exchange of views. In addition, several laypeople, married and unmarried, addressed the bishops and met them informally.

Shortly after his election, Pope Francis constituted a small group of cardinals to help him implement reform in the Roman Curia, overhaul Vatican finances, and advise him on other church matters. The group meets four times a year, with Pope Francis usually attending. The meetings offer the Pope a wide perspective on many problems and their possible solutions.

While the Synod is in session, there is little time for other work. However, on October 19, 2014, Pope Francis beatified Pope Paul VI (1963–78). The ceremony, which was held in St. Peter's Square, marked the last step before canonization, the declaration that Blessed Paul is a saint.

< QUIET REFLECTION
Pope Francis bows his head during a prayer service in St. Peter's Square as the 2014 Synod of Bishops opens to discuss the role of the family.

> EASY MANNER
Pope Francis's relaxed style puts everyone at ease, including his assistants. He proudly wears a simple cross, which he received when he was made Archbishop of Buenos Aires.

∨ PHOTOGRAPHIC MEMENTO
As the crowds disperse after the Prayer Vigil for the Family on October 4, 2014, these religious sisters take a photographic memento of their participation in the event.

OCTOBER

FAMILIES, SYNODS, AND BEATIFICATION

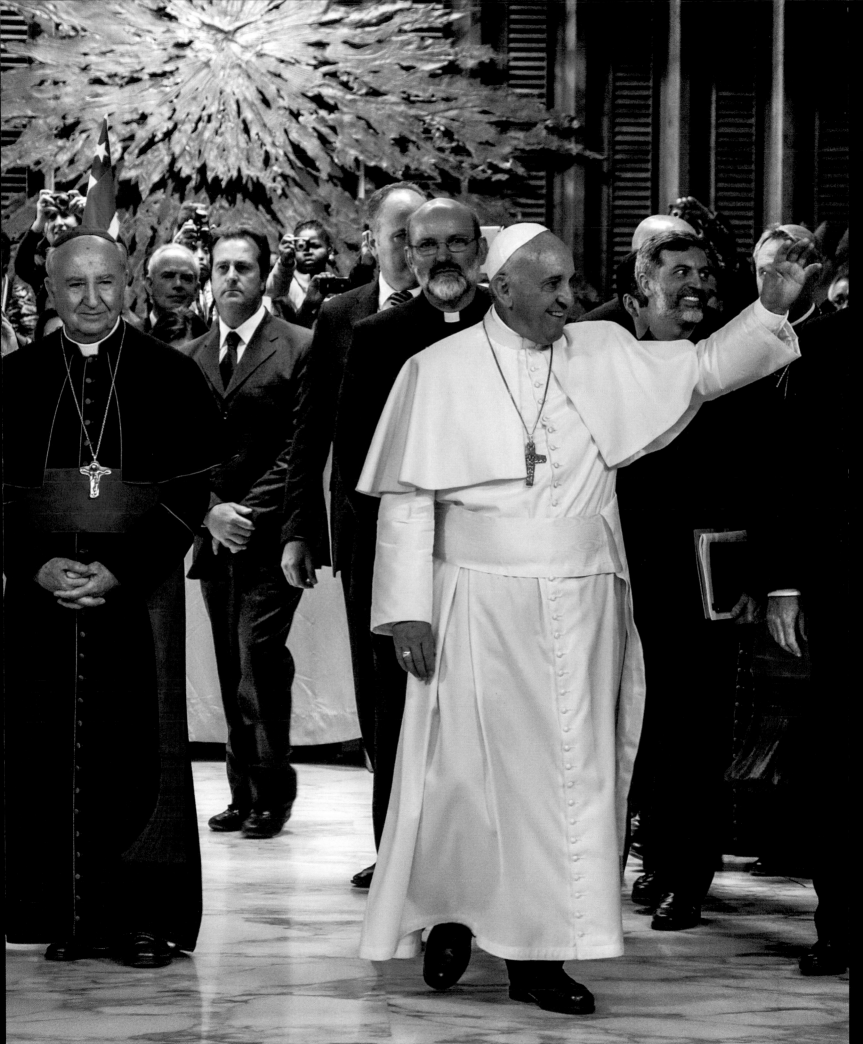

MORE THAN 80,000 PEOPLE RESPONDED TO POPE FRANCIS'S INVITATION TO A VIGIL IN

ST. PETER'S SQUARE ON OCTOBER 4, 2014, TO PRAY FOR THE SUCCESS OF THE SYNOD ON THE

FAMILY, WHICH WAS TO TAKE PLACE ON THE FOLLOWING DAY. OPENING THE PRAYER SERVICE,

THE POPE NOTED THAT IT WAS ALMOST TIME FOR FAMILIES TO ENJOY THEIR EVENING MEAL

AT HOME TOGETHER AFTER FINISHING A DAY'S WORK OR A DAY AT SCHOOL. HE ADDED THAT

SUSTENANCE IS ALWAYS MADE RICHER WHEN TAKEN IN THE COMPANY OF ONE'S FAMILY.

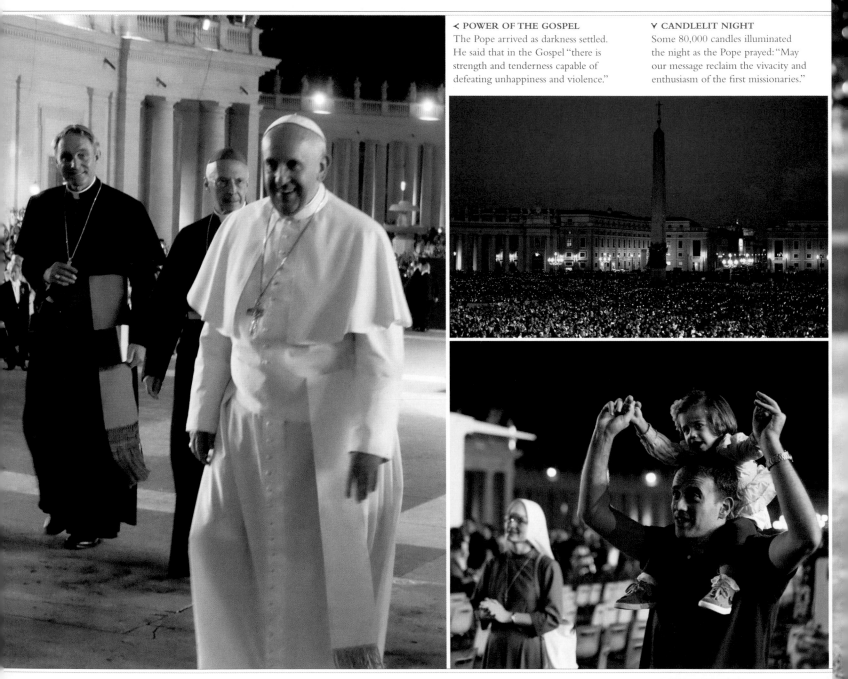

< POWER OF THE GOSPEL
The Pope arrived as darkness settled.
He said that in the Gospel "there is
strength and tenderness capable of
defeating unhappiness and violence."

∨ CANDLELIT NIGHT
Some 80,000 candles illuminated
the night as the Pope prayed: "May
our message reclaim the vivacity and
enthusiasm of the first missionaries."

∧ SHARING LIVES
"In each person there remains an
essential need for someone with whom
to weave and to share the story of his
or her life," said Pope Francis.

PRAYER VIGIL
THE EVE OF THE SYNOD ON THE FAMILY

< FAMILY LIFE
The Pope contrasted the warmth of family life to the loneliness of broken dreams, and listened to people give testimonies about their married lives.

v LIGHTING VOTIVE LAMPS
Young children light votive lamps in front of an icon of Jesus, with his parents and grandparents, on the steps of St. Peter's Basilica.

^ VIGIL MUSICIANS
A group of musicians leads the songs at the vigil, which concluded in time for people to return to their homes and enjoy their evening meal.

MEETING THE WORLD'S BISHOPS IS AN IMPORTANT PART OF POPE FRANCIS'S RESPONSIBILITIES.
THE SYNOD OF BISHOPS, AN ADVISORY BODY THAT WAS ESTABLISHED IN 1965 BY POPE PAUL VI,
CONVENES EVERY TWO OR THREE YEARS AT THE VATICAN. IT PROVIDES AN IMPORTANT OPPORTUNITY
FOR A SELECTION OF BISHOPS AND ADVISORS TO DISCUSS IMPORTANT CONTEMPORARY ISSUES WITH
THE PONTIFF. THE SYNOD ON THE FAMILY, INSTIGATED BY POPE FRANCIS, TOOK PLACE IN 2014 AND 2015.
IT TACKLED THE RAPIDLY CHANGING AND COMPLEX ROLE OF THE FAMILY IN SOCIETY.

> **SHARING A LAUGH**
Pope Francis and Cardinal Gerhard Müller
enjoy a light-hearted moment. The Pope
asked the bishops to debate openly and
honestly, and welcomed disagreement.

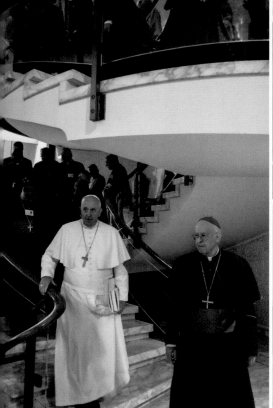

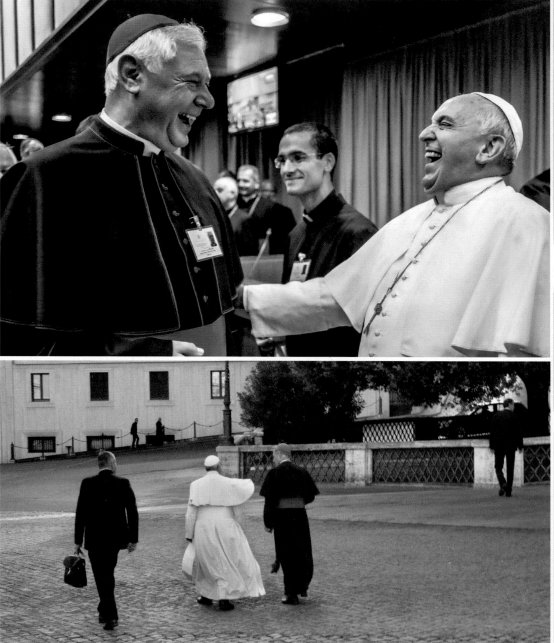

⋏ **INFORMAL APPROACH**
Pope Francis's informal style is in contrast
to that of his predecessors, and he insists
on simply joining in with his colleagues
without any fuss or distinction.

⋏ **ENJOYING THE WALK HOME**
Accompanied by Archbishop Georg
Gänswein, Prefect of the Papal
Household, the Pope returns to
his residence at Casa Santa Marta.

SYNOD OF BISHOPS
DISCUSSING CONTEMPORARY ISSUES

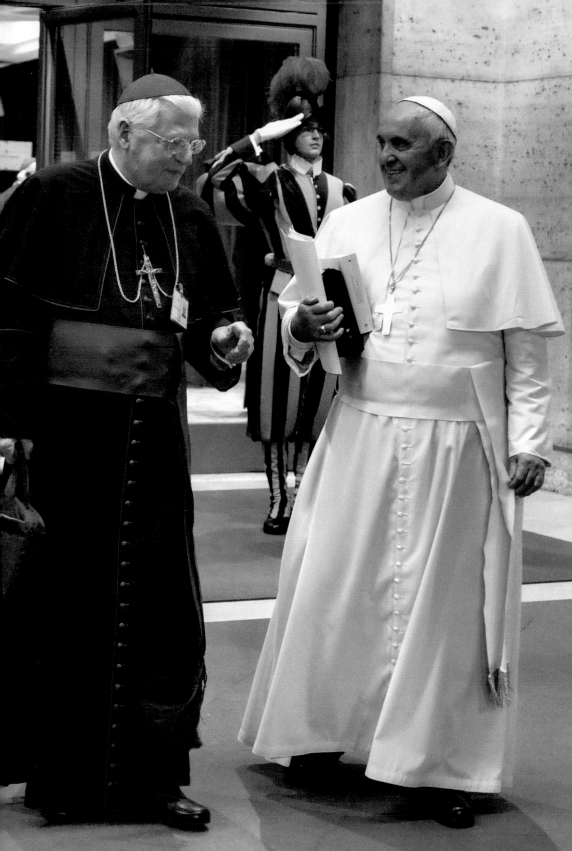

Cardinal Angelo Scola of Milan and
Pope Francis chat as they leave the
Synod Hall. Some cardinals are still
adapting to the Pope's laid-back style.

∨ SUBVERTING PROTOCOL
Centuries of protocol isolated the figure
of the Pope as a remote monarch. The
Argentinian pontiff continues to surprise
many with his availability and spontaneity.

∧ ORDER OF THE DAY
Cardinal Lorenzo Baldisseri, Secretary
General of the Synod of Bishops (left),
explains to the Pope the order of the
day following the opening prayers.

ON OCTOBER 19, 2014, AT THE CONCLUSION OF THE SYNOD ON THE FAMILY, POPE FRANCIS PRESIDED AT THE BEATIFICATION OF POPE PAUL VI (1962–78). THE BEATIFICATION CEREMONY IS A PUBLIC DECLARATION OF THE SANCTITY OF A DECEASED PERSON WHO IS HELD UP FOR VENERATION IN THE CHURCH. POPE PAUL WAS A NATIVE OF BRESCIA IN NORTHERN ITALY AND HAD SPENT HIS LIFE AS A CHURCH DIPLOMAT. HE BROUGHT THE SECOND VATICAN COUNCIL, WHICH HAD BEEN STARTED BY POPE JOHN XXIII IN 1962, TO ITS CONCLUSION AND IMPLEMENTED ITS DECREES.

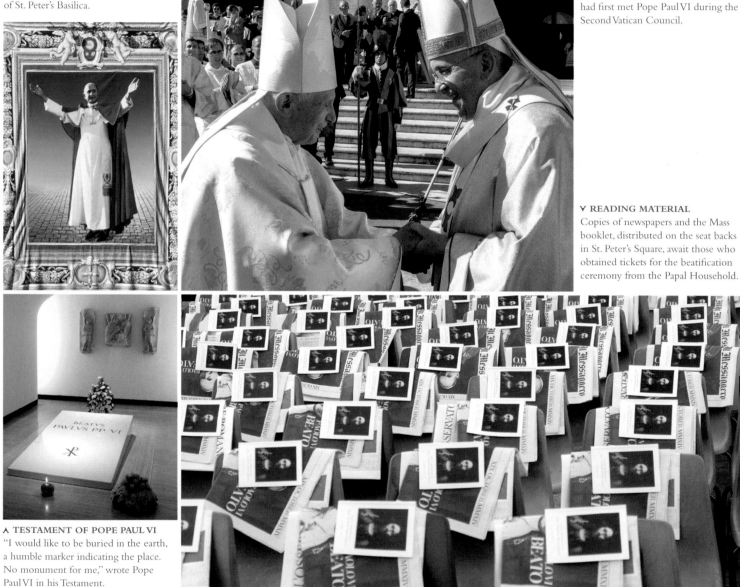

⋎ POPE PAUL VI
During the beatification ceremony, a banner bearing the image of Pope Paul VI was unveiled on the central balcony of St. Peter's Basilica.

⋖ GREETING HIS PREDECESSOR
After the Mass of Beatification, Pope Francis greeted his predecessor, Emeritus Pope Benedict XVI, who had first met Pope Paul VI during the Second Vatican Council.

⋎ READING MATERIAL
Copies of newspapers and the Mass booklet, distributed on the seat backs in St. Peter's Square, await those who obtained tickets for the beatification ceremony from the Papal Household.

⋏ TESTAMENT OF POPE PAUL VI
"I would like to be buried in the earth, a humble marker indicating the place. No monument for me," wrote Pope Paul VI in his Testament.

BEATIFICATION
THE BEATIFICATION OF POPE PAUL VI

< COMPANIONS
Emeritus Pope Benedict is
accompanied by Archbishop
Georg Gänswein, his former private
secretary, who now serves Pope Francis
as Prefect of the Papal Household.

∨ SHIELDED FROM THE SUN
Emeritus Pope Benedict, under
an umbrella, awaits the arrival
of the concelebrants of the
Mass of Beatification at the end
of the Synod on the Family.

⋏ FOLLOWING THE NEWS
A member of the Sistine Choir
avidly reads a copy of the Italian daily
newspaper *Il Messaggero* as he waits
for the Mass to begin.

⋏ INCENSING THE RELIQUARY
A deacon incenses the silver reliquary.
Pope Paul VI, greatly admired by Pope
Francis, lived during the turbulent years
following the Second Vatican Council.

⋎ FAMILIES AND FAITH
On October 26, 2013, more than 150,000 people from 75 countries gathered in St. Peter's Square to celebrate "Families living the joy of Faith."

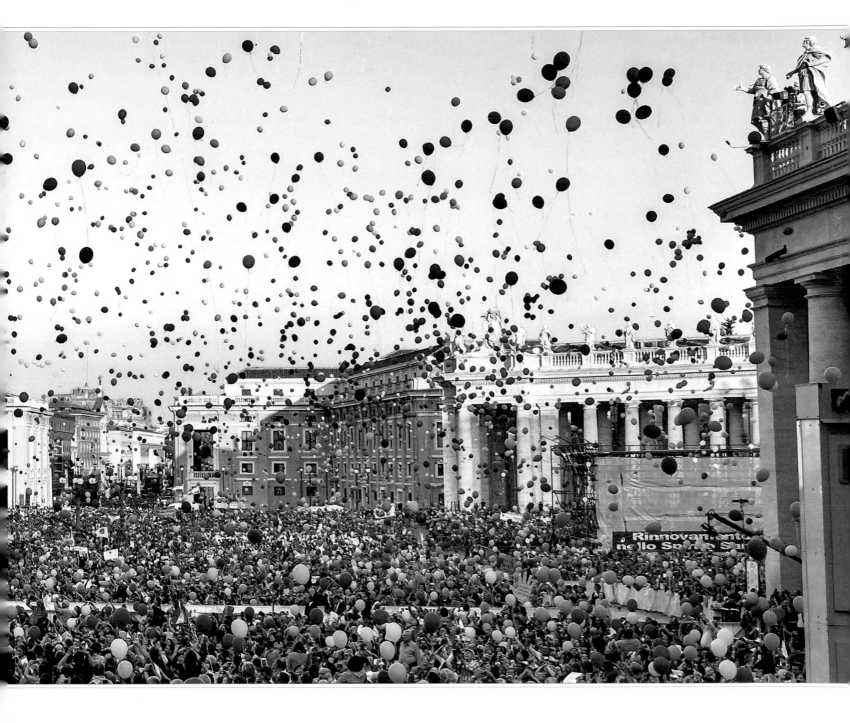

The chilly month of November, typically the wettest of the year in Rome, begins with a public holiday, the Feast of All Saints. This is one of the most important feasts of the year for Italians. It recalls the saints whose lives on earth achieved so much, and seeks their intervention from heaven. Catholics respect those who led exemplary lives and seek to emulate their example. At midday, the Pope delivers his Angelus address from his study window at the Apostolic Palace. That afternoon he travels to the vast city cemetery of Campo Verano, where he celebrates Mass close to the gates.

For Catholics, November is a month that commemorates the "faithful departed." Pope Francis celebrates an annual Mass for deceased cardinals at the Altar of the Chair, recalling those who died within the previous 12 months.

The Pope is nominally head of Vatican City State, but it is in his role as a religious leader that he is often invited to address political gatherings. In November 2014, he addressed the European Parliament in Strasbourg. During his speech, he made an impassioned plea on behalf of migrants arriving in Europe from Africa. The pontiff reproached European politicians and reminded them of the migrants who had drowned before reaching European soil. "We must not allow the Mediterranean to become a vast cemetery." He also appealed for the just treatment of workers. The Pope's no-nonsense plain speaking was widely reported in the media and has won him much popularity.

The liturgical year closes on a Sunday in late November with the celebration of the Feast of Christ the King. The following Sunday, which is the last in November, a new liturgical year opens on the first Sunday of Advent. The Pope presides at Vespers, the Saturday evening service that marks the vigil of Sunday. The liturgical color of Advent is purple, which signifies the period of waiting as Christians prepare to celebrate the annual season of Christmas and the return of Jesus at the end of time.

Since 1964, Constantinople and Rome have moved closer together, culminating in a visit in March 2013, when the Patriarch of Constantinople, Bartholomew I, attended the Mass of Inauguration in Rome. While in the city, he issued an invitation to the Pope to visit him. Pope Francis accepted and, on November 28, 2014, he traveled to Istanbul for the feast day of St. Andrew.

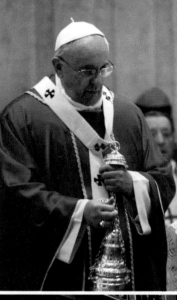

< BUSY MONTH
November is one of the busiest months, with liturgies, meetings, and foreign visits. These require a vast amount of preparation by the Roman Curia.

> MICHELANGELO'S DOME
The dome over St. Peter's tomb was Michelangelo's last architectural project. Unfinished at his death in 1564, it was finally completed in 1590.

∨ SISTINE CHOIR
Since the 5th century, professional singers have provided music at the liturgies. The 15th-century Sistine Choir is one of the oldest in the world.

NOVEMBER

REMEMBERING SAINTS AND THE DECEASED

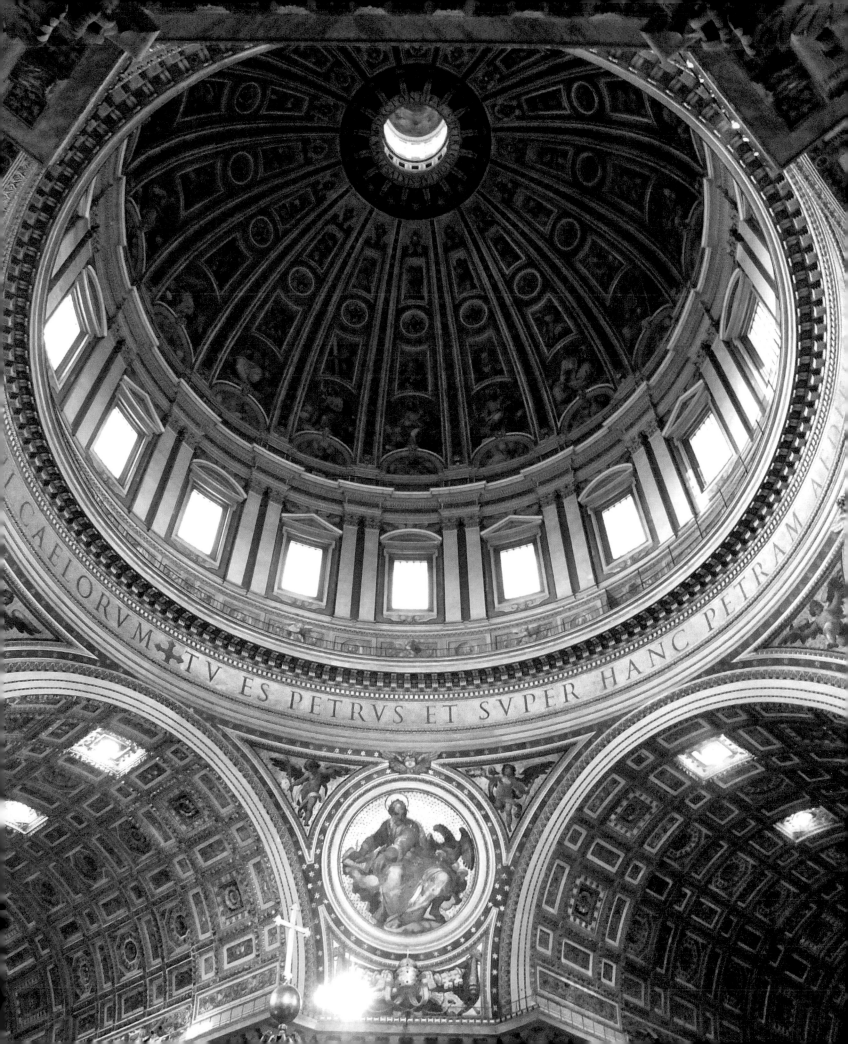

NOVEMBER IS THE MONTH WHEN PEOPLE PRAY PARTICULARLY FOR THE DEAD. IT BEGINS WITH THE FEAST OF ALL SAINTS, WHEN CATHOLICS CELEBRATE THE MEMORY OF THOSE WHO HAVE COMPLETED THEIR LIVES ON EARTH AND ARE BELIEVED TO DWELL IN HEAVEN. ALTHOUGH SOME ARE VENERATED THROUGHOUT THE CHURCH, THE FEAST CELEBRATES ALL WHO TRIED TO LIVE HOLY LIVES. AFTER THE FESTIVITIES OF ALL SAINTS' DAY COMES THE COMMEMORATION OF THE FAITHFUL DEPARTED, WHEN CATHOLICS RECALL THE DECEASED WHO MUST YET BE PURIFIED IN ORDER TO ENTER HEAVEN.

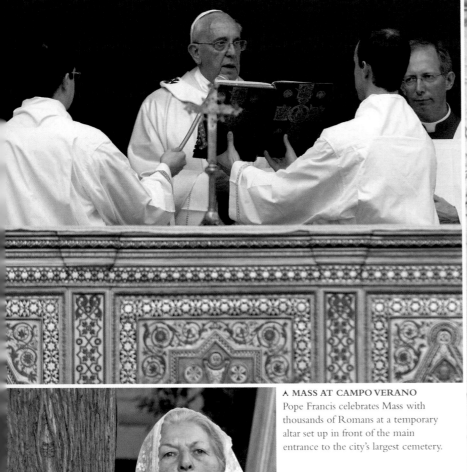

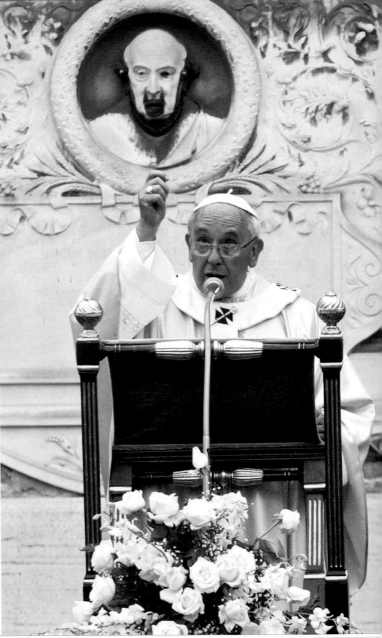

ᴧ MASS AT CAMPO VERANO
Pope Francis celebrates Mass with thousands of Romans at a temporary altar set up in front of the main entrance to the city's largest cemetery.

ᐸ REMEMBERING THE DEAD
The Feast of All Saints, when relatives visit the graves of their families and loved ones, is one of the most important feast days for Italians.

ᴧ POPE'S HOMILY
"In order to journey back to God the Father, in this world of devastation, of wars... we must act according to the beatitudes," said Pope Francis.

ALL SAINTS' DAY
CELEBRATING THE MEMORY OF THE DEAD

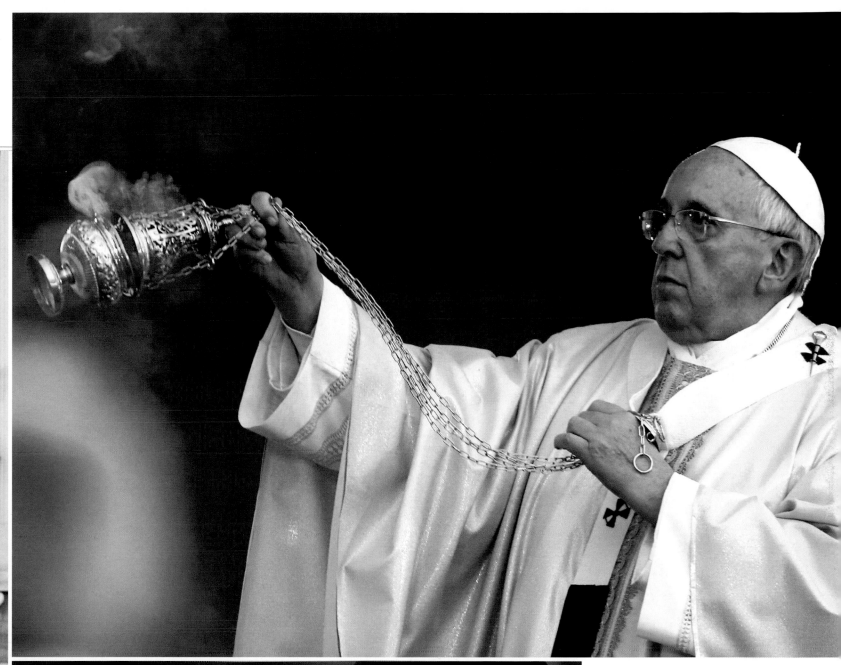

⋏ PURIFIED BY HOPE

"Life has its difficult moments but the soul moves on with hope and sees what awaits us. Hope purifies us and makes us lighter," said Pope Francis.

⋖ HOPE AND JOY

"All of us will pass away one day. Do I look at this with hope, with the joy of being received by the Lord?" asked Pope Francis rhetorically.

✝ POPE FRANCIS CELEBRATES MASS IN ST. PETER'S BASILICA SEVERAL TIMES A YEAR. IN NOVEMBER, HE CELEBRATES A MASS FOR THE CARDINALS WHO HAVE DIED DURING THE COURSE OF THE PREVIOUS 12 MONTHS. THIS MASS, WHICH TAKES PLACE AT THE ALTAR OF THE CHAIR, IS ATTENDED BY RELATIVES AND FRIENDS OF THE DECEASED CARDINALS. BEFORE EVERY MASS, THE POPE MEETS THE SERVERS AND MINISTERS WHO ASSIST IN THE CELEBRATION OF THE LITURGY. HE GLADLY POSES FOR PHOTOGRAPHS, WHICH BECOME IMPORTANT SOUVENIRS FOR THOSE ATTENDING THIS SPECIAL OCCASION.

⌄ PROUD TO SERVE
There are young servers who assist at Mass every day in St. Peter's Basilica. It is a particular honor to serve Mass with the Pope.

⟩ EXPECTANT FACES
Prior to Mass, young servers and deacons wait in the transept for the arrival of the Pope from his residence at nearby Casa Santa Marta.

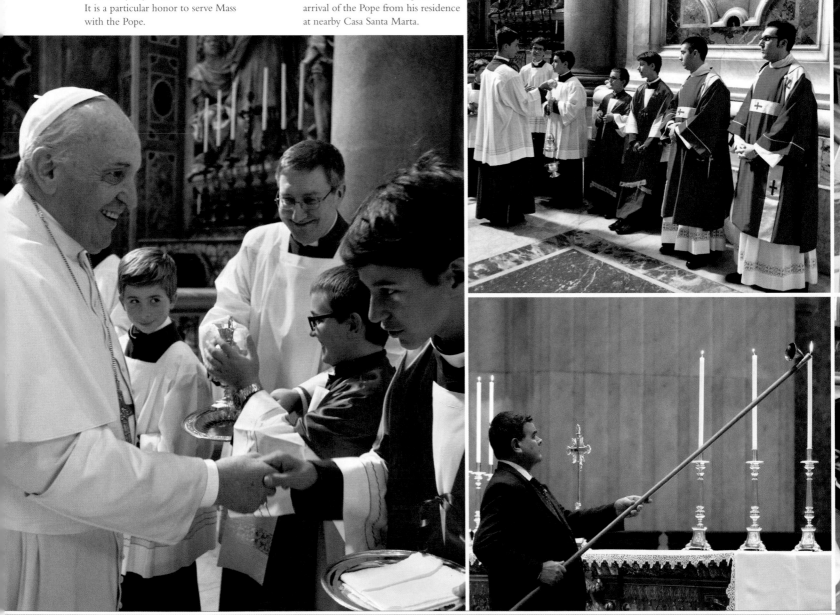

⌃ LIGHTING CANDLES
A sacristan lights candles on silver candlesticks as he prepares the altar for Mass in the transept of the basilica.

SPECIAL MASS
MASS FOR DECEASED CARDINALS

ASKING FOR A SELFIE
A young deacon asks the Pope if he will pose for a selfie with him. The Pope quips by asking if taking selfies is allowed in St. Peter's.

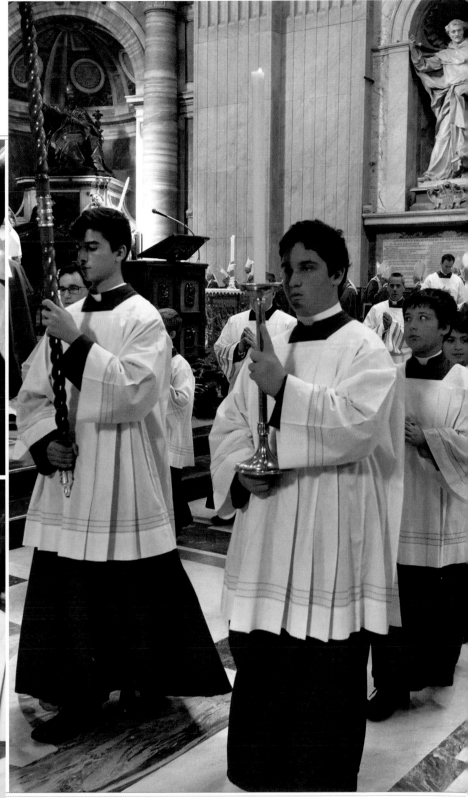

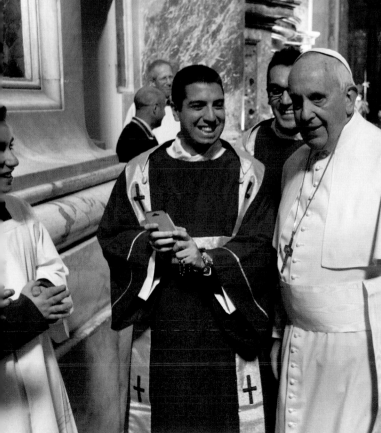

< POSING FOR THE CAMERA
Pope Francis poses for a photograph for papal photographer Giuseppe Felici, to the evident delight and amusement of the onlookers.

^ YOUTHFUL DILIGENCE
The young servers at the Mass are invaluable in assisting the Pope and his ministers, and carry out their duties with great care and attention.

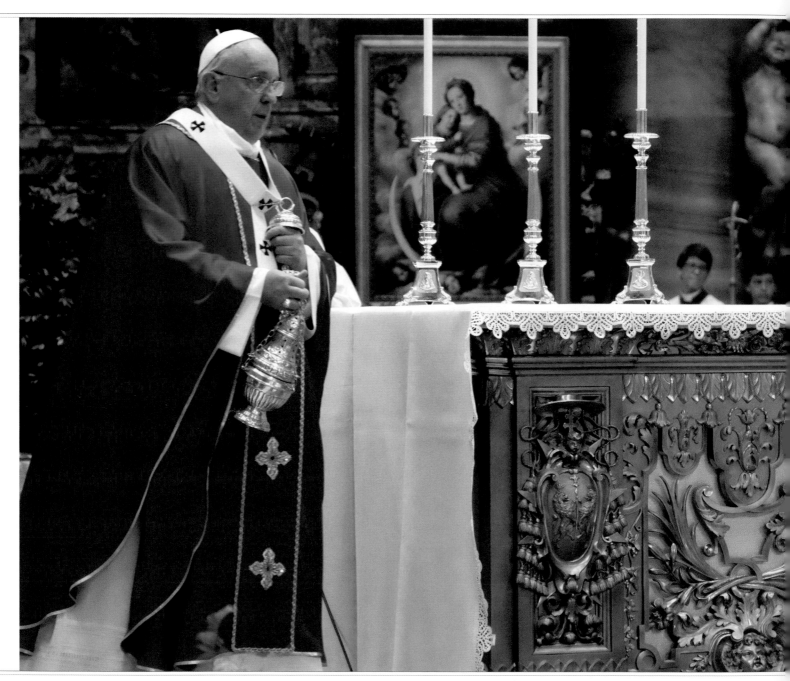

⋏ SIMPLICITY AND ART
Although Pope Francis personally lives
a simple lifestyle, he is still surrounded by
a centuries-old artistic patrimony created
by some of the world's greatest artists.

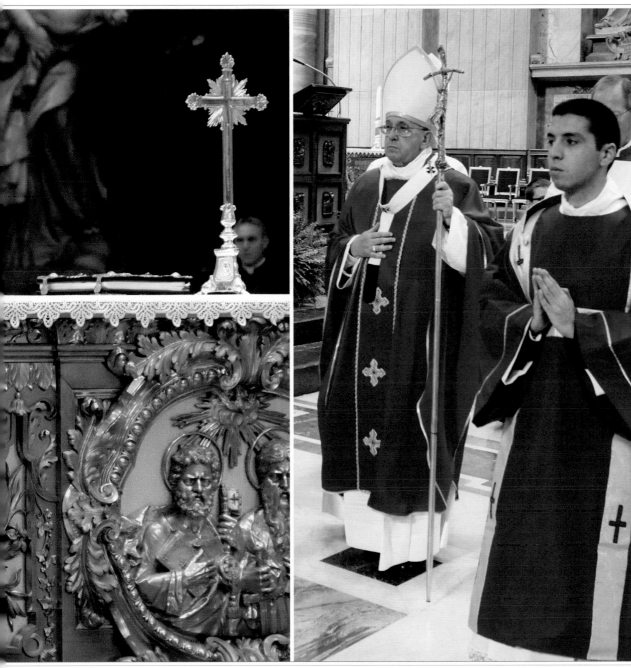

↑ SILVER STAFF
Pope Francis carries a silver staff with
a figure of the crucified Christ, made
by the Italian artist Lello Scorzelli for
Pope Paul VI in 1965.

∨ **EXUBERANCE OF YOUTH**
Pope Francis always enjoys meeting young people,
who are happy to get close to him and eager to record
their encounter on cameras and phones.

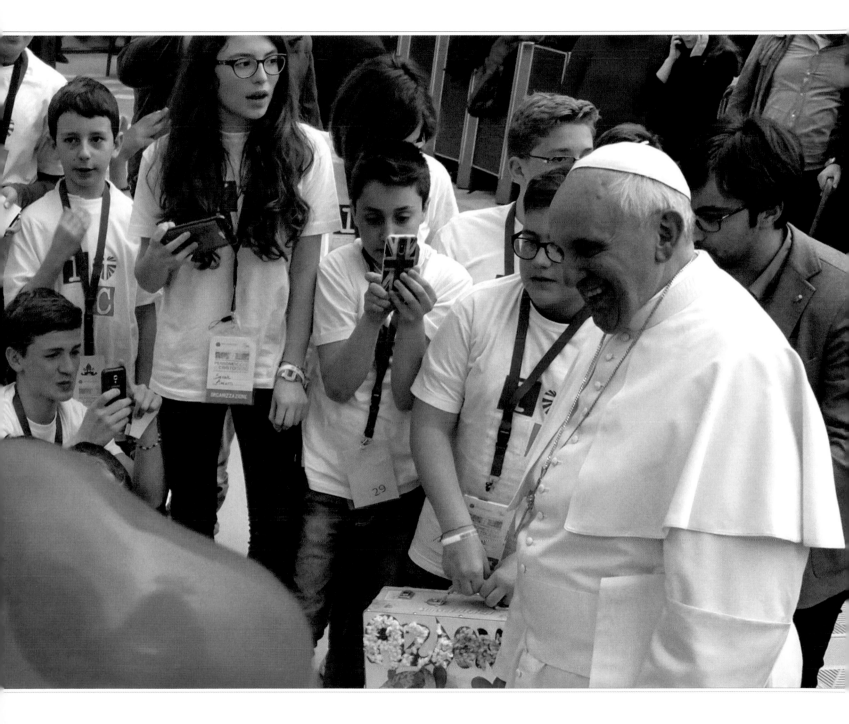

Preparations are now put into place to welcome the thousands of visitors who come to the Vatican at Christmas. A large Christmas tree is erected in St. Peter's Square beside the nativity scene, which will remain until February.

The Feast of the Immaculate Conception, which commemorates the conception of the Virgin Mary, falls on December 8. Pope Francis marks the occasion by crossing the city to pay homage to a statue of the Blessed Virgin Mary, close to the Spanish Steps.

Four days later, Pope Francis celebrates the Feast of Our Lady of Guadalupe. On December 9, 1531, Juan Diego Cuauhtlatoatzin, a Mexican shepherd, claimed he had a vision of the Blessed Virgin Mary in Guadalupe. A church was built on the site, and devotion to Mary spread throughout Latin America.

Pope Francis has long nurtured a devotion to Mary, the Madonna of Guadalupe. Accordingly, on December 12, 2014, St. Peter's Basilica resounded to the lively strains of a Creole Mass with piano, guitar, and other instruments.

Shortly before Christmas, the Pope meets members of the Roman Curia in the Sala Clementina of the Apostolic Palace to exchange season's greetings. In 2014, he surprised his audience by itemizing 15 "illnesses" that sometimes characterize the work of its members. These included arrogance, superiority, rivalry, and vainglory. The unambiguous reprimand came as the Pope prepared to unveil the reform of the Curia the following year.

The season's liturgical celebrations begin the night of Christmas Eve, when Pope Francis celebrates Mass in St. Peter's. Afterward, the pontiff goes in procession to the nativity scene in the basilica, where the image of the infant Jesus is placed in the manger.

The next day, the Pope again celebrates Mass in the basilica. At midday, he delivers his Christmas Day address, which is broadcast all over the world.

In the days after Christmas, Pope Francis has a well-earned rest. Most of his companions at the Casa Santa Marta go to visit their families, and the Pope has much of the spacious house to himself.

On the last day of the year, Pope Francis leads the celebration of Vespers, the Church's evening prayer. This is followed by the singing of the *Te Deum*. As midnight strikes, the great bells in St. Peter's tower break into a cheerful welcome of the New Year.

∧ FIRST NATIVITY SCENE
Tradition attributes the creation of the first nativity scene to St. Francis of Assisi in the 12th century. Most churches erect a nativity scene during the Christmas holidays.

< OUR LADY OF LOURDES
Young priests, following postgraduate theology courses, hold ciboria filled with hosts, which are consecrated during Mass to celebrate the Feast of Our Lady of Lourdes.

> SERVING THE WEAK
"We must proclaim that the poor must be defended, and not defend ourselves from the poor; we must serve the weak and not make use of them," Pope Francis preaches.

DECEMBER

THE IMMACULATE CONCEPTION AND BIRTH OF JESUS

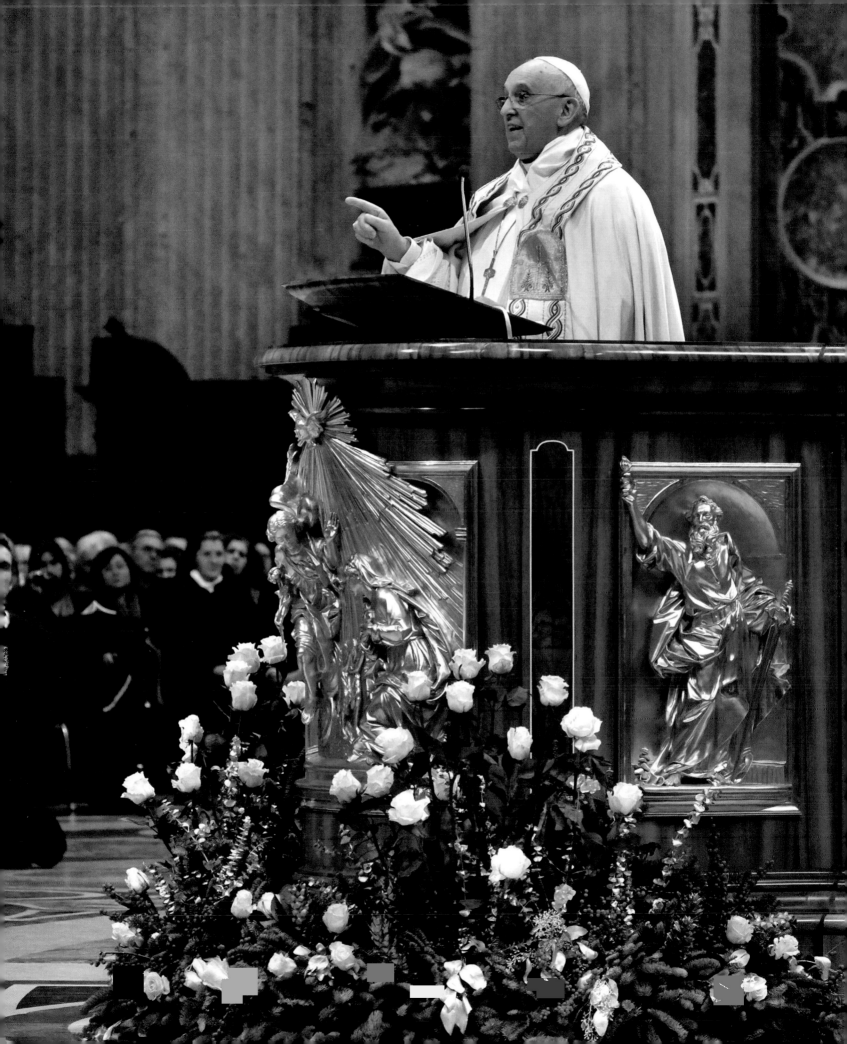

ON DECEMBER 8, POPE FRANCIS CROSSES THE CITY OF ROME TO PAY HOMAGE TO A STATUE OF THE

✝ BLESSED VIRGIN MARY, CLOSE TO THE SPANISH STEPS. THE FEAST OF THE IMMACULATE CONCEPTION

CELEBRATES THE CONCEPTION OF THE VIRGIN MARY. THOUSANDS OF PEOPLE CROWD THE STREETS

IN THE HOPE OF CATCHING A GLIMPSE OF POPE FRANCIS. SOME OF THEM ARE LUCKY—THE POPE OFTEN

STOPS ON THE VIA CONDOTTI TO GREET THE CROWD. AS IS USUAL FOR HIS JOURNEYS THROUGH THE

CITY, THE POPE TRAVELS IN HIS FORD FOCUS WITH AN ESCORT OF TWO ITALIAN OUTRIDERS.

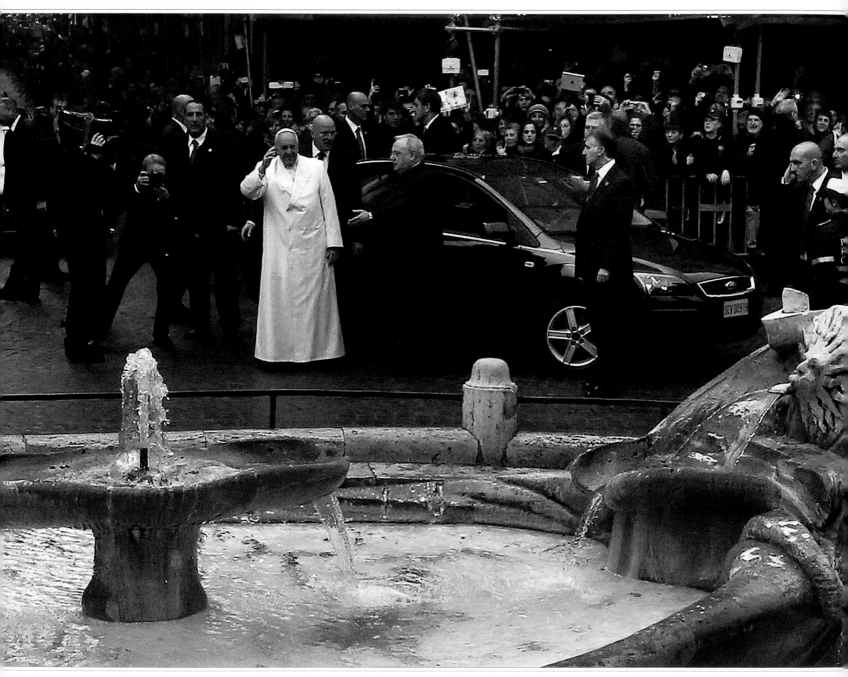

HOMAGE TO MARY

FEAST OF THE IMMACULATE CONCEPTION

⋀ GREETING THE CROWD
On his way to the statue of the Blessed
Virgin Mary, Pope Francis steps out of
his Ford Focus to greet the expectant
crowd on the Via Condotti.

˅ PAYING HOMAGE
Pope Francis pays homage to the statue
of the Blessed Virgin Mary in Piazza di
Spagna. Thousands of people crowd the
sidewalks and spill onto the streets.

˄ PRAYER TO MARY
"Mary, teach us to go against the flow,
to strip ourselves, to be humble and
giving, giving space to God, source of
true joy," Pope Francis prayed.

˄ MERCIFUL GOD
"Mary, may Grace prevail over pride
in us, your children, and may we
become merciful as our heavenly Father
is merciful," Pope Francis prayed.

ON DECEMBER 9, 1531, A NATIVE MEXICAN SHEPHERD, JUAN DIEGO CUAUHTLATOATZIN, CLAIMED HE HAD HAD A VISION OF THE BLESSED VIRGIN MARY. FROM THEN, DEVOTION TO MARY SPREAD THROUGHOUT LATIN AMERICA, WITH THE SHRINE AT GUADALUPE BEING THE MOST VISITED CATHOLIC SHRINE IN THE WORLD—MORE THAN 7 MILLION PEOPLE VISIT EVERY YEAR. POPE FRANCIS HAS LONG NURTURED A DEVOTION TO MARY AND, ON DECEMBER 12, 2014, HE CELEBRATED A LIVELY CREOLE MASS FOR OUR LADY OF GUADALUPE, ACCOMPANIED BY GUITAR, PIANO, AND OTHER INSTRUMENTS.

ᐱ COSTUMES AND FLAGS
Young people hold flags representing countries of Central and Latin America. Our Lady of Guadalupe is regarded as the patron saint of the Americas.

CREOLE MASS

FEAST OF OUR LADY OF GUADALUPE

> CLOAK OF ST. JUAN

This image is a copy of the cloak of St. Juan, which dates from the mid-16th century. It is the most popular image of the Virgin Mary in Latin America.

< MASS CHOIR AND MUSICIANS

"I first heard the *Misa Criolla* when I was a student," recalled Pope Francis. "I really liked it, especially the *Agnus Dei*, which is magnificent."

∧ AT THE HIGH ALTAR

Pope Francis arrives at the High Altar. In his homily, he said Mary "hastened attentively to greet the new American people at their dramatic birth."

∧ NATIVE TRADITIONS

Rome has a large population of migrants from Latin America, and many of them hold on proudly to their native traditions of language, culture, and religion.

ON DECEMBER 17, POPE FRANCIS CELEBRATES HIS BIRTHDAY. FOR JORGE BERGOGLIO IN ARGENTINA,

✝ IT MUST HAVE SEEMED INCONCEIVABLE THAT HE WOULD CELEBRATE THE LAST BIRTHDAYS OF HIS LIFE AT THE VATICAN. DESPITE THE GRUELING SCHEDULE THAT HE HAS TO FOLLOW EACH DAY, POPE FRANCIS EVIDENTLY ENJOYS HIS NEW VOCATION. HE OFTEN ADMITS TO VISITORS THAT HE IS STIMULATED BY ALL THE NEW PEOPLE FROM DIFFERENT WALKS OF LIFE THAT HE MEETS AND BY THE KNOWLEDGE THAT HE CAN HELP TO MAKE A CHANGE IN THE PUBLIC PERCEPTION OF SO MANY PROBLEMS.

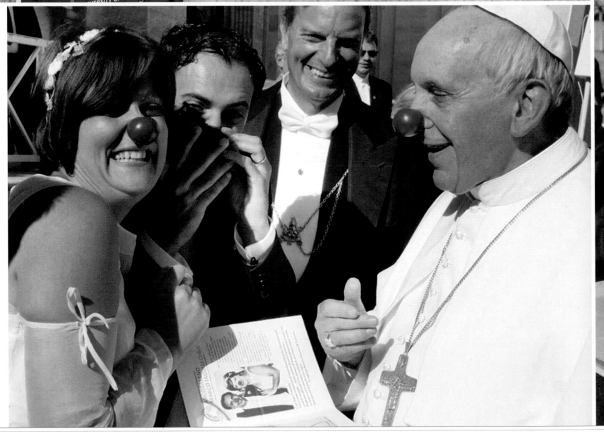

⋏ BIRTHDAY GREETINGS
Well-wishers at the General Audience on December 17, 2014, spell out birthday greetings in Pope Francis's native Spanish as the pontiff nears the podium.

❯ JOINING IN THE FUN
The Pope puts on a red nose when meeting these newlyweds, members of the Rainbow Association Marco Iagulli Onlus, which cheers up sick children.

HAPPY BIRTHDAY!
CELEBRATING POPE FRANCIS'S 78TH BIRTHDAY

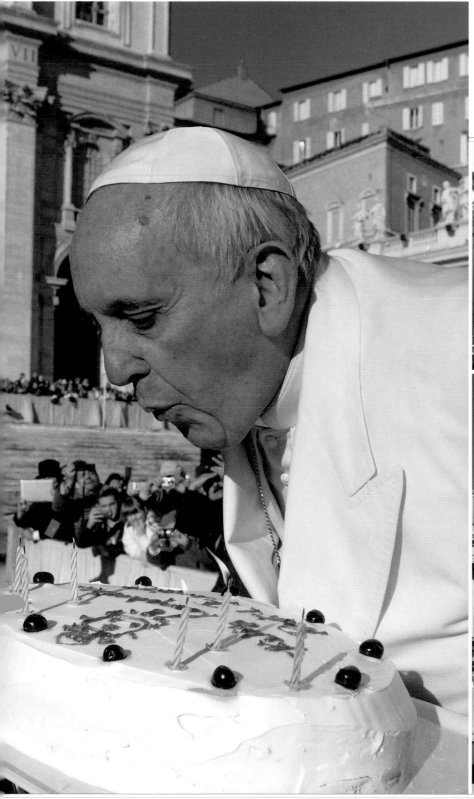

◄ BLOWING OUT THE CANDLES

In 2014, Pope Francis's birthday fell on a Wednesday, the day of the General Audience. He was given a birthday cake by a well-wisher and was happy to blow out the candles.

∨ TRYING ON A HAT FOR SIZE

People regularly offer Pope Francis hats and scarves from their native lands. He enjoyed trying out this Alpine hat but, as always, returned it to its owner afterward.

∧ A BOY AND HIS BALLOON

A young child holding a colorful balloon is held up to wish the Pope a happy birthday as the General Audience begins in St. Peter's Square on December 17, 2014.

207

✠ THE SEASON'S LITURGICAL CELEBRATIONS BEGIN ON THE NIGHT OF CHRISTMAS EVE, WHEN POPE FRANCIS CELEBRATES MASS, ATTENDED BY MEMBERS OF THE DIPLOMATIC CORPS, IN ST. PETER'S BASILICA. AFTERWARD, THE PONTIFF GOES IN PROCESSION TO THE NATIVITY SCENE NEAR THE ATRIUM OF THE BASILICA, WHERE THE IMAGE OF THE INFANT JESUS IS PLACED IN THE MANGER. EACH YEAR, VATICAN CARPENTERS CONSTRUCT AN ELABORATE DISPLAY WITH LIFE-SIZE STATUES. AS THE CHOIR SINGS THE FESTIVE HYMN *ADESTE FIDELES*, ACCOMPANIED BY BRASS INSTRUMENTS, THE CONGREGATION DISPERSES.

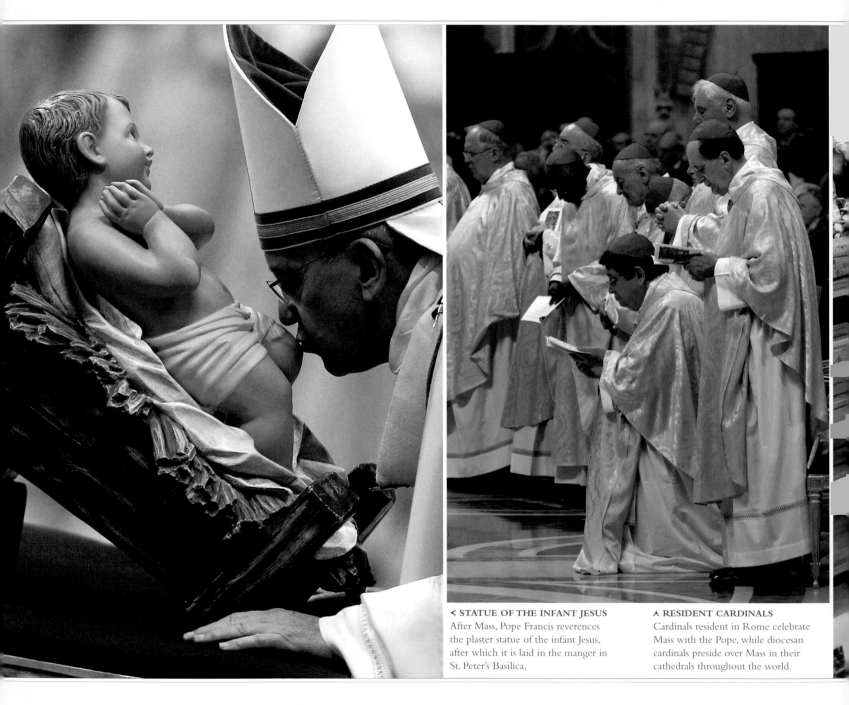

< STATUE OF THE INFANT JESUS
After Mass, Pope Francis reverences the plaster statue of the infant Jesus, after which it is laid in the manger in St. Peter's Basilica.

ʌ RESIDENT CARDINALS
Cardinals resident in Rome celebrate Mass with the Pope, while diocesan cardinals preside over Mass in their cathedrals throughout the world.

CHRISTMAS EVE
CELEBRATING MIDNIGHT MASS

➤ SIMPLE VESTMENTS

Even on the most solemn of occasions, Pope Francis insists on wearing simple vestments, such as his miter, which he has used since his days in Argentina.

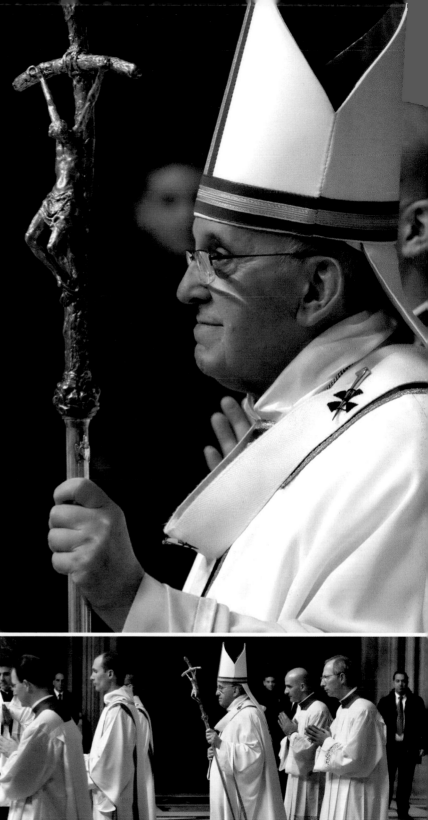

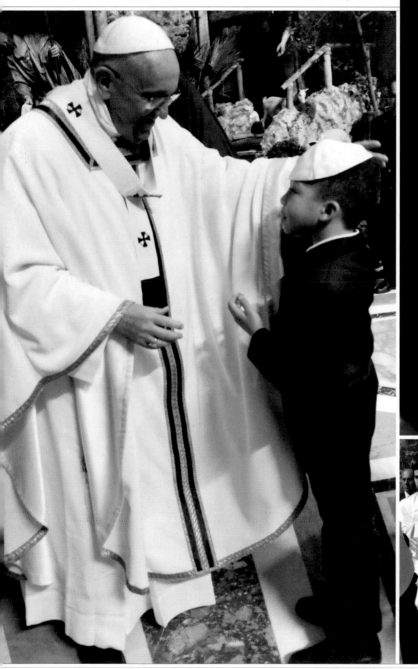

ᴧ EXCHANGING SKULL CAPS

A young boy offers Pope Francis a white *zucchetto*, or skull cap. The Pope jovially exchanges his and places it on the boy's head.

ᴧ LITURGICAL HELPERS

In all papal liturgies, the Pope is accompanied by two or four deacons (front) and assisted by two Papal Masters of Liturgical Ceremonies (rear).

✠ ON CHRISTMAS DAY, POPE FRANCIS OFFERS HIS SEASON'S GREETINGS FROM THE CENTRAL BALCONY OF ST. PETER'S BASILICA. HIS MESSAGE IS BROADCAST THROUGHOUT THE WORLD. IT IS A DAUNTING TASK TO BE THE SPIRITUAL LEADER OF THE WORLD'S 1.2 BILLION CATHOLICS. SO MANY FOLLOWERS HAVE PLACED THEIR HOPE AND TRUST IN HIM, AND IT IS DIFFICULT TO FULFILL THEIR DIFFERENT EXPECTATIONS. POPE FRANCIS IS, HOWEVER, PRAGMATIC AND SAYS THAT HE CAN ONLY TRY TO DO WHAT HE SEES IS THE REQUEST THAT GOD MAKES OF HIM.

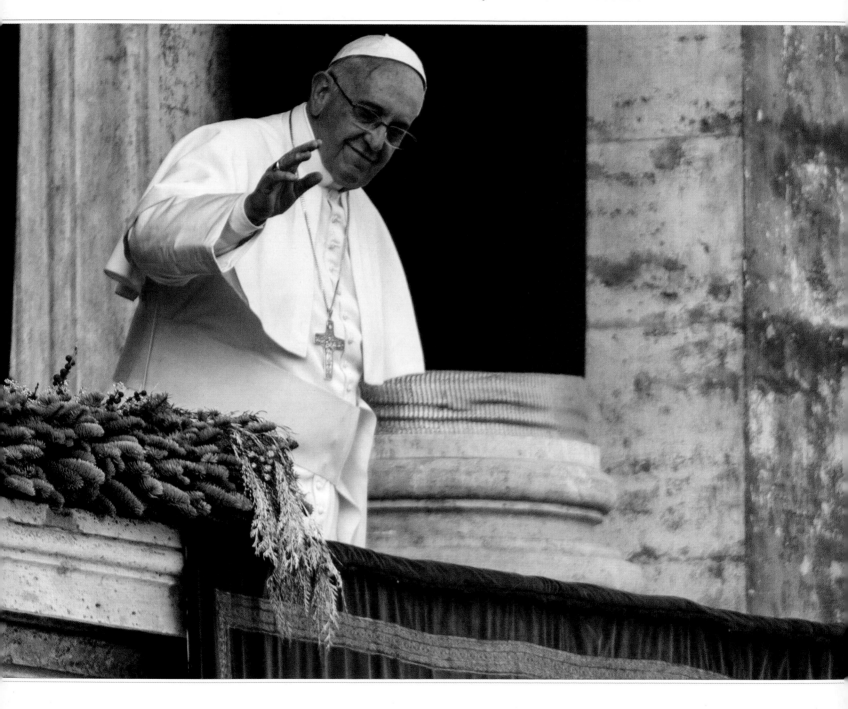

CHRISTMAS DAY

POPE FRANCIS DELIVERS HIS *URBI ET ORBI* ADDRESS

> **MEXICAN FLAG**
The Mexican flag, waved by children, is a reminder that more than 90 percent of the population of Mexico is Catholic, the second-largest number after Brazil.

ʌ **CHRISTMAS DAY MESSAGE**
The Pope delivers his *Urbi et Orbi* (To the City and to the World) message from the central balcony of St. Peter's Basilica on Christmas Day. It is broadcast all over the world.

✝ CHRISTMAS IN ROME HAS A VERY SPECIAL ATMOSPHERE. IN THE PAST, SHEPHERDS CAME FROM THE NEARBY COUNTRYSIDE AND PLAYED FESTIVE MUSIC ON THEIR PIPES, AS ROASTED CHESTNUTS WERE SOLD ON STREET CORNERS. TODAY, MANY OF THE TRADITIONS HAVE DISAPPEARED, BUT THE NATIVITY SCENE IN ST. PETER'S SQUARE, ERECTED EACH YEAR, IS ONE THAT SURVIVES AND FLOURISHES. VARIOUS ITALIAN REGIONS VIE WITH EACH OTHER TO ASSEMBLE THE LARGE STAGE AND ELABORATELY COSTUMED TERRA-COTTA FIGURES, WHICH ARE SEEN BY THOUSANDS OF VISITORS.

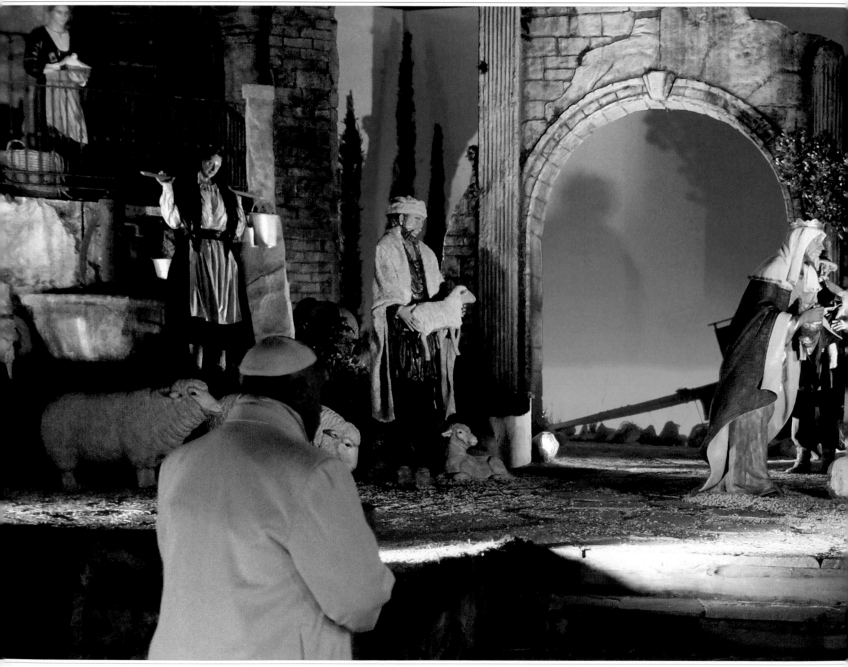

Ʌ **PRAYERS AT THE MANGER**
Following the *Te Deum* and Vespers on December 31, 2014, Pope Francis went to pray before the nativity scene in St. Peter's Square.

NEW YEAR'S EVE
PRAYING AT THE MANGER IN ST PETER'S SQUARE

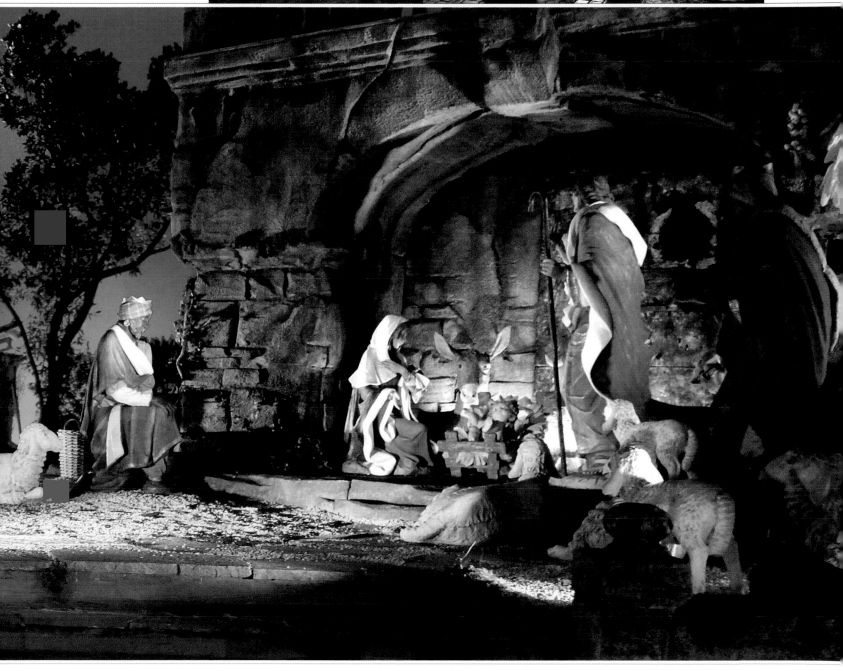

> GIFT OF WARMTH
Pope Francis is protected from the cold
by a woolen scarf, a gift from 102-year-old
Signora Emilia Orlandi, whom the Pope
thanked in a telephone call.

213

✝ THE YEAR ENDS AT THE VATICAN ON THE EVENING OF DECEMBER 31, WHEN THE POPE LEADS THE CELEBRATION OF VESPERS, THE EVENING PRAYER OF THE CHURCH. THIS IS FOLLOWED BY THE SINGING OF THE *TE DEUM*, A CHRISTIAN HYMN IN PRAISE OF GOD, COMPOSED IN THE 4TH CENTURY. AS MIDNIGHT STRIKES, THE GREAT BELLS OF ST. PETER'S BREAK INTO A CHEERFUL WELCOME OF THE NEW YEAR. AS IN MANY COUNTRIES THROUGHOUT THE WORLD, THE END OF ONE YEAR AND THE BEGINNING OF ANOTHER ARE ACCOMPANIED BY FESTIVITIES.

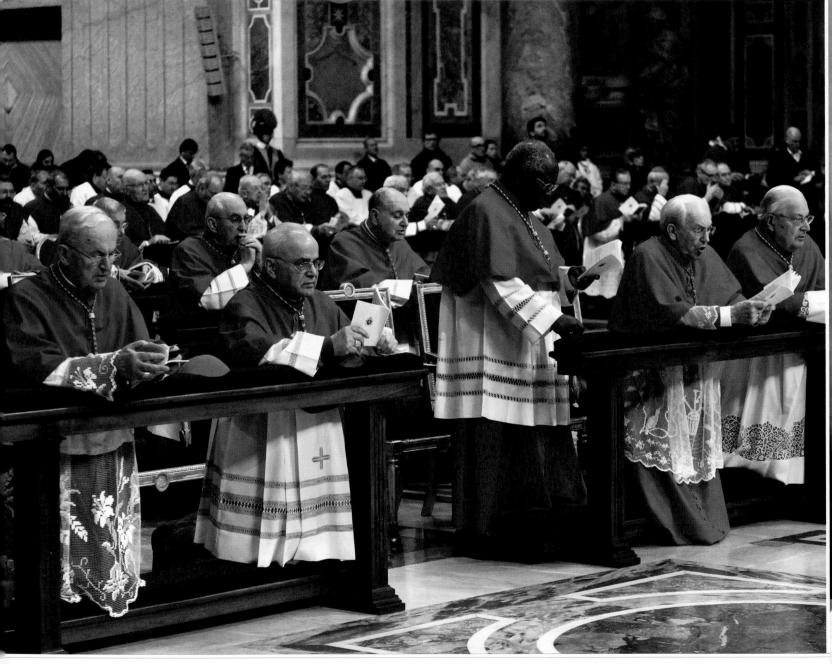

⋏ VESPERS
Members of the College of Cardinals kneel during Vespers, the Evening Prayer of the Church, to mark the last night of the year.

A NEW YEAR

TE DEUM, VESPERS, AND PEALING BELLS

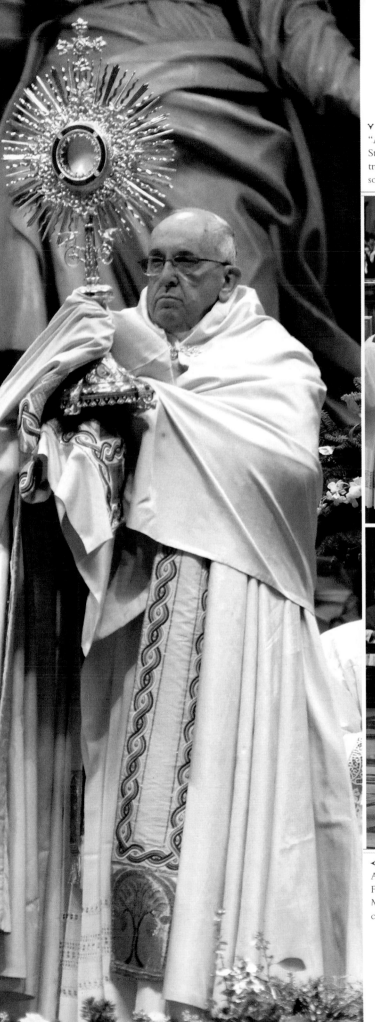

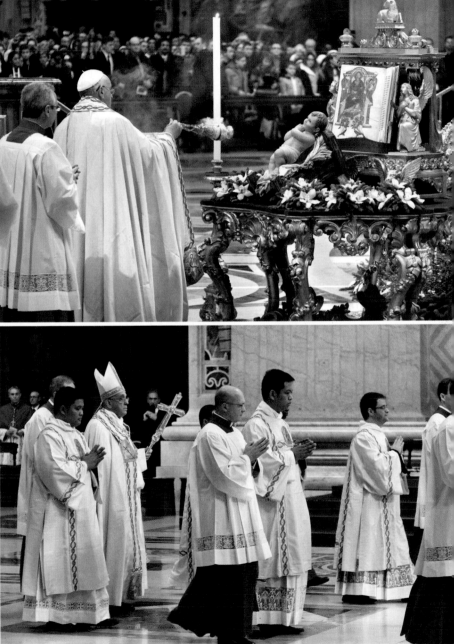

Y **BRING US THE POOR**
"A Roman deacon can help us. When St. Laurence was asked to bring and show the treasures of the Church, he simply brought some of the poor," Pope Francis preached.

< BENEDICTION
At the end of Evening Prayer, Pope Francis gives Benediction with the Monstrance, which contains the host consecrated during Mass.

A ASKING FOR GRACE
"It will do us good to ask for the grace to be able to walk in freedom in order to repair the many damages done," Pope Francis counseled.

215

⅄ CHRISTMAS TREE

Each year, a country or a region of Italy offers the gift of a Christmas tree, which is erected beside the nativity scene in front of St. Peter's Basilica.

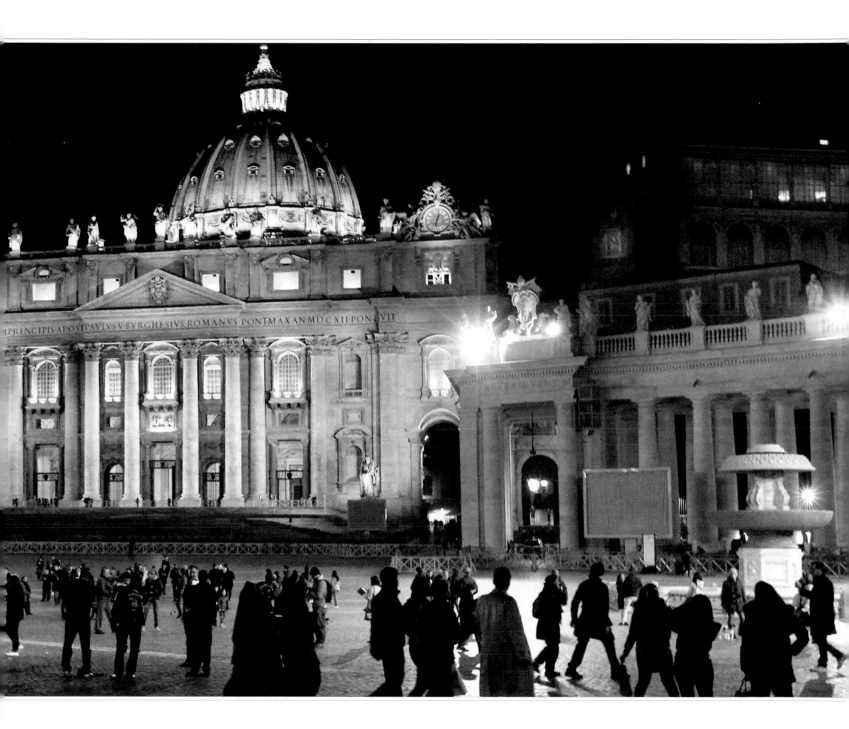

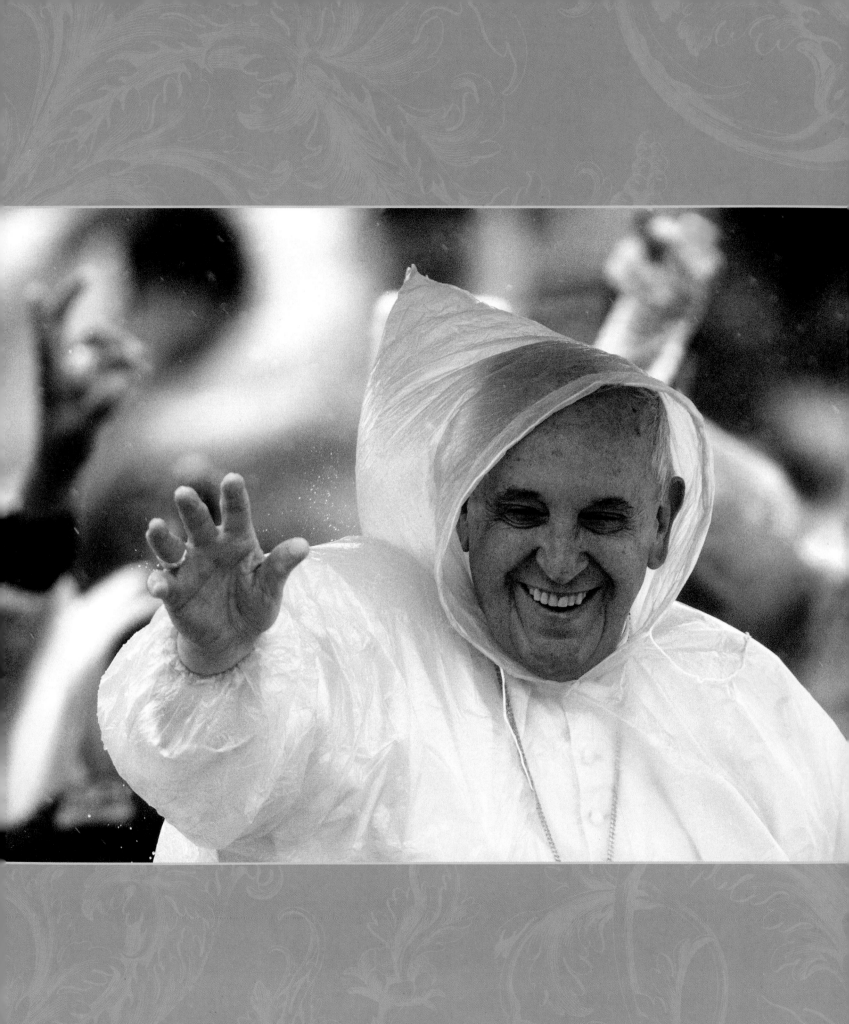

PAPAL VISITS

REACHING OUT

During the first two thousand years of the papacy, the popes traveled very little, relying on representatives such as envoys or legates to transmit their messages. In 1964, Pope Paul VI (1963–78) became the first pontiff to travel outside Italy since 1809, when the Emperor Napoleon forced Pope Pius VII into exile in Savona. Pope Paul VI went on to travel widely, visiting 19 countries on six continents during his pontificate. Pope John Paul I, who succeeded him, died after just a month in office, but Pope John Paul II (1978–2005) crisscrossed the globe in 104 international pastoral visits. A gifted linguist, he was fluent in more than 10 languages. Pope Benedict XVI (2005–13) continued the traveling tradition and visited 25 countries during his eight-year pontificate. Pope Francis has also embraced the challenge of foreign visits and makes several international journeys each year.

Some months after his election, Pope Francis heard about the plight of thousands of illegal African migrants who paid traffickers to take them from Tunisia to the tiny Italian island of Lampedusa—the shortest crossing from Africa to Europe. Many drowned as they made the journey in rickety wooden boats. Those that survived were held in inadequate refugee camps on the island.

Arriving on Lampedusa on July 8, 2013, the Pope threw a floral wreath into the waters where hundreds of migrants had drowned. He then met some of the young, impoverished survivors. Using a chalice carved of driftwood, the Pope celebrated Mass on the remains of a shipwrecked migrant boat. The visit shone the spotlight of world attention on the scandal of trafficking and the indifference shown to the migrants.

Two months later, on September 22, Pope Francis visited Cagliari on the island of Sardinia, where he encouraged young people struggling with unemployment.

The Pope traveled to the Umbrian town of Assisi on October 4 to celebrate the Feast of St. Francis, the 13th-century saint who had inspired his choice of name. During a talk in the town, he warned the Church to resist amassing riches and pay greater attention to helping poor people.

On June 21, 2014, Pope Francis made a trip to the southern district of Cassano all' Ionio in Calabria. His first stop was the state penitentiary at Castrovillari, where he addressed the detainees, staff, and their families. He met victims of Mafia violence and comforted the imprisoned father of a 3-year-old boy killed in the mob's turf wars. Speaking at a Mass later that day at Marina di Sibari, he denounced the Mafia's "adoration of evil" and challenged members of the Mafia to reform their lives, confirming that all *mafiosi* were excommunicated from the Church.

On his next pastoral visit, on July 5, to Campobasso in Molise, southern Italy, the Pope made a second visit to a state penitentiary. He confided that every two weeks he calls a prison in Buenos Aires and talks to young detainees.

On September 13, 2014, the Pope visited the military memorial at Redipuglia to commemorate the outbreak of World War I. By now, people knew that Pope Francis's visits were not to grand cities but to the peripheral places. It was part of his humble style that endeared him to many.

⌃ SPEAKING OUT
In the Mass celebrated at Lampedusa, the Pope drew the world's attention to the plight of the illegal migrants trafficked from North Africa.

⌃ GETTING IN CLOSE
A nun keeps her eye on proceedings during the Pope's visit to Assisi.

⌃ NAMESAKE
Pope Francis celebrates Mass at the Marian Shrine of Bonaria in Cagliari, Sardinia. The Pope's home town of Buenos Aires gets its name from Bonaria.

ITALIAN TRIPS
PASTORAL VISITS CLOSE TO HOME

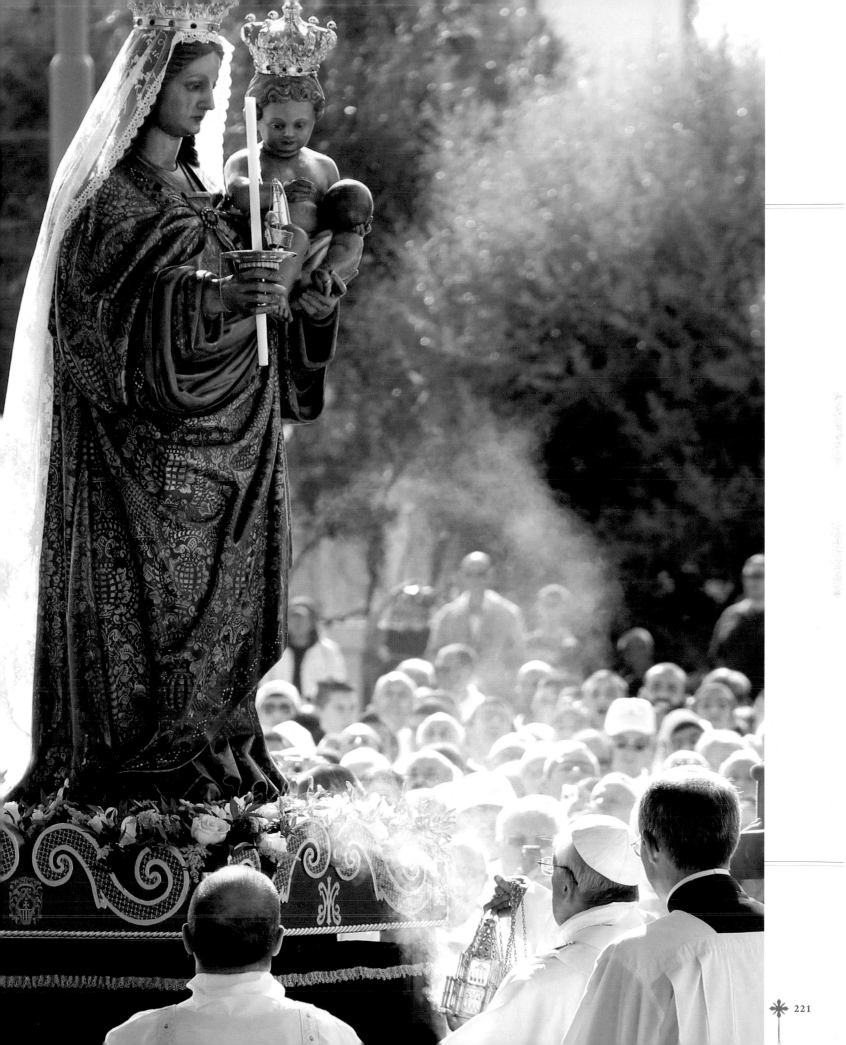

POPE FRANCIS CHOSE THE ITALIAN ISLAND OF LAMPEDUSA FOR HIS FIRST VISIT OUTSIDE ROME.

✟ IT TOOK PLACE ON JULY 8, 2013. THE ISLAND, WHICH LIES JUST 75 MILES (120 KM) NORTH OF TUNISIA, HAS BEEN A TEMPORARY REFUGE FOR THOUSANDS OF ILLEGAL AFRICAN MIGRANTS FOR MANY YEARS. IN RECENT DECADES, TENS OF THOUSANDS HAVE MADE THE DANGEROUS JOURNEY ACROSS THE MEDITERRANEAN IN SEARCH OF A NEW LIFE IN EUROPE. POPE FRANCIS WANTED TO SHOW HIS SOLIDARITY WITH BOTH THE MIGRANTS AND THE ISLANDERS.

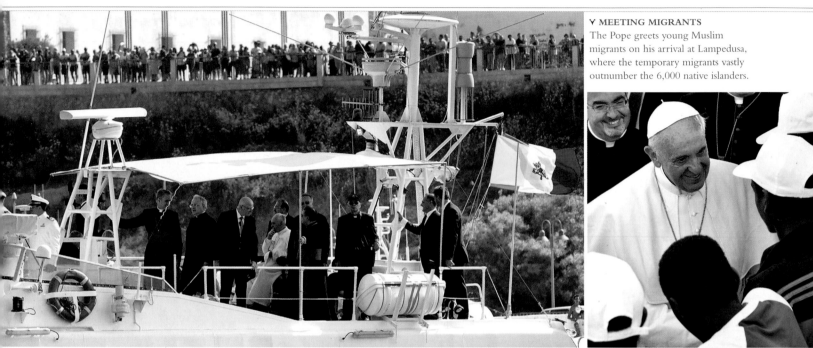

Ⅴ MEETING MIGRANTS
The Pope greets young Muslim migrants on his arrival at Lampedusa, where the temporary migrants vastly outnumber the 6,000 native islanders.

⋀ NAVY ESCORT
The Italian navy accompanied the pontiff to Lampedusa, where he threw a wreath of flowers into the sea, in memory of the hundreds of African migrants who had drowned.

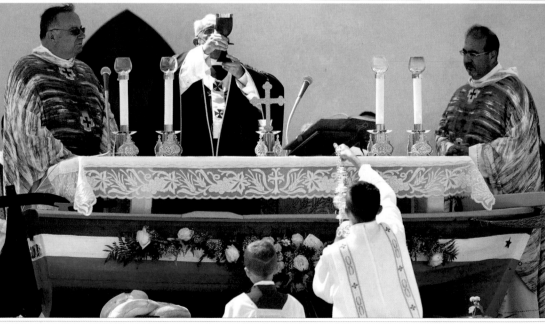

➤ CELEBRATING MASS
Pope Francis celebrates Mass for all the victims of the traffickers on a simple altar fashioned out of one of their boats. The chalice was carved from driftwood.

LAMPEDUSA
SHOWING SOLIDARITY

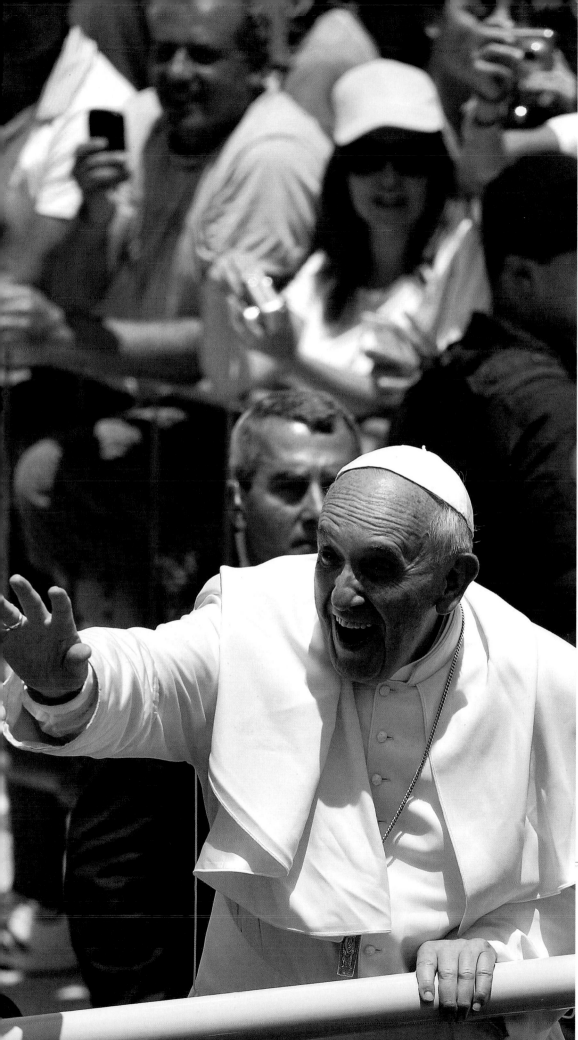

< WAVING TO THE CROWD
"I had to come here today to offer a sign of closeness, but also to challenge our consciences lest this tragedy be repeated," Pope Francis said.

A APPEAL TO POLITICIANS
During Mass, Pope Francis denounces the human traffickers, who profit from the migrants' misery, and urges politicians to help the victims.

POPE FRANCIS TRAVELED TO THE UMBRIAN TOWN OF ASSISI TO CELEBRATE THE FEAST DAY OF ST. FRANCIS, ONE OF ITALY'S PATRON SAINTS AND HIS PAPAL NAMESAKE. HE BEGAN HIS VISIT, ON OCTOBER 4, 2013, WITH AN EMOTIONAL MEETING WITH YOUNG PEOPLE WITH DISABILITIES IN THE SERAPHIC INSTITUTE. LATER, IN THE "STRIPPING ROOM," WHERE ST. FRANCIS HAD REMOVED HIS EXPENSIVE CLOTHES, RENOUNCING WORLDLY GOODS, THE POPE URGED CHRISTIANS NOT TO BE ARROGANT, VAIN, OR PROUD, OR TO GIVE IN TO THE IDOLATRY OF SEEKING MATERIAL RICHES.

< ROUND OF APPLAUSE
Franciscans wave off Pope Francis as he leaves the San Damiano Sanctuary. During a Mass, he called for an end to armed conflict.

v WATCHING THE ACTION
Assisi was packed with visitors and pilgrims during the Pope's day-long visit. These two religious sisters found a good vantage point.

^ BLESSING THE PEOPLE
The Pope blesses the people with the Gospel during Mass. He prayed that hatred might yield to love, injury to pardon, and discord to unity.

^ OPEN-AIR MASS
In a Mass held in the piazza, in front of the basilica where St. Francis is buried, the Pope included the well-being of Italy's citizens in his prayers.

ASSISI
CELEBRATING ST. FRANCIS

< HERMITAGE VISIT
Pope Francis visits the hermitage of
Eremo delle Carceri, just outside Assisi,
where St. Francis often withdrew in
order to pray in solitude.

ᴠ MEDIEVAL FRESCOES
The 13th-century Gothic basilica of
St. Francis is decorated with frescoes by
some of Italy's greatest medieval artists,
including Cimabue and Giotto.

ᴧ PAPAL BLESSING
During his visit to the Seraphic
Institute, a rehabilitation center for
young people with disabilities, the
Pope takes time to bless an inmate.

SOUTHERN ITALY HAS LONG BEEN THE POORER NEIGHBOR OF THE PROSPEROUS NORTH.

✝ FOR MANY OF HIS EARLY VISITS AS PONTIFF, POPE FRANCIS CHOSE OBSCURE SOUTHERN AREAS WHERE CRIME, POVERTY, AND CORRUPTION WERE AN EVERYDAY WAY OF LIFE. WHILE ENCOURAGING THE PEOPLE TO LIVE UPRIGHT, HONEST LIVES, HE UNDERLINED THAT THE MAFIA AND OTHER SUCH CRIMINAL ORGANIZATIONS WERE EXCOMMUNICATED FROM THE CHURCH. THIS WAS THE MOST EXPLICIT CONDEMNATION OF ORGANIZED CRIME EVER MADE BY A POPE.

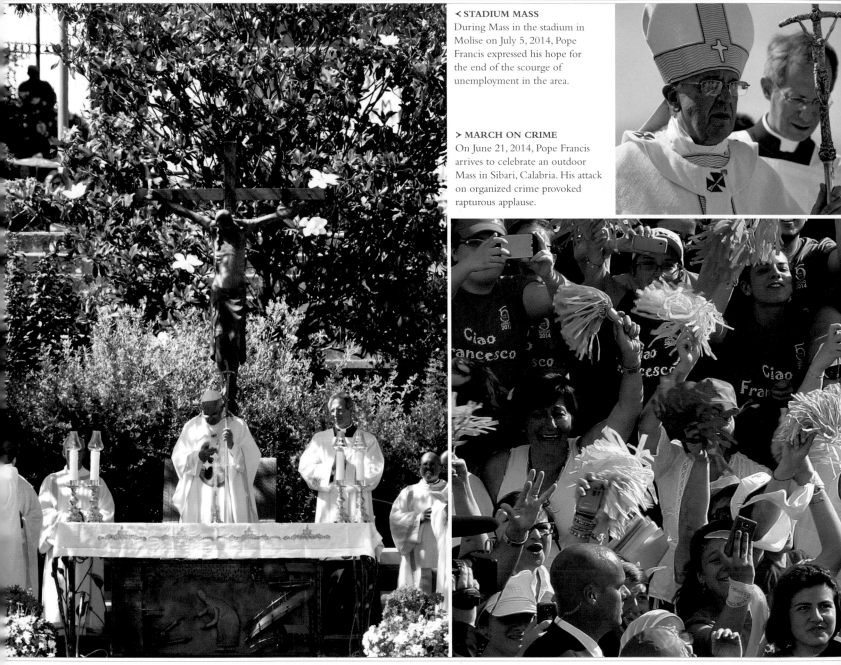

< STADIUM MASS
During Mass in the stadium in Molise on July 5, 2014, Pope Francis expressed his hope for the end of the scourge of unemployment in the area.

> MARCH ON CRIME
On June 21, 2014, Pope Francis arrives to celebrate an outdoor Mass in Sibari, Calabria. His attack on organized crime provoked rapturous applause.

ᴧ PAPAL CHEERLEADERS
The Pope greets well-wishers in the Piazza of Isernia Cathedral, Molise, on July 5, 2014. In his address, he called for the equal sharing of the world's goods.

SOUTHERN ITALY

MAKING A STAND AGAINST CRIME

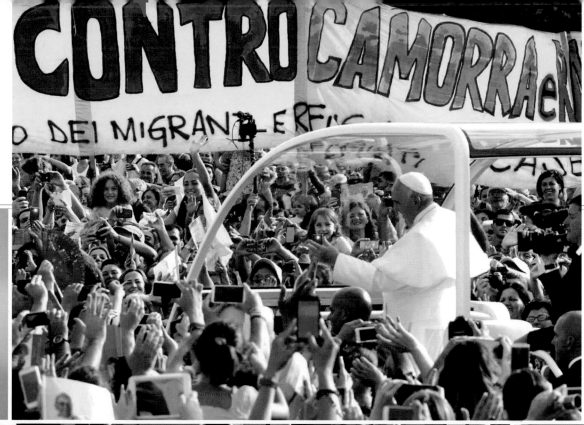

< AGAINST ORGANIZED CRIME
A large "Contro Camorra" banner, protesting at the Camorra clan of organized crime, greets Pope Francis in Caserta, Campania, on July 26, 2014.

Υ SPEAKING OUT
Preaching in Sibari on June 21, 2014, the Pope condemned the Mafia for its "adoration of evil" and confirmed that its members were excommunicated.

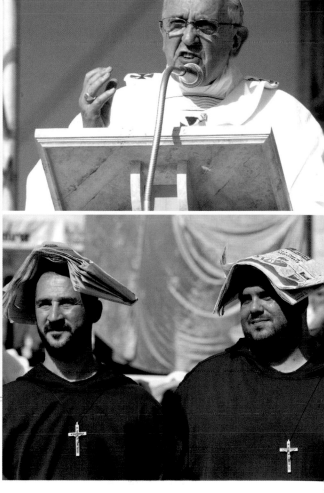

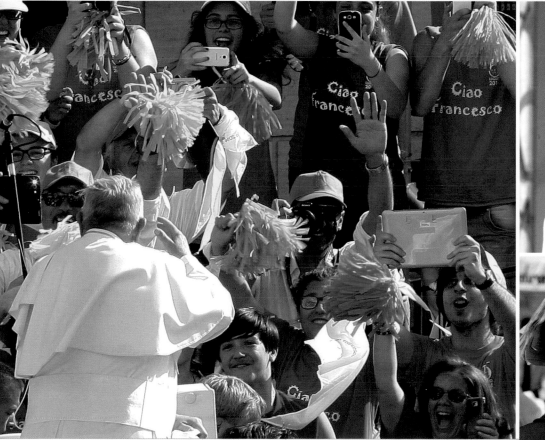

> WELL-READ FRIARS
Two friars protect themselves from the sun with newspapers on their heads while waiting for the Pope to arrive at Isernia Cathedral on July 5, 2014.

✞ **VISITING THE MILITARY MEMORIAL AT REDIPUGLIA ON SEPTEMBER 13, 2014 TO COMMEMORATE** THE OUTBREAK OF WORLD WAR I, THE POPE RECALLED THAT HIS GRANDFATHER, CARLO GIOVANNI BERGOGLIO, HAD SERVED AS A RADIO OPERATOR AT A NEARBY BATTLEFIELD A HUNDRED YEARS EARLIER. DURING MASS AT THE CEMETERY, POPE FRANCIS SAID, "EVEN TODAY, AFTER THE SECOND FAILURE OF ANOTHER WORLD WAR, PERHAPS ONE CAN SPEAK OF A THIRD WAR, ONE FOUGHT PIECEMEAL, WITH CRIMES, MASSACRES, AND DESTRUCTION."

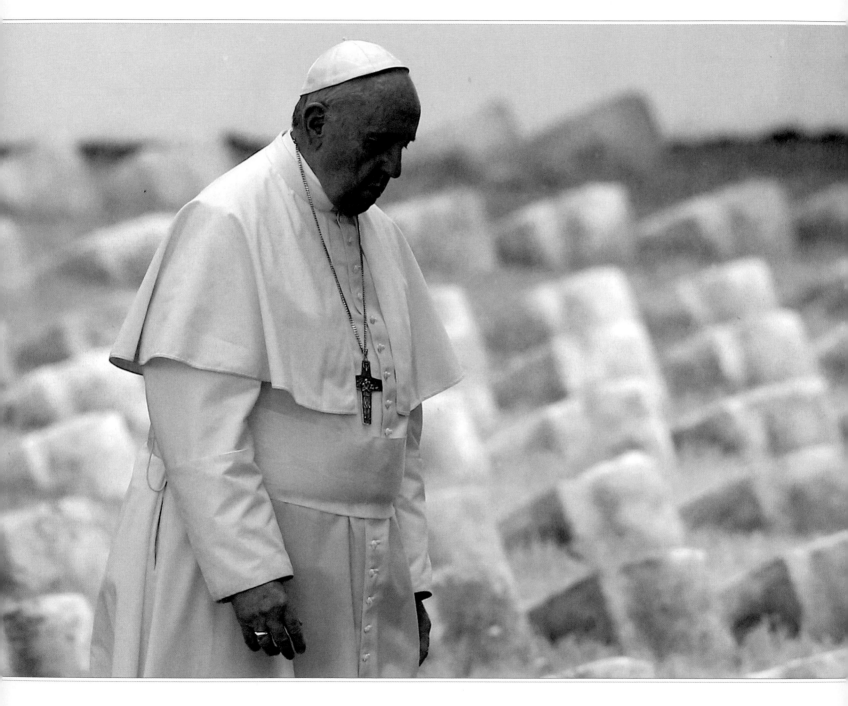

REDIPUGLIA

A DAY OF REMEMBRANCE

REMEMBRANCE
The Pope walks in the cemetery where more than 100,000 Italian soldiers who died on the battlefield in northern Italy are buried.

FLORAL TRIBUTE
The Pope laid a floral tribute. "I heard many painful stories of the war from the lips of my grandfather," he said.

REMEMBERING RELATIVES
Bergoglio is not a common name, and on his visit the Pope learned of other relatives of his who had been killed in service.

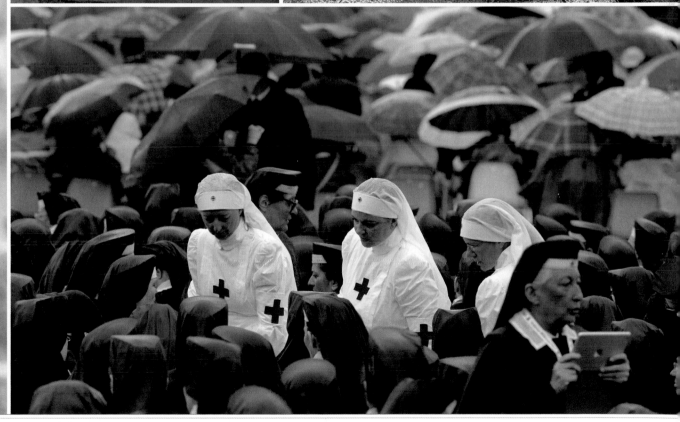

RED CROSS NUNS
Nuns and nursing sisters wearing the Red Cross insignia attended the commemorations, a reminder of that organization's role in caring for the wounded in World War I.

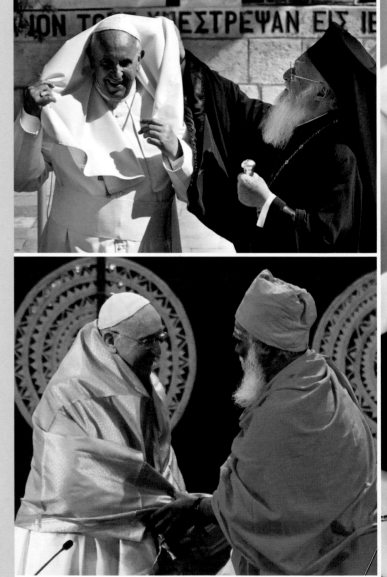

˅ FLYAWAY CAPE
Patriarch Bartholomew I helps Pope Francis with his cape during a meeting on May 26, 2014, on the Mount of Olives in Jerusalem.

Pope Francis has undertaken a number of significant pastoral voyages. Just four months after his election in March 2013, he visited Rio de Janeiro, Brazil, for World Youth Day, an event actually spread over a week. Wherever he went, he was mobbed by thousands of young people. One of his most significant appointments was inaugurating a drug rehabilitation clinic at the St. Francis of Assisi hospital. He used the occasion to criticize the plans of some Latin American countries to liberalize drug laws.

Between May 24 and 26, 2014, he traveled to the Holy Land. The visit began in Jordan, where he prayed at the site of Jesus's baptism in the Jordan River before meeting refugees and young people with disabilities. After crossing into Israel, he celebrated Mass in Bethlehem and met Palestinian children in a refugee camp.

Reconciliation was the theme of the meeting between Pope Francis and Patriarch Bartholomew I of Constantinople, held in Jerusalem. The two leaders prayed together in public and signed a common declaration. While in the Holy City, the Pope also attended a gathering at the Yad Vashem Memorial to commemorate those who perished in the Holocaust.

Pope Francis made his first trip to Asia between August 13 and 18, 2014, starting with South Korea. More than 10 percent of the South Korean population is Catholic, but Christianity is officially repressed in North Korea. The Pope encouraged dialogue between the two countries. At a Mass in Seoul, he beatified 124 Koreans who died for their faith in the 19th century.

The Pope's first trip within Europe, and his first to a Muslim-majority country, was to Albania on September 21, 2014. During its Communist era, Albania was the world's only officially atheist nation, and religion was ruthlessly suppressed. Today, Albanians are free to follow their religious beliefs. Pope Francis praised the peaceful coexistence of the various religions and ethnic groups. This theme was taken up when the Pope made a three-day visit to Turkey starting on November 28, 2014.

His second visit to Asia started in Sri Lanka on January 12, 2015. Catholics are in the minority here, but the Pope's presence encouraged dialogue in a country recovering from civil war. He continued to the Philippines, where he comforted survivors of Typhoon Yolanda. Several million people attended his final Mass of the trip in Manila.

˄ HANDSHAKE
A Hindu priest shakes the Pope's hand after presenting him with a shawl during an interfaith meeting on January 13, 2015, in Colombo, Sri Lanka.

˃ SNAPSHOT
A priest takes a photograph of Pope Francis during a Mass for local Catholic leaders at Manila Cathedral in the Philippines' capital, on January 16, 2015.

FOREIGN TRIPS
PASTORAL VISITS FARTHER AFIELD

POPE FRANCIS'S FIRST FOREIGN VISIT AFTER HIS ELECTION IN 2013 WAS TO BRAZIL. LASTING FROM JULY 22 TO 29, IT CULMINATED IN AN OPEN-AIR MASS ON COPACABANA BEACH IN RIO DE JANEIRO FOR WORLD YOUTH DAY, WITH SOME 3 MILLION WORSHIPPERS. THE LATIN AMERICAN POPE RECEIVED A TUMULTUOUS WELCOME IN THE CITY, WHERE HE VISITED A DRUG REHABILITATION CENTER FOR YOUNG PEOPLE AND SPENT SEVERAL HOURS IN THE CITY'S SLUMS. HE INSISTED ON DISPENSING WITH SECURITY AND TRAVELED IN A SMALL CAR, WHICH WAS ALMOST SWAMPED BY THE CROWDS.

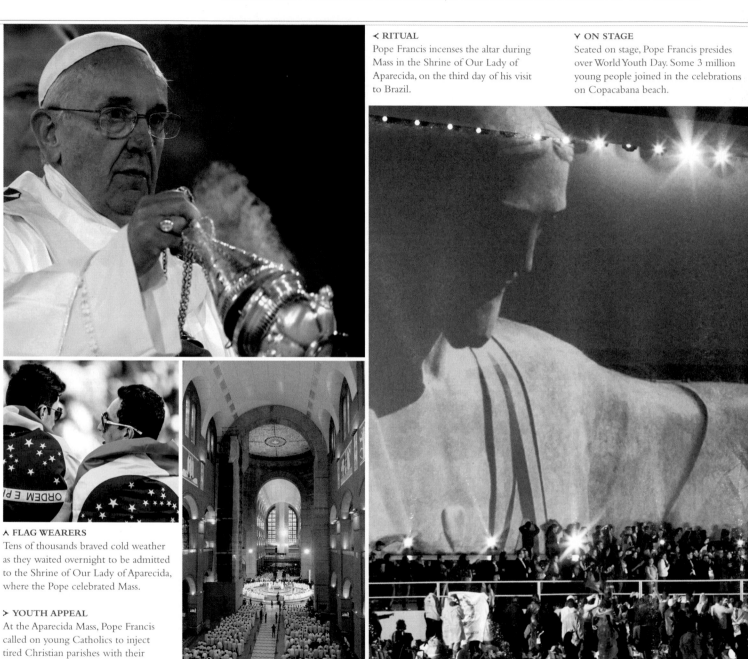

< RITUAL
Pope Francis incenses the altar during Mass in the Shrine of Our Lady of Aparecida, on the third day of his visit to Brazil.

v ON STAGE
Seated on stage, Pope Francis presides over World Youth Day. Some 3 million young people joined in the celebrations on Copacabana beach.

^ FLAG WEARERS
Tens of thousands braved cold weather as they waited overnight to be admitted to the Shrine of Our Lady of Aparecida, where the Pope celebrated Mass.

> YOUTH APPEAL
At the Aparecida Mass, Pope Francis called on young Catholics to inject tired Christian parishes with their youth, energy, and enthusiasm.

BRAZIL

THE ENERGY OF THE NEW WORLD

< JOYFUL NUNS
World Youth Day is also for the young at heart, and the joy of the occasion was infectious. These religious sisters joined in the fun from their balcony.

Y CHILD OF THE WORLD
The international character of the Church is very visible at World Youth Day events, where young people from around the globe gather in friendship.

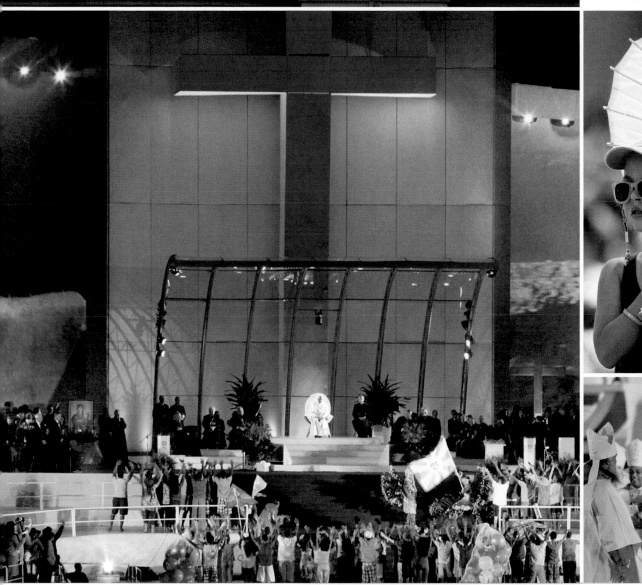

> IT'S A GOAL!
As this young priest shows, there is always time for fun as well as prayer. Part of the attraction of such international meetings as World Youth Day is the new friendships made.

ʌ CANDID CAMERA
Archbishops and bishops take snapshots before the start of the inaugural Mass on Copacabana beach during World Youth Day.

∨ **A SEA OF PILGRIMS**
Pilgrims attending World Youth Day crowd
Copacabana beach in Rio de Janeiro, Brazil,
on July 28, 2013, waiting for the Pope's final
Mass during his trip to Brazil.

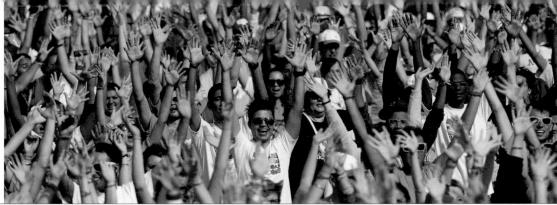

> YOUTHFUL EXUBERANCE
Joyful young pilgrims anticipate Pope
Francis's arrival at Copacabana beach to
say Mass. Many spent the night before
sleeping on the beach.

POPE FRANCIS TRAVELED TO THE HOLY LAND FROM MAY 24 TO 26, 2014. THE MAIN PURPOSE OF THE TRIP WAS TO COMMEMORATE THE 50TH ANNIVERSARY OF THE MEETING OF POPE PAUL VI AND ATHENAGORAS, PATRIARCH OF CONSTANTINOPLE, IN JERUSALEM. THE POPE VISITED JORDAN FIRST BEFORE CONTINUING TO ISRAEL, BUT SURPRISED HIS HOSTS BY MAKING AN UNSCHEDULED STOP AT BETHLEHEM'S SEPARATION WALL, WHICH DIVIDES THE PALESTINIAN CITY FROM ISRAEL. DURING HIS VISIT, THE POPE SOUGHT TO BRING ISRAELI AND PALESTINIAN LEADERS TOGETHER.

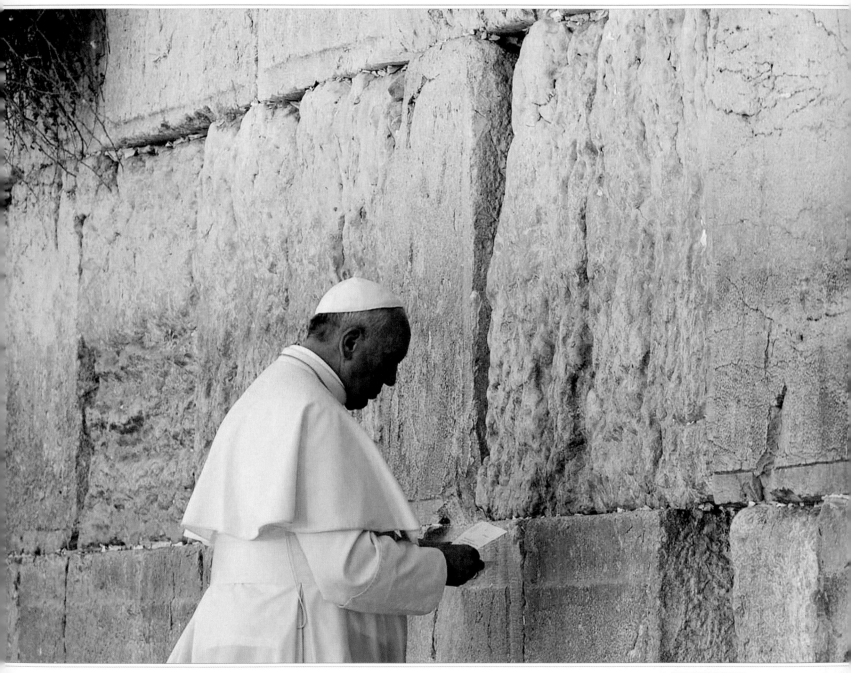

A WESTERN WALL
Following Jewish tradition, the Pope prayed silently for peace at the Western Wall, or Wailing Wall—the foundations of the ancient Temple of Jerusalem.

HOLY LAND

IN THE FOOTSTEPS OF JESUS

➤ LORD'S PRAYER
Pope Francis placed a
copy of the Lord's Prayer,
handwritten in his native
Spanish, in a crack in the
Western Wall, Jerusalem.

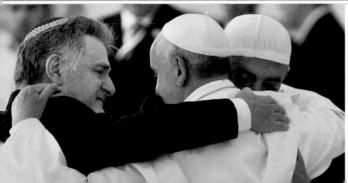

< FRIENDS REUNITED
Rabbi Abraham Skorka and Imam Omar
Abboud, friends of Jorge Bergoglio before
he was made Pope, helped to organize the
papal visit to the Holy Land.

POPE FRANCIS FULFILLED A LIFELONG DREAM WHEN HE FINALLY VISITED ASIA IN AUGUST 2014.

✝ HIS FIRST STOP WAS SOUTH KOREA, WHERE HE SPENT FIVE DAYS. CATHOLICS CURRENTLY NUMBER 5.4 MILLION IN THE COUNTRY, SOME 10 PERCENT OF THE POPULATION. DURING HIS VISIT, THE POPE BEATIFIED 124 KOREANS WHO KEPT THE FAITH ALIVE IN THE 19TH CENTURY DURING A PERIOD OF PERSECUTION. EVEN THOUGH ONLY 3 PERCENT OF ASIA IS CATHOLIC, THE CHURCH IS GROWING RAPIDLY, WITH MORE PEOPLE BAPTIZED IN ASIA IN 2014 THAN IN EUROPE.

⋏ RECONCILIATION
At a Reconciliation Mass at Myeong-dong Cathedral, Seoul, the Pope greeted elderly women who had been sold into sexual slavery in World War II.

⋎ FORGIVENESS
Pope Francis was delayed in meeting 5,000 nuns because he spent extra time blessing 60 disabled children. The nuns gladly forgave him when he explained.

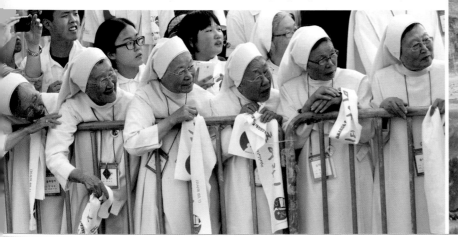

SOUTH KOREA
A LAND OF MARTYRS

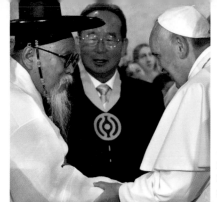

◄ PEACE TALKS

Han Yang-won, chairman of the Association for Korean Native Religion, leads a delegation of religious leaders at Myeong-dong Cathedral.

▼ QUIET REFLECTION

A quiet moment at the birthplace of St. Andrew Kim Taegon (1821–46), the first Korean-born priest, who was baptized at the age of 15 and tortured and beheaded at 25.

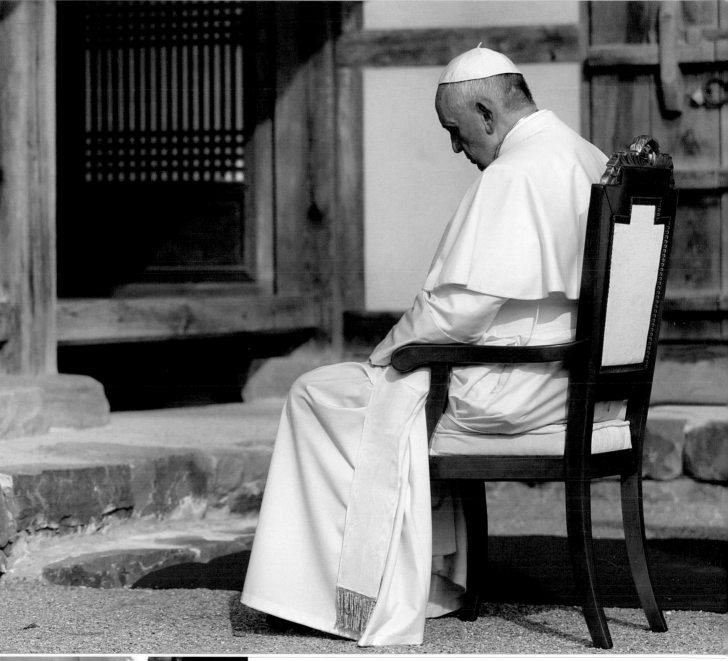

◄ PATIENCE REWARDED

A young girl waits to meet Pope Francis at the end of his visit to the Shrine of Solmoe, where Catholicism first took root in Korea.

POPE FRANCIS CHOSE ALBANIA FOR HIS FIRST OFFICIAL VISIT TO EUROPE ON SEPTEMBER 21, 2014.

✝ A COUNTRY LONG IGNORED BY GLOBAL LEADERS, ITS POPULATION IS 56.7 PERCENT MUSLIM AND 10 PERCENT CATHOLIC. THE POPE EXPLAINED THAT HE WAS INSPIRED TO MAKE THE DAY-LONG JOURNEY BY THE "EXEMPLARY PEACEFUL COEXISTENCE OF THE PEOPLE." THE POPE MADE HIS SHORTEST VISIT ABROAD—JUST FOUR HOURS—WHEN HE ADDRESSED THE DELEGATES OF THE 28 MEMBER STATES OF THE EUROPEAN PARLIAMENT IN STRASBOURG ON NOVEMBER 25, 2014.

⌄ SALUTES FOR A SAFE JOURNEY
The Italian authorities work closely with the Vatican to ensure Pope Francis's safety. At Rome's Fiumicino airport, he waves to the crowd before boarding his flight to Albania.

⌄ HARD-HITTING ADDRESS
Pope Francis leaves the European parliament, with EU President Martin Schulz on his left. In his earlier speech, the Pope claimed Europe was dominated by technological and economic concerns "to the detriment of… human beings."

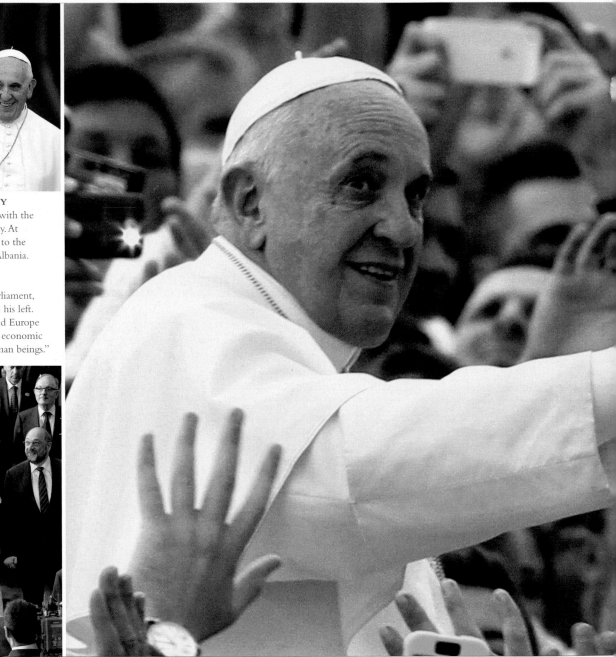

EUROPE

THE FIRST EUROPEAN VISITS OUTSIDE ITALY

> SOMBER REMINDER
Banners at the outdoor Mass in the Albanian capital, Tirana, depict 40 Catholic martyrs killed under Communism in the 20th century. Bishops, priests, nuns, and laypeople were among those massacred.

∧ PRAYERS
A young Albanian religious sister prays during an outdoor Mass, celebrated by the Pope, in Mother Teresa Square in Tirana. The Square was named after Mother Teresa of Calcutta, whose parents were from Albania.

< WAVING IN HARMONY
Pope Francis held up Albania as an example of religious harmony and urged people not to use God "as a human shield… to justify acts of violence and oppression."

THE REASON FOR POPE FRANCIS'S THREE-DAY TRIP TO TURKEY, A PREDOMINANTLY MUSLIM COUNTRY, WAS PRIMARILY TO STRENGTHEN RELATIONS WITH THE ORTHODOX CHURCH, BUT ALSO TO BUILD BRIDGES WITH ISLAM. DURING HIS VISIT, WHICH TOOK PLACE FROM NOVEMBER 28 TO 30, 2014, THE POPE SPENT TIME IN ISTANBUL, WHERE HE CELEBRATED MASS IN THE CATHEDRAL OF THE HOLY SPIRIT. HE WAS ALSO A GUEST OF THE GRAND MUFTI AT THE HISTORIC BLUE MOSQUE IN THE CITY.

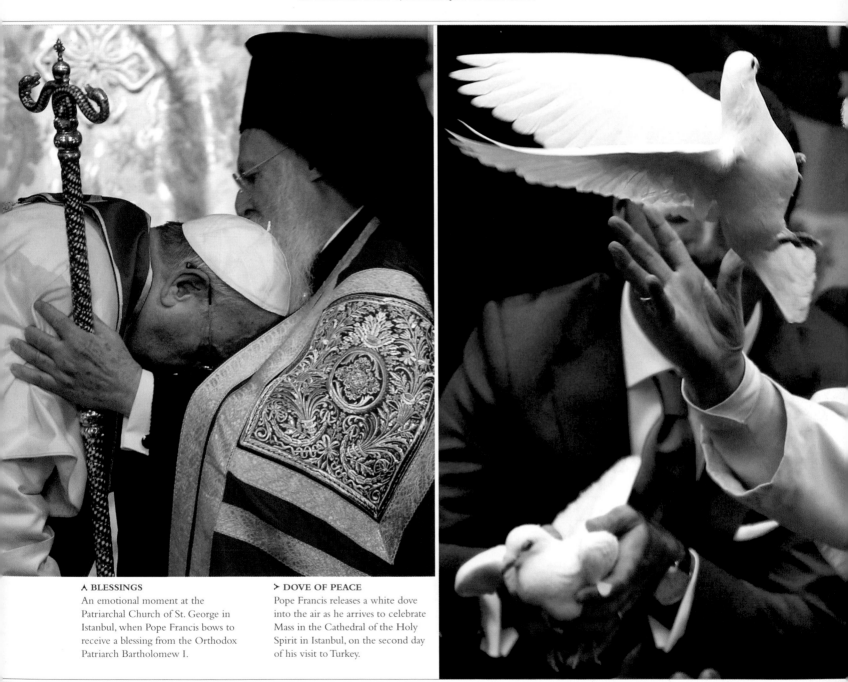

⋏ BLESSINGS

An emotional moment at the Patriarchal Church of St. George in Istanbul, when Pope Francis bows to receive a blessing from the Orthodox Patriarch Bartholomew I.

➤ DOVE OF PEACE

Pope Francis releases a white dove into the air as he arrives to celebrate Mass in the Cathedral of the Holy Spirit in Istanbul, on the second day of his visit to Turkey.

TURKEY

AN OUTSTRETCHED HAND OF FRIENDSHIP

< FEAST OF ST. ANDREW
Pope Francis celebrates Mass for the Feast of St. Andrew at Istanbul's Cathedral of the Holy Spirit, which was built in the Baroque style in 1846.

∨ INTERFAITH DIALOGUE
Pope Francis, a guest of the Grand Mufti at the Sultan Ahmet mosque, or Blue Mosque, urged interfaith dialogue to overcome religious fundamentalism.

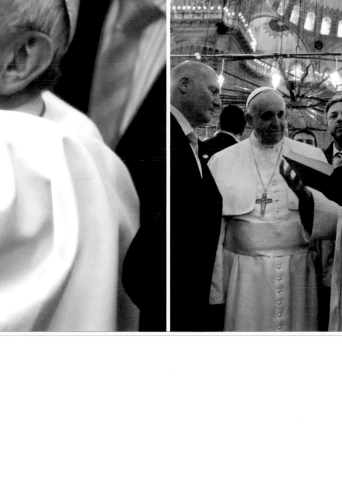

HIS FIRST OVERSEAS VISIT OF 2015, WHICH TOOK PLACE FROM JANUARY 12 TO 15, SAW POPE FRANCIS

✝ TRAVEL TO ASIA FOR THE SECOND TIME IN HIS PAPACY. THE TRIP BEGAN IN SRI LANKA BEFORE CONTINUING TO THE PHILIPPINES. THE CATHOLIC POPULATION OF SRI LANKA NUMBERS 1.2 MILLION, OR 6 PERCENT OF THE POPULATION. PART OF FRANCIS'S REASON FOR VISITING SRI LANKA WAS TO BEATIFY JOSEPH VAZ, THE 17TH-CENTURY MISSIONARY. HE ALSO URGED RECONCILIATION BETWEEN THE DIFFERENT ETHNIC GROUPS AND RELIGIONS FOLLOWING THE DEVASTATING 25-YEAR CIVIL WAR.

⋎ GARLAND OF ROSES
On his arrival at Colombo airport in Sri Lanka, the Pope was presented with a garland of yellow and white roses, representing the colors of the papal flag.

⋎ BUDDHIST SCRUTINY
A Buddhist monk observes Pope Francis, who made an unscheduled stop to visit a temple. He is only the second pontiff in history to visit a Buddhist shrine.

➤ SAFFRON SHAWL
Pope Francis receives a saffron shawl from Hindu priest Kurukkal SivaSri T. Mahadeva at an interfaith meeting in Colombo. During his visit to Sri Lanka, the pontiff urged the different religions in the country to unite and heal the divisions caused by civil war.

SRI LANKA
A LAND OF RELIGIOUS DIVERSITY

˅ OUR LADY OF MADHU
Pope Francis holds a statue of Our Lady of Madhu at
the holy shrine in northern Sri Lanka. Some 300,000
people welcomed the Pope to the shrine, where he
urged reconciliation following the civil war.

˃ PRAYERS OF THE FAITHFUL
A young woman prays as she awaits the
arrival of Pope Francis at the shrine of
Our Lady of Madhu, the holiest Christian
site on the island.

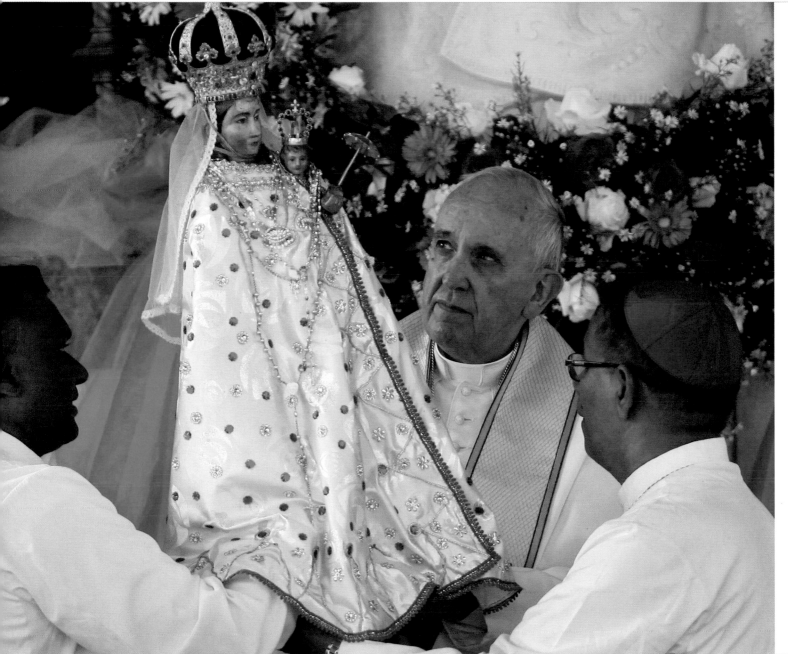

˂ COVERING THE HEAD
A woman places a white lace mantilla over
her head before the canonization Mass of
Joseph Vaz, Sri Lanka's first saint. Such head
coverings are traditionally worn during
worship in some parts of the world.

∨ PAPAL BLESSING
Pope Francis blesses the altar during the beatification of Sri Lanka's first saint, Joseph Vaz. Thousands packed into the Colombo seafront where the Mass took place.

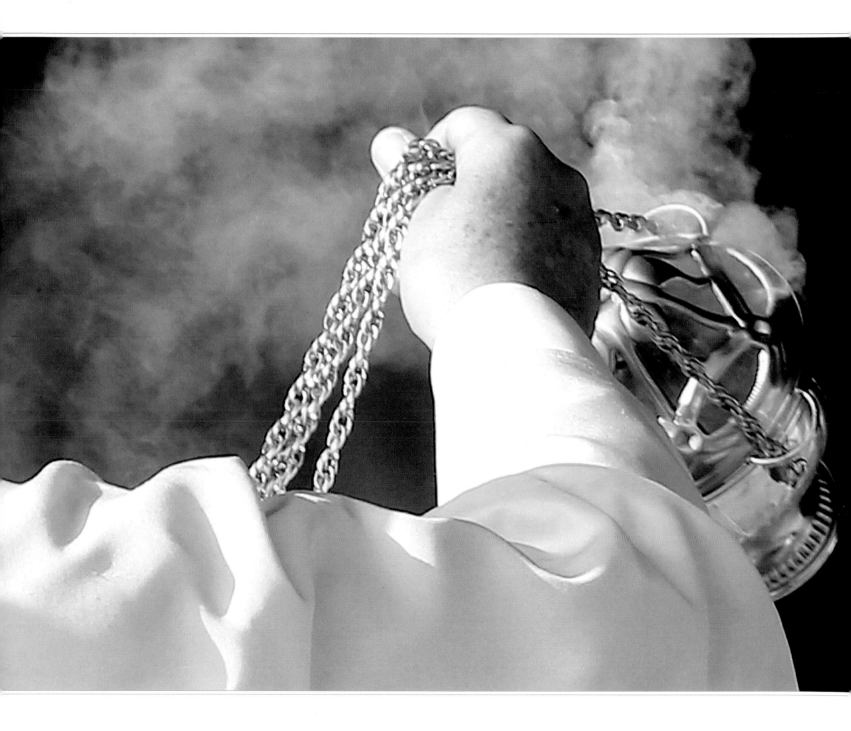

POPE FRANCIS TRAVELED TO THE PHILIPPINES, WHERE 86 PERCENT OF THE POPULATION IS CATHOLIC, FROM JANUARY 15 TO 19, 2015. HE OFFERED SUPPORT AND ENCOURAGEMENT TO THE SURVIVORS OF A DEVASTATING TYPHOON THAT HAD HIT THE REGION THE PREVIOUS YEAR. IRONICALLY, ANOTHER TROPICAL STORM FORCED THE PONTIFF TO CUT SHORT HIS VISIT, ALTHOUGH HE BRAVED THE ELEMENTS TO MEET THE MILLIONS WHO TURNED OUT TO GIVE HIM A RAPTUROUS WELCOME. AT HIS DEPARTURE, HE PROMISED TO RETURN.

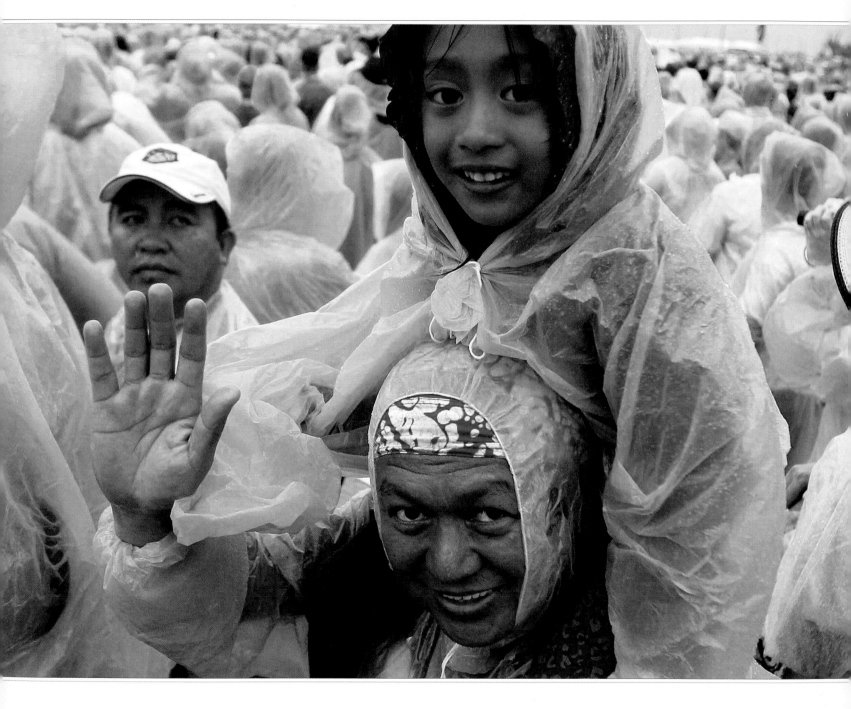

PHILIPPINES

LOOKING TO THE FUTURE

< RAINY WELCOME
The Pope admitted that he was
irritated by the appalling weather
and asked pardon of his hosts for any
impatience he showed during the visit.

∨ BEATING THE ELEMENTS
The Pope donned one of the yellow
ponchos distributed to the people
before the papal Mass at Tacloban.

∨ HISTORIC ICON
A nun prays with a replica of the Infant
Jesus, an important religious icon in the
Philippines since the 16th century.

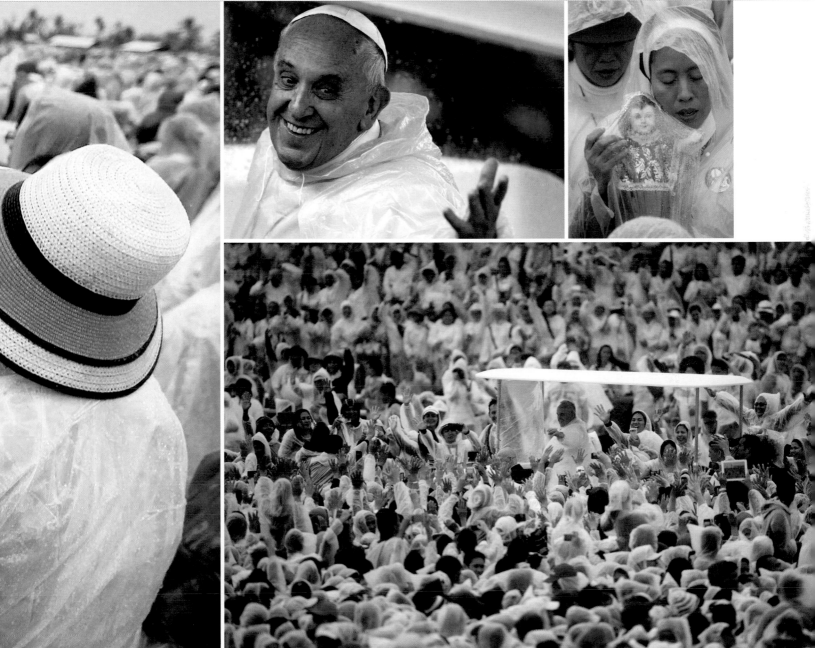

∧ SMILES OF HOPE
Officials urged the Pope to abandon plans for
a Mass to be held near the airport of Tacloban
for victims of Typhoon Yolanda, but he refused.

∧ GIVING COMFORT
The Pope said he could not find words to express
his sorrow for the victims of the typhoon but he
hoped his presence would be of some comfort.

∨ FAREWELL TO THE PHILIPPINES
"Faith teaches us to see that every man and woman represents a blessing for me, that the light of God's face shines on me through the faces of my brothers and sisters," Pope Francis said in his first encyclical, *Lumen Fidei* ("Light of Faith").

INDEX

PF is abbreviation for Pope Francis

ACKNOWLEDGMENTS

The publisher would like to thank the following for their kind permission to reproduce their photographs:

Fotografia Felici: Rodolfo Felici, Giuseppe Felici, Alberto Felici, and Gianlorenzo Pontrandolfi.

(Key: a–above, b–below/bottom, c–center, f–far; l–left; r–right; t–top; ftl–far top left; ftr–far top right; fbl–far bottom left; fbr–far bottom right)

1 Giuseppe Felici. **2** Giuseppe Felici: (tl, cla, fbl, bl, bc). **Alberto Felici:** (tr, fbr). **Rodolfo Felici:** (cra, br). **3** Rodolfo Felici: (tl, cla, cra, tr, clb, bc, fbr). **Giuseppe Felici:** (fbl, crb). **8–9 Corbis:** Filippo Fiorini / Demotix. **10 Getty Images:** API. **11 Getty Images:** Franco Origlia. **12 Getty Images:** Franco Origlia (t, b). **13 Getty Images:** API. **14 Getty Images:** Mario Tama / Staff. **15 Corbis:** Tony Gomez / DyN / Reuters (b). **Getty Images:** Emiliano Lasalvia / STR (t). **16 Corbis:** AFP (t); Marco Longari (b). **17** Rodolfo Felici. **18–19 Dorling Kindersley:** Christopher Pillitz. **20–21 Corbis:** Radek Pietruszka / epa. **22 Corbis:** Osservatore Romano / Reuters (t, bl, br). **23 Corbis:** Osservatore Romano / Reuters (l, tr, br). **24–25 Corbis:** Osservatore Romano / Reuters. **26 Corbis:** Osservatore Romano / Reuters. **27 Corbis:** Alessandro Bianchi / Reuters (tr); Osservatore Romano / Reuters (tl, bl, bc, br). **28 Corbis:** Alessandra Benedetti (r); Osservatore Romano / Reuters (tl); Michael Kappeler / EPA (bl). **29 Corbis:** Maurizio Brambatti / epa (l); Michael Kappeler / EPA (r). **Rodolfo Felici:** (br). **30** Rodolfo Felici: (t, c, b). **31** Rodolfo Felici: (t, b). **32–33** Rodolfo Felici. **34 Corbis:** Osservatore Romano / Reuters (tl, bl). **34–35 Corbis:** Osservatore Romano / Reuters. **35 Corbis:** Osservatore Romano / Reuters. **36 Corbis:** Alessandro Bianchi / Reuters (tl); Max Rossi / Reuters (tr); Massimo Percossi / ANSA (b). **37 Corbis:** Maurizio Brambatti / ANSA (t); Massimo Percossi / ANSA (b). **38–39 Getty Images:** Joe Raedle. **39 Getty Images:** Joe Raedle (r). **40 Corbis:** Maurizio Brambatti / ANSA (l). **40–41 Corbis:** L'Osservatore Romano. **41 Corbis:** Michael Kappeler / dpa (r). **42 Giuseppe Felici:** (l, r). **43 Giuseppe Felici:** (t, bl, br). **44** Rodolfo Felici: (t, b). **45 Giuseppe Felici:** (t, b). **46 Giuseppe Felici:** (tl, bl).

46–47 Rodolfo Felici. **47** Rodolfo Felici: (tr). **Giuseppe Felici:** (br). **48 Corbis:** Ciro Fusco / epa (bl). **Rodolfo Felici:** (tl). **Giuseppe Felici:** (cl). **48–49** Giuseppe Felici. **49** Rodolfo Felici: (tr). **50–51 Corbis:** Alessandro Bianchi / Reuters. **52–53** Rodolfo Felici: (b). **53 Corbis:** Tony Gentile / Reuters (tr). **54 Corbis:** Alessia Giuliani / CPP / Vatican Pool / Alessandra Benedetti (b). **Giuseppe Felici:** (t). **55** Giuseppe Felici. **56** Alberto Felici: (l, tr, br). **57** Giuseppe Felici: (t). **Alberto Felici:** (b). **58** Giuseppe Felici: (tl). **Rodolfo Felici:** (tr, bl, br). **59** Rodolfo Felici. **60–61** Rodolfo Felici. **62** Giuseppe Felici: (tl, tr, bl, br). **63** Giuseppe Felici. **64–65** Giuseppe Felici. **66–67 Corbis:** Andrew Medichini / Pool / epa. **67 Corbis:** Alessandra Benedetti (cr); Andrew Medichini / Pool / epa (tr, br). **68–69 Corbis:** Alessandra Benedetti (br); Stefano Costantino / Splash News (t). **70** Giuseppe Felici: (l). **70–71** Giuseppe Felici: (c). **71** Giuseppe Felici: (tr, br). **72** Rodolfo Felici: (t). **Getty Images:** Vincenzo Pinto / AFP (b). **73** Rodolfo Felici. **74–75** Rodolfo Felici: (c). **75** Rodolfo Felici: (tr, br). **76–77** Rodolfo Felici: (t). **78** Giuseppe Felici: (tl, tr); Alberto Felici: (tr). **79** Rodolfo Felici: (l, tr). **Giuseppe Felici:** (br). **80–81** Giuseppe Felici. **82 Corbis:** Alessandra Benedetti (l). **82–83 Corbis:** Alessandra Benedetti (r). **83 Corbis:** Alessandra Benedetti (r). **84 Corbis:** Kevin Lamarque / Reuters (b); Claudio Peri / epa (t). **85** Rodolfo Felici. **86 Corbis:** Alessandra Benedetti / Vatican Pool (b); Alessandro Bianchi / Reuters (tl); Claudio Peri / ANSA (tr). **87 Corbis:** Max Rossi / Reuters. **88 Alamy Images:** EPA / Osservatore Romano. **89 Alamy Images:** EPA / Osservatore Romano (t, b). **90 Corbis:** infitmi–02 / INFphoto.com (b); Claudio Peri / epa (tl, tr). **91 Corbis:** Gabriel Bouys / POOL / epa (b). **Getty Images:** Franco Origlia (t). **92** Rodolfo Felici: (l, tr, br). **93 Giuseppe Felici:** (l, tr, br). **94 Corbis:** Alessandra Benedetti (t); Stefano Rellandini / Reuters (b). **95 Corbis:** Giuseppe Ciccia / NurPhoto. **96–97** Giuseppe Felici. **97 Corbis:** Alessandro Bianchi / Reters (br). Giuseppe Felici: (tl, tr). **98–99** Giuseppe Felici. **100–101** Giuseppe Felici: (c). **101** Giuseppe Felici: (tl, br). **Rodolfo Felici:** (tr). **102–103** Rodolfo Felici. **104 Corbis:** Osservatore Romano / Reuters. **105 Corbis:** Osservatore Romano / Reuters (t). **106** Giuseppe Felici: (tl). **106–107 Corbis:** Alessandro di Meo / ANSA (tc). **Rodolfo Felici:** (b). **107** Rodolfo Felici: (tr). **108–109 Corbis:** Osservatore Romano / Reuters. **110 Corbis:**

Claudio Peri / epa (tl). **Getty Images:** Evren Atalay / Anadolu Agency (bl). **110–111 Corbis:** Alessandra Benedetti (c). **111 Getty Images:** Evren Atalay / Anadolu Agency (t); Franco Origlia (cr, br). **112 Corbis:** Stefano Rellandini / Reuters (br). **Giuseppe Felici:** (l, tr). **113** Giuseppe Felici: (l, r). **114–115** Giuseppe Felici. **116** Rodolfo Felici: (tl, bl). **116–117 Getty Images:** Franco Origlia (c). **117** Rodolfo Felici: (tr, cr, br). **118** Giuseppe Felici: (tl). **118–119** Alberto Felici. **119** Alberto Felici: (br). **120** Rodolfo Felici: (tl, tc, tr, br). **Giuseppe Felici:** (bl). **121** Rodolfo Felici: (tl). **Giuseppe Felici:** (tr, br). **122–123** Rodolfo Felici. **124 Corbis:** Alessandra Benedetti / Alessandra Benedetti (b). **124 Rodolfo Felici:** (bl). **124–125 Corbis:** Alessandra Benedetti / Alessandra Benedetti (b); Tony Gentile / Reuters (t). **125** Giuseppe Felici: (t, b). **126** Giuseppe Felici: (t, b). **127** Giuseppe Felici. **128** Rodolfo Felici: (bl, br). **Giuseppe Felici:** (r). **129** Giuseppe Felici: (tl). Rodolfo Felici: (bl, tr, br). **130** Alberto Felici: (bl). **131** Giuseppe Felici: (l, tr, br). **132–133** Giuseppe Felici. **134** Alberto Felici: (tl, b). **134–135** Giuseppe Felici: (t). **135** Alberto Felici: (tc, r). Rodolfo Felici: (bc). **136** Rodolfo Felici: (l). Giuseppe Felici: (r). **137** Giuseppe Felici: (t). Gianlorenzo Pontrandolfi: (c, b). **138–139** Rodolfo Felici. **140** Giuseppe Felici: (l, br). **140–141** Giuseppe Felici. **141** Rodolfo Felici: (bl). **Giuseppe Felici:** (br). **142** Giuseppe Felici. **142–143** Rodolfo Felici. **143** Rodolfo Felici: (tl, tr). **144** Giuseppe Felici. **144–145** Rodolfo Felici. **145** Rodolfo Felici: (bl, tr, br). **146–147** Rodolfo Felici. **147** Giuseppe Felici: (t, b). **148** Rodolfo Felici: (r). **Getty Images:** Andreas Solaro / AFP (b). **149** Giuseppe Felici. **150** Rodolfo Felici: (tl, bl). **150–151 Getty Images:** Giulio Origlia. **151** Giuseppe Felici: (t). **152** Rodolfo Felici: (tr, br). **Giuseppe Felici:** (l). **153** Rodolfo Felici: (t, b). **154–155 Corbis:** Alessandra Benedetti / Alessandra Benedetti (t, cr); Alessandra Benedetti / Vatican Pool (br). **156 Corbis:** Andrea Franceschini / Demotix (br). **157 Corbis:** Andrea Franceschini / Demotix (br). **Getty Images:** Franco Origlia (tr); Andreas Solaro / AFP (cl, bl). **158** Giuseppe Felici: (l). Gianlorenzo Pontrandolfi: (r). **159** Rodolfo Felici: (t). Giuseppe Felici: (c, br). Gianlorenzo Pontrandolfi: (bl). **160** Rodolfo Felici: (t, b). **161** Rodolfo Felici. **162–163** Rodolfo Felici. **163** Rodolfo Felici: (t, b). **164** Rodolfo Felici:

(tl). **Giuseppe Felici:** (b). **164–165** Rodolfo Felici. **165** Rodolfo Felici: (b, t, r). **166** Rodolfo Felici: (l). **166–167** Rodolfo Felici. **167** Rodolfo Felici: (tl, tr, br). **168–169 Corbis:** Eberts Peter / Arcaid. **170** Giuseppe Felici: (t). **Rodolfo Felici:** (b). **171** Alberto Felici. **172–173** Giuseppe Felici. **173 Corbis:** Alessandra Benedetti (t). **Giuseppe Felici:** (br). **174–175** Rodolfo Felici. **175** Giuseppe Felici: (t). **176 Getty Images:** Franco Origlia / stringer. **176–177 Getty Images:** Franco Origlia / stringer (b). **177** Rodolfo Felici: (tr, br). **Giuseppe Felici:** (bc). **178–179** Rodolfo Felici. **180** Giuseppe Felici: (t). **Rodolfo Felici:** (b). **181** Rodolfo Felici. **182** Rodolfo Felici: (tr, br). **Giuseppe Felici:** (bl). **183** Rodolfo Felici: (l, tr, br). **184** Giuseppe Felici: (l, tr). **Gianlorenzo Pontrandolfi:** (br). **185** Giuseppe Felici: (l, tr). **186 Corbis:** Alessandra Benedetti / Alessandra Benedetti (tl). **Giuseppe Felici:** (bl, tr). **Rodolfo Felici:** (br). **187** Rodolfo Felici: (tl, bl, tr, r). **188–189** Rodolfo Felici. **190** Rodolfo Felici: (t). Rodolfo Felici: (b). **191** Rodolfo Felici. **192 Corbis:** Ettore Ferrari / ANSA (tl); Massimo Valicchia / Demotix (bl); Massimo Valicchia / NurPhoto / NurPhoto (r). **193 Getty Images:** Franco Origlia (t, b). **194** Giuseppe Felici: (l, tr). **Rodolfo Felici:** (br). **195** Giuseppe Felici: (tl, bl, r). **196–197** Giuseppe Felici. **197** Giuseppe Felici: (r). **198–199** Rodolfo Felici. **200** Giuseppe Felici: (t). Rodolfo Felici: (b). **201** Rodolfo Felici. **202 Corbis:** Alessandro Bianchi / Reuters. **203 Corbis:** Tony Gentile / Reuters (bl). **Getty Images:** Tiziana Fabi / stringer (t); Franco Origlia / stringer (br). **204** Rodolfo Felici. **205** Rodolfo Felici: (tl). Giuseppe Felici: (bl, br). Gianlorenzo Pontrandolfi: (tr). **206** Rodolfo Felici: (t). Giuseppe Felici: (b). **207** Rodolfo Felici: (t). Giuseppe Felici: (b). **208 Corbis:** Alessandro di Meo / ANSA (l). Rodolfo Felici: (r). **209** Rodolfo Felici: (tr, br). Giuseppe Felici: (l). **210–211 Getty Images:** Giulio Origlia. **211 Getty Images:** Franco Origlia / stringer (t). **212–213** Giuseppe Felici. **213** Giuseppe Felici: (t). **214** Rodolfo Felici. **215** Rodolfo Felici: (l, tr, br). **216–217 Corbis:** Alessandro di Meo / epa. **218–219 Getty Images:** Johannes Eisele / AFP. **220 Corbis:** Alessandro Bianchi / Reuters (t); Stefano Rellandini / Reuters (b). **221 Getty Images:** Franco Origlia / stringer. **222 Alamy Images:** epa european press photo agency b.v. (r). **Getty Images:** Tullio M Puglia / stringer (tl, tr). **223 Getty Images:** Tullio M Puglia / stringer (l);

(r). **224 Corbis:** Alessandra Benedetti (bl); Stefano Dottori / NurPhoto / NurPhoto (tr, br). **Getty Images:** Marco Secchi / stringer (tl). **225 Corbis:** Pool / Reuters (tr, br). **Getty Images:** Vatican Pool (l). **226 Getty Images:** Vincenzo Pinto / AFP (r); Andreas Solar / AFP (l). **226–227 Getty Images:** Franco Origlia (b). **227 Corbis:** Fotonews / Splash News (tl). **Getty Images:** Alberto Rizzoli / AFP (br); Franco Origlia / stringer (tr). **228–229 Corbis:** Stefano Rellandini / ANSA (tr); Stefano Rellandini / Reuters (tl); Matteo Chinellato / XianPix (b). **230 Corbis:** Chamila Karunarathne / Demotix (b); Eyal Warshavsky (t). **231 Getty Images:** Giuseppe Cacace / AFP. **232 Corbis:** Aline Massuca / epa (bl); Stefano Rellandini / Reuters (tl); Luca Zennaro / Pool / epa (bc). **232–233 Corbis:** Ricardo Moraes / Reuters. **233 Corbis:** Sergio Moraes / Reuters (b); Luca Zennaro / Pool / epa (t, br); Max Rossi / Reuters (tr). **234–235 Getty Images:** Christophe Simon / AFP. **235 Getty Images:** Yasuyoshi Chiba / AFP (tr). **236–237 Corbis:** GPO / Pool / NurPhoto. **237 Corbis:** Jim Hollander / epa (b); Andrew Medichini / Pool / epa (t). **238 Corbis:** Daniel Dal Zennaro / epa (t, b). **238–239 Corbis:** Issei Kato / Reuters. **239 Corbis:** Jung Yeon–Je / Pool / epa (t); Daniel Dal Zennaro / epa (b). **240 Corbis:** Tony Gentile / Reuters (tl); Christophe Karaba / epa (bl). **240–241 Corbis:** Arben Celi / Reuters. **241 Getty Images:** Armend Nimani / stringer (r); Gent Shkullaku / stringer. **242 Getty Images:** Filippo Monteforte / AFP (l). **242–243 Corbis:** Tolga Bozoglu / epa. **243 Corbis:** Alessandro di Meo / epa (t). **Getty Images:** Anadolu Agency / contributor (r). **244 Corbis:** Ettore Ferrari / epa (b); Stefano Rellandini / Reuters (tl, tr). **244–245 Corbis:** Chamila Karunarathne / Demotix. **245 Corbis:** Ettore Ferrari / epa (b); Alessandro Tarantino / Pool / epa (t). **246–247 Corbis:** Stefano Rellandini / Reuters. **248–249 Corbis:** Dennis M Sabangan / epa. **249 Corbis:** Dennis M Sabangan / epa (tl, c). **Getty Images:** Ted Aljibe / AFP (cr); Johannes Eisele / AFP (b). **250–251 Corbis:** Ezra Acayan / Reuters. **256: Fotografia Felici**

Jacket images: Fotografia Felici

For further information see: www.dkimages.com

DK would like to thank Steve Crozier (Butterfly Creative Services Ltd) for color retouching and Margaret McCormack for the index.

FOTOGRAFIA FELICI

Fotografia Felici is a family-run photographic studio founded by Giuseppe Felici in Rome in 1863. With a history of more than 150 years, it is one of the oldest remaining studios run by the same family.

In 1888, Giuseppe Felici received the gold medal for the Vatican Universal Exhibition, but the document appointing him as papal photographer, first signed by Pope Pius X, is from October 15, 1903. Since then, the work of the studio has been almost exclusively within the Vatican.

Today, Fotografia Felici is one of two studios, along with *L'Osservatore Romano*, that shares the privilege of photographing papal events in the Vatican. Their role is to create a photographic record of these events and to provide people who see or meet the Pope with a special memento of the emotions experienced.

THE FELICI STUDIO, C. 1910

Rodolfo Felici represents the fifth generation to follow in this family tradition. A trained architect, he has worked as a photographer in the Vatican since 1999, together with his father, Giuseppe, and other members of the family.

Fotografia Felici has donated the entire proceeds of the royalties from this book to the Office of Papal Charities, an organization entrusted by Pope Francis himself with caring for the poor of the city of Rome. Under its auspices, people are fed and clothed, and also offered health and medical services, in the shadow of St. Peter's Basilica. Those in financial difficulties can seek help from the Papal Almoner, who acts personally for Pope Francis.

For further information, see **www.fotografiafelici.com**